CHICANO ART INSIDE/OUTSIDE THE MASTER'S HOUSE

D0223075

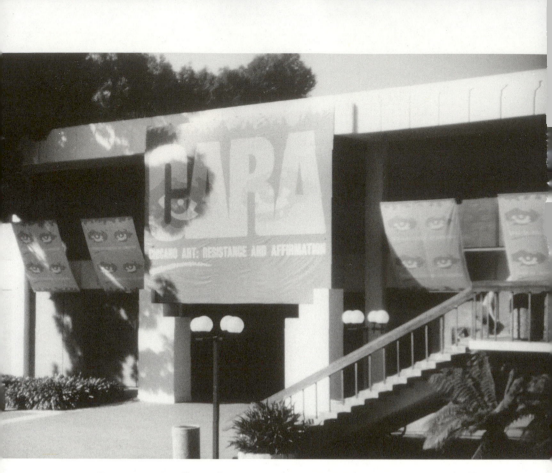

Frontispiece: Installation shot. Main entrance. CARA: Chicano Art: Resistance and Affirmation, exhibition held at UCLA's Wight Art Gallery, September 9–December 9, 1990. Photograph provided courtesy of the Wight Art Gallery.

Chicano Art

INSIDE/**OUTSIDE** THE MASTER'S HOUSE

CULTURAL POLITICS AND THE CARA EXHIBITION

Alicia Gaspar de Alba The University of Texas Press

This book has been supported by a grant from the National Endowment for the Humanities, an independent federal agency.

Second paperback printing, 2000

Requests for permission to reproduce material from this work should be sent to Permissions, University of Texas Press, Box 7819, Austin, TX 78713-7819.

⊗ The paper used in this publication meets the minimum requirements of American National Standard for Information Sciences—Permanence of Paper for Printed Library Materials, ANSI Z39.48-1984.

Library of Congress Cataloging-in-Publication Data

Gaspar de Alba, Alicia, 1958–
 Chicano art inside/outside the master's house : cultural politics and the CARA exhibition / by Alicia Gaspar de Alba. — 1st ed.
 p. cm.
 Interdisciplinary cultural study and discussion of an exhibition of Mexican-American art, known as C.A.R.A. (Chicano Art: Resistance and Affirmation) which toured mainstream U.S. museums between 1990–1993.
 Includes bibliographical references and index.
 ISBN 0-292-72801-8 (cloth : alk. paper). — ISBN 0-292-72805-0 (paper : alk. paper)
 1. Mexican American art. 2. Politics in art. 3. Mexican American art—Public opinion. 4. Mexican Americans—Civil rights.
I. Title.
N6538.M4G37 1998
704'.0368'72073—dc21 97-11398

For DJG
and
Yolanda M. López

The master's tools will not dismantle the master's house.
—Audre Lorde, *Sister/Outsider*

From within, we must help the United States become an enlightened neighbor on this continent and a respectful landlord in its own house.
—Guillermo Gómez-Peña, *Warrior for Gringostroika*

In the rich man's house, the only
place to spit is in his face.
—Daniel Martínez (paraphrasing Diogenes),
from his installation at the 1993 Biennial Exhibition,
Whitney Museum

Contents

Figures

Tables

Pre-Face/

Pre-CARA

I belong to that generation of Chicano/a scholars who grew up during the Chicano Civil Rights Movement, too young to physically participate in the marches, strikes, boycotts, sit-ins, and blow-outs that characterized el Movimiento during the quaking sixties, but old enough to reap the benefits of affirmative action, bilingual education, and "minority" fellowships. I am also entering the academy at a time when the survival of Chicana/Chicano Studies is threatened as much by the external bureaucratic backlash against anything "multicultural" as by the internecine hostilities of a discipline unwilling to change its ideological and methodological guard. But, as I explain in my personal essay "Literary Wetback," I am used to negotiating borders and contradictions. I was brought up in a Mexican immigrant, Spanish-Only, Catholic, middle-class, light-skinned family who deeply resisted assimilation and yet at the same time believed that

> Mexican-Americans, or Pochos, as my family preferred to call them, were stupid. Not only could they not even speak their own language correctly (meaning Spanish), but their dark coloring denounced them as

ignorant. Apart from being strict, Mexican, and Catholic, my family was also under the delusion that, since our ancestors were made in Madrid, our fair coloring made us better than common Mexicans. If we maintained the purity of la lengua Castellana, and didn't associate with Prietos or Pochos, our superiority over that low breed of people would always be clear.[1]

I did not arrive at my own *concientización*[2] as a Chicana until my third year in college when I took one of the only Chicano Studies courses offered at the University of Texas at El Paso, taught by one of a handful of Chicana professors on the faculty. At the same time that I was decolonizing my mind through poetry and fiction, I was coming out as a lesbian. Eleven years later, as a doctoral student and teaching assistant in American Studies making waves about the ethnocentrism of the discipline, I walked into the Albuquerque Museum of Art and encountered the *Chicano Art: Resistance and Affirmation, 1965–1985* exhibition, better known by its acronym, CARA.

Upon completing my three-hour tour of the show, I realized that, my doctoral education notwithstanding, I was embarrassingly ignorant about the historical and political context, the breadth and scope of Chicano/a visual art. Despite Art Appreciation, American History, and Political Science classes in college (all of which should have accommodated at least one pertinent section on the artistic, historical, or political developments of the Chicano Movement); despite growing up in El Paso, home of the original Pachucos and turf of La Raza Unida party; despite a five-year course of study on "American life and thought" (which treated matters of race and ethnicity, if at all, as tangents or supplements to the reading list)—despite all the knowledge I had gained on the road to becoming "Doctor" Gaspar de Alba, I knew relatively little of the political history and cultural production of Chicanos/as. Standing in the CARA exhibit, surrounded by this history and this material culture, I understood that in order to really "see" Chicano and Chicana art, I would have to make the exhibition the focus of an extended study.

In seeking to fill this "blank spot" in my education, which, as Alice Walker says, "needed desperately to be cleared if I expected to be a whole woman, a full human being, a [Chicana] full of self-awareness and pride,"[3] I saw CARA more times than I care to admit in Albuquerque, then traveled to see it in its last four venues: Washington, D.C., El Paso, New York, and San Antonio. I spoke with curators, museum staff and arts administrators, artists, art historians, academics, gallery owners, mem-

bers of the exhibit's different organizing committees, viewers. I collected viewer comments and three inches of press clippings on the show. I badgered the Wight Art Gallery to let me use the CARA archives for my research before they were even completed and traveled to Stanford University to pore through the personal papers of the two key organizers of the exhibition. I waited impatiently for the catalog, which was not released until a year after CARA opened at UCLA.

All of this exploration and immersion led me back to Chicano/a history and culture, back home to myself. In fact, I saw CARA so much that it became a home to me, a physical space, recreated in different venues, where I could see and hear the story of la Raza again. Names that didn't mean anything to me when I first saw the exhibition in Albuquerque became dear and familiar: Malaquías, Carmen, Yolanda, Rupert, José, Ester, Delilah, Harry, Juana Alicia, Carlos, César, Barbara. I disagreed with some, admired others, argued with a few, and slowly realized that this dialogue was part of CARA's intention: to open the doors to the master's house—the hitherto exclusionary space of the mainstream museum—to remodel the interior *al estilo Chicano* and create an environment where Chicano/a art could be the vehicle for dialogue and reflection. For the thousands of Raza across the country who had never felt addressed or represented in an art museum until CARA, the exhibition signified a personal and collective victory. They, too, were home for the first time in a public place. The old Mexican adage Mi *casa es su casa* was on the other foot, for once. The "white" house of the museum was now also a Raza house: *bienvenidos/as*.

This idea of home kept resonating for me with an image of a house from my studies in popular culture. Although I discuss this at length in Chapter 1, it is important to note here that the connection I made between the idea of being "home" in a historically inhospitable place for Chicanos/as and the idea of using a house to conceptualize the study of popular culture helped me to see that, in fact, Chicanos/as were not at home in the academy just as they were not at home in the art world. "Home," say Becky Thompson and Sangeeta Tyagi, "is where people have gone to feel comfortable, to be with people like themselves, to be rejuvenated, to see a reflection of themselves in those around them."[4]

The connection underscored my own invisibility as a Chicana. Not only was I seeing Chicano/a art for the first time in the master's house, I was seeing myself reflected in that art as well. Conversely, in my Popular Culture Studies, I was not being seen at all. Chicano/a popular culture did not exist as an academic category of analysis. We read about lowriders, to

Pre-Face/Pre-CARA

xv

be sure, and about *La Bamba* and Los Lobos, but this was all interesting "ethnic" stuff, introduced in the curriculum for the sake of diversifying the syllabus, lumped together with Alice Walker, Paula Gunn Allen, and Ronald Takaki under the classification of "subculture."

The connection, finally, between the master's house where Chicano/a art was currently installed and the house of popular culture where things "ethnic" were barely visible helped me to build an argument against the hegemonic and hegemonizing view of Popular Culture Studies, which subjugates the popular texts, traditions, customs, values, beliefs, and political identities of Other American cultures to subcultural status. Through this work, I arrived at the hypothesis that Chicano/a culture is an *alter-Native* culture within the United States, both alien and indigenous to the landbase known as the "West." My conclusion, then, that mi *casa [no] es su casa*[5] signifies that while Chicanos/as are cultural citizens of the United States, neither the mainstream art world nor the dominant popular culture is a hospitable place for Chicano/a cultural production. Twisting the adage around even more appropriately, I conclude that mi *CARA [no] es su CARA*, for the face of Chicano/a art constructed by the exhibition, the face of Chicano/a identity, is both an insider's and an outsider's face, both present and absent in the discourse of American art, life, and culture. This book, then, is the story of how an alter-Native culture came to represent itself, to create its own face, within the master's house. Gloria Anzaldúa calls this *haciendo caras*, which, more than making or creating face, "has the added connotation of making *gestos subversivos*, political subversive gestures, the piercing look that questions or challenges, the look that says 'Don't walk all over me,' the one that says, 'Get out of my face.'"[6]

The Introduction examines the theoretical framework of the study, a three-pronged approach that analyzes the aesthetics, politics, and methodologies used in my cultural critique of CARA and explores the contours of my social and cultural description of both the mainstream art world and the historical moment in which the CARA exhibition made its debut. In my analysis of the artworks and ideologies contained in the CARA exhibit, I situate the representation of this alter-Native culture within the cultural narrative of multiculturalism, which for a few golden years reigned supreme as the predominant cultural discourse of the academy in general and of American Studies in particular.

In Chapter 1, I deconstruct the ethnocentric paradigm of Popular Culture Studies by constructing a separate paradigm for studying Chicano/a popular culture. This chapter also takes the reader on an "open house" tour of Chicano/a art, history, and popular culture, briefly visiting the ten

Pre-Face/Pre-CARA

xvi

rooms of the exhibition and reconstructing the architectural model by which to study Chicano/a popular culture.

The chapters in the second section explore CARA's organizational structure and politics of representation. Chapter 2 analyzes the making of the exhibition, the ideological visions underlying the show, the conflicts and contradictions between them, and the untraditional (some call it democratic) process of the exhibit's development. Chapter 3 carries the critique of the show's politics of representation into the gender arena. By juxtaposing the three separate *grupo* installations with the "Feminist Visions" gallery, I deconstruct the image of "la Chicana," as it was visualized and manipulated by the patriarchal tenets of the Chicano Art Movement, and its antithesis, "la Malinche," as it has been appropriated, subverted, and transformed by Chicana artists and Chicana feminists to construct a new theory of resistance. The chapter is an overt critique of the selection process of the exhibit which privileged those male interpretations of la Chicana, while at the same time using the work of Chicana artists to reproduce the sexist messages of el Movimiento.

Chapter 4 examines public reception to CARA through the analytical lens of Stuart Hall's reception theory, tracing the dominant, negotiated, and oppositional responses that the exhibit received in two domains of discourse: published reviews and viewer comments. Contextualized within three separate frameworks, the reviews and comments illuminate the Quality/Diversity debate that destabilized the mainstream art world in the late eighties; the "discovery" narrative of the Quincentennial that set the stage for a national exploration of Chicano/a art and culture; and the grateful, gratified, and resilient voices of la Raza, who for the first time felt not only represented in the public art museum, but also respected.

The Conclusion explores the multiple meanings and uses of multiculturalism in different registers of the culture industry and shows how CARA was, in fact, paradigmatic of the rise and fall of the "Diversity" moment. The study ends with an Appendix of selected viewer responses to the exhibition. Taken from three of the comment books generated by CARA, the responses tell a story about what it meant to those Chicanos and Chicanas[7] who saw the show in different parts of the country to have found la Raza filling the rooms and halls of the master's house.

Thanks to this most powerful, most stimulating, most prideful exhibit, I have gotten motivated to research more deeply into Chicano art, which, as a Chicana trained in Anglo schools, brought up by parents who denied any connections to Chicanos/Chicanas, I was

unaware of. *Ahora me estoy saliendo de la ignorancia. Gracias.* This show has moved my own resistance and affirmation. 4/27/91 [8]

Indeed, the CARA exhibition has been a vehicle of *concientización* in my training as a Chicana cultural critic, permitting me to arrange pieces of three separate puzzles—Chicanismo, feminist theory, and Popular Culture Studies—into a hybrid, alter-Native methodology in the study of a face that is not your face, a house that is not your house.

Acknowledgments

Without the artists and the organizers involved in the making of the CARA exhibition, and without those who graciously agreed to let me ply them with questions about the show, there would be no book. Special thanks to all of my interviewees for sharing their "insider" views on the different facets of my research, but especially to Andrew Connors, who gave freely of his time and insights and generously provided me with copies of comments and other archival materials relating to CARA, and to Tomás Ybarra-Frausto, who mentors every time he speaks.

Thanks to my colleague Chon Noriega for his detailed comments and suggestions on the early drafts of the manuscript as well as for his continued friendship and encouragement over the last five years. Thanks to Jane Caputi for being a fine example of a teacher and a critic and for helping me see the inextricable link between political identity and popular culture.

Thanks to Antonia Castañeda, fellow "bloomie," for asking the right questions in the early phases of the theoretical framework. Thanks to my editor, Theresa May, for waiting patiently for the manuscript and for helping me secure one of the last publication subsidies granted by the National En-

dowment for the Humanities. Thanks to Sydney Kamlager of SPARC and my colleague Judy Baca for assistance with permissions and artwork. And immeasurable thanks to Elizabeth Shepherd, curator of the Wight Art Gallery (now at the Armand Hammer Museum), and her staff—Farida Baldonado and Claudine Isé, curatorial assistants, as well as Ava Avalos, programming coordinator for CARA—for permitting me access to the CARA archives even before they were completed and for charitably providing me with slide duplicates of the CARA artwork, lists of names and addresses, and copies of archival material. I am proud to include this book as part of the national CARA archives.

To Yolanda M. López I would like to express my admiration as well as gratitude, not only for allowing me to badger her with questions and to dig through her personal archives, but for being the best example I know of someone who practices what she preaches. Yolanda's commitment to documenting and showing the work of Chicana/Latina artists at her own expense is both a political act and a labor of selfless love.

I must express my deepest *gratitud* to my *compañera*, Deena J. González, for everything from folding laundry to finding citations—both my jobs—to putting up with my *locuras* and keeping me from wandering off into the abstractosphere. *Historiadora al fin*, you have helped me to understand the complexities of Chicana identity by showing me on a daily basis the differences between a fourteenth-generation Chicana from New Mexico and a first-generation *fronteriza* from El Paso/Juárez.

I would also like to acknowledge the several institutions that provided me with invaluable support: the Committee on Research at UCLA for a 1994–1995 Faculty Research Grant; the Office of Academic Development and Associate Vice Chancellor Raymund Paredes for summer research monies in 1994 and 1995; the Minority Scholars-in-Residence Program at Pomona College for a postdoctoral fellowship in 1994–1995 that afforded me the time to fine-tune my theoretical construct and to organize a symposium of Chicana Art; the National Research Council, the Chicano Studies Department at the University of California, Santa Barbara, and the Tomás Rivera Center Summer Institute for grants and other resources during the early incarnations of this project, 1992–1994; and, finally, the American Studies Association for awarding the dissertation version of this book the Ralph Henry Gabriel Prize for the Best Dissertation in American Studies, 1994.

Last but absolutely not least, thanks to my research assistants, William Pérez and Julie Amador at the Claremont Colleges and Jeffrey Lamb and Ramona Ortega at UCLA. Thank you, Jeff, for those long hours you spent

hunched over the transcription machine transcribing interviews; and, bless you, Ramona, for tackling the miscellaneous tasks involved with the permissions. You have the satisfaction of knowing that each image reproduced here appears thanks to your persistence.

Only artwork for which I received permission from the artist or the collector has been reproduced in this book. Some artwork, though discussed in the text, could not be used because I could not contact the artist or the artist did not respond to my request for permission to reproduce his/her work. Please see the CARA exhibition catalog for more reproductions of Chicano/a art.

Finally, a word about accents. I have complied with the rules involving accents on Spanish surnames and accented all names that require accents except those of Marcos Sanchez-Tranquilino and Holly Barnet-Sanchez, who specifically requested that no accents appear on their names.

CHICANO ART INSIDE/OUTSIDE THE MASTER'S HOUSE

A Theoretical Introduction:

Alter-Native Ethnography,

a lo rasquache

Overview of the Show

CARA opened at its host institution, UCLA's Wight Art Gallery, on September 9, 1990, and closed at the San Antonio Museum of Art on August 1, 1993, after a national tour of ten U.S. cities, including Denver, Albuquerque, San Francisco, Fresno, Tucson, Washington, D.C., El Paso, and the Bronx.[1] The exhibition featured 128 pieces of art and 54 mural images by some 140 Chicano and about 40 Chicana artists (including the muralists named in the catalog). There were ten sections in the exhibit, beginning with a historical timeline and proceeding thematically through nine different visual interpretations of the goals and struggles of *la Causa*. Through a rear-projected slide display viewers were introduced to the murals of the Chicano Art Movement in California, the Southwest, and the Midwest. The show also included three metainstallations in the form of *casitas* that featured three of the more influential collectives of Chicano artists.

According to the generic floorplan of the exhibition, the very first section of the exhibit provided an abridged history of Chicanos/as and their ancestors. Called a "Selected

1

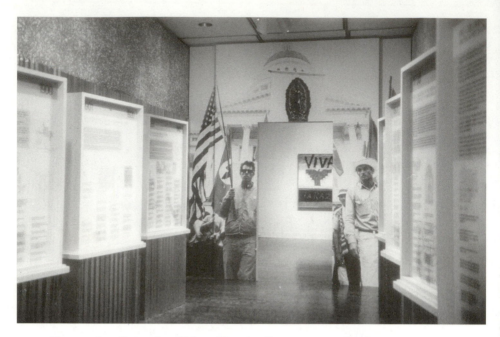

Figure 1. Installation shot. "Selected Timeline" room. CARA: Chicano Art: Resistance and Affirmation, exhibition held at UCLA's Wight Art Gallery, September 9 – December 9, 1990. Photograph provided courtesy of the Wight Art Gallery.

Timeline," this history began with "Pre-Columbian America and Aztlán, 1345–1699" and ended with "The Chicano Movement Is Born, 1951–1964."

As context or countertext to this synopsis of Chicano/a history, the text panels also outlined U.S. and international events. The last items in this first room were two Masonite boards embossed with text—one defining in Spanish and English the main signifier of the exhibition, the word "Chicano," and the other displaying quotations from some of the featured artists and activists about what it means to call oneself Chicano.

> Whatever the derivation of the word "Chicano" . . . to apply it to oneself is a political act. It is an act of cultural identification with one's Mexican-Spanish-Indio heritage. One who seeks to become assimilated in the Anglo-American society would not use "Chicano."—Carlota Cárdenas, 1977

> We artists and activists created an artistic visual identity of who we were, American with Mexican heritage, "Chicano" was our new name.—Chaz Bojórquez, 1990[2]

A Theoretical Introduction

2

After this selective introduction to Chicano/a history and identity (and, again, according to the original installation of the show at UCLA), the viewer passed under a photo-mural shaped like a triumphal arch, an image documenting the farm workers' historic 250-mile march from Delano to Sacramento in 1966. Led by César Chávez, the march was a protest against the human and civil rights violations against Mexicans, Chicanos/as, and Filipinos in the pesticide-poisoned grape fields of California.[3] Thousands of sympathizers and supporters from the factories, the schools, and the barrios attended the demonstration. Considered to be the genesis of el Movimiento, this march was chosen to signal the beginning of the exhibition, itself a protest.

Only after it had been contextualized within a historical and political framework could the art show begin. The epigraphal "La Causa" section, focusing on the farm worker struggles that ignited the march on Sacramento, blended seamlessly into "Cultural Icons," a display of heroic portraits meant to signify the beliefs and struggles of the Chicano Art Movement. From here, viewers moved into the central "Civil Liberties" and "Urban Images" rooms, both filled with images and objects that highlighted civil rights issues such as police brutality, deportation, and racism, as well as the urban survival strategies adopted by Chicanos. Then came the "Murals" display, accompanied by a closed-circuit documentary video entitled Through Walls, which presented brief interviews with some of the muralists whose work was being displayed in the slide show.[4] The video replayed every ten minutes, providing viewers throughout the exhibit with Chicano and Chicana voices, Raza music, and the recurring theme of el grito Chicano: "Chicano! Power!" Another video in the exhibition showed an artists' round table: eight artists involved in the selection process of the exhibition discussing Chicano/a art and the politics of representation in the mainstream art world.

"Regional Expressions," the largest section in CARA, attempted to document the presence of Chicano/a artists across the country and contained a wide diversity of media, whereas "Reclaiming the Past," the section devoted to family and religious traditions that featured Amalia Mesa-Bains's fragrant altar to Mexican movie star Dolores del Río, was composed almost exclusively of mixed-media installations.

In the rooms between "Civil Liberties" and "Reclaiming the Past" visitors to the exhibition encountered the grupos installations. Each of the grupos, also known as Chicano art collectives, like the Rebel Chicano Art Front or Royal Chicano Air Force (RCAF for short), ASCO (which means Nausea), and Los Four, merited its own casita, complete with three walls,

A Theoretical Introduction

3

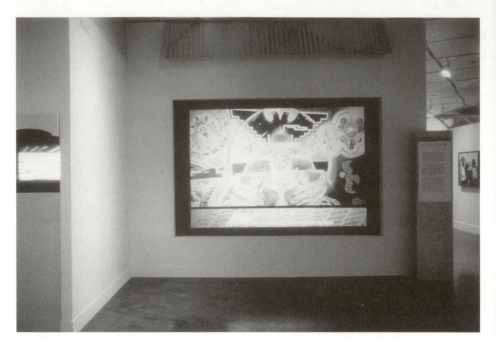

Figure 2. Installation shot. "Murals" display with *Through Walls* video. CARA: Chicano Art: Resistance and Affirmation, exhibition held at UCLA's Wight Art Gallery, September 9–December 9, 1990. Photograph provided courtesy of the Wight Art Gallery.

columned doorways, zinc roofs, and chain-link windows. Within these metaspaces, the *grupos* set up assemblages representing their collective ethos during the Chicano Art Movement (see Chapter 4).

"Feminist Visions," the penultimate room, displayed Chicana feminist re-visions of female iconography. Used as a transitional device between the religious/family past (iconographed in el Movimiento as the domain of the feminine) and the more individualized future of Chicano/a art (less informed by community values, more representative of a personal voice or vision), the section communicated the Chicano ideals of motherhood and *familia*.[5] The exhibit closed with "Redefining American Art," meant to demonstrate not only that individual Chicano/a artists such as Rupert García, Carmen Lomas Garza, Carlos Almaraz, Frank Romero, and Gronk have had an impact on the mainstream art world, but also that Chicano/a art is an indigenous art from the margins of U.S. culture and as such must be contextualized within both national and international mainstreams in the history of Western art. Another way in which to contextualize CARA

A Theoretical Introduction

4

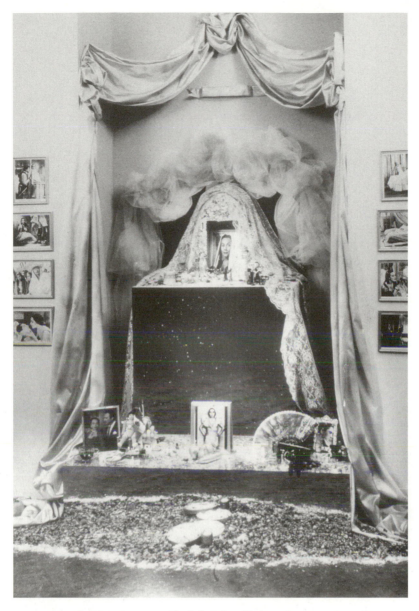

Figure 3. Amalia Mesa-Bains, *An Ofrenda for Dolores del Río*, 1984; reconstructed 1990, mixed media altar installation. Reproduced by permission of the artist.

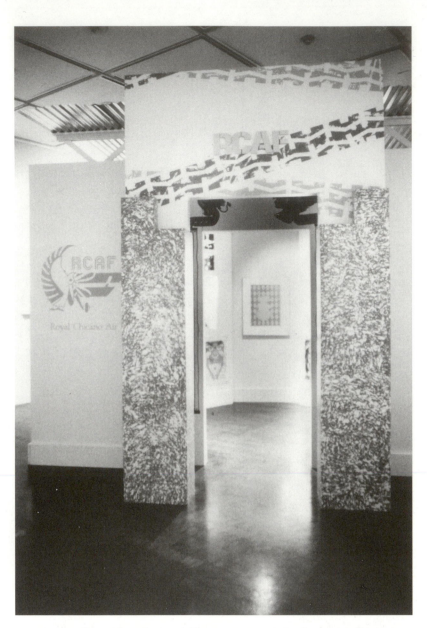

Figure 4. Installation shot. The Royal Chicano Air Force (RCAF) *casita*. Installation that was part of CARA: Chicano Art: Resistance and Affirmation, exhibition held at UCLA's Wight Art Gallery, September 9–December 9, 1990. Photograph provided courtesy of the Wight Art Gallery.

is as a text about the life-practices of an "Other" American culture, and so it falls within the purview of Cultural Studies.[6]

Chicanos/as in the Master's House

CARA was more than an art exhibition. As the first major national art show organized and represented by Chicanos and Chicanas in collaboration with a mainstream art institution, it constituted a historic, cultural, and political event. Historically, CARA marked the large-scale intervention of a marginalized art and culture in the master's house, the elite space of the "public" art museum. Culturally, CARA engaged in the critical debates and struggles of a postmodern society, particularly those focusing on the tensions between identity/difference, margin/center, subjectivity/representation, high/low culture, insider/outsider. Politically, CARA countered the aesthetic traditions of the mainstream art world, challenging institutional structures of exclusion, ethnocentrism, and homogenization.

In his survey of Chicano art exhibitions since 1965, Jacinto Quirarte says that "Chicano public and nonpublic art has been included in exhibitions in the barrios, in college and university libraries . . . and in public museums and galleries since the late 1960s."[7] Indeed, other national art shows that included the work of artists of Mexican descent had already toured the country: in 1987, *Hispanic Art in the United States*, curated by John Beardsley and Jane Livingston, opened at the Museum of Fine Arts, Houston; in 1988, *The Latin American Spirit*, organized by Luis Cancel, opened at the Bronx Museum. In 1990, one month after CARA opened at UCLA, the mammoth *Mexico: Splendors of Thirty Centuries*, organized by the Metropolitan Museum of Art, opened in New York.[8]

Aside from these larger national mainstream shows, other exhibitions of Chicano and Chicana art had sprung up in California and the Southwest as early as 1965. Regional or local in scope, these early shows, which were held for the most part in community centers and on local campuses, Quirarte tells us, "received virtually no attention from the press";[9] they also had no funds for catalogs or other forms of institutional support. Later shows included the *Arte del Barrio* exhibitions sponsored by Galería de la Raza in San Francisco (1968 and 1970), exhibitions in San Antonio, Taos, and Albuquerque (1973) that followed the publication of Quirarte's *Mexican American Artists*, Los Four's exhibition at the Los Angeles County Museum of Art (1974), said to be the first time Chicano art was exhib-

ited in a mainstream museum, *Chicanarte* (1975) in Los Angeles, *Dále Gas* (1977) in Houston, and *Homage to Frida Kahlo* (1978) in San Francisco.[10]

Of these, perhaps the most significant in terms of laying out an exhibition structure and programming agenda that can be called a precursor to CARA was *Chicanarte*, which Quirarte deems "the most important exhibition of this early phase [of Chicano art]."[11] Organized by several Chicano artists and Chicano cultural centers from across California and sponsored in part by the Fine Arts Department and the Chicano Studies Research Center at UCLA, this exhibition provided an early model of curation by committee and collaboration between members of the Chicano art world, UCLA, and the larger art community of Los Angeles. Moreover, *Chicanarte* also included public outreach activities such as dance and *teatro* performances, film screenings, concerts, and poetry readings as part of the exhibition's educational programming, yet another feature that was adopted by the organizers of the CARA exhibition.

CARA's unique significance and contribution to the history of Chicano/a art exhibitions, then, is not just its presence in public museums across the country, but rather, as we shall see in this study, its resistance to traditional museum and market practices, its complex organizational structure, its politics of self-representation, and its reception by the different communities that it addressed and/or confronted.

In its twenty-year retrospective of the Chicano Art Movement, CARA rendered an interpretive visual history of the goals and struggles of el Movimiento, the Chicano Civil Rights Movement that began in the mid-1960s. The artists who affiliated with the Chicano Art Movement did not identify themselves as Mexican Americans, Latinos, or Hispanics, but as *Chicanos* whose work expressed resistance to the hegemonic structures of mainstream America—particularly "melting pot" ideologies—and affirmation of their multilingual, multicultural heritage as expressed in the concepts of *mestizaje* and la Raza.[12] In rejecting outwardly imposed labels such as Mexican American and Hispanic, and naming themselves Chicano, these artists and activists were making a political statement about their lives, a proclamation of emancipation from the homogenizing labels and manifest destiny of oppression inscribed by Anglo America through its discriminatory political structure and other ethnocentric cultural institutions, including its educational system, its mass media, and its arts industry.

Chicano artists were not the first to question and challenge hegemonic codes within the mainstream art world. In *Mutiny and the Mainstream*, a col-

A Theoretical Introduction

8

Figure 5. Harry Gamboa, Jr., *Zero Visibility*, 1979, black-and-white photograph. Collection of Diego Gamboa. Reproduced by permission of the artist.

lection of over 200 talks, reports, and panel presentations that "changed art" between 1975 and 1990, editor Judy Seigel says that "artists across the land launched a mutiny, defied modernist rules, jettisoned mainstream purity, and set out for the uncharted seas of pluralism."[13] Pluralism was the name given to the several movements within the art world that rejected purely formalist standards and reinserted elements such as "narrative, decoration, figuration, and allegory" back into art.[14] Among them were the Women's Movement, the Native American Fine Art Movement, and the Chicano Art Movement. Like other marginalized members of the mainstream art world, Chicanos had a specific agenda, which, says Seigel:

> really did *set about to change* the philosophy and structure of the art world . . . to proselytize for the acceptance, maybe the ascendance, of women's art and ideas, as well as art by African-American and "Third World" artists; to celebrate formerly forbidden styles; and, perhaps most thumb-in-the-eye to art's conventional wisdom, to incorporate overtly political themes into art. . . .[15]

A Theoretical Introduction

9

El Movimiento's opposition to class oppression, for example, was manifested in the Chicano Art Movement as resistance to the dichotomy in mainstream aesthetics between "high" culture and popular culture, and its affirmation of the vernacular, the rasquache,[16] and the communal in its artistic production, including form as well as content. By subverting the dichotomies between high culture and popular culture, then, and drawing from local customs, folk traditions, vernacular forms, and everyday life, by opposing the ideology of individualism at the core of "art for art's sake," and expressing, instead, the symbiotic relationship between art and its social context, and by affirming a syncretic identity that manifested itself in the fusion of national/international, experimental/oppositional, personal/political artistic discourses, the Chicano Art Movement, as represented in CARA, created a unique aesthetics and social practice.

Because of its inherently counterhegemonic ethos, CARA deserves to be theorized within discourses of what Chela Sandoval calls "oppositional consciousness."[17] Although the framework of Sandoval's argument situates hegemony and marginalization in terms of feminist theory, which posits gender-based Euro-American feminisms as the norm and the race and class consciousness of feminists of color as the "Other," her idea that all of these constitute a generic oppositional ideology that resists domination and exploitation by the different means encoded within their particular subjugations, as well as an oppositional consciousness that produces its own alternative canon of texts, identities, and strategies distinguished by differing political agendas, applies, I think, to all counterhegemonic efforts. What follows, then, is a brief discussion of three such oppositional discourses within the framework of Chicano/a Cultural Studies that inform my analysis of the CARA exhibition: (1) rasquachismo, a theory and praxis of popular pleasure as a uniquely working-class strategy of resistance to dominant aesthetic codes in the art world, otherwise known as the "Quality" issue; (2) alter-Nativity, an antinativist approach that contests the ethnocentric academic practice of categorizing marginalized indigenous cultures as "subcultures" or objects of discovery (e.g., the Quincentenary); alter-Nativity underscores the relationship between "Other" and "native," particularly in the neighborhood of Popular Culture Studies as well as in the exhibition agendas of mainstream museums; (3) the politics of native ethnography, an approach that problematizes the insider/outsider dynamics of ethnographic methodology and ethnographic criticism, both of which serve to ground analytical practices in Cultural Studies.

Rasquachismo: The Subversive Power of Popular Pleasure

"Pleasure," says Tania Modleski, "(or 'comfort' or 'solace') remains the enemy for the postmodernist thinker because it is judged to be the means by which the consumer is reconciled to the prevailing cultural policy, or the 'dominant ideology.'"[18] Like the Frankfurt School and the postmodernists, even critics of postmodernism such as Roland Barthes and Fredric Jameson see popular culture as a weapon of hegemony that manipulates the audience through pleasure. The masses, the argument seems to run, are controlled by the hegemonic messages couched in the pleasure of the text. Reading the horror film as oppositional cinema, however, Modleski shows how the perverse pleasure of horror films can be subversive to the status quo. "Many of these films," she argues, "[such as *The Brood* and *The Texas Chainsaw Massacre*] are engaged in an unprecedented assault on all that bourgeois culture is supposed to cherish—like the ideological apparatuses of the family and the school."[19] Thus, we have two views of pleasure: as resistance, as complacency—but we also have, according to John Fiske, two kinds of pleasure.

In *Understanding Popular Culture* Fiske explains the difference between hegemonic pleasures which exert social control by producing meanings and practices in the interest of power and popular pleasures which subvert the meanings and values of hegemony and thereby evade being controlled. "High" culture, for example, is said to uplift, edify, and inspire, while "low" culture merely entertains, amuses, or distracts. The former occupies the spiritual, mental domain and is considered "good for the soul"; the latter focuses on the excesses of the body—eating, drinking, vocalizing, being physically stimulated rather than mentally challenged or spiritually renewed. Fiske finds popular pleasures inherently subversive because they "arise from the social allegiances formed by subordinated people[;] they are bottom-up and thus must exist in some relationship of opposition to power (social, moral, textual, aesthetic, and so on) that attempts to discipline and control them."[20] The relationship between popular pleasures and aesthetic values is one of resistance from both ends; the popular resists the imposition of elitist interests and discourses; the aesthetic resists the infiltration of public tastes and standards into its sacred domain.

Perhaps the best example of a popular pleasure in Chicano/a culture is what Tomás Ybarra-Frausto calls *rasquachismo*, a uniquely working-class aesthetic of Mexican origin—resourceful, excessive, ironic, and, in

its transformation of utilitarian articles into sacred or aesthetic objects, highly metaphoric.

> Bright colors (chillantes) are preferred to somber, high intensity to low, the shimmering and sparkling over the muted and subdued. The rasquache inclination piles pattern on pattern, filling all available space with bold display. Ornamentation and elaboration prevail and are joined with a delight in texture and sensuous surfaces.[21]

In the context of Minimalism and Modern art, rasquachismo is more than an oppositional form; it is a militant praxis of resistance to hegemonic standards in the art world. Therein resides its popular pleasure, for in subverting dominant ideologies, in "[turning] ruling paradigms upside down . . . [this] witty, irreverent and impertinent posture that recodes and moves outside established boundaries" both evades power and empowers itself.[22]

"Kitsch" is not an accurate translation or example of rasquachismo, but, in terms of the dominant culture, it signifies a kind of cultural production that also originates in and represents the popular, the vernacular, the working class. In her study on religious paraphernalia, Celeste Olalquiaga describes three kinds of kitsch: "first-degree kitsch" is the real thing, so to speak, a tradition that goes back at least a hundred years. As she explains, "statuettes, images, and scapularies embody the spirits they represent, making them palpable. Consequently, this imagery belongs in sacred places, such as home altars, and must be treated with utmost respect."[23] Next, Olalquiaga names "second-degree kitsch" or "neo-kitsch," which is bereft of history and devotional qualities and "leaves us with an empty icon, or rather an icon whose value lies precisely in its iconicity, its quality as a sign rather than as an object."[24] Whereas first-degree kitsch is bought by devotees, neo-kitsch is mass-marketed and sold as souvenirs and collector's items. Finally, "third-degree kitsch" includes icons and paraphernalia that have been recycled by the art world in the making of "happenings," assemblages, and mixed-media installations. In Chicano/a and Latino/a art, this takes the form of altares, such as Amalia Mesa-Bains's altar in the CARA exhibit, constructed as an homage to Mexican movie star Dolores del Río (see Figure 3). This artistic installation differs from home altars of the first-degree kind, says Olalquiaga. "As a recent exhibition title suggests, the recasting of altares is often meant as a 'ceremony of memory' that invests them with a new political significa-

Figure 6. Rudy Martínez, *A Juanderful Piece*, 1976, polychrome glazed ceramic. Collection of Scripps College, Claremont, California, gift of Mr. and Mrs. Fred Marer. Reproduced by permission of the Registrar, Williamson Gallery.

tion and awareness. This artistic legitimization implies formalizing home altars to fit into a system of meaning where they represent the culture that once was." [25]

Like kitsch, *rasquachismo* comes in at least the three flavors noted by Olalquiaga: first-degree *rasquachismo*, or icons, objects, and practices that are rooted in the oral and popular traditions of Chicano/a culture; second-

degree *rasquachismo*, which is appropriated from its original context by mainstream commercial enterprises such as stores that sell "ethnic" paraphernalia by taking, for example, iconography from Mexican and Chicano culture (such as the Popocatépetl/Ixtaccihuatl imagery taken from *calendarios*, the José Guadalupe Posada *calaveras*, and reproductions of Frida Kahlo's work) and appliquéing these images to clothing, mouse pads, coffee mugs, throw rugs, etc., all bearing the business's own label; and third-degree *rasquachismo* that informs the work of Chicano and Chicana artists— writers, musicians, filmmakers, and other producers of culture—and that is recast in several of the pieces in CARA.

One recurring icon in Chicano/a art is the *calavera* or skeleton that is used in Chicano/a art both in Day of the Dead observances for November 2 and in ironic resistance to cultural annihilation. The tradition of using humor and irony for political commentary goes back as far as colonial Mexico, but it became an especially popular pleasure in the nineteenth century with the *calavera* caricatures of José Guadalupe Posada, from whom Chicano/a artists like Peter Rodríguez and Ester Hernández adapted the tradition (see Figures 32 and 38). "Posada's *calaveras* and broadside illustrations depicted crimes of passion, political and social events, religious imagery, natural disasters, and scenes from Mexican daily life." [26] Because they represented the common denominator between the rich and the poor, the skeletons spoke to all, judged all, respected nobody, and impersonated Everyman and Everywoman.

Commenting on the subversive power of caricature art, José Zuno, author of *Historia de las artes plásticas en la revolución mexicana*, describes the caricaturist as a revolutionary and a social critic:

> Como juzgador, el caricaturista usa de la ironía. De todo se burla, a todo se sobrepone. Hace notar los contrastes entre la belleza y la fealdad, entre la verdad y la mentira. . . . Llega, cuando es necesario hasta la crueldad, hasta la tragedia. Pero la ironía sólo es destructora y negativa en apariencia, pues lo que destruye es lo falso, lo ridículo. Ella representa el esfuerzo que hacemos para triunfar de todo aquello que se opone a la ascensión del espíritu hacia el infinito. [27]

That "esfuerzo . . . para triunfar," or effort to triumph over adversity and oppression, is the pleasure of survival, the most resistant act of all. Indeed, it is through resistance to cultural domination, psychological abuse, and physical hardship that people of color have survived and evolved after 500 years of colonialism.

A Theoretical Introduction

Alter-Nativity and the "Subculture" Model

The CARA exhibit represents the cultural politics and aesthetics of a colonized people within the United States; it also offers us a three-dimensional model by which to organize and conduct a study of Chicano/a popular culture. Michael Schudson says that "popular culture can be understood broadly as beliefs and practices, and the objects through which they are organized, that are widely shared among a population."[28] Because the CARA exhibition displays artistic representations of many of those objects, images, beliefs, values, and *costumbres*[29] that are widely shared among the population of Mexican descent in the United States, I argue that CARA can be deconstructed as a text about the life-practices of an "Other" American culture which is both indigenous and alien to the United States, an *alter-Native culture*, whose identity has been carved out of a history of colonization and struggle. Rudy Acuña clarifies the distinction between *historical* nativism, which is fundamentally a racist, white-supremacist attitude of the kind we see enacted by Proposition 187 and the so-called California Civil Rights Initiative (CCRI), and *anthropological* nativism, which is a way of describing indigenous cultures that resist acculturation.[30] My construction of alter-Nativity is based on the latter interpretation of nativism.

Aside from resisting acculturation, alter-Nativity also disputes the "subculture" model imposed by ethnographic methodology, which presupposes the monolithic influence of the dominant culture, and uses the "subculture" as a filter by which to analyze that influence. This model is also used in all levels of scholarship in the field of Cultural Studies, from introductory course readers in popular culture to feminist scholarship. In *Feminism without Women: Culture and Criticism in a "Postfeminist" Age*, for example, Tania Modleski writes: "By focusing on subcultures and studying the values and beliefs associated with them, the analyst is able to make sense of the ways in which 'messages' are 'decoded' according to the shared cultural orientation of particular groups."[31] Though it is true that Modleski is invoking an ethnographic criticism that can monitor revolutionary responses to dominant ideologies, she fails to question the hierarchical assumptions that organize cultures into "sub" categories.

Similarly, Dick Hebdige, a cultural critic of the Birmingham School and author of *Subculture: The Meaning of Style*, finds that the cultures of subordinate classes and groups represent challenges to hegemony, primarily through a recoding of dominant styles.[32] Again we have a critic who, although he can lucidly explain the power dynamics of hegemony and the insidious

A Theoretical Introduction

15

ways in which the "rhetoric of common sense" penetrates our everyday lives,[33] himself normalizes the vertical stratification of cultures, thus reifying the ideology that creates those categories in the first place and that the field of cultural studies is supposed to question. When "minority" or "Other" groups are relegated to the status of "subcultures," they are subsumed by and subjected to an ethnocentric methodology of cultural studies. This, in effect, produces academic segregation, which in turn reproduces the hegemonic view of popular culture.

This is not to say that subcultures do not exist in the genealogy of the dominant culture; but, rather, that the term "subculture" is applicable only to those cultures which derive from the dominant one, as in white youth cultures like Hippies, punks, and fraternities or in the separatist communities of senior citizens. These are subcultures, though not necessarily subordinate ones, because they are enclaves of difference within the same ethnicity as well as by-products of the dominant culture's values. Although subcultures appear to resist the dominant value system, they are not, in fact, resisting the dominant culture as much as dominance itself. A subordinate culture, on the other hand, lives in a direct power relation with the dominant culture; it is not a recalcitrant offspring, but a disenfranchised colony of the dominant ethnicity. Although I agree with Hebdige that "subcultures . . . express, in the last instance, a fundamental tension between those in power and those condemned to subordinate positions and second-class lives,"[34] I disagree with his premise that white youth cultures are sentenced to second-class lives and that "minority" groups who have a history of colonization can be compared to groups who, though they may be at the bottom of the capitalist structure, racially and historically represent the colonizer.

Rather than using the restrictive and reductive prefix "sub," I propose that we rethink cultures that are racially and ethnically different from the dominant one as "alter-cultures." Issuing from the Latin word for "other," "alter" means to change, to make or become different, as in the altering of consciousness or the alteration of an outfit, as we see in Yolanda M. López's alteration of the Guadalupana icon.

Moreover, the concept of "alter ego" represents another self, another identity. In postmodern, poststructuralist discourses, the word "alterity" is used to connote the condition of Otherness; a "subaltern," therefore, as in the British colonial notion of a "subaltern continent," is the underground, the Fourth World, the lowest rung of Otherness. But the term "subaltern" is a colonialist construct, reinforcing the connection between inferiority and people of color. I suggest that Chicano/a culture is not

Figure 7. Yolanda M. López, *Margaret F. Stewart: Our Lady of Guadalupe*, 1978, oil pastel on paper. Collection of Shifra Goldman. Reproduced by permission of the artist and Shifra Goldman.

only an "alter-culture" that simultaneously differs from, is changed by, and changes the dominant culture, but is also an *alter-Native culture*—an Other culture native to this specific geography, once called an outpost of New Spain, then the Mexican North, then the American Southwest, and most contemporarily the Chicano/a homeland of Aztlán.

To effect my analysis of Chicano/a alter-Nativity through the CARA exhibition, I appropriate a methodology popular in the first thirty years of American Studies scholarship, the now controversial myth-symbol-image approach which purported to define a collective American identity through the study of symbols and images. Although I agree fundamentally with critics of the myth-symbol-image school who argue against the method's totalizing definitions of "the" American mind, I do find this method useful for constructing a model by which to analyze the CARA exhibition and also for deconstructing the implicit assumptions of the discipline of American Studies and its several branches. The image I use in my construction/deconstruction of an analytical paradigm is that of the house (see Chapter 2). If symbols and myths, as Henry Nash Smith believed, are synonymous, a collective rather than an individual "intellectual construction that [fuses] concept and emotion into an image,"[35] how does the image of the house reveal the concepts and emotions inherent in the mind that calls itself Chicano/Chicana,[36] that is both "native" and "Other" to the "American" neighborhood?

Before moving on to our "open house" tour of the exhibit, it is necessary to emphasize that this is not an art history analysis whose focus is the artwork and its forms, styles, and historical trajectory, but rather an analysis of how the artwork manifests the politics, ideologies, and historical specificities of Chicano/a culture. It is also a case study of an alter-Native culture which is represented ethnographically in the mainstream art world by the "Diversity/Discovery" paradigm, otherwise known as multiculturalism.

Ever since Gene Wise's 1979 retrospective essay on the history of American Studies,[37] the term "paradigm drama" has become engraved in the vocabulary of the discipline. Wise explains his use of "paradigm" as both a consistent pattern of thought and an "actual instance of that pattern of thinking in action";[38] he divides the history of American Studies, from its inception in the late twenties to the late seventies when the essay was written, into four "paradigm dramas" (also called "representative acts"). According to Wise, these dramas—encapsulated in two books, a methodology, and two college seminars—represent distinct phases in the evolution of the study of "American" life and culture. For those of us engaged in that study, we find ourselves now in the fifth phase, what I call the *quinto sol* of multiculturalism,[39] which experienced its zenith on the cultural horizon in the 1980s and its nadir in the 1990s and which, like a comet, left a lingering tail that illuminates more than American Studies.

Indeed, multiculturalism has itself become a discipline, a methodology, a curriculum, a culture industry, and now a governmental scapegoat; thus, it has its own representative acts. The CARA exhibition was one of those acts that epitomized the theory and practice of multiculturalism within the mainstream art world. Thus, this book is also a story about the paradigm drama of multiculturalism in mainstream museums.

I define multiculturalism broadly as close encounters of the Third World kind between the dominant culture and "aliens"—a category which includes immigrants of both the documented and undocumented varieties as well as citizens and residents who for generations have grappled with racial, ethnic, and cultural bigotry. The CARA exhibit was an enactment of one of those close encounters, produced on the stage of the mainstream art world, sponsored by mainstream capital, and peddled to mainstream museum audiences across the country. The group of "aliens" who call themselves Chicanos and Chicanas had already invaded the national consciousness in the sixties, but this had occurred in the paradigm drama of the Civil Rights Movement. That particular encounter had an ugly denouement in the Chicano Moratorium of August 29, 1970, when 20,000 protesters from the several separate movements—including Chicanos/as, Asian Americans, blacks, feminists, Native Americans, and counterculture youth (a.k.a. Hippies)—convened in Los Angeles to oppose the Vietnam War. Chicanos/as were also protesting the disproportionate number of Mexican-American fatalities in Vietnam. It was a peaceful demonstration; nevertheless, police had their gas masks and other riot gear at hand. The police brutality that ensued resulted in the death of three Chicanos, among them Los Angeles Times reporter Rubén Salazar, who was killed by a tear-gas projectile inside the Silver Dollar Café where he had taken refuge from the violence.[40] In the general protocol of the period, no indictments were made for the crimes, and Salazar became one of the earliest martyrs of the Chicano Movement. Twenty years later, on August 25, 1990, a memorial march in honor of the moratorium took place on Whittier Boulevard just two weeks before the CARA show opened at UCLA.

The close encounter offered by the CARA exhibition was different, more civilized, more on the symbolic terms of the dominant culture, and it could not have happened before the culture industry and the educational system assumed control of multiculturalism. Liberals would argue that it was, in fact, the other way around, that multiculturalism assumed control not only of the culture industry and the educational system but of the nation itself—wishful thinking, to be sure. The bottom line of

multiculturalism is difference, and difference has never had power in this country. Difference gets melted down, exoticized, stereotyped, invisibilized. On the one hand, difference becomes "Santa-Fe style," or a Benetton label, or a funding category. On the other hand, difference gets denied a public education, health services, and a decent place to live.[41] Difference forgets its history, its name, itself. It was precisely in resistance to that trajectory of erasure and historical amnesia that CARA was organized.

CARA was primarily a historical exhibition that documented the relationship between the social circumstances of Chicanos/as and Mexicans in the United States and the work of Chicano/a artists.[42] To assess that relationship, the CARA exhibition explored the ways in which the social issues affecting the community of Mexican descent impacted the art of the Chicano Art Movement and, conversely, how the Chicano Art Movement, as a cultural extension of el Movimiento, helped to represent, educate, and empower its own community. The show was also a direct affront to the elitist standards of the mainstream art world. Thus, it was a historical exhibition with a political intent, and its politics functioned on two levels: the local level of the Chicano/a community and the national level of the mainstream art world.

In *Shows of Force: Power, Politics, and Ideology in Art Exhibitions*, Timothy Luke's central premise is that, regardless of their intent, "museum exhibitions [are] political texts" that perpetuate and represent the power dynamics of contemporary culture.[43] In other words, Luke argues, art is not distinct from politics; it is politics. Janet Wolff would disagree with this assessment, seeing as she does a particular "nature" to the aesthetic that exists beyond politics; however, her own "sociology of the aesthetic" argues for seeing art within its social and ideological context.[44] Indeed, Wolff argues that all art, all aesthetic measure, is "class-based, gender-linked and in general ideologically produced."[45] Nevertheless, modernist standards continue to dictate in the art world. As a show with an overtly political focus, CARA's presence in mainstream art venues was questioned by art critics and museum audiences alike. Is CARA art or politics? The question implies that the categories are mutually exclusive, which, as any cultural analyst knows, is simply not the case. In fact, through a reading of the signs that compose CARA's interpretation of the Chicano Art Movement, it is possible to glean the cultural politics of both the exhibition and the mainstream art world that was its context. Reading CARA as a cultural text also makes it possible to assess the process and implications of multiculturalism in both mainstream museums and the dominant culture at large.

A Theoretical Introduction

20

Figure 8. Frank Romero, *The Death of Rubén Salazar*, 1985–1986, oil on canvas. Collection of the National Museum of American Art, Smithsonian Institution. Museum purchase made possible in part by the Luisita L. and Franx H. Denghausen Fund. Reproduced by permission of the artist.

Let me clarify here what I mean by the term "mainstream," using the definition of Uruguayan artist and professor Luis Camnitzer:

> Although the term "mainstream" carries democratic reverberations, suggesting an open and majority-supported institution, it is in fact a rather elitist arrangement reflecting a specific social and economic class. In reality, "mainstream" presumes a reduced group of cultural gatekeepers and represents a select nucleus of nations. It is a name for a power structure that promotes a self-appointed hegemonic culture.[46]

In the exhibition catalog, CARA is called by its organizing committee an "atypical mainstream exhibit,"[47] because most of the artists represented in the show had ties to the Chicano Movement and, in the case of some of the Chicana artists, to the Women's Movement as well. In other words, the art of the exhibition was informed by an oppositional perspective and was also an expression and celebration of Chicano/a life and history. Yet

A Theoretical Introduction

21

CARA was packaged as a mainstream show, funded in the early part of its planning phase by the National Endowment for the Humanities (NEH) and later by the Rockefeller Foundation and Anheuser-Busch Companies.

How did CARA bridge its own contradictions? The organizational process, based on the experimental idea of intercultural collaboration rather than on traditional museum curation, was intended to provide a new model for installing museum exhibitions of living cultures. What were the inner workings of that experiment, in relation both to the outcome of the exhibit and to the "diversity" agenda knocking at the canonical doors of mainstream museums? How did the ideological discourses of the CARA organizers—Movimiento politics, multicultural rhetoric, gender/sexuality dialectics—manifest themselves in the process of developing and designing the exhibit? To what extent did CARA practice the politics of self-representation that it preached? The four general factors that influence the politics of representation in mainstream museums are the cultural assumptions of the exhibitors, insider/outsider dynamics, the interplay of artists/exhibitors/audiences, and funding issues. What was CARA's experience with each of these factors?

An art exhibit is usually classified as high culture; yet, because of its "ethnic" orientation and its merging of "art," "folk," and "street" forms, the CARA exhibit stands on the faultlines of the controversial "Quality" debate presently destabilizing the notion of high culture. CARA was, in other words, part of a national "class" conflict between a mass public and a cultural elite. Given the popular nature of much of the artwork in CARA, was the exhibit more oriented toward *la gente* (the Chicano/Latino community) or *el arte* (the "art world")? And finally, to what extent did the exhibit, "housed" in mainstream art venues, both promote and subvert the popular Chicano/Mexicano belief that *mi casa es su casa?* These are the critical questions that guide the present cultural study of *Chicano Art: Resistance and Affirmation.*

For many who saw the show, mainstream reviewer and Raza viewer alike, CARA signified the first time they had ever seen Chicano/Chicana art in a mainstream museum. Some interpreted it as trespassing, others as breaking through the walls of the master's house. Under Camnitzer's definition above, a mainstream museum is one that represents the interests, tastes, desires, and values of the dominant race, class, and gender: white, upper-class men. How the CARA exhibition worked its way into the agendas of these white, upper-class, male-dominated institutions, which collectively signify the master's house in the art world, is a narrative waiting to be constructed and deconstructed.

A Theoretical Introduction

22

One of the great benefits of multiculturalism in academia is that it has spurred interest and investments in interdisciplinary work such as that practiced in Cultural Studies, American Studies, and Ethnic Studies. What characterizes these fields, aside from their tendency toward social analysis and openness to interdisciplinarity, is an inherent problem of methodology. How do you cross disciplines to study culture, especially "different" cultures within a hegemonic, homogenizing culture? Again, ethnographic methods save the day. But, like the paradox of presence and representation engendered by the dominant culture's rhetorical appropriation of multiculturalism, the basic problem with appropriating ethnographic methods for cultural studies is that traditional ethnography is both a colonialist and a narcissistic practice. Renato Rosaldo's idea of an ethnographer revolves on the axis of positionality: "The ethnographer, as a positioned subject, grasps certain human phenomena better than others. He or she occupies a position or structural location and observes with a particular angle of vision. . . . The notion of position also refers to how life experiences both enable and inhibit particular kinds of insight." [48] Positionality is a relatively new practice in anthropology and accounts for "how age, gender, being an outsider, and association with a neocolonial regime influence what the ethnographer learns." [49] The kind of ethnographic practice adopted by American Studies, however, is more along the lines of what Rosaldo, in an earlier work, depicted as "from the door of his tent," [50] in which the ethnographer sets him/herself apart and above his/her subjects and passes judgment, as it were, on the data. At a safe distance from the natives, this form of participant-observation lacks the introspective quality of positionality.

Moreover, classic ethnography is a form of domination, a way of condescending to the natives under study. Because both native and alter-Native cultures are "othered" and exoticized in order to be quantified and studied, they get categorized as "subcultures." Such categorization poses several problems: by definition, "subculture" implies the presence of a superior culture; and, rather than being analyzed in their own right, "subcultures" are used as filters for analyzing the effects of the messages that the ethnographer's own culture, the dominating culture, projects onto the so-called subculture. When approached from the outside, these Other cultures become grist for the appropriator's mill. As Coco Fusco says, "the mainstream appropriation of subaltern cultures in this country has historically served as a substitute for ceding those peoples any real

political or economic power."[51] The implicit problem here, of course, can be succinctly described as an insider/outsider dilemma, another side effect of multiculturalism.

In what Gene Wise calls the "Golden Years" of American Studies, for example, there was no insider/outsider dilemma;[52] indeed, there was no methodological dilemma, either, once all the white men in the discipline agreed to do the same thing: myth-symbol-image studies. Stripped of rhetoric, the assumptions underpinning the scholarship and methodology of the Golden Years can be summarized like this: (1) there is one American Mind and it is homogeneous; (2) because it is rooted in the European idea of the New World, this American Mind operates on the notion of "boundless opportunity," an idea which finds metaphoric expression in the myth of the frontier and the symbol of the garden; (3) this mentality can be discerned in all (white) Americans; (4) the American Mind is a cultural and historical legacy; and, finally, (5) although the American Mind is homogeneous and occurs in anyone "American," it is best expressed in "high culture," rather than in mass or popular culture.[53]

When the first wave of civil rights tsunamis hit U.S. colleges in the late sixties and early seventies, American Studies was among the first Eurocentric, male-dominated disciplines to experience fragmentation and radicalization. The tsunami is my metaphor for the cataclysmic changes that surged through American Studies at the decline of the Golden Years, instigated by a radical new breed of scholars, feminists among them, who viewed the entrenched assumptions of the discipline as a product of "an overly timid and elitist white Protestant male enterprise which tended to reinforce the dominant culture rather than critically analyzing it."[54] Thus, congruent with what Gene Wise called the "earthquake-like jolts of the sixties,"[55] and what Linda Kerber in her keynote address to the American Studies Association in 1989 termed a "cultural explosion,"[56] American Studies experienced its first postmodern rite of passage: the seismic movement from consensus to diversity.[57] While early Americanist scholars had asked, "How do you do American Studies?" for twenty years, once the myth-symbol-image approach was declared racist, sexist, classist, and obsolete, the quest for a new methodology began. As more women and people of color joined the discipline, as race, ethnicity, and sexual orientation created more sites of study, as postmodernism became the prevailing academic philosophy, this quest for a method was further compounded by issues of subjectivity, identity, difference, appropriation, positionality, insider/outsider.

I situate myself within this history of American Studies because I am an

A Theoretical Introduction

24

outsider to the discipline (as of 1994, there were less than five Chicanas with Ph.D.s in American Studies, for example) who nonetheless draws on the discipline's questions and methods to perform both insider and what Deena González, Chicana historian and theoretician, calls "outside-insider" studies on Chicano/a culture. Says González:

> Outside-insiders have . . . special relationships with their topics— we know we cannot know many things, but we also know that much of what we do know we can explain primarily as feelings or as images; evidence serves as verification of these expressions. . . . Outside-insiders such as myself . . . have elided scientific methodologies (insofar as that is possible in a First World society) and rely heavily on participant-observation from critical vantage points.[58]

One of those "critical vantage points" for me, when I understood that I indeed had a role to play as a cultural critic, occurred when I walked into the CARA exhibition for the first time and saw it with my outside-insider's vision.

Because I am, in effect, writing a social and cultural description of both Chicano/a art and multiculturalism in the mainstream art world, I am experiencing the same need to position myself as a subject vis-à-vis the CARA exhibition that Renato Rosaldo finds imperative in the work of an ethnographer committed to "remaking social analysis."[59] If, as Rosaldo tells us, "[Victor] Turner connects the 'eye' of [classic] ethnography with the 'I' of imperialism,"[60] how can I connect the rasquache, counter-Colón(ialist), alter-Native "eye" of the CARA exhibition which literally looks back at me as I study it with the native "I" of a Chicana cultural critic?

An analysis of the CARA exhibition performed by a Chicano or Chicana can minimize the ethnographic filter and illuminate a discourse community based on shared cultural values, practices, and beliefs, albeit nuanced by the critic's own class, gender, and political and sexual orientations. My own reception of CARA, for example, and my analysis of different audience responses to the show are colored both by my identity as a first-generation Chicana lesbian feminist from the U.S.-Mexico border and by the fact that my knowledge of el Movimiento is not experiential. As a Chicana, I felt empowered by CARA; as a lesbian feminist, I felt excluded and manipulated; as a fronteriza, I felt underrepresented; as a latecomer to Chicanismo, I felt awed by the richness, the quality, the history of Chicano/a art; and as a cultural critic, I felt like an explorer in a section of

my own neighborhood that I had never seen and was just "discovering," in Tomás Rivera's sense of the word.[61] Thus, due to my own diverse subject positions as interpreter of the exhibit, I am predisposed to seeking out multiple audience responses and to working within the contradictions of being what Renato Rosaldo calls a "native ethnographer" of Chicano/a popular culture.[62] My approach may not qualify as "ethnography," native or otherwise, because I do not employ "the ethnographer's elevated, distanced, normalizing discourse."[63] Nonetheless, this critical endeavor draws on ethnographic methodologies (i.e., participant-observation and oral interview) without subscribing to or perpetuating its colonizing gaze. As another critical strategy, I use the ethnographic method to describe and interpret that colonizing gaze in both popular culture studies and the mainstream art world.

In an intriguing essay depicting Hollywood as "the ethnographer of American culture,"[64] Ana López argues that a power relationship exists between the ethnographer and the culture that he/she is interpreting. This power relationship is equivalent to a colonizer/colonized duality. Hence, because "Hollywood does not represent ethnics and minorities [but rather] creates them, and provides its audience with an experience of them,"[65] Hollywood, in effect, colonizes "Other" cultures. Hollywood directors interpret "Other" cultures, choosing specific images and narratives to create the ethnic experience on the screen, and thus act as agents/representatives of the industry.

In this respect, the curator of a mainstream exhibition about ethnic "Others" can fill the role of the traditional ethnographer. Like the traditional ethnographer, the curator is in the position of interpretive authority without accounting for the sociopolitical differences that comprise the ethnographer's subjectivity—the very subjectivity that not only interprets the data, but chooses from it the images to be used for representation.

In the case of the *Hispanic Art in the United States* exhibition (1987), for example, curators Jane Livingston and John Beardsley decided to organize a survey of thirty artists (painters and sculptors only) in the United States who were "of Hispanic descent" and therefore shared some "stylistic affinit[ies]."[66] The very premise of the show reflected the melting pot mentality of the curators: in the interest of "coherence and a strong underlying assertion of aesthetic will," racial and cultural differences were erased. Furthermore, only two forms of artistic expression were chosen to promote the curatorial interpretation of the Hispanic "subculture" in the art world. Writing in defense of the "Hispanic" label, Livingston and Beards-

ley outline the difficulties they had in selecting an accurate signifier for their exhibition:

> No other term seemed any better. To use *Latin American* seemed to suggest that the artists were not North American; in fact, nearly two-thirds of them were born in the United States. *Latino* seemed to exclude the Spanish Americans of the Southwest. *Chicano* excluded those not of Mexican origin. Compelled by necessity to include some descriptive term in the title of the exhibition, we decided *Hispanic* was the least incorrect. . . . Moreover, we think it reflects fairly the fact that there are legitimate shared characteristics, both in terms of subject matter and style, among artists in the North American environment who share New World Spanish-Native American roots. That is, there are ways in which "Hispanic" culture, no matter how diverse internally, is distinct from mainstream European American or African American culture.[67]

They were, of course, deeply criticized for their patent homogenization and for the vision they created of "Hispanic" art as primitive, folksy, and religious. The real issue, however, is not how accurately or realistically Livingston and Beardsley represented the cultures under scrutiny, but how the exhibition revealed the social and historical discourses about those "Others" which the curators themselves represented.[68]

A native ethnographic analysis of the CARA exhibition, on the other hand, can deconstruct the "insider" and "outsider" polemics at the heart of both the show and the "Quality" debate in the mainstream art world. The native eye/I does not assume only one correct, authentic interpretation (if that even exists), but allows for an interpretive stance framed by the politics of self-representation. As Renato Rosaldo points out, "not unlike other ethnographers, so-called natives can be insightful, sociologically-correct, axe-grinding, self-interested, or mistaken . . . [but] they do know their own cultures."[69] Besides, native ethnography of an alter-Native culture seems particularly fitting.

The final point I would like to make is that the exhibition itself can be seen as an exercise in ethnography. Although the CARA organizers intended to demonstrate that Chicano/a art was, in fact, an *American* art and not the cultural production of a foreign culture and that, therefore, it had to be shown in art rather than anthropological museums, the fact remains that the mainstream art world knew little about the Chicano Art Move-

ment, much less about Chicano/a culture, identity, and history. Regardless of the kind of museum in which the art was displayed, then, the traditional museum audiences who saw the show across the country experienced Chicano/a art as an ethnographic display of an alien culture. Although Svetlana Alpers argues that in representations of culture "museums turn cultural materials into art objects," because the "museum effect" isolates something from its original world and situates it in a space created specifically for "attentive looking,"[70] in the case of an alter-Native culture that has been historically invisible to the mainstream museum's "way of seeing," art objects become cultural signifiers that represent "Other" lives. Thus the art of difference is transformed into ethnography. As Clifford tells us: "To see ethnography as a form of culture collecting . . . highlights the ways that diverse experiences and facts are selected, gathered, detached from their original temporal occasions, and given enduring value in a new arrangement."[71]

In the following section, I arrange the CARA exhibition in a new way, selecting, gathering, and detaching individual pieces both from their "original temporal location" in the Chicano Art Movement and from their temporary installation in the exhibition and placing them within an ethnographic paradigm meant to conceptualize Chicano/a popular culture from the perspective of a native eye/I.

PART ONE **OPEN HOUSE**

CHAPTER 1

The *Solar* of Chicano/a

Popular Culture:

Mi casa [no] es su casa

E pluribus unum

Inscribed on the foremost symbol of U.S. culture—the national currency—the motto *e pluribus unum* (out of many, one) epitomizes one of the dominant ideologies of the country's so-called national character: the Melting Pot Principle. Invented by a white male democratic idealism rooted in colonialist politics, the Melting Pot Principle has manifested itself in every facet of "American" life, from government to popular culture. American Studies, conceptualized as the study of American life and thought, reproduces this paradigm of uniformity in all of its branches not only by seeking the transcendent and universal American mind, as Americanists did during the first three decades of the discipline's existence, but by perpetuating, even in the age of multiculturalism, the myth of a singular American culture. The best representative of this monolithic culture is the white male individual whose "official language" is English and whose dreams are mortgaged to his house, his very own piece of the rock, or his share of private property.

Houston Baker, Jr., in his essay "Of Ramadas and Multiculturalism," finds the trope of the "American house" an

31

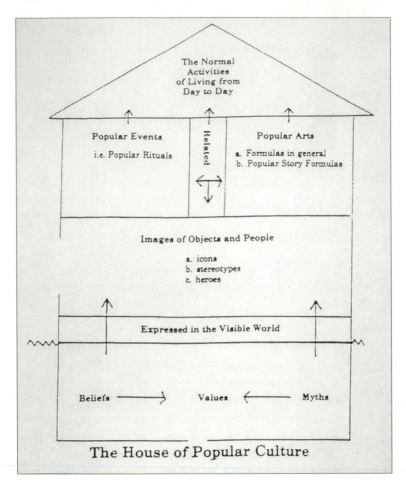

The House of Popular Culture

Figure 9. From the cover of *The Popular Culture Reader* (1983). Reproduced by permission of Bowling Green University Popular Press.

appropriate image for the ideal of patriarchal individualism that is the basic structure of Anglo-American culture:

> The spatial arrangements of the house were apportioned as follows: all the main portion is to be reserved for a fatherly *Oneness* . . . yet a chamber shall be super-added for the woman domestic, Chinese laborer, African slave, Mexican migrant, Indian servant. *Unum* in the bighouse and *pluribus* in the attic . . . a New World architectural fantasy par excellence, relegating whole populations of colorfully different pasts to a single interpellation: "you people" in the attic.[1]

The image of the house is a recurrent metaphor for the popular culture branch of American Studies. *The Popular Culture Reader* (1983), a standard text in popular culture survey courses, uses the house as the central organizing device. Editors Christopher D. Geist and Jack Nachbar employ the image of the house to structure and simplify their introductory study of popular culture.[2] The scholars who define popular culture in the first three essays of the *Reader* construe it as the culture of the middle-class white majority of "Americans." Ray B. Browne's essay, for example, describes mainstream popular culture as "the dominant culture of minorities—of ethnic, social, religious, or financial minorities—simply because their way of life is . . . not accepted into the elite culture of the dominant group."[3]

Although Browne attempts to explain the absence of "minority" neighbors on the block of popular culture studies, he is actually justifying what I see as the restrictive covenants,[4] the segregation, of the discipline. In this context, in this neighborhood, Geist and Nachbar build their "house of popular culture." The house heuristic aims to contain and focus the great diversity of material that composes popular culture.[5] For all this diversity, however, the house pictured on the cover of the *Reader* is a mainstream-U.S.A., middle-class, nuclear-family-sized suburban bungalow, certainly not a generic house, certainly not representative of the cultural Others who dwell in "America."

In a more recent version of the same text, *Popular Culture: An Introductory Text* (1992), edited by Jack Nachbar and Kevin Lause, an interesting caveat tempers the paradigm of the bungalow that was used in the 1983 text. "For purposes of this introduction our 'house' will be an *American* one. Similar houses can be drawn for any culture, of course, but let's keep things as familiar as possible at this part" (emphasis added).[6] Of particular interest in the caveat above is the blatant ethnocentrism of the editors. While attempting to acknowledge the cultural specificity of the bungalow they use for their model, Nachbar and Lause are, in fact, equating the bungalow structure with Anglo-American culture, which the mainstream readers of the text (the presumably white students of the discipline) will find "familiar"; implicitly, other structures, like other cultures, are not American and therefore could not be used to represent "American" cultural values, beliefs, icons, heroes, rituals, or art forms. In other words, "your *casa* may be my *casa, amigo,* but my house ain't your house."[7]

According to Jack Solomon in *The Signs of Our Time: The Secret Meanings of Everyday Life:*

The Solar of Chicano/a Popular Culture

33

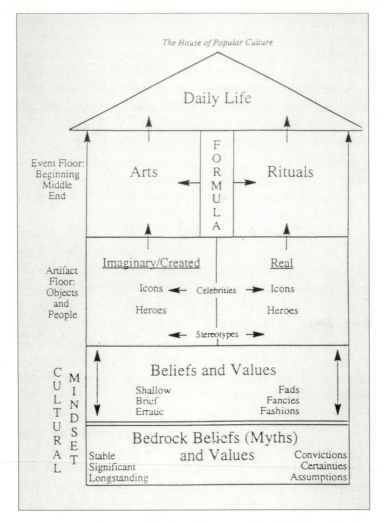

The House of Popular Culture

Daily Life

Event Floor:
Beginning
Middle
End

Arts

FORMULA

Rituals

Artifact
Floor:
Objects
and
People

Imaginary/Created

Real

Icons ← Celebrities → Icons

Heroes

Heroes

← Stereotypes →

CULTURAL

MINDSET

Beliefs and Values

Shallow
Brief
Erratic

Fads
Fancies
Fashions

Bedrock Beliefs (Myths)
and Values

Stable
Significant
Longstanding

Convictions
Certainties
Assumptions

Figure 10. From the cover of *Popular Culture: An Introductory Text* (1992).
Reproduced by permission of Bowling Green University Popular Press.

When we view them from a semiotic perspective, the buildings in which we live and work can be seen to reflect the desires and perspectives of the culture that builds them, and by 'reading' the codes that are invisibly inscribed in both public and private territories, we can often cover the fundamental values of the society in which we live.[8]

Semiotically speaking, then, the bungalow used in Geist and Nachbar's *Reader* and in Nachbar and Lause's *Introductory Text* communicates a fundamental value of mainstream culture, the famous "American Dream," which, based on individual landownership, "reflects the consciousness of a nation whose frontier history once held out the promise of unlimited land to anyone who would go out and claim it, and its modern symbol is the detached, single-family suburban home."[9]

The frontier myth espoused by Frederick Jackson Turner at the turn of the century saw the "meeting point between savagery and civilization" as the moment of the American Mind's conception.[10] The first parents, so to speak, the symbolic American Adam and Eve, were the "civilized" English pilgrims and the savage landscape of what became the colonies of New England and Virginia. The landscape included not only the wilderness but also the people who inhabited that wilderness, the subaltern, subhuman "Indians" who, like the land, were destined to be tamed and taken. At every crossroads between savagery and civilization, the American Mind was born, a product of cultural and biological conquest.

Conquest, the *modus operandi* of all imperialist cultures, and the myth of the frontier, with its ideas of "free land" and the "rise of the common man" (whose skin color was never red, brown, yellow, or black), are the invisible codes inscribed on the architecture of the modern bungalow. Because these conquest codes do not speak in the same way to those who were dispossessed by the westward expansion of the nineteenth century, namely Mexicans and Native Americans, the bungalow does not mean "home" to every American citizen; thus, the "house of popular culture," based on the image of the bungalow, fails to address the ways in which the Euro-American values of conquest and expansion that are etched onto the architecture of the bungalow speak to the colonized descendants of the Mexicans and Native Americans who found themselves literally homeless in the wake of the "great migration."

The "house of popular culture" depicted by Geist, Nachbar, and Lause is not everybody's house, not everybody's popular culture, but it positions itself as such. Houston Baker states that "we have arrived today . . . at a moment when our challenging national differences cannot be neatly housed. . . . The house is now, and has always been, inadequate for America."[11] Baker's position as then-president of the Modern Language Association gives his "house" the shape of the literary canon, though it can also mean the cultural canon in its various manifestations. But even Baker's comments assume a particular architecture to the house, based on a main floor, a second or "superadded" story, and an attic.

The Solar of Chicano/a Popular Culture

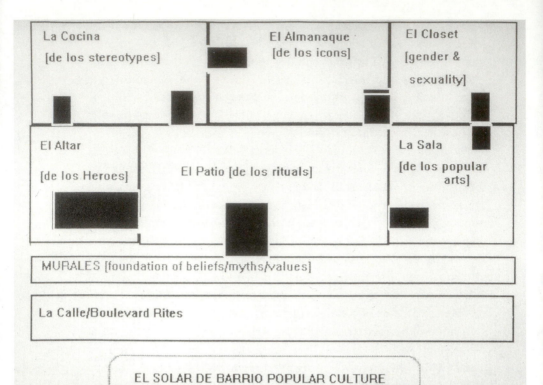

La Cocina [de los stereotypes]

El Almanaque [de los icons]

El Closet [gender & sexuality]

El Altar [de los Heroes]

El Patio [de los rituals]

La Sala [de los popular arts]

MURALES [foundation of beliefs/myths/values]

La Calle/Boulevard Rites

EL SOLAR DE BARRIO POPULAR CULTURE

Figure 11. Author's Blueprint for the *Solar*.

Rather than throwing the baby out with the bathwater, I argue that it is not the house that is necessarily an inadequate metaphor, but rather the kind of house used not only to conceptualize but more significantly to *hegemonize* contemporary U.S. culture. Indeed, I find the house to be a germane device for organizing a study and constructing a model of the politics, aesthetics, and representations of Chicano/a popular culture. This house, however, must be a different type of structure, one that better expresses Chicano/a values and beliefs. Thus, I propose the more culture-specific *solar*: a sequence of rooms or apartments built around a central patio.[12] Although the *solar* is but one model in the variety of living/housing arrangements experienced by la Raza—tents, boxcars, shacks, trailers, tenements, and, yes, even bungalows are other models—the *solar* image is inscribed with the concepts of community, family, and homeland—all central issues in Chicano/a consciousness—and represents cultural values through architectural design in the same way that the bungalow repre-

sents the mainstream American values of conquest, individualism, and private property.

Murales: The Foundation of Myths, Beliefs, and Values

In Geist and Nachbar's *Popular Culture Reader*, mainstream popular culture is divided into four categories which correspond to the "foundation and three rooms" of the bungalow that they call "the House of Popular Culture." The foundation consists of the myths, beliefs, and values that characterize "American" culture and are expressed in three-dimensional form by the popular images, icons, rituals, art forms, and stereotypical representations in the ascending rooms. In *Popular Culture: An Introductory Text*, edited by Nachbar and Lause, the interior of the bungalow consists of a two-tiered basement that comprises the "cultural mindset" of superficial beliefs and the deep-seated myths and values of the bedrock foundation; the downstairs of the house is an "artifact floor" of heroes and icons divided into two rooms; and the upstairs is the "event floor" of popular arts and rituals, each with its own room.

Although the *solar* paradigm—which is meant to signify the popular culture of *la Raza*—argues for a separate and historically specific cultural reality that transcends and subverts the notion of "subculture," it contains the same categories of popular culture as those depicted by the different floors and rooms of the bungalow: a foundation of abstract beliefs manifested concretely in popular images, icons, heroes, rituals, and art forms. I have added another category to the *solar*, the closet of gender, wherein issues of sexuality and so-called women's issues unfold behind closed doors.

Despite the similarities, the solar is also an inversion of the pop culture categories, for often the popular beliefs, objects, and practices of Chicano/a culture are antagonistic or anathema to the dominant culture in the same way that the architecture of the bungalow or rather the cultural codes inscribed therein speak the offensive language of conquest and dispossession to the native peoples of the "West." Consider, for example, the concept of the foundation of values and beliefs.

Regardless of the minor changes in the interior, the builders/editors of the texts named above agree that the foundation of the house of mainstream popular culture is "slightly underground" and "can't be seen"; it is composed, say Geist and Nachbar, of "those elements contained within the human mind: popular beliefs, values, superstitions and movements of thought."[13] Nachbar and Lause say that "the visible aspects of our

Figure 12. Wayne Alaniz Healy, *Ghosts of the Barrio*, 1974, mural. Ramona Gardens Housing Project, East Los Angeles. Reproduced by permission of the artist.

[sic] culture (artifacts and events) are expressions of the invisible parts (our cultural mindset)."[14] This belief that the ideological foundation of U.S. culture is invisible to its citizens is itself a pervasive myth of the mainstream cultural mindset. This is the myth of the "universal" Euro-American, whose ethnicity and color, language and beliefs, are the norm from which cultural "Others" deviate and differ. For historically colonized and marginalized groups, however, Eurocentric ideology is *so* visible that it renders their own realities invisible. In the *solar*, by contrast, we find the foundation of Chicano/a popular culture not at the bottom of the structure, nor in the basement where its invisibility can be perpetuated, but on the inner and outer walls of the building, boldly and lyrically rendered in the most public form of Chicano/a art, *murales*.

As Eva Sperling Cockcroft and Holly Barnet-Sanchez note in their introduction to *Signs from the Heart: California Chicano Murals*: "A truly 'public' art provides society with the symbolic representation of collective beliefs as well as a continuing re-affirmation of the collective sense of self. Paintings on walls, or 'murals' as they are commonly called, are perhaps the

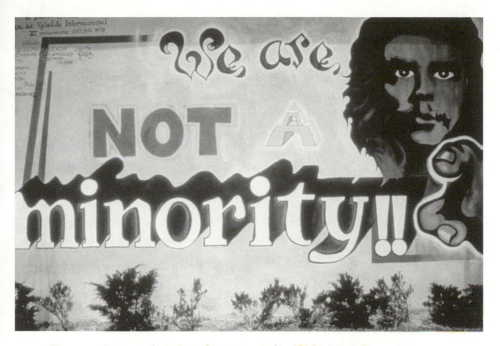

Figure 13. Congreso de Artistas Chicanos en Aztlán (CACA; Mario Torero, Mano Lima, Tomás "Coyote" Castañeda, and Balazo), *We Are Not a Minority*, 1978, mural. Estrada Courts Housing Project, East Los Angeles. Photograph provided courtesy of the Social and Public Art Resource Center (SPARC). Reproduced by permission of Mario Torero.

quintessential public art in this regard."[15] Thus, covered in the bright murals of el Movimiento, the internal and external facades of the *solar* symbolically interpret, represent, and reaffirm the cultural mindset of Chicanismo.[16]

"The popular beliefs, values, superstitions, and movements of thought" that Geist and Nachbar see as the foundation of the mainstream house of popular culture are, for Chicanos/as of the twentieth century, largely those expressed by el Movimiento.[17] One form of activism was the Chicano Art Movement, which, through the popularly accessible forms of murals and posters, represented the community's social problems and injustices while creating a new artistic and politically responsible sensibility. In response to these injustices, the two most persistent values that emerged from el Movimiento were, as the subtitle of the CARA exhibit tells us, *resistance* and *affirmation*.

Tomás Ybarra-Frausto describes one aspect of the new artistic sensibility promoted by the Chicano Art Movement in his essay "Arte Chicano:

The Solar of Chicano/a Popular Culture

39

Images of a Community": "In opposition to the hierarchical dominant culture with implicit distinctions for 'fine' and 'folk art,' attempts were made to eradicate boundaries and integrate categories. An initial recognition was that everyday life and the lived environment were the prime constituent elements for the new aesthetic."[18] Everyday life for Chicanos/as, or what Geist and Nachbar would call "the normal activities of living day to day," included agrarian exploitation, civil rights violations, subminimum wages and working conditions, a standard of living marked by the color line, police brutality, gang warfare, and the loss of cultural memory.

Like their African-American counterparts marching behind Dr. Martin Luther King, Jr., Chicanos/as were not only underrepresented in higher education, middle-class neighborhoods, and white-collar jobs, but also denied access to many restaurants, hospitals, movie houses, and other public places. They had no authentic political representation. They faced deportation and fragmentation of their families. They attended segregated schools in which their names were "Americanized," their native language forbidden and replaced by English, their culture derided, and the history of their people reduced to "Remember the Alamo."

Thanks to the historical and cultural amnesia provoked by the melting pot ideology and reinforced by mainstream popular culture, Chicanos/as were seen and learned to see themselves as "immigrants or the children of immigrants in a new land."[19] Although their ancestors had occupied what is now known as the American Southwest centuries before the Anglo conquest and colonization of that territory, Chicanos/as were now not only "aliens" (as we saw in the film Born in East L.A.), but dirty, thieving, lazy, drunken, lecherous, treacherous, ignorant "mess-cans."[20] The resistance aspect of the Chicano Movement was both a reaction against these derogatory stereotypes and a counteraction to the assimilationist tactics of the dominating culture. In "Murales del Movimiento: Chicano Murals and the Discourses of Art and Americanization," Marcos Sanchez-Tranquilino explains that

> although classified as an American minority, U.S. Mexicans nevertheless found little acceptance unless they would assimilate. This meant that acceptance was predicated upon the expressed display of a preference for Anglo culture—especially the use of English—over Mexican culture. While some members of this group could and would assimilate, others were not willing or able.[21]

In 1966, those Mexican Americans not willing or able to jum the Great American Melting Pot—men and women from the fiel universities, and the barrios of the Southwest—took to the stre hind United Farm Workers flags and the banner of the Virgen de lupe. Thus began what Oscar Zeta Acosta calls "the revolt of the cockroach people." [22]

Embedded in the images of the brown-skinned Virgin and the black thunderbird on the red United Farm Workers flag (both icons appropriated by Chicano/a artists in every medium) was the ideology of resistance—to dehumanization, colonization, and assimilation—as well as the politics of affirmation of the mestizo/a heritage whose roots were Toltec as much as Spanish. Indeed, one of the main points of dissension between Hispanics and Chicanos/as (as current now as it was in 1910 when the Mexican Revolution brought a wave of Mexican refugees into the barrios of the Southwest, creating for many residents the need for distinction between themselves and the "foreigners," or in the 1920s when the "Latin" or "Spanish" label became the "polite" way of saying Mexican) is the issue of what roots to claim. "Hispanics," who derived from the Spanish-Americans of the 1930s and the hispano-americanos of the turn of the century—all of whom saw assimilation into the Euro-American mainstream as the only road to equality—continue to believe they find racial acceptance from Anglo society more readily if they claim Spanish ancestry. Chicanos/as, on the other hand, reject Euro-American assimilation by celebrating their multilingual, binational identity and Native American heritage or mestizaje. Although not technically a value in the same sense that freedom or individualism are values, mestizaje functions as a value in that it celebrates the racial and cultural mixing inherent in Chicano/a existence. As the pieces in the CARA exhibit demonstrate, Chicano/a art combines mainstream as well as experimental pan-American genres and styles with elements of Mexican, Euro-American, Native American, and Chicano/a popular culture to produce a truly New World mestizo/a art.

Pride in the pre-Columbian past emerged in the days of el Movimiento. Shifra Goldman and Tomás Ybarra-Frausto tell us in their extensive introduction to Arte Chicano: A Comprehensive Annotated Bibliography of Chicano Art, 1965–1981 that not only did the Chicano Movement inspire its followers to reclaim their Toltec, Aztec, Mayan, Olmec roots, but activists of the Movement allied themselves with Native Americans of the Southwest, who, like Chicanos/as, were protesting treaty violations, land usurpa-

Figure 14. Victor Ochoa, *Geronimo*, 1980, mural. Centro Cultural de la Raza, Balboa Park, San Diego, California. Photograph provided courtesy of the Social and Public Art Resource Center (SPARC). Reproduced by permission of the artist.

tions, and the human rights crimes of Manifest Destiny. Despite the tendency toward romanticism in this "neo-indigenist consciousness" of the Movement, Goldman and Ybarra-Frausto found that "pre-Columbian motifs in Chicano art served to establish pride and a sense of historical identity . . . [and] were an antidote to modern anti-Indian racism which considered all Indians and mestizos inferior peoples."[23]

What did it mean to be Chicano/a rather than Hispanic or Mexican American? Perhaps the "movement of thought" that most characterized and unified el Movimiento was the act of self-definition by the name "Chicano/Chicana." Unlike "Hispanic," "Spanish American," and "Mexican American"—all labels imposed by the dominant culture—"Chicano/a" was chosen by the activists of *la Causa* to baptize themselves and their Movement. "The word achieves its significance in being chosen and given political legitimacy by Chicano activists. The appropriation of this word marked the exceptional sense of power which naming oneself

signifies." [24] One popular definition of the term says that the word derived from the Nahuatl pronunciation of *Mexicano* (pronounced me-shi-cano), signifying a person of Aztec or *Mexica* (me-shica) affiliation. Thus, the term "Chicano/a" underscores and uplifts the indigenous heritage of U.S. Mexicans and challenges the classist and racist discourses internalized by those who insist on claiming what Carey McWilliams calls "the fantasy heritage." According to McWilliams, U.S. Mexicans who Hispanicize their roots are, in effect, collaborating with their own oppression:

> By emphasizing the Spanish part of the tradition and consciously repudiating the Mexican-Indian side, it has been possible to rob the Spanish-speaking minority of a heritage which is rightfully theirs. . . . The constant operation of this strategy has made it difficult for the Spanish-speaking people to organize and it has retarded their advancement. [25]

As Chicanos/as reclaimed their Aztec heritage and their Native American ties, the myth of Aztlán was born or, rather, resurfaced in the collective unconscious of the Movement. In Chicano/a mythology, Aztlán is the place of origin of the Aztec forbears, located in the conquered northern territories of Mexico (a.k.a. the American Southwest). "Since Aztlán had been the Aztec equivalent of Eden and Utopia, [Chicano/a] activists converted that ancient idealized landscape into an ideal of a modern homeland where they hoped to help fulfill their people's political, economic, and cultural destiny." [26]

This myth, John Chávez argues, like the Anglo myth of the frontier that propelled western expansion under the aegis of Manifest Destiny, is central to Chicano/a consciousness. The belief that Aztlán/the Southwest is the lost homeland of the people of Mexican descent—and the belief in the recuperation of that homeland, if not in physical terms certainly in cultural and spiritual ones—is shared by the Mexican immigrant, whose northward expansion under the aegis of cheap labor has gradually extended Aztlán from the U.S.-Mexico border to the northwest and the midwest. The walls of the *solar*, in other words, now embrace more territory, stretching from San Diego's Barrio Logan and El Paso's Segundo Barrio to Chicago's Westtown and the Yakima Valley of Washington State.

The problem with Aztlán is that it continues to be dominated by a patriarchal cultural nationalism that embraces the symbolic ideology of *indigenismo* and restricts its activism to race and class struggles. Gender and

Figure 15. José Gamaliel González and youth of Westtown, *La Raza de Oro*, 1975, mural. Hubbard Street, Chicago. Reproduced by permission of the artist.

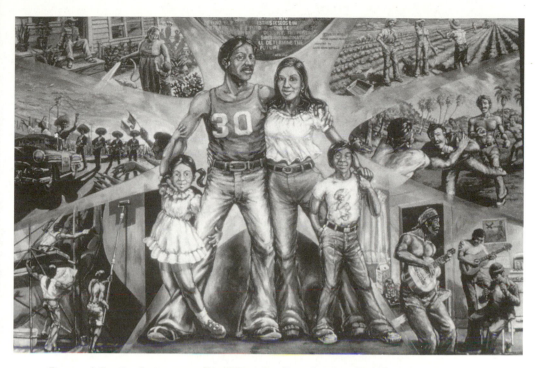

Figure 16. East Los Streetscapers (David Rivas Botello and Wayne Alaniz Healy), "La Familia" from *Chicano Time Trip*, 1977, mural. Lincoln Heights, East Los Angeles. Reproduced by permission of Wayne Healy.

sexuality—as we shall see in more depth later, if they fail to adhere to the essentialist, traditional values of the Chicano Holy "Familia"—are taboo issues in the kingdom of Aztlán.

There are those, both Chicanas and Chicanos among them, who believe that the intersection of feminist and Chicano identity politics did not occur until the 1980s and 1990s, but in fact *feministas* as early as 1970 were calling the gender bluff on el Movimiento's rhetoric of liberation, as Teresa Córdova's historical overview of twenty years of Chicana feminist writings makes abundantly clear.[27]

In "Speaking Secrets: Living Chicana Theory" Deena González speaks of a Chicana continuum whose roots go back to the Spanish conquest of Mexico and whose branches extend into all the neighborhoods of Aztlán.

[This] continuum of oppression and repression connects the choices of women, but especially of women who refuse to abide male authority, women like Malinche in the 16th century . . . and out Chi-

The Solar of Chicano/a Popular Culture

45

cana lesbians in the academy. That continuum was founded on the twin devils of patriarchy and misogyny, and is supplemented in steady doses today by the heterosexism—that hegemonic ideology that says all people are heterosexual—of most straight Chicanos and Chicanas.[28]

Although my analysis of the foundation of *el solar de cultura popular chicana* is not inclusive of all the popular beliefs and values that inform Chicano/a culture, those already described—resistance, affirmation, self-determination, *mestizaje*, *machismo*, and the myth of the homeland, with its twin themes of loss and recuperation—are what Nachbar and Lause would call "bedrock" myths of el Movimiento and provide enough information about Chicano/a culture to allow us entry into the different rooms of the CARA exhibit, representative of *el solar de* Chicano/a popular culture.

Bienvenidos/as: A Tour of the CARA Exhibition

Often, exploited or oppressed groups of people who are compelled by economic circumstances to share small living quarters with many others view the world right outside their housing structure as liminal space where they can stretch the limits of desire and the imagination.[29]

In her dialogue with black architect LaVerne Wells-Bowie, bell hooks describes architecture as a cultural practice, determined by the way people live their lives, by their economic realities, values, dreams, and desires.[30] Both Wells-Bowie and hooks believe that for African Americans the yard, the porch, and the outside space (including landscape, swings, outdoor furniture, and a cooking area) are as important architecturally as the inside. The relationship of the two spaces accounts for what Wells-Bowie calls "a deep structure" in which the outside and inside are "married" in order to "mitigate the hot climate and to accommodate needing more space . . . [as well as a] need for communal space, a space where everyone could come to."[31]

I see the *solar* of Chicano/a popular culture as its own "deep structure," both in the relationship that exists between the indoor dwellings and the central patio around which they are built and in the physical connection of the rooms to each other, as small individual spaces contained within a larger space. The sense of separateness and togetherness evoked by this architecture reflects the private individualism of mainstream American capitalist culture and the collective solidarity of a Mexi-

can working-class culture—both of which inform Chicano/a cultural practices.

As a place in which to extend the living quarters or alleviate intense heat, as a gathering place, a common space open to everyone, the African-American yard is the equivalent of the central patio in the *solar*. This is the "liminal space" that hooks mentions in the epigraph above, the space most amenable to the proclivities of desire and the whims of the imagination. Because it is the most communal space of the *solar*, and thus the most representative "room" of Chicanismo, the patio is both the beginning and the end of our tour of Chicano/a popular culture. Let us enter, then, by the patio, wherein popular Chicano/a rituals such as the telling of *chistes* and *cuentos*, the exchange of *curanderismo* remedies, the playing of *lotería*, the planning of a *huelga*, the building of a *día de los muertos altar*, and the hanging and folding of the ubiquitous laundry are enacted simultaneously by the different residents of the *solar*. Let us begin our tour of the house of Chicana/o popular culture by examining the altar, an installation of three-dimensional objects that symbolize some of la Raza's most deep-seated beliefs, values, and practices. Representations of these same objects can be found in the different rooms of the CARA exhibition.

El *Altar de* Cultural Icons and Heroes

> The first [room] of our house contains popular artifacts—objects and people widely accepted or approved of by the masses.[32]

The two earliest icons of Chicano/a popular culture are the images of the brown-skinned Virgen de Guadalupe and the black thunderbird, both revolutionary symbols of Raza empowerment (see Figures 1 and 2). Known as the "empress of Mexico," the Virgin signifies Mexican racial and religious *mestizaje*. While this is a problematic image for contemporary Chicana feminists, during el Movimiento the Virgin iconographed the biological source of Chicano brotherhood (i.e., the Mexican motherland) and also constituted a symbol of indigenist resistance to spiritual colonization,[33] transmuted by the goals of la *Causa* into a symbol of Chicano/a resistance to assimilation and territorial conquest.

The thunderbird, referred to as the "UFW eagle," is the "icon of the collective struggle of urban and rural Chicanos."[34] Throughout CARA we find the UFW eagle on paintings, woodcuts, murals, buttons, posters, newspapers, and altars; in the "Cultural Icons" section, however, there is not one artistic representation of the thunderbird, despite the fact that

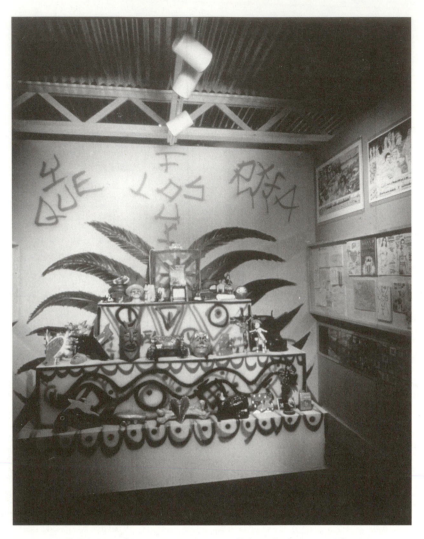

Figure 17. Early stage of the Los Four *casita*. Installation that was part of CARA: Chicano Art: Resistance and Affirmation, exhibition held at UCLA's Wight Art Gallery, September 9–December 9, 1990. Photograph provided courtesy of the Wight Art Gallery.

this and the Guadalupe image were the icons that galvanized the farm worker marches and strikes—the first organized protests of el Movimiento. True, the thunderbird figures prominently in three of the four pieces in "La Causa," the opening section (from which Figure 18 has been taken), but its absence in the gallery devoted to icons of the Movement is conspicuous. The *Guadalupana* is similarly underrepresented;

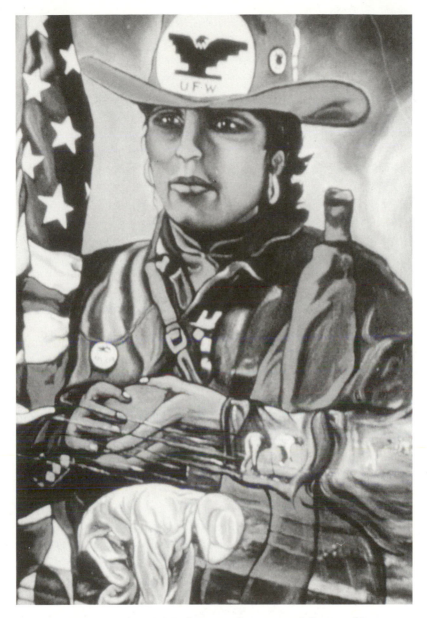

Figure 18. Ernesto Martínez, *Si Se Puede*, 1973, oil on canvas. Collection of Bert Salazar, *El Paseño* Newspaper. Reproduced by permission of the artist.

although she appears in other sections—the traditional image as well as updated versions of her as a marathon runner (see Figure 47), a seamstress (see Figure 7), and a karate expert (see Figure 58)—only one representation, Amado Peña's *Rosa del Tepeyac*, was chosen for the "Cultural Icons" room.

The icon that el Movimiento chose to symbolize the racial and cultural consciousness of Chicanos/as is known as the Mestizo Head:

> a tripartite head which represents the Mexican identity as a mixture of the two originally opposing cultures of Spain and peoples indigenous to Mexico. For Chicanos, this image also serves to represent their extended mestizaje (cultural mixture) which includes their North American (U.S.) heritage.[35]

This icon is rendered on Emanuel Martínez's *Mestizo Banner* and on Amado Peña's silkscreen *Mestizo*.[36]

Interestingly, however, it is Frida Kahlo's image that dominates the "Cultural Icons" room, outnumbering even the representations of one of the idols of the Chicano Movement, Emiliano Zapata.[37] Kahlo is very clearly a hero for the artists of el Movimiento, especially for *las mujeres*, though she does not enter the discourse of Chicano/a popular culture prior to 1975. Emiliano Zapata, on the other hand, with the figures of the Pachuco and the late César E. Chávez (*que en paz descanse*), forms what I call the holy trinity of Chicano popular heroes, as conceptualized by the CARA exhibition.[38] "Popular heroes," say Geist and Nachbar, "are people who represent for the members of a culture the ideals of that culture."[39] Zapata, representing the Mexican and Chicano agrarian ideal of territorial integrity, the Pachuco, representing cultural pride and resistance to assimilation, and Chávez, representing solidarity and justice for the working class, have been heroes of el Movimiento since its beginnings. Kahlo entered the heroic scene first as a calendar "girl" for Galería de la Raza in San Francisco, then as a role model for Chicana artists seeking to liberate themselves from the male-dominated structures of both el Movimiento and the Chicano Art Movement.[40] Frida was also heroized by Chicano/a artists for her innovative vision as an artist and her commitment to communism and *indigenismo*. Hence, even if Frida Kahlo was not, historically, a hero of Chicano/a popular culture, her positioning in the CARA exhibit constructs her as a popular hero of Chicano/a art.

According to Geist and Nachbar, popular heroes must meet three criteria:

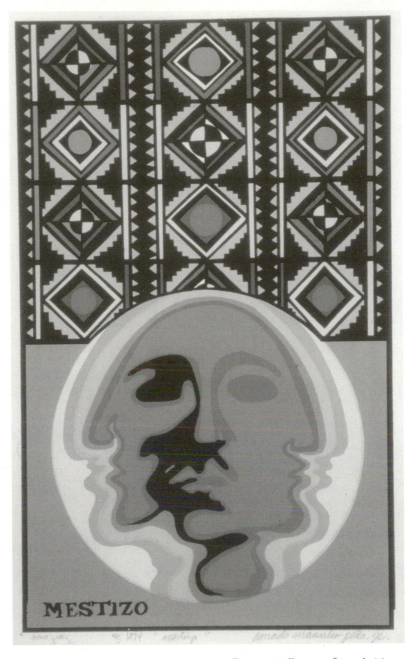

Figure 19. Amado M. Peña, Jr., *Mestizo*, 1974, silkscreen. Collection of Amado M. Peña, Sr. Reproduced by permission of the artist.

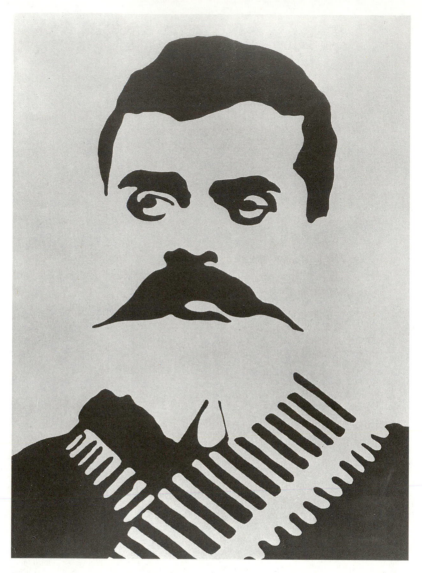

Figure 20. Rupert García, *Emiliano Zapata*, 1969, silkscreen. Reproduced by permission of the artist.

The first condition is that the person must be exceptionally gifted in some way. . . . [The second is that] the hero must possess qualities the culture highly values. . . . The third necessity for the true popular hero is his [or her] duty to the culture itself. Heroes must be defenders of their culture.[41]

Zapata, the principal hero of the Mexican Revolution of 1910, was gifted with the vision of a revolutionary and the charisma of a prophet.[42] As a politician of *los de abajo* (the underdogs) during Mexico's longest and most oppressive dictatorship,[43] Zapata denounced the Mexican upper classes and European and North American industrialists for their colonization of the Mexican peasants or *campesinos*. Apart from leading *el ejército libertador del sur* (the liberating army of the south), Zapata drew up a manifesto known as "El Plan de Ayala," which called for a new government, the confiscation of agricultural lands from the landlords, and the redistribution of these lands to the peasants. On May 21, 1911, Zapata's forces and Pancho Villa's troops from the north overthrew Porfirio Díaz's regime and occupied the capital.[44] As a broker for the oppressed, Emiliano Zapata "became a symbol of revolutionary resistance in the defense of lands and culture for the Chicano Movement."[45] Zapata's image is centralized in the "Cultural Icons" section of CARA and is a recurrent motif in Chicano murals. A poster of Zapata in the exhibit shows him pointing his finger in the typical Uncle Sam pose of army recruitment posters; the lettering says "The Chicano Movement Wants YOU." The artist who created this poster employs a Mexican/Chicano icon to appropriate and subvert the discourse of mainstream military recruitment and to serve the needs of el Movimiento.

It can be said that César Chávez, because of his devotion to the *campesinos*, was the Emiliano Zapata of the Farm Worker Movement, whose membership includes not only Chicanos/as and Mexicans, but also colonized people of different cultures, among them Filipinos, Central Americans, and Asian immigrants. As a believer in nonviolent resistance, however, Chávez would not have condoned Zapata's guerrilla tactics. In this he was reminiscent of another politician of the underdogs, the African-American preacher Dr. Martin Luther King, Jr., whose ideas, demands, and actions Chávez integrated into those of the United Farm Workers' Union. Chávez's *huelgas* (strikes), boycotts, marches, pilgrimages, fasts, jail stints, and endless consciousness-raising campaigns demonstrated not only his gift for creative organizing on a mass scale and his remarkable ability to attract public support for his cause, but also his compassion and persistence, as well as his commitment to the struggle of resistance and affirmation of both rural and urban workers of color. Indeed, as acknowledged by President Bill Clinton at the time of Chávez's death in 1993: "The labor movement and all Americans have lost a great leader with the death of César Chávez. An inspiring fighter for the cause to which he dedicated his life, César Chávez was an authentic hero to millions of people throughout the

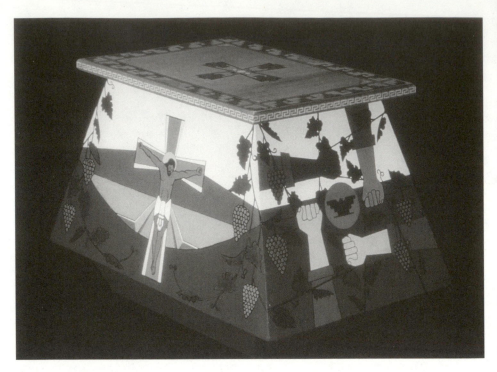

Figure 21. Emanuel Martínez, *Farm Workers' Altar*, 1967, acrylic on wood. Collection of the National Museum of American Art, Smithsonian Institution. Gift of the International Bank of Commerce in honor of Antonio R. Sánchez, Sr. Reproduced by permission of the artist and the National Museum of American Art.

world."[46] Posthumously, Chávez received the Presidential Medal of Freedom, the highest honor bestowed on a civilian.

The first altar in CARA, which is placed at the entrance to the exhibit in the center of the "La Causa" gallery, is Emanuel Martínez's *Farm Workers' Altar*, constructed in homage to César Chávez and used in the Mass that was celebrated after he broke his first fast.[47] Although there are no portraits of Chávez anywhere in the exhibition, images of him appear throughout the show in photographs and ephemera memorializing his commitment to improving the lives of fieldworkers through his indefatigable defense of the civil and human rights of the poor and the disenfranchised. In San Antonio's Museum of Art, where CARA's tour was scheduled to close on August 2, 1993, the exhibit hall displayed a *broche de oro*,[48] a plaque dedicating CARA to the memory of César Chávez; thus, ironically, the closure of this visual history of Chicanismo coincided with the death of one of its principal heroes.

Open House

54

More than 35,000 people attended César Chávez's funereal march on April 29, 1993, among them farm workers, politicians, actors, academics, and *veteranos* of el Movimiento; the march was what the *Los Angeles Times* called "the working people's state funeral." [49] A week earlier, on the other side of the border, *mexicanos* were attending their own "working people's state funeral" in honor of beloved comic actor Cantinflas/Mario Moreno. [50] He was laid out in state at the Palace of Fine Arts in Mexico City, and tens of thousands of Mexicans filed by his coffin to pay their last respects. Nearly forty years earlier another wake was held in the same marble foyer of the *palacio de bellas artes* to honor "a sister of the people [and] great daughter of Mexico," [51] who, like Cantinflas, was a national idol, and who, like César Chávez, is now immortalized on the altar of Chicano/a popular heroes: Frida Kahlo.

Apart from Frida Kahlo's political activism and solidarity with her indigenous Mexican heritage, both highly valued in Chicanismo, she was a painter of exceptional talent devoted to creating her identity and recording her life through art. Every piece she painted included an image of herself, usually the central image of the work, the main vehicle through which to transmit her political and emotional messages about pain, oppression, and survival. Her physical hardships began with a bout of polio in her childhood that left her right leg slightly paralyzed, followed by an accident in her eighteenth year in which "the handrail [of the bus she was on] pierced through [her] like a sword through a bull" and fractured "her leg, her pelvis, and her spinal column." [52] The accident would require her to undergo thirty-nine operations in her 45-year lifetime. These operations kept her bedridden for months and turned her into a convalescent, an invalid, a manic depressive, and a morphine addict. Martha Zamora tells us that Frida attempted suicide several times. A year before her death she attended the opening of her first exhibition at the *museo de bellas artes* in an ambulance, brought into the museum on a stretcher. Two months after her exhibition closed, Frida's pain culminated in the gangrene that led to the amputation of her right leg. [53]

Not long afterward, the woman whose motto was *Viva la Vida* (Long Live Life) relinquished her existence. That she managed to paint as beautifully, disturbingly, and prolifically as she did attests to the indomitability of her spirit, and it is this quality that gives Frida Kahlo her heroic proportions. Chicana artists like Ester Hernández, Yreina Cervántez, Barbara Carrasco, and Amalia Mesa-Bains resonate with Kahlo's artistic activism, her incessant questioning of her identity and her subjectivity, her conflicts with the formal and patriarchal tenets of the art world. But, as we shall

Figure 22. Yreina D. Cervántez, *Homenaje a Frida Kahlo*, 1978, watercolor. Reproduced by permission of the artist.

see in the next chapter, Kahlo has become an icon for Chicano artists as well, a metaphor for their own "feminine" subjectivity and their "roots" as artists.

Of the five pieces in the "Cultural Icons" section that represent Frida Kahlo, only the one done by a woman, Yreina Cervántez's watercolor *Homenaje a Frida Kahlo*, works Frida's image into the multicultural fabric of Chicano/a popular culture. In the rays of light radiating from behind the image of Frida, Cervántez's picture alludes to the iconic Virgin of Guadalupe;[54] the twin fetuses in her belly and the mask in Frida's hand suggest issues of identity and nationalism, but they also imply Frida's inability to bring her pregnancies to term as a result of the bus accident that fractured her spine—all of which resonate with Raza concerns about identity, citizenship, and involuntary sterilization. The calla lilies and the image of Diego Rivera are clear references to the influence of Rivera, David Alfaro Siqueiros, and José Clemente Orozco, also known as *los tres grandes*, in the work of Chicano/a artists. The jaguar on which Frida is riding, the butterfly about to be trampled at her feet, and the snake wrapped around her neck are all symbols from Toltec mythology, just as Frida's pose on the jaguar and her path strewn with flowers and fronds are reminiscent of Christ's entrance into Jerusalem. In the rendition of Diego Rivera as the frog, Cervántez is visually interpreting one of Frida's endearments for Diego, *sapito* or "Frog-toad,"[55] but the image is also an unmistakable allusion to a European fairy tale, "The Frog Prince," in which the frog is transformed into a handsome prince by the kiss of a kind princess who is not repelled by the frog's ugliness (and "otherness," I might add). Indeed, transformation is the leitmotif of Cervántez's *Homenaje*, which depicts not only the syncretism of indigenous and European traits in the life and work of Frida Kahlo, but also the transformative effects of *mestizaje*.

Before we proceed to the hearth of the *solar* to stir the pots of popular mainstream stereotypes of Chicanos/as, we must examine two more icons, extremely significant to la Raza: the lowrider and the zoot suit. Neither of these really lives on the altar of icons and heroes except in reproduction: a model car or a photograph. They are, nonetheless, symbols invested with meaning and history as well as material culture directly linked to a popular ritual. Lowriders and zoot suits function both as iconic objects in themselves and as signifiers of the social events in which they figure. To get a sense of a lowrider, and witness the ritual of "cruising," let us follow the homegirl with the rose tattoo on her shoulder in Ricardo Valverde's photograph *Boulevard Night* out of the *solar* and onto the boulevard.

The Solar of Chicano/a Popular Culture

Figure 23.
Ricardo Val-
verde, *Boule-
vard Night*,
1979, sil-
verprint
photograph.
Reproduced
by permis-
sion of the
artist.

Boulevard Rites

In "*Bajito y suavecito*: Low Riding and the 'Class' of Class," published in the *Journal of Latin American Popular Culture*, Michael Cutler Stone defines the low-rider for an audience of popular culture scholars as "any automobile, van, pickup truck, motorcycle, or bicycle lowered to within inches of the road. It refers as well to any individual or club associated with the style and the 'ride' characterized as 'low and slow, mean and clean.'"[56]

All the *vatos locos* know, however, that the real lowrider is an older car, preferably a Chevy from the late 1950s, restored, painted, installed with hydraulics, made *bien bajito* (real low), then chromed, airbrushed, and up-holstered in velour. The lowrider as a status symbol, as a symbol of community affiliation and identification, Cutler Stone's research has found, "contests stereotypes of Mexican Americans. It evokes a self-consciously positive, stylized public representation of Mexican American identity and pride."[57] Lowriding also defies the capitalist consumer mentality, as well as the mainstream's obsession with speed and efficiency. George Lipsitz sees lowriders as masters of postmodern cultural manipulation because they "juxtapose seemingly inappropriate realities—fast cars designed to

Open House

58

go slowly, 'improvements' that flaunt their impracticality, like chandeliers instead of inside overhead lights. . . . They are [also] intertextual—cars are named after songs or incidents in Mexican history. . . ."[58]

The informants of Brenda Jo Bright's ethnographic study on lowriders (based in Houston, Los Angeles, and Española, New Mexico) indicated that lowriding was the alternative to gang-banging for Chicano male socialization. Though both choices lead to a communal experience, be that a car club or a *clica*,[59] gang-banging is perceived (in this research, anyway) as "limiting" and potentially dangerous while lowriding is viewed as a road to self-improvement. "The road of gang membership involves one in a locally based community, where neighborhood, cohort, and identity converge and must be protected. The other [road], lowriding, involves one with others from all over the city in both cooperative and competitive networks."[60]

Because of their continued juxtaposition in popular films about Chicanos, it has become a common misconception to link gang-bangers with lowriders, but, as Bright's research suggests, gang membership and car customizing do not necessarily go hand in hand. Indeed, if Bright's informants have been interpreted correctly, there appears to be a good/bad dichotomy implicit in the distinction between these two types of Chicano youth. Joining a club, raising and saving money, their sights fixed on the goal of owning their own car and customizing it to reflect their individuality, competing with others rather than engaging in inter- and intraracial warfare, winning prizes, cruising the neighborhood to show off the fruits of their labor—lowriders are constructed here as good Chicanos, more American than Mexican, who prefer playing with cars to joining gangs. Gang-bangers, the implicit argument insinuates, are the bad boys, the dangerous boys living by the essentialist and territorial codes of their tribe, and they lack the individual desire and collective support necessary to bring them out of their vicious circle of violence. "In working-class and poor neighborhoods, adolescent males engage in both [activities]," Bright explains, "but extensive modifications to cars are discouraged both because of cost and because such cars frequently become targets in gang conflicts."[61] Apparently, gang-bangers also cruise, but usually with drugs and guns in the car that inevitably result in a drive-by shooting.

Because every lowrider is painstakingly customized, and absorbs so much time, energy, and money, the car becomes a sculpture on wheels, or as Bright says a " 'territory' in motion,"[62] that makes a statement about its driver/artist more than a commodity that gets traded in for next year's newer and faster model. Unlike the hot-rodder, the lowrider's goal is not

The Solar of Chicano/a Popular Culture

59

to reach his destination in the least amount of time, but rather to attract attention. As one of Cutler Stone's informants told him: " 'You want to see and be seen. A car doesn't look as good going fast, and you see people better when you're cruising slow. Above all, you must be cool.' " [63]

But the lowrider, as an automobile, is also iconic of the Chicano's cultural *mestizaje*. Geist and Nachbar remind us that in mainstream popular culture, "the automobile we [sic] own becomes a tangible representation of who we are, and who we want our friends and neighbors to believe we are." [64] The lowrider look, originally superimposed (in the fifties) on domestically manufactured cars like Chevys and Fords, represents the hybridization of a principal icon of the American Dream. Moreover, there is an implicit message about citizenship in the lowrider. Although nowadays it is possible to see lowriding Honda Civics, Volkswagen Beetles, and Isuzu trucks, the fact that lowriders originated as American cars (now almost collector's items) affirms the "native" nature of the lowriding experience. Indeed, lowriders are "born [and made] in the U.S.A."

With the purchase of a lowrider by the National Museum of American History in Washington, D.C., in the spring of 1992, this icon of Chicanismo has been "discovered" as an art form by the dominant culture.

> The Smithsonian Institution acquired the car as part of "American Encounters," a new permanent exhibition that explores the interactions of Native Americans, Hispanics, and Anglo-Americans in New Mexico's Rio Grande Valley. "Dave's Dream" was originally created by David Jaramillo, a resident of La Cuchilla de Chimayó who died six months after beginning work on the car. [65]

Dave's Dream, completed by the Jaramillo family ten years before its purchase by the Smithsonian, is a 1969 Ford LTD that literally bounced its way into the permanent car collection of the Hall of Transportation on its customized hydraulics, displaying what its new owners proudly labeled "minority-influenced technology." [66]

Although we find no actual lowriders in the CARA exhibit, [67] lowrider images do appear, connoting either the cars or their drivers, especially in the photographs of the "Urban Images" room (as we see in Figures 24 and 27). Car iconography also figures in the other sections of the exhibit: in the Los Four installation (see Figure 17), the base of the three-tiered altar is an actual bumper from a '57 Chevy (one of the most popular cars for lowrider transformation) and several papier-mâché and ceramic

Figure 24. Joe B. Ramos, *Lowrider Couple*, 1980, silver gelatin print. Reproduced by permission of the artist.

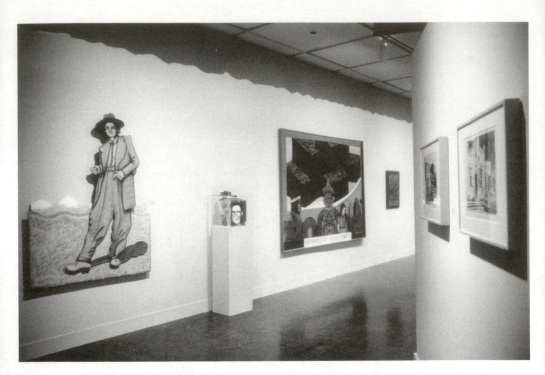

Figure 25. Carlos Fresquez, *Zoot Suit en los Rockies*, 1984, acrylic on wood. Reproduced by permission of the artist. Pictured within the "Regional Expressions" room. CARA: Chicano Art: Resistance and Affirmation, exhibition held at UCLA's Wight Art Gallery, September 9–December 9, 1990. Photograph provided courtesy of the Wight Art Gallery.

models of cars appear on the altar. In the "Reclaiming the Past" room, we find David Avalos's *Hubcap Milagro #3*, a metal sculpture of a saint mounted on an actual hubcap, as well as Carlos Santistevan's *Santo Niño de Atocha*, the patron saint of travelers, welded here from car parts. In "Redefining American Art," we see Gilbert Luján's mixed-media installation of a tropicalized, coyote-driven *carrucha* (old car) that is, according to its title, *Powered by the Heart*, and a Carlos Almaraz painting of a car crash, *West Coast Crash*, signifying the clash of cultures in California.

At no time in the history of California was the clash between the dominant culture and Chicano/a culture more volatile and visible than during the so-called Zoot Suit Riots of the early 1940s. This, too, was a popular ritual of the boulevard, for, as the Pachuco Spirit in Luis Valdéz's film explains it: "The city's cracking down on Pachucos, *carnal*. Don't you read the newspapers? . . . the Mirror *Valley* has declared an all-out war on Chicanos. . . . Forget the war overseas, *carnal*. The war's on the homefront."[68]

Open House

62

Like the lowrider, the zoot suit symbolized the fashion of resistance to stereotypes and affirmation of cultural identity (see Carlos Fresquez's three-dimensional rendition in the "Regional Expressions" room in Figure 25 and Richard Duardo's rendition in the "Urban Images" room pictured in Figure 29). To refute the "dirty Mexican" cliché, zooters insisted on sharply pressed creases and pleats, highly polished shoes, and an overall appearance of affluence. Ranging from $18 to $125, zoot suits were not cheap, although the style was distinctive in that it originated and took hold in urban communities of color, typically among the most impoverished. The zoot suit was a national and international teenage trend in the 1940s. According to Mauricio Mazón's *The Zoot Suit Riots: The Psychology of Symbolic Annihilation*, the zoot suit fad was especially popular in cities like London, New York, Philadelphia, Detroit, Chicago, El Paso, and Los Angeles. In the cities of the eastern seaboard and the Midwest, it was worn predominantly by African-American youth who called themselves "hepcats" or "swing-mad kids" and signified their taste in music and dance styles; in California and the Southwest, the zoot suit was primarily the garb of barrio youth or Pachucos.

Regardless of their ethnicity, "zooters" emerged from marginalized and segregated communities that systematically endured egregious acts of humiliation and racial discrimination like the ones described by George I. Sánchez, professor of Latin American education at the University of Texas. In his 1944 study "Pachucos in the Making," Sánchez lists one indignity after another occurring throughout California and the Southwest, perpetrated by white landlords, shopkeepers, restaurant owners, public officials, union organizers, real estate brokers, cemetery managers, in short, by the white citizenry in general, against people of Mexican descent.[69] It was in this political climate that the popular culture of the oppressed took on a distinctly rebellious ethos, as seen in the popular "swing" and "jitterbug" music of the ghetto and in the clothes fashioned for dancing to the new rhythms.

"Besides being the ideal attire for dancing the jitterbug," says Mazón, "the zoot suit also represented defiance"[70]—primarily defiance of adult conventions and of the suffocating patriotism of World War II. The zoot suit look involved more than the "loose-fitting Drape Shapes . . . ankle-tight pegged cuffs, reet pleats, peg tops, lids, and DA hairstyles."[71] As just illustrated, a particular slang came with the zoot suit, as well as a stylized gait, stance, and attitude—all of which painted a picture of a very different Mexican, a U.S. Mexican, not a foreigner and certainly not a criminal, despite being stereotyped as both in the mass media. The most dis-

tinctive attribute that Luis Valdéz ascribes to the "real Pachuco" is his "American-ness."

> As a second-generation American, he [the Pachuco] was not content—as his parents had been—merely to be living in the United States. He expected the full benefits of citizenship, and, like second-generation Irish, Polish, or Chinese Americans, he was a product more of the new country than of the old one. The flashy neon lights of Hollywood drew the Pachuco away from the tranquillity of his parents' way of life and into the theatricality of a contrived style.[72]

This contrived style depended, in large part, on the flamboyance of the zoot suit. "The clothes attracted attention," Valdéz says, "and the *pachuco* stood out in the crowd—sometimes to the dismay of conservative Mexican Americans as well as to the anger of Anglos. But even disapproval and notoriety were preferable to being ignored."[73] Indeed, this focus of attention, this strategy of "strutting your stuff," like the desire to be seen driving in the 'hood low and slow, is prototypically *American Me.*

The zoot suit was not unique to the Chicano community, having been borrowed from the black youth culture of urban ghettos on the East Coast;[74] however, the Zoot Suit Riots of 1943, which targeted the Pachuco zoot suiters of Los Angeles, turned the mass media's attention to this group, and the zoot suiter label soon became synonymous with Pachuco or Chicano.[75] Various silkscreens, paintings, sketches, and mixed-media pieces in CARA portray the icon of the zoot suit. Our discussion of this important symbol and its diverse manifestations, however, must be continued in the kitchen of the *solar* of Chicano/a popular culture, wherein the mainstream's common beliefs about Chicanos/as and Mexicans have been cooking for over 150 years.

Melting Pots in *La Cocina de los* Stereotypes

> Since stereotypes are public beliefs, like other commonly accepted beliefs, they are the causes of certain human actions that are sanctioned by the culture in which they take place. Hence, a negative stereotype is likely to cause negative reactions against those being stereotyped.[76]

It warrants repeating that one of the fundamental values of the Chicano Movement was resistance to the damaging stereotypes that the dominant culture cooked up about Chicano/a and Mexican people living in

the United States. Of these stereotypes, the "alien," the "greaser," the "loser," and the "criminal" were all projected onto the figure of the Pachuco. These culturally sanctioned stereotypes go back as far as the Treaty of Guadalupe-Hidalgo in 1848, and even further back than the Anglo Texans who migrated, some legally, most illegally, into Mexican territory.[77] Américo Paredes's landmark study "*With His Pistol in His Hand*": *A Border Ballad and Its Hero* formulates the characteristics of Anglo racism against Mexicans—the cause of the stereotypes—into what he calls a "border legend." Below I transcribe four of the six points that make up this legend, all of them negative stereotypes about Mexicans that caused groups like the Texas Rangers, the Border Patrol, and (in the case of the zoot suiters in Los Angeles) the armed forces to persecute Mexicans and their descendants in the United States:

1. The Mexican is cruel by nature. The Texan must in self-defense treat the Mexican cruelly, since that is the only treatment the Mexican understands.

2. The Mexican is cowardly and treacherous. . . . He can get the better of the Texan only by stabbing him in the back or by ganging up on him with a crowd of accomplices.

3. Thievery is second nature in the Mexican . . . on the whole he is about as degenerate a specimen of humanity as may be found anywhere.

4. The degeneracy of the Mexican is due to his mixed blood. . . . He is descended from the Spaniard, a second-rate type of European, and from the equally substandard Indian of Mexico.[78]

The "legend" justified Anglo hostility toward Mexicans and reified Anglo-Texans like Jim Bowie, Davy Crockett, and Sam Houston, perpetually inscribing their "freedom fighter" memories, along with the memory of the savage Mexicans, into the popular culture of the border.

One of the principal dangers of stereotyping that Geist and Nachbar discuss, "culturally accepted persecution,"[79] was blatantly acted out against the Pachuco youth of Los Angeles in the 1940s by a California judge, jury, and prosecution who convicted seventeen Pachucos of first and second degree murder, as well as by the mass media, American servicemen, and local civilians who exacerbated the issues with their sensationalist reports and racist actions. The Anglo "legend" of the cruelty, treachery, and degeneracy of the Mexican was wielded by the prosecution of the Sleepy Lagoon Case in 1942 that launched the Zoot Suit Riots the

The Solar of Chicano/a Popular Culture

65

Figure 26. José Montoya, *Pachuco: A Historical Update*, 1978, silkscreen. Reproduced by permission of the artist.

following year.[80] Much like the L.A. "riots" of 1992, the Zoot Suit Riots broke out as a result of a court case. Unlike the Rodney King case, however, which sparked a furious response from African Americans and Latinos in South Central Los Angeles and spread throughout, the Sleepy Lagoon case generated a response from the dominant culture, which at the

time was operating on severe Asia-phobia thanks to another Anglo "legend" at work, particularly in California: the "yellow peril stereotype."[81]

In "Yellow Devil Doctors and Opium Dens: A Survey of the Yellow Peril Stereotypes in Mass Media Entertainment," Gary Hoppenstand outlines three characteristics of the "yellow peril stereotype" that resonate with the Mexican stereotypes summarized by Paredes; two of these characteristics, as we shall see below, directly affected the outcome of the Sleepy Lagoon case. The first of these, "the belief that Orientals [sic] are part of a great, undifferentiated horde that robs non-Orientals of economic resources,"[82] is the product of a guilt complex on behalf of a country that was shaped by hordes of European migrants who rapidly proceeded to appropriate and exploit the resources of the countries they were (and are) invading. The second and third characteristics of this yellow peril stereotype, "the belief that Orientals are schemers" and the "notion that Orientals are blood-thirsty killers,"[83] were actually part of the prosecution's case against the seventeen Pachucos accused of killing one of their peers at the Sleepy Lagoon.

Mazón tells of a lieutenant of the sheriff's department who testified before the grand jury

> [and] presented a discourse on genetics in making a case for the racial determinants responsible for Mexican juvenile delinquency and violence. He directed the grand jury's attention to the oriental background of Mexico's pre-Columbian ancestors, underscoring their mutual disregard for human life. . . . Referring to Aztec human sacrifice, [the lieutenant] added: "This total disregard for human life has always been universal throughout the Americas among the Indian population, which of course is well known to everyone."[84]

Hoppenstand contends that it was the yellow peril stereotype "that enabled this country to whip itself into a war fever" against Japan.[85] This fever manifested itself in an unmitigated rash of patriotism that erupted in all sectors of American life, and it was, in part, to rebel against this wave of racist patriotism that Pachucos adopted the zoot suit and its mannerisms. Implicit in the lieutenant's testimony above is his patriotic paranoia against the Japanese. Linking the Mexican to the "Oriental" helped the prosecution build a case for the defendants' "un-Americanness." Hence, the Pachucos on trial, because of their Aztec—and, by extension, Asian—ancestry, were, according to the prosecution, capable of murder, conspiracy, and treason.

The Solar of Chicano/a Popular Culture

Figure 27. José Gálvez, *Home Boys/White Fence*, 1983, black-and-white photograph.
Reproduced by permission of the artist.

The guilty verdicts imparted in this case spurred racist acts against
Mexicans, and the zoot suit–draped Pachuco became the scapegoat. Five
months after the seventeen Chicanos accused of killing a teenager at the
Sleepy Lagoon were tried and convicted, true-blue sailors and soldiers
in Los Angeles, San Diego, Chicago, Detroit, and Philadelphia took to
ganging up on Pachucos, beating them and stripping them of their un-
Americanness by literally stripping them of their zoot suits. These were
the famous Zoot Suit Riots. As Mazón puts it: "The zoot suiters, attacked
by servicemen and civilians in June 1943, were symbolically annihilated,
castrated, transformed, and otherwise rendered the subjects of effigial
rites."[86]

Through el Movimiento and the Chicano Art Movement, specifically
with the work of José Montoya and César Martínez,[87] the figure of the
Pachuco has stepped out of the Dirty-Mexican Hall of Fame and into the
gallery of Chicano heroes as a primary icon of resistance and affirmation.
In the CARA exhibit, at least fifteen major pieces depict either the Pachuco
in his zoot suit or some derivation of Pachuco culture (see Figure 29).
Montoya has five drawings from his 1977 Pachuco series included, as

Open House

68

Figure 28. Charles "Chaz" Bojórquez, *Placa/Roll Call*, 1980. Collection of the National Museum of American Art, Smithsonian Institution. Gift of the artist. Reproduced by permission of the artist and the National Museum of American Art.

well as the silkscreen *Pachuco: A Historical Update* (Figure 26), depicting the icon of the skeleton in Pachuco "rags." Richard Duardo's silkscreen *Zoot Suit* shows two fancy *vatos* in stylish "zoots" who look like prototypes of the characters in the Luis Valdéz play. Carlos Fresquez's nearly life-size and three-dimensional *Zoot Suit en los Rockies* (Figure 25) attests to the presence of Pachucos outside of Los Angeles.

Pieces that depict scenes and imagery of urban culture also signify *Pachuquismo* and its legacy in the barrio. Rudolfo Ornelas's black-and-white photograph *A Manera* juxtaposes a classy whitewall, mag wheel with a pair of black and white "Stacy's," considered by Pachucos the ultimate style in shoes. José Gálvez's *Homeboys/White Fence* (Figure 27) shows a modern-day Pachuco, a Cholo homeboy, adjusting a younger boy's bandana "to its appropriate coded and ritualized level." [88] The can of Pepsi in the younger

The Solar of Chicano/a Popular Culture

69

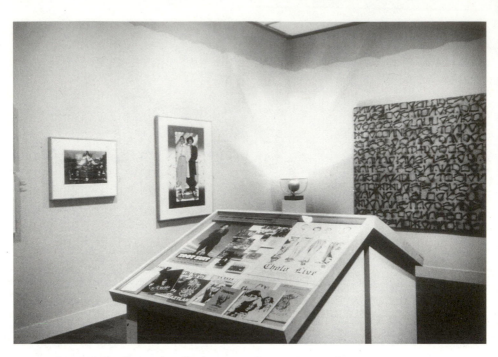

Figure 29. Installation shot. "Urban Images" room. CARA: Chicano Art: Resistance and Affirmation, exhibition held at UCLA's Wight Art Gallery, September 9–December 9, 1990. Photograph provided courtesy of the Wight Art Gallery.

Cholo's hand fits into the barrio landscape as easily as the rosary and crucifix tattooed on the older Cholo's hand, a clear statement about cultural *mestizaje*.

A large acrylic by Charles Bojórquez called *Placa/Roll Call* is meant to represent a barrio wall inscribed with "spider writing," the stylized calligraphy (a.k.a. graffiti) of the barrio that is a legacy of Pachuco culture and that resists interpretation except by those who can read the language. "Placas are eminently legible to those they address and their creators receive recognition, praise, and respect for their artistic ability as well as for their verbal skill." [89] We see *placas* again in Miguel Gandert's *Juanito with Pork Pie Hat, Albuquerque, NM*, signed on the wall of a New Mexican barrio, which signifies the homeboy's community. Finally, Rene Yañez's hologram *Pachuco and Pachuca* (visible in the installation shot in Figure 29) is an amazing construction that shows a three-inch Pachuco couple dancing in thin air in the midst of what looks like a large, slowly gyrating lampshade, the two figures caught, like decentered subjects in the postmodern condition of Chicano/a urban identity, between technology and memory.

Open House

70

Indeed, memory or the act of remembering/forgetting one's cultural heritage is—like the dancing, "spider-writing," cruising, and tattooing of Pachucos and Cholos—another popular ritual of la Raza, all vividly enacted out on the patio, in which the values, beliefs, mythologies, heroes, icons, and debunked stereotypes of all the previous spaces come together and manifest themselves ritualistically.

El Patio de los Rituals

Geist and Nachbar explain that popular rituals "are regularly repeated, patterned social events" that celebrate a community's "highly valued ideals and myths . . . [and that] help us to shape our relationship to other people and to our culture as a whole." [90] The Popular Culture Reader simplifies the study of popular rituals by dividing them into three general categories: rites of passage, rites of season, and rites of unity:

> Rites of passage . . . are designed to publicly mark a transition in social status or lifestyle of a person or group. . . . Rites of unity primarily celebrate the togetherness of the social group, as participants revel in the virtue of belonging, of being part of something. . . . Rites of season . . . are generally more traditional, often having their roots in the depths of prehistory. [91]

Certainly a popular ritual such as a wedding ceremony partakes of the three definitions, blurring the distinctions above; but the categories are meant to simplify study by taxonomically classifying popular rituals according to their primary intentions. Rituals intended to mark a particular time of the year, then, though they may indeed bring people together and ultimately celebrate a symbolic transition from one state of existence to another, still would be classified in Geist and Nachbar's paradigm as rites of season (e.g., Halloween, Thanksgiving, or Christmas).

Intentions, however, are culturally and historically determined. The purpose of a wedding ceremony in mainstream Anglo-American culture, for example, may be diametrically opposite in Chicano/Mexicano culture, as John Valadez shows us in his oil pastel The Wedding, found in the last section of CARA, "Redefining American Art."

The Wedding is a pastoral portrait of the bride in her regalia, but also of the bride's mother, who is seated authoritatively to her daughter's right and literally on the train of the bride's dress. If we classify the wedding ceremony in patriarchal societies as a ritual that primarily marks a wom-

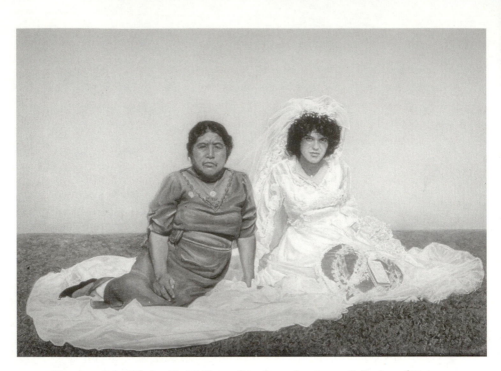

Figure 30. John Valadez, *The Wedding*, 1985, oil pastel on paper. Collection of Dixie Swift. Reproduced by permission of the artist.

an's passage from her father's property to her husband's, and the white dress is the symbolic virginity of the bride which the groom allegorically penetrates when he is allowed to lift the veil and "kiss the bride," then the portrayal of the mother-in-law seated on the wedding dress recasts the patriarchal tenets of the wedding ceremony, as the daughter is shown to belong not to her father but to her mother, and signifies that the groom is marrying not only his *novia*, but the train of her entire *familia*, represented by the mother. Moreover, the mother, whose phenotype is distinctly mestiza, may well be the seamstress of the dress, just as she is also the maker of the bride—a biological association that also connects the political realities of race, class, and gender.

We can say, then, that a Chicano wedding ceremony functions primarily as a rite of unity, rather than a rite of passage, for the families of the bride and groom are joined into each other's extended family and become not distant and hyphenated "in-laws," legally (i.e., patriarchally) bound, but actual relations, *suegros* and *cuñados*, who are linked matrilineally. An outsider to Chicano/Mexicano culture may view this linkage as the ultimate mother-in-law joke, or, at best, a rite of disunity, but the adage mi

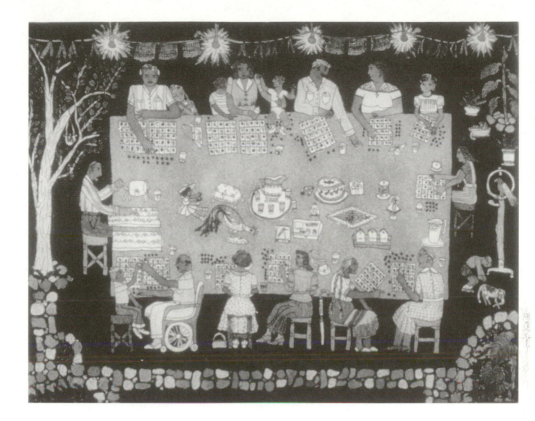

casa es su casa, arguably the most typical expression of Mexican culture—which stands not only for hospitality, but also for the traditional values of *familia* and community solidarity—is inscribed in Valadez's placement (comic, unintentional, or otherwise) of the mother on the wedding dress in the bride's portrait.

Other pieces in CARA which depict the same values as Valadez's painting enacted through different popular rituals are images of "brotherhoods" such as Adam Avila's silver print photographs *Golden Gloves* and *Cuatro Hermanos* and Antonio Pérez's black-and-white photographs *School Kids* and *Three Graduates,* all in "Urban Images." Carmen Lomas Garza's hand-colored intaglio print *Lotería—Tabla Llena,* located in "Regional Expressions," shows members of several families (perhaps residents of a *solar*) gathered around a table playing *lotería* or Mexican bingo. Gaspar Enríquez's three mixed-media pieces from his *La Familia* series, located in "Reclaiming the Past," are small metal shrines reminiscent of Day of the

Figure 31. Carmen Lomas Garza, *Lotería—Tabla Llena,* 1974, etching/ watercolors. Reproduced by permission of the artist.

The Solar of Chicano/a Popular Culture

Dead altars, worked with photographic images of different members of his family.

Indeed, another highly valued ideal that is celebrated ritualistically in Chicano/a popular culture is reclaiming the past, for, as the Mexican proverb warns, *el pueblo que pierde su memoria pierde su destino* (a people that loses its memory forfeits its destiny). Memory and ceremonies of memory, both personal and collective, pivot on the annual celebration of the Day of the Dead and the tradition of altar-making. As a ritual that commemorates the dead—be they ancestors, civic leaders, or personal heroes—*día de los muertos*, traditionally celebrated every November 2, is a rite of memory/rite of season that can be traced to the pre-Columbian history of the Americas. In the voiceover narration of *La Ofrenda*, Lourdes Portillo's filmic depiction of the *muertos* ceremony in Mexico, we learn of the syncretic nature of this ritual:

> Before the arrival of the Spanish, the Indians dedicated an entire month to honoring the dead. The last days of the celebration coincided with the Catholic feast of All Saints and All Souls. The Indians incorporated the Catholic rituals into their ancient celebrations for the dead, today known as *los días de muertos*, or the days of the dead.[92]

As part of the syncretism of this celebration, home altars are constructed to honor and sanctify the dead. They include traditional Catholic artifacts such as rosaries, crucifixes, *milagros* ("miracles" or miniature metal amulets) and statues of favorite saints, as well as materials sacred to the indigenous ceremony of remembrance: water, fruit and bread offerings, and fresh flowers, usually the *cempazuchitl* or marigold, whose scent, it is believed, when mixed with the smell of burning copal, reaches the dead. Incense, candles, images of the Virgin of Guadalupe, photographs of the departed, personal mementos, and seasonal symbols such as gourds or sugar skulls are all standard elements of a *muertos* installation—everything integrated into a unique expression of remembrance. *Altares* that commemorate the death of a cultural hero would add to this standard list of elements objects that are culturally recognized as symbols of that individual's involvement with the community.

Ybarra-Frausto sees *altares* as "expressive forms of cultural amalgamation . . . [that] fuse traditional items of folk material culture with artifacts from mass culture."[93] The combination of the traditional and the contemporary, the sacred and the secular, lends *altares* their dynamic ethos. In November 1993, for example, the three-tiered altar constructed by the

Figure 32. Peter Rodríguez, *Día de los Muertos I*, 1985, mixed media. Reproduced by permission of the artist.

Chicano Studies Program at Pomona College included hoes and fruit crates, plastic bunches of grapes, actual cuttings of citrus trees, real lettuce, and a section of barbed-wire—all symbolizing César Chávez's various campaigns for farm worker justice.

Day of the Dead altars, or *altares* in general, traditionally part of the domestic worship of Mexican and Chicano/a families, found their way into the Chicano/a art movement as artists like Amalia Mesa-Bains, Rene Yáñez, and Carmen Lomas Garza recognized these installations as both

The Solar of Chicano/a Popular Culture

75

Figure 33.
Amalia
Mesa-Bains,
detail, *An
Ofrenda for
Dolores del Río*.
Photograph
provided
courtesy of
Chon
Noriega.

cultura popular Chicana and ceremonial art whose main function was the ritual celebration and preservation of cultural memory. Thus altar-making was integrated into the Cultural Reclamation Project of el Movimiento:

> a concerted effort by Chicano scholars, intellectuals, and community activists to destroy external configurations of Chicano experience that stressed cultural determinism while at the same time presenting fluid, dynamic, and historically derived versions of Chicano identity and culture. . . . The Cultural Reclamation altars responded to the emergence of new ceremonial forms instigated by the artists in Chicano communities. Reconstituted in galleries and museums, altar installations began to teach, to reinvent and to forge group pride by revitalizing an ancient and ongoing devotional expression.[94]

The CARA exhibit contains numerous altars: actual, three-dimensional altar installations like Emanuel Martínez's *Farm Workers' Altar* (already discussed in the Cultural Icons and Heroes section of this chapter), Amalia Mesa-Bains's altar in honor of Dolores del Río, David Avalos's *Donkey Cart Altar*, and the altars in the *casita* installations of ASCO and Los Four. We

find several altar representations, as well: in works on paper such as Ralph Maradiaga's silkscreen *Dolor* and Carmen Lomas Garza's gouaches *Curandera* and *La Virgen de San Juan de los Lagos*; in mixed-media pieces such as Santa Barraza's *El Descanso Final* or *La Entrada*, Larry Yáñez's *Hey Zeus*, and Liz Lerma Bowerman's *Muertos Helmet: For Celebrations of Life*; in boxes and shrines like Patricia Rodríguez's *José Montoya* (1973), Barbara Carrasco's *Self-Portrait in Coffin Form*, and the Gaspar Enríquez series mentioned above; and in the nichos/niches of the Royal Chicano Air Force installations. Moreover, ephemera of el Movimiento, such as pamphlets, buttons, flyers, posters, clippings, handbills, and periodicals, are grouped and enshrined in glass cases that stand as memorials to the Chicano Civil Rights Movement.

The most imposing of all of these *altares* is Mesa-Bains's *An Ofrenda for Dolores del Río*, first constructed in 1984 and then reconstructed in 1990.[95] Located in the "Reclaiming the Past" section, *Ofrenda* not only commemorates but also canonizes "a successful bilingual film actress . . . [who] worked on both sides of the border."[96] As a successful crosser of national borders, Dolores del Río became an icon of binational/bilingual representation in mainstream popular culture. But Mesa-Bains's *Ofrenda* abstracts the physical reality of the U.S.-Mexico border, blurring the fact that del Río, like her compatriot and fellow Hollywood *hispano* Ramón Novarro, "no habían tenido que luchar para triunfar, sino eran aristócratas que probaron del cine como diversión."[97] They were, in other words, border crossers of the elite class who used Hollywood as their green card.[98] At the time of del Río's rise to fame in the silent films of the mid-1920s and the "talkies" of the early 1930s, Mexican *campesinos* and *obreros* immigrating to the United States were greeted first by the short-handled hoe, then by militarized resistance on the border.[99] Despite the fact that Mexican labor had been sought for the fields, the packinghouses, the railroad yards, the industrial factories, and the sweatshops of the United States, hundreds of thousands of Mexicans, along with Mexican Americans, were deported or, to put it euphemistically, repatriated to Mexico in the decade between 1929 and 1939.

Indeed, the "greaser go home" attitude of American nativists was amply represented in Hollywood "Westerns,"[100] which always depicted villainous, dark-skinned Mexicans, and in the early "Greaser" films such as *The Greaser's Gauntlet* (1908), *The Girl and the Greaser* (1913), *The Greaser's Revenge* (1914), *Bronco Billy and the Greaser* (1914), and *Guns and Greasers* (1918).[101] The image of "greasers," depicted on the silver screen as incompetent, stupid, merciless, sadistic, and treacherous, was projected onto Latinos as a whole, but particularly onto Mexican immigrants, who, from the time

The Solar of Chicano/a Popular Culture

of the U.S.-Mexican War to the present, have been persecuted relentlessly on the border.

This is the physical reality of the U.S.-Mexico border represented in David Avalos's *Donkey Cart Altar*. "Developing ways to subvert cultural stereotypes," writes Philip Brookman:

> [Avalos] recycled the image of Tijuana donkey carts, props on which tourists are photographed in front of idyllic scenes from preindustrial Mexico. . . . He substituted a Border Patrol agent frisking an undocumented worker for the usual *calendario*-style paintings (idealized landscapes, domestic scenes, or heroic depictions of Mexican mythology) found on traditional donkey carts.[102]

Constructed in 1985 as an intermediate-scale model for his full-sized sculpture *San Diego Donkey Cart*, which he was allowed to install outside the San Diego Federal Courthouse in 1986, *Donkey Cart Altar* is festooned on one side with icons of mainstream popular culture such as the Statue of Liberty, the dollar sign, and the "ladder-of-success," juxtaposed with typical elements of a Day of the Dead altar: candles, a *calavera*, and bleeding *milagros* in the shape of arms (in commemoration of migrant workers or *braceros*). The back of the altar is covered with a section of chain-link fence, behind which are images of the *nopal* cactus pricked with nails, and a fuzzy photographic reproduction of Francisco Sánchez, "shot to death by the Border Patrol on December 8, 1980."[103]

David Avalos's altar is, indeed, a *muertos* installation, but it is also an homage to border crossers and an indictment of the violence and the injustices they encounter as part of their migrations *al norte*. Going north or immigration, depending on what side of the border you use as your point of view, which enacts the highly valued ideal of recuperation—of land, culture, language, and identity—is a third ritual in the repertoire of Chicano/a popular culture. Says Gloria Anzaldúa:

> [Chicanos and Mexicans] have a tradition of migration, a tradition of long walks. Today we are witnessing *la migración de los pueblos mexicanos*, the return odyssey to the historical/mythological Aztlán. . . . *El retorno* to the promised land first began with the Indians from the interior of Mexico and the *mestizos* that came with the *conquistadores* in the 1500s. Immigration continued in the next three centuries, and, in this century, it continued with the *braceros* who helped to build our railroads and who picked our fruit. Today tens of thousands of

Figure 34. David Avalos, *Donkey Cart Altar*, 1985, mixed media and paint on wood. Reproduced by permission of the artist.

Mexicans are crossing the border legally and illegally; ten million people without documents have returned to the Southwest.[104]

If we recall that a rite of passage is a ritual that marks a transformation in status or lifestyle, then clearly immigration across the U.S.-Mexico border, most commonly engaged in to alter one's economic status or to change one's lifestyle from political prisoner to political refugee, qualifies as a rite of passage.

Geist and Nachbar identify three stages in a rite of passage: preparation, transition, and celebration.[105] In the first stage, the participant prepares for the changes that will occur as a result of the ritual, a process that involves bidding farewell to the old life. For border crossers like Ramón "Tianguis" Pérez who must prepare for the inevitable isolation on the other side, this means carrying a "mountain of goodbyes."[106] It also means collecting money for the journey and money for the *coyote* or *burro* who will get them across the border, not to mention learning the rudiments of a foreign language and adopting some variation of what Debbie Nathan calls "The Look": a style of clothing that the Border Patrol associates with U.S. citizenship, which for men includes running shoes (preferably Reeboks or other name-brand), a baseball cap, a T-shirt emblazoned with a university logo, and jeans.[107] In the "Civil Liberties" room of CARA, Pedro Rodríguez's *La Migra II* depicts two migrants who obviously did not prepare well enough for their rite of passage *al norte* as neither of them has donned "The Look" (the image can be found in the right-hand corner of Figure 1). In "Regional Expressions," Delilah Montoya's photocollages *Se Abre el Mundo/The World Opens Up #1* and *#2* poetically portray the beginning of this ritual as a journey into canyons and hills, the world of the "American Dream" a golden illusion in the distance.

In the second stage of a rite of passage, "the participants exist in a sort of limbo between two lives, the old and the new."[108] This limbo state, as it pertains to both border crossers and Chicanos/as, has been renamed *nepantla* by *fronteriza* writers like Anzaldúa and Pat Mora.

> *Nepantla* is the Nahuatl word for an in-between state, that uncertain terrain one crosses when moving from one place to another, from the present identity into a new identity. The Mexican immigrant at the moment of crossing the barbed wire fence into a hostile "paradise" of *el norte*, the U.S., is caught in a state of *nepantla*. . . . The marginalized, starving Chicano/a artist who suddenly finds her/his

Figure 35. Delilah Montoya, *Se Abre el Mundo/The World Opens Up #1*, 1981, cibachrome. Reproduced by permission of the artist.

work exhibited in mainstream museums . . . as well as the once neglected writer whose work is in every professor's syllabus, for a time inhabit *nepantla*.[109]

In his silkscreens *Abajo con la Migra* and *Undocumented* (also located in "Civil Liberties"), Malaquías Montoya portrays the *nepantla* state of undocu-

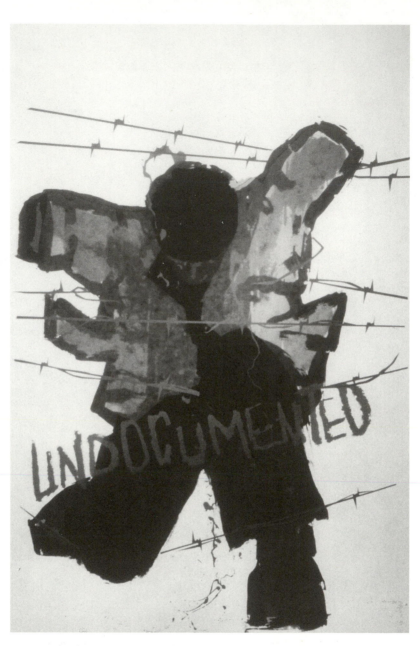

Figure 36. Malaquías Montoya, *Undocumented*, 1981, silkscreen. Reproduced by permission of the artist.

mented immigrants, trapped in the barbed wire of the Tortilla Curtain or impaled on the crown of a Statue of Liberty that wields a cleaver rather than a torch. Behind the statue runs Montoya's signature, the strands of barbed wire that figure in all of his work. Indeed, this image, along with the chain-link fence, can be read as iconic of border politics in general and of the *nepantla* state of Chicano/a citizenship in particular,[110] which is neither U.S. nor Mexican, rejected on one side as "alien" and on the other as *vendido* (sell-out), but at the same time *native* to both and caught between them.

Rupert García's silkscreen ¡*Cesen Deportación!* places three rows of barbed wire against a blood-red background to signify Chicano/a resistance to the bloody politics of racism at the core of deportation. When Chicanos/as are stopped on the street and asked for documentation to prove their citizenship, they are being submitted to a racist ideology that questions a person's nationality on the basis of skin color and racial features. Inability to provide a birth certificate or other form of national identification results in deportation, a practice that did not end with "Operation Wetback" in the 1950s, but which continues to this day.[111] This is the other side of the immigration ritual, which does not apply just to undocumented immigrants, but also to residents and citizens of the United States. As Cheech Marín's *Born in East L.A.* reminds us, Chicanos/as also suffer the indignities of deportation, a reverse rite of passage that changes their status from U.S. citizens to foreigners and alters their working-class lifestyle into a homeless and liminal existence.

"The last stage in the rite of passage," say Geist and Nachbar, "is the period following the moment of transition . . . marked by celebration of the event."[112] As illustrated above, however, the "moment of transition" between one identity and another is, like the border, a floating signifier of Chicano/a consciousness, a permanent reminder of impermanence. Thus, celebrations that mark the successful completion of undocumented immigration can only be indexes of survival in the *nepantla* state. In the context of the urban jungle or the migrant camp, for example, getting a job, sending money to the family in Mexico, or escaping *la migra* is the equivalent of a celebration.

But there are, as well, bona fide celebrations in Chicano/a popular culture, more commonly known as *fiestas*. The parades of *16 de septiembre, cinco de mayo*, and the Fourth of July all mark historical milestones of independence and national sovereignty for the two nations that compose la Raza's cultural *mestizaje*. Like *bodas* (weddings), baptisms and *quinceañeras* signal initiations into the family's social and spiritual community and depend

The Solar of Chicano/a Popular Culture

83

Figure 37. Daniel De Siga, *Campesino*, 1976, oil on canvas. Collection of Alfredo Aragón. Reproduced by permission of the artist.

upon the presence of the entire extended family, including the *madrina* and *padrino* (the initiate's foster parents), and, of course, everyone's friends. Graduates and contestants in beauty pageants—embodying the values of education and upward mobility—are honored with a *pachanga* (the equivalent of a "block party") and serenaded by everything from mariachi music to rap.

If celebrations are commemorative events that draw a community together, an extremely public form of celebration in Chicano/a popular culture honors and proclaims the civil and human rights of all workers and border crossers, of all those citizens victimized by racism and cultural amnesia: *las huelgas*, the strikes and boycotts that ignited el Movimiento in the mid-1960s. Indeed, ¡*Huelga!* was the rallying cry of that first march to Sacramento that reverberated in the consciousness of la Raza, reaching Chicanos/as across the nation, even as far as the Capitol.

José Antonio Burciaga (may he rest in peace), Chicano artist and writer from El Paso, recalls that "as young, professional Chicanos in Washington, D.C., [he and his wife] both supported the United Farm Workers'

grape and lettuce boycotts, the Coors boycott, the Gallo wine boycott, the Farah Pants boycott, and the Frito Bandido boycott."[113] To that list we should add the pecan shellers' strike, the garment workers' strike, the miners' strike, the farm workers' strike, the janitors' strike, and the hunger strikes practiced by César Chávez for nearly thirty years and duplicated by workers and student activists of el Movimiento.[114]

Indeed, boycotts and *huelgas* are, perhaps, the most political of the popular rituals of la Raza, and their representations in CARA occupy prominent space. Rudy Treviño's painting *Lettuce on Ice*, which depicts a head of iceberg lettuce in a champagne bucket, "symbolizes the exploitation of Chicano agricultural laborers" who paradoxically cultivate "a delicacy to be consumed by the upper class."[115] In a similar vein, Daniel De Siga's monumental *Campesino* documents the agricultural injustice of the short-handled hoe which forced the workers to bend lower to perform their literally back-breaking job.

Ester Hernández's *Sun Mad*, in which she substitutes a bonneted calavera holding a basket of grapes for the logo of the smiling girl holding a basket of raisins, is a satiric portrayal of the effect of pesticides on grape workers: instant death or the onslaught of life-threatening diseases. Hernández's screenprint is a reminder of the grape boycott, which will continue until growers suspend the use of deadly pesticides in the fields.

This same theme recurs in Juana Alicia's mural *Las Lechugueras*, painted in the Mission District of San Francisco, which shows an airplane dusting a lettuce crop with pesticides that are absorbed by the pregnant women working in the fields. It is an act of remembrance to document these violations of human rights, as well as a testimony to the legacy of survival that has been forged out of defiance to colonization, racism, and oppression. These CARA commemorated.

Rites of memory and recuperation, family unity, and community solidarity in the framework of a colonized culture imply more than seasonal festivities, temporal togetherness, or the nostalgic celebration of belonging to that which has been left behind. For Chicanas/os, these rituals mean conviviality and connection, certainly, but also continuance, perseverance, endurance, and ultimately survival—all of which are acts of resistance to cultural annihilation that reaffirm the existence of an alterNative people. For Chicana/o artists like Amalia Mesa-Bains, art that draws from and documents popular rituals or "ceremonial work is linked to our struggle for our land and our cultural life. It is based on a resistance to [mainstream] American culture."[116] Indeed, we can say, then, that the rites of unity, rites of passage, and rites of season that we find in Chi-

The Solar of Chicano/a Popular Culture

85

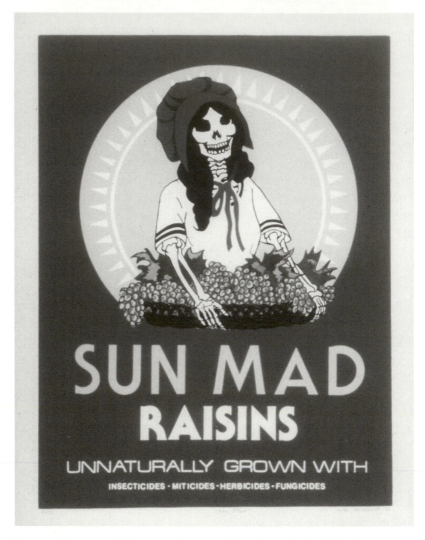

Figure 38. Ester Hernández, *Sun Mad*, 1982. Full image. Reproduced by permission of the artist.

cano/a popular culture are ultimately, as the CARA exhibition demonstrates, rites of resistance and affirmation.

> Through all the migrations, despite all the pressures to assimilate, we have carried in ourselves the roots and strength of our culture. . . . Whether in a city barrio or mountain village, our culture is more than fiestas and tortillas. It is more than mariachis and "Buenos

días." It is an affirmation of our peoplehood and our resistance to racism.[117]

Exit Slowly

Thank you for coming to this Open House of *la casa de* Chicano/a popular culture. Although your tour covered only a fraction of the *solar*, you have, I hope, seen that the word "subculture" is a misrepresentation of this alter-Native culture within the United States. Despite hegemonic strategies of homogenization and erasure, such as English-Only laws, California's Proposition 187 and Proposition 209, and the University of California's ban on affirmative action, Chicanos/as have not capitulated to the all-American meltdown. Chicano/a culture may be colonized by the United States, but, like Puerto Rican and Filipino culture, it is certainly not underdeveloped in its autochthonous history, its artistic production, and its *cultura popular*. The segregated neighborhood of Popular Culture Studies has empty lots, lacunae that need to be filled in; it is in one of these lots, a rather large one on a corner, that I have started to build *la casa* which is not *su casa*, the house of Chicano/a popular culture.

If we pull popular culture from under the shadow of elite culture, it must also be yanked from the totalizing whiteness of Euro-America. Michael Schudson and Chandra Mukerji warn us in their introduction to *Rethinking Popular Culture*:

> The legitimation of popular culture should not be taken—though it sometimes is—as an uncritical welcome to all that popular culture contains. The study of popular culture is too often its celebration. Although the celebration helps legitimate the aesthetic and political expressions of common people, the democratic aspiration of popular culture studies is sometimes undiscriminating. We can happily celebrate discoveries in popular culture of sociability, fellowship, and creative resistance to exclusionary cultural forms; but that should scarcely blind us to popular traditions of racism, sexism, and nativism that are just as deeply rooted. This is popular culture too.[118]

Indeed, those "popular [mainstream] traditions of racism, sexism, and nativism" are brought into sharp relief against the alter-Native grain of the CARA exhibition.

For all of my elaborate construction of a new model by which to study

this alter-Native American culture, however, the CARA exhibition was not organized as a paradigm of Chicano/a popular culture. Its organizers had other goals, other motivations, not least of which was the representation of Chicano/a artists within the exclusionary walls of the mainstream art world. The two chapters in the following section investigate the controversies and contradictions that attended CARA's politics of representation by exploring the history of its development and the organizational process of the exhibit and by scrutinizing the gender politics of the Chicano Movement which were reflected in the project.

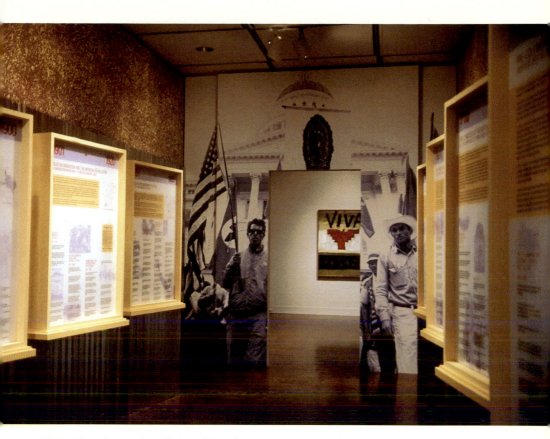

Plate 1. Installation shot. "Selected Timeline" room. CARA: Chicano Art: Resistance and Affirmation, exhibition held at UCLA's Wight Art Gallery, September 9–December 9, 1990. Photograph provided courtesy of the Wight Art Gallery.

Plate 2. Rudy Martínez, *A Juanderful Piece*, 1976, polychrome glazed ceramic. Collection of Scripps College, Claremont, California, Gift of Mr. and Mrs. Fred Marer. Reproduced by permission of the Registrar, Williamson Gallery.

Plate 3. Yolanda M. López, *Margaret F. Stewart: Our Lady of Guadalupe*, 1978, oil pastel on paper. Collection of Shifra Goldman. Reproduced by permission of the artist and Shifra Goldman.

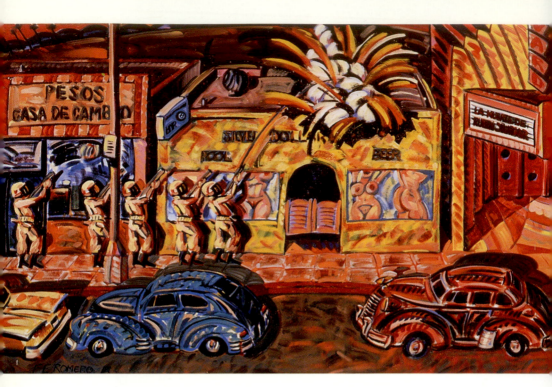

Plate 4. Frank Romero, *The Death of Rubén Salazar,* 1985–1986, oil on canvas. Collection of the National Museum of American Art, Smithsonian Institution. Museum purchase made possible in part by the Luisita L. and Franx H. Denghausen Fund. Reproduced by permission of the artist.

Plate 5. (*opposite, top*) Congreso de Artistas Chicanos en Aztlán (CACA; Mario Torero, Mano Lima, Tomás "Coyote" Castañeda, and Balazo), *We Are Not A Minority,* 1978, mural. Estrada Courts Housing Project, East Los Angeles. Photograph provided courtesy of the Social and Public Art Resource Center (SPARC). Reproduced by permission of Mario Torero.

Plate 6. (*opposite, bottom*) Victor Ochoa, *Geronimo,* 1980, mural. Centro Cultural de la Raza, Balboa Park, San Diego, California. Photograph provided courtesy of the Social and Public Art Resource Center (SPARC). Reproduced by permission of the artist.

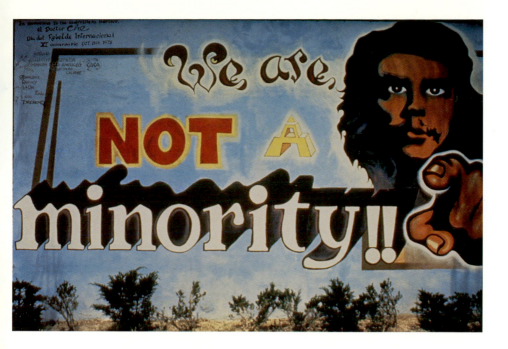

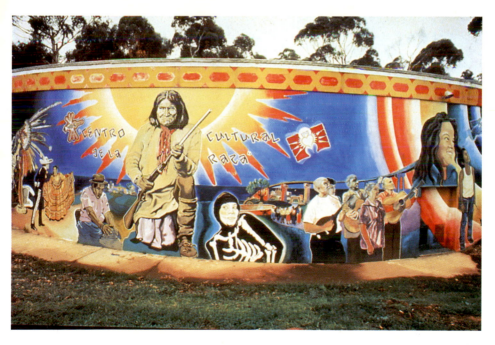

Plate 7. East Los Streetscapers (David Rivas Botello and Wayne Alaniz Healy), "La Familia" from *Chicano Time Trip*, 1977, mural. Lincoln Heights, East Los Angeles. Reproduced by permission of Wayne Healy.

Plate 8. (*opposite*) Ernesto Martínez, *Si Se Puede*, 1973, oil on canvas. Collection of Bert Salazar, *El Paseño* Newspaper. Reproduced by permission of the artist.

Plate 9. Yreina D. Cervántez, *Homenaje a Frida Kahlo*, 1978, watercolor. Reproduced by permission of the artist.

Plate 10. *(opposite, top)* Carlos Fresquez, *Zoot Suit en los Rockies*, 1984, acrylic on wood. Reproduced by permission of the artist. Pictured within the "Regional Expressions" room. CARA: Chicano Art: Resistance and Affirmation, exhibition held at UCLA's Wight Art Gallery, September 9–December 9, 1990. Photograph provided courtesy of the Wight Art Gallery.

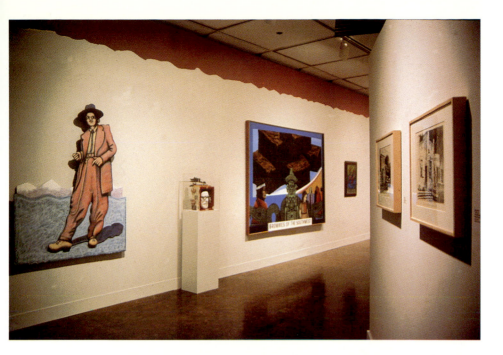

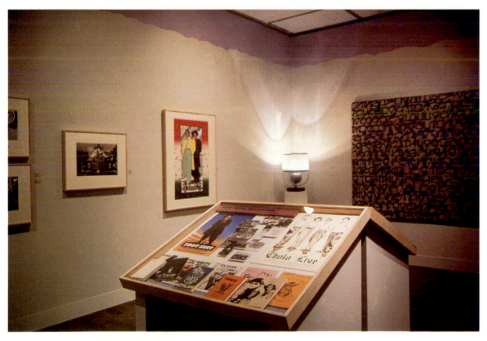

Plate 11. Installation shot. "Urban Images" room. CARA: Chicano Art: Resistance and Affirmation, exhibition held at UCLA's Wight Art Gallery, September 9–December 9, 1990. Photograph provided courtesy of the Wight Art Gallery.

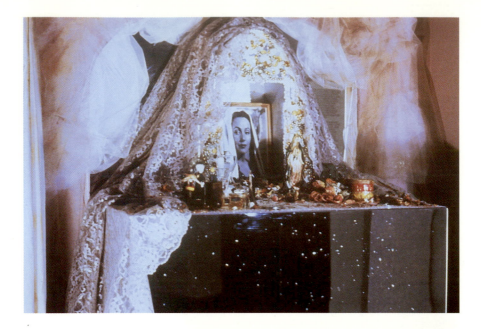

Plate 12. (*above*) Amalia
Mesa-Bains, detail, *An Ofrenda
for Dolores del Río*. Photograph
provided courtesy of Chon
Noriega.

Plate 13. (*right*) Delilah
Montoya, *Se Abre el Mundo/
The World Opens Up #1*, 1981,
cibacrome. Reproduced by
permission of the artist.

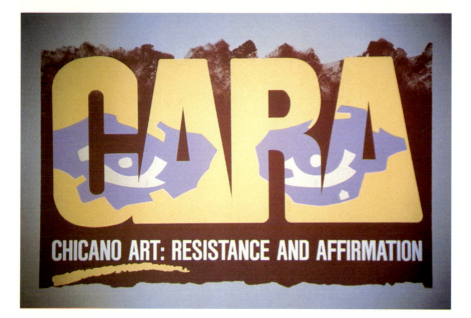

CHICANO ART: RESISTANCE AND AFFIRMATION

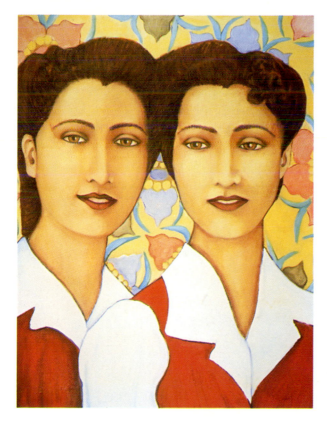

Plate 14. (*above*) CARA exhibition logo, designed by Willie Herrón and Patrice Roberts. Photograph provided courtesy of the Wight Art Gallery. Reproduced by permission of Willie Herrón.

Plate 15. (left) Cecilia Concepción Alvarez, *Las Cuatas Diego*, 1979, oil on canvas. Reproduced by permission of the artist.

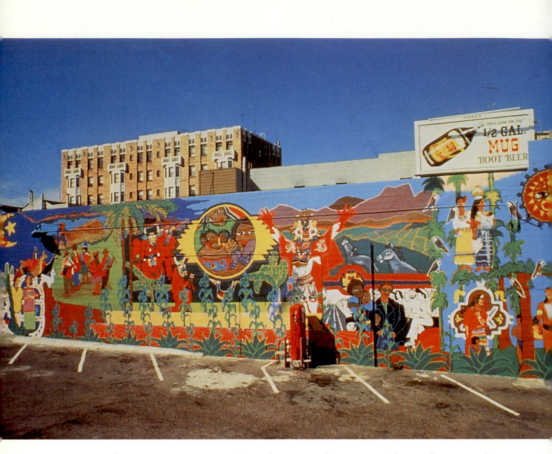

Plate 16. Las Mujeres Muralistas (Patricia Rodríguez, Graciela Carrillo, Consuelo Méndez, and Irene Pérez), *Latinoamérica*, 1974, mural. Mission District, San Francisco, California (not extant). Photograph provided courtesy of the Social and Public Art Resource Center (SPARC). Reproduced by permission of Irene Pérez.

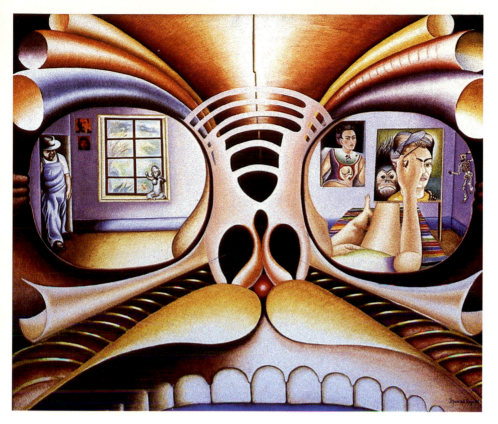

Plate 17. Marcos Raya, *Through Frida's Eyes*, 1984, acrylic on canvas. Collection of Dolores M. Díaz. Reproduced by permission of the artist.

Plate 18. Carmen Lomas Garza, *Camas para Sueños*, 1985, gouache. Collection of the National Museum of American Art. Reproduced by permission of the artist.

Plate 19. Amado M. Peña, Jr., *Chicano Gothic,* 1974, silkscreen. Collection of the Texas Union Chicano Culture Committee. Reproduced by permission of the artist.

Plate 20. (right) Ester Hernández, *Sun Mad*, 1982, screenprint. Reproduced by permission of the artist.

Plate 21. (below) Installation shot. "Redefining American Art" room with *Artists' Round Table* video. CARA: Chicano Art: Resistance and Affirmation, exhibition held at UCLA's Wight Art Gallery, September 9–December 9, 1990. Photograph provided courtesy of the Wight Art Gallery.

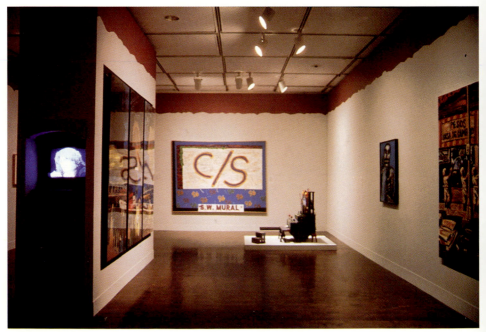

PART TWO **CARA'S POLITICS OF REPRESENTATION**

2 CHAPTER

Through Serpent and Eagle Eyes:

Intercultural Collaboration

The CARA Genesis Story

The idea for a national show of Chicano/a art was the brain-child of three art history students at UCLA: Marcos Sanchez-Tranquilino, Holly Barnet-Sanchez, and María de Herrera. In 1983, in conjunction with art history professors Shifra Goldman and Cecelia Klein, the students approached Edith Tonelli, then the new director of UCLA's Wight Art Gallery, "about doing something that presented Chicano art in a context different from the conventional, modernist art-museum presentation, where the focus is on the formal qualities of an object to the exclusion of social or cultural context."[1]

Sanchez-Tranquilino and Barnet-Sanchez, who eventually became "project coordinators" for CARA, insisted on "recognizing Chicano art as a distinct and influential art movement . . . [that was] not *Hispanic* nor *Latino* art, but serious art made in support of the Chicano civil rights movement."[2] Almost immediately adopted by the professors and the professionals of the Wight Art Gallery, the project was tentatively titled "The Search for Survival, Identity and Power: Fifteen Years of Chicano Art." The exhibit was to be

co-curated by Shifra Goldman and Tomás Ybarra-Frausto with the help of "student participation from UCLA: Marcos Sanchez and others [who would be of use in] planning a symposium." [3] By the spring of 1984, the Wight Gallery had drafted a proposal for a planning grant to the National Endowment for the Humanities (NEH), seeking funding for two meetings in Los Angeles of what would later come to be known as the CARA Advisory Committee—a "national panel . . . of scholars, curators and artists in the field of Chicano studies . . . [who would meet] to explore the possibilities for a comprehensive, multi-layered exhibition of the Chicano art movement." [4] By then, the exhibit's subtitle had increased the historical scope to "Twenty Years of Chicano Art." While the first meeting was meant to investigate the existence and definition of a "Chicano" art movement, as well as the content, objectives, and overall structure of the project, the second meeting of the panel would address budgetary concerns, fundraising, publications, and the best format for representing Chicano/a art to the UCLA community.

The first planning grant proposal, we are told by Tonelli, "was denied funding . . . because the funders were uncomfortable with the term *Chicano*, which some thought was inappropriate and even offensive to some members of the Mexican American community, and with the political resonance of the art." [5] A second proposal was submitted to the NEH the following spring, explaining that the artists who affiliated themselves with the Chicano Civil Rights Movement in the mid-1960s had chosen the term "Chicano" to signify their commitment to a social cause and their affirmation of cultural pride. [6]

The planning grant was funded on that second attempt, signaling the beginning of the actual organizational process as well as the end of NEH support for the project, whose leftist focus grated on the nerves of political conservatives. "In fact," says Tonelli, "the project was later turned down twice by NEH for implementation funds, even after the Endowment's peer panel had recommended funding." [7] Here are excerpts from the NEH's first rejection letter:

> The panelists understood that Chicano art arose from a variety of political movements and social causes, and therefore the political aspect of this proposal is appropriate to the subject matter. . . . Even so, the panelists worried that the project makes a political statement, that it is *politics masquerading as culture*, and that the proposal contains jargon and reads like a manifesto. [8] (emphasis added)

One of the reviewers complained that defining Chicano art in terms of "struggle" was too restrictive and that it excluded artists who did not participate in the movement but who nonetheless called themselves "Chicano" and created such artistic installations as "home altars to President Kennedy." This same reviewer objected to the concept of "Aztlán," to the language of Harry Gamboa's abstract for his essay in the catalog, to the design team's history as graphic artists for advertising firms, and to the exhibit's lack of representation of the "drug issue" in the Chicano community.[9]

When the second proposal for an implementation grant was rejected, the CARA Executive Committee, Alicia González, Teresa McKenna, and Victor Sorell, issued a letter of protest to the NEH chair, Lynne Cheney, stating in no uncertain terms that the endowment's decision was politically motivated and implicitly racist:

> We are not unaware of the recent climate under which art exhibitions have not been funded due to exertion of political pressure from certain interest groups in the Capitol. It appears to us that CARA has suffered from the "chill effect" of the debates in Washington regarding support for artistic projects. Moreover, it has also come to our attention that a number of projects dealing with Latino subjects have received no support.[10]

Again, the organizers were encouraged to revise and resubmit the proposal, a process that would further delay CARA's implementation, particularly of the catalog, and not take into account any of the expenses prior to CARA's opening at UCLA. But the organizers found Lynne Cheney's request for resubmission confusing because "from what [they] read in the reviews and heard from the staff, the problem was not in getting a good evaluation from the peer panels. Rather, it was either at the Council level or at [her] desk that the decision was made to fund other projects instead of [CARA]."[11] Nonetheless, the lengthy, two-inch-thick proposal was submitted a third time, requesting $292,476, significantly less than the $415,051 requested in the second submission and the $684,047 of the original proposal.[12]

On November 21, 1990, two months before CARA was scheduled to begin its national tour, and halfway through its stay at the Wight Gallery, the NEH sent a letter to Tonelli "to provide information regarding the Endowment's decision not to support [the CARA] proposal." Although it

was pointed out that all of the panelists found the art "visually compelling" and that two of the reviewers specifically commented on the trailblazing nature of the exhibition, the majority of the review panel could not recommend support.

> [The panelists] observed that there is a disjunction between [the organizers'] intentions and the exhibition. They argued that [the] proposal does not differentiate clearly between Chicano art and Hispanic art and, in its dependence on self-referential analysis rather than a comparative perspective, *the exhibition does not place the art in the "bigger picture."* . . . One [reviewer] wrote, "I found the proposal exhausting because it was such a *political harangue.*" . . . [Another reviewer] argued that the exhibition lacks the necessary intellectual underpinning: "There is a chronology of the civil rights movement but no explanation of it. *Who were the leaders? What specific forces gave rise to it? I see propaganda and rhetoric but no meaningful analysis.*" [13] (emphasis added)

We should remember the context in which this stalemate occurred: the Bush administration's euphemistic "new world order," in which right-wing conservatives like Jesse Helms and Patrick Buchanan were strategically placed as gatekeepers to the master's house. This was the heyday of the National Endowment for the Arts (NEA) controversy when conservatives in Congress targeted the work of gay and lesbian artists, particularly that of Robert Mapplethorpe, Marlon Riggs, Ron Athey, Holly Hughes, and Annie Sprinkle, as "obscene," "vulgar," "immoral," "indecent," and therefore unworthy of federal support. It was in this climate that Patrick Buchanan wrote in the *Washington Times:* "The decade has seen an explosion of anti-American, anti-Christian, and nihilist 'art.' . . . Many museums now feature exhibits that can best be described as cultural trash." [14] It was, in short, the beginning of the backlash against multiculturalism.

If we analyze the reviewers' comments above, we can easily read the conservative agenda between the lines. The call for comparison between Chicano/a art and "Hispanic" art, for example, was simply a way to diffuse the cultural specificity of the project by placing it within a supposed "bigger picture," framed by the discourses of immigration and assimilation that the reviewers both recognized and found comfortable as ways of understanding the Mexican "Other." The calls for analysis and explanation reveal that, despite 300 pages of information detailing who the leaders were and what forces catalyzed the Chicano Civil Rights Movement, the reviewers' memory of the black and white issues of the sixties

did not coincide with the history recorded by the CARA exhibition, a history focusing on the plights and patterns of resistance and survival of brown Americans. Clearly the reviewers missed the point that the messages contained in what they called "political harangue" and "propaganda and rhetoric" were a social analysis meant to reflect back upon the dominant culture's relationship with Chicanos/as. It was not a pretty reflection, to be sure, and no amount of justification and convoluted syntax could mask the dis-ease which lay at the core of the endowment's rejection. "It was clear they were making us jump through hoops," said Elizabeth Shepherd, curator of the Wight Art Gallery. "I just don't think they liked the project; I think it was too political." [15] Needless to say, NEH resources for the implementation of CARA were never granted.

Without funding from the UCLA Art Council, the UCLA Chancellor's Challenge in the Arts and Humanities, and the Rockefeller Foundation, the early stages of the implementation process would not have been possible. Still, the bottom line was over a million dollars, and private and corporate funding was needed to make up the difference. The Rockefeller Foundation hosted a development meeting in New York and invited representatives from the Andy Warhol Foundation for the Visual Arts and the Lila Wallace–Reader's Digest Fund as well as corporate representatives to listen to the CARA pitch. A substantial part of the private foundation funding resulted from that meeting. Then a larger than expected NEA grant came through, as well as monies from the California Arts Council, the City of Los Angeles Cultural Affairs Department, the 1990 Los Angeles Festival, and La Opinión. The education packets were sponsored by the Anheuser-Busch Companies and the Rockefeller Foundation. A year after CARA opened, the catalog was published with the help of the Getty Grant Program.

One of the difficulties in the quest for funding was that the CARA organizers were selective about sources of support. In the CARA Ethics Statement, drawn up by three members of the Advisory Committee at the July 1987 meeting, we find a list of companies that were barred from solicitation either because their "policies and actions have precipitated divisiveness and discord within the Chicano community" or because the "national or international profile [of these companies] are inconsistent with the mission statement of [the exhibition] or are likely to conflict with the success of the project." [16] Among those companies that were not to be solicited were Bank of America, Chase Manhattan Bank, Coca-Cola, Coors, IBM, Mobil Oil, General Motors, Ford Motor Company, and Union Carbide. [17]

Through Serpent and Eagle Eyes

At its first planning meeting in November 1986, the Advisory Board generated several of the project's guidelines as well as the exhibition's official title, "Chicano Art: Resistance and Affirmation." We learn in the exhibition book that the discovery of the acronym CARA, which means face in Spanish, occurred serendipitously after the title of the exhibition had been accepted.[18] The exhibition logo (discussed at length below) showing the stylized, disembodied eyes staring out from between the letters of the acronym (see Figure 39) in part signifies the absence of Chicano/a representation in mainstream museums. But the logo, as we shall see later, also represents the several visions of the makers of the exhibit; the primary task of this chapter is to scrutinize that vision, to look behind the face at the goals and ideologies of the first national exhibition of Chicano/a art.

These were some of the objectives set forth at the first meeting:

> The exhibition must have dignity and be focused on the art. The objects cannot be presented in any sort of primitivizing, ethnic artifactual sort of way, but must maintain the role of the "locura" (earthy spiritedness) and beauty of the "plebe" or working class basis from which it springs. . . . The exhibition must have an integrative, holistic approach (without folk/fine/popular arts distinctions). . . . There must be an awareness of gender issues in all aspects of the exhibition, in both process and product. . . . The exhibition must present Chicano art as American art with references to its complex heritage. . . . The organizers must emphasize the educative aspect of the exhibition. . . . All materials must be bilingual.[19]

Let us examine how and if those objectives were made manifest.

Essential Chicanos/as and American Me's

The goals of the CARA exhibit were determined by the Chicano/a organizers of the project and the Anglo staff of the Wight Art Gallery, a collaborative effort meant to challenge "the traditional system of exhibition organization wherein a single curator selects and interprets works" for the show.[20] This unique organizational process within the canonical art world was supposed to serve as a model for future projects involving the artwork of underrepresented groups in mainstream museums. The process—which included the input of a National Advisory Committee, an Executive Committee, a Selection Committee, nine regional committees,

a Steering Committee composed of the chairs of the regional groups, six national task forces, an editorial board, the project coordinators, and the Wight Gallery Staff—was intended as an experiment in intercultural collaboration (see Appendix B).[21] "Intercultural," however, does not refer only to the racial and ethnic differences of Chicano and Anglo cultures; there were also gender, generational, and ideological differences within and between the two groups that Tomás Ybarra-Frausto, a member of the National Executive Committee until 1988,[22] believes accounted for much of the tension characterizing the Advisory Board meetings.[23]

Perhaps the easiest differences to assess were those that occurred between the Wight Gallery Staff and the Raza members of the organizing committee. Sanchez-Tranquilino and Barnet-Sanchez, the project coordinators who also served as researchers, grant writers, meeting organizers, newsletter editors, networkers, fundraisers, letter writers, mediators, archivists, and tour guides, found that the organizational process, originally intended as a laboratory for intercultural collaboration, was consistently "undermined by Anglo authority."[24] For Sanchez-Tranquilino, rather than rendering an authentic politics of Chicano representation, what the organizational process ultimately achieved was the brokering of a "politics of cultural refraction."[25] What was refracted, according to Sanchez-Tranquilino, what was bent and distorted, were the Chicano ideals of community and resistance, which had to be continuously negotiated with the assumptions of the non-Chicanos in power. Employing the passive voice, Edith Tonelli explains the ambivalences of her own position:

I was *forced* to face the managerial consequences of a project that emphasized self-representation and consensus. . . . I am, after all, not a Chicana, and my institution is white, middle-class, and mainstream, and does not have the best track record of inclusion and diversity. . . . The forced reevaluation of how I manage and lead, and of how our gallery team normally works, led me to understand how many common, unspoken assumptions and values we in museums share, and how those who work outside of museums or who were raised with different values might have difficulty understanding them or might be unwilling to accept them without question.[26] (emphasis added)

I shall return to these cross-cultural differences that constituted the ideological visions of the exhibition. But the "insider"/"outsider" polemics that informed the organizational process were polarized not only be-

Through Serpent and Eagle Eyes

97

tween one culture and another. Within the Chicano/a contingent of the Advisory Board,[27] for example, at least four generations of identity politics were represented, each with its own race, gender, and class ideology: those who experienced the Zoot Suit Riots firsthand; those who endured the Ritchie Valens syndrome of assimilation; those who marched under UFW flags and chanted "Chicano Power!"; and those who lobbied for women's rights. Gay men and lesbians were also on board. Moreover, vocational differences affected the dynamics: board composition included artists, academics, activists, and administrators. And we cannot overlook the presence of the modernists and the postmodernists, with their varying definitions of art and clashing views on the function of the museum.

The following excerpt from a letter written by one of the members of the Advisory Committee to Edith Tonelli in response to the first planning conference exemplifies several of the divisions that existed in the organizational process: (1) that between traditionally trained art historians and what the letter-writer calls "non-specialists"; (2) that between the academy and the activists; and (3) that between the Marxists of el Movimiento and what Rodolfo Acuña calls cultural "brokers," proponents of a Chicano middle class.[28]

This potentially great opportunity to organize a serious scholarly and historical exhibition of Chicano art deteriorated rapidly into one of the principal problems which has plagued Chicano art in the past and its appreciation by a wider public as a serious art movement . . . that a vaguely defined Chicano art has been promoted self-consciously but unsuccessfully by little-qualified non-specialists lacking in the most basic knowledge of art history (or by those who dismiss it cavalierly in pseudo-Marxist diatribes) and its fundamental methodologies (both traditional and progressive), or by well-intentioned but unsuccessful artists. . . . It was very disappointing, to say the least, to attend this conference . . . and observe an *art* exhibition turn into a proposed "Folklife" exhibition of Chicano Cultural Curio extravaganza. The paranoid political machinations that developed at the conference and the very notion of attempting to plan an art exhibition through committees of committees of committees were equally discouraging.[29]

Yet another letter, written two years later by Holly Barnet-Sanchez to José Montoya, one of the artists on the Advisory Committee, expresses

similar intra-Chicano conflict: "The exhibition process is going well, although at times Marcos and I feel we are walking through a supercharged minefield. . . . César [Martínez] is voicing certain reservations about the show, specifically that it is being run entirely by academics." [30]

But the artists themselves were not univocal. Some agreed with Malaquías Montoya and José Montoya that the only true Chicano art was art that toed the political lines of el Movimiento, art of liberation, art of protest, working-class art. In "A Critical Perspective on the State of Chicano Art," first published in the Chicano magazine *Metamorfosis* ten years earlier and later reprinted in *Cambio Cultural*, while CARA was installed in its San Francisco venue, Malaquías Montoya names two schools of Chicano/a artists (a third group is discounted as opportunistic): those who think they can effect changes within the art world by participating in mainstream events and those who have remained true to the "original goals," "original aspirations," and "original intentions" of the Chicano Art Movement. Opposition to assimilation, imperialism, and capitalism, separatism from the traditional structures of the art world, and a reeducation of Chicanos/as in barrios across the country constituted three of those original commitments that Chicano/a artists wishing to empower themselves and their communities made in the name of *la Causa*. But, asks Montoya, what happened in the eighties?

> What became of those commitments and what caused their modification? Could it be that the same system which was opening the museum doors and at the same time planning the overthrow of Allende in Chile had changed? Or was it the artists who had started to change? Had Chicano artists really not understood that the system that supported apartheid in South Africa and at the same time provided funds for the advancement of Chicano liberation had something up its sleeve? A system that feeds with one hand and strangles with the other? [31]

José Montoya sounded the same clarion. In his personal statement published in *Imagine* during the organizing period of CARA, he answers his brother's questions:

> It's not too difficult to understand why some Chicano artists have become fed up maintaining a facade of struggle when the rest of the cause has gone Chuppy—Chicano urban professionals who buy hi-

Through Serpent and Eagle Eyes

99

tech prints and flaunt their status. . . . Young Chicano artists are not interested in proselytizing, art is no longer a tool to organize; it should be to make money. . . . What is sadder yet, is to see *veteranos* going in that direction.[32]

As a *veterano* himself sitting on the Advisory Board of the CARA exhibition, which was ultimately a major mainstream show, did José Montoya feel that he was in some way fulfilling his own prophecy? Malaquías warned that, like using traditional media in their work, participating in any mainstream events was the sure path toward assimilation, co-optation, and commercialization, the equivalent of "cutting the throats of other Chicanos."[33] And yet four of Malaquías's silkscreens were in the show, as were six of José's pieces, not including his RCAF work in the group's installation and in the murals display. Were the Montoya brothers selling out? Were these *veteranos* of the Chicano Movement, like "El Louie," getting buried, killed not in action, but in contradiction?[34] Or did they see the possibilities for Raza activism and empowerment in the exhibition?

And what about those other artists who, like Carmen Lomas Garza, Santa Barraza, César Martínez, and Amado Peña (all members of the group Los Quemados, who had broken off from the Con Safos group in San Antonio), "did not believe that Chicano art had to deal exclusively with social and political issues,"[35] nor that it should be the "artistic arm of any political ideology."[36] Instead of an art of opposition Los Quemados proposed an art of cultural representation, best exemplified by Lomas Garza's *monitos.*

> I felt that I had to be able to reach the Chicano audience with a lot softer impact than what the other Chicano artists were doing because [they] were doing images either heavily influenced by the muralists with very heavy political messages of anti-Vietnam, anti-migra, antiviolence, anti-racism, and images of Villa and Zapata, and direct liftoffs from the pre-Columbian imagery, but nothing that dealt with just the everyday life of the Chicano. That's where I felt I should concentrate, just to show the everyday life, so that ordinary people could look at it and recognize themselves in the artwork and start to feel proud of their culture and their heritage.[37]

Lomas Garza, arguably one of the best-known Chicana artists of el Movimiento, especially after her recent retrospective show at the Hirsh-

horn Museum in 1995,[38] has been criticized by *veteranos* of the Chicano Art Movement like Pedro Rodríguez, also on the CARA Advisory Committee, for having "chosen a different way of focusing her work," preferring to portray the "more socially conscious nature" of Chicano/a art "over more confrontational and political work." Although Rodríguez feels that Lomas Garza's "primitive looking *monitos* are very reflective of a lot of things in our culture and make an important cultural contribution," they are, nonetheless, "very safe" and "the kind of stuff that is very welcome in the Smithsonian Institution or [other] large museums." The main problem Rodríguez sees with cultural work like Lomas Garza's is not only that "critics love it," but that, when placed "in an array of other artists, many of whom may be political, those critics and the curators of those institutions ignore the [political work]. Offered as a menu to the mainstream, [cultural work] is a winner every time."[39]

If the artists themselves fail to agree on the definition of Chicano/a art, how were forty people as diverse and opinionated as the Advisory Committee of CARA going to sit around a table and decide whose lottery card would win the game (see Figure 31)? The diverse concepts of Chicano/a identity articulated by all of the generational, ideological, and vocational differences within the Chicano/a segment of the Advisory Committee created at least two overarching and conflicting visions of representation: the *veterano* view and the view of the "new kids on the block." We can say that, in general, the *veteranos* stressed what I call an *essentialized* level of representation in which Chicano/a identity is determined by differences without and similarities within its community, specifically looking at the ways that race, language, religion, and class work in opposition to the "national" American identity. In contrast to White Anglo-Saxon Protestants of the dominant culture, Chicanos/as honored their Native American heritage, Spanish language, Mexican customs, and Catholic faith. Paradoxically, both Pedro Rodríguez's and Carmen Lomas Garza's views would fit into the *veterano* perspective since they were both arguing for the same effect, though through different methods: encouraging and preserving the heart of Chicanismo. The "new kids on the block," on the other hand, advocated what I see as an *Americanized* level of representation in which Chicano/a identity extends outside of its essentialist demarcations and finds affinity with political crosscurrents in mainstream culture, particularly issues of gender, sexuality, and artistic license that actually oppose the "essential" Chicano/a identity. Feminists, gays and lesbians, and those seeking to make "art for art's sake" rather than for social change clashed with

Through Serpent and Eagle Eyes

101

the patriarchal revolutionaries of Chicanismo. Here, too, were the more conservative of the university-bred artists and art historians as well as the postmodern radicals.

Each group contained its own contradictions. And there were cross-hatchings, too, as subjectivities and allegiances sometimes bordered both groups (though rarely in the same ways) à la Gloria Anzaldúa's "mestiza consciousness."[40] A final paradox was that, while displaying the American citizenship and artistic *mestizaje* of Chicano/a art—the hybridization of genres, techniques, and forms—CARA celebrated and documented the racial and cultural *mestizaje* of Chicano/a identity, the level of identification that emerged through and during el Movimiento.

One of the essays in the CARA exhibition book, "The Pachuco's Flayed Hide: The Museum, Identity, and Buenas Garras" by Marcos Sanchez-Tranquilino and John Tagg, discusses the dialectic outlined above between Chicano essentialism and border identities such as Anzaldúa's *Mestiza*. Arguing against what they see as the regressive cultural essentialism of el Movimiento and seeing the Pachuco as, on the one hand, the embodiment of el Movimiento's nationalist discourse and, on the other hand, the male equivalent of "mestiza consciousness" (which goes beyond Chicano nationalism), Sanchez-Tranquilino and Tagg contend that "nationalist discourses remain prisoner to the very terms and structures they seek to reverse, mirroring their fixities and exclusions."[41] This essay was co-written by one of the project coordinators of CARA who later left the project because of conflicts with the Anglo element of the organizational structure and who, though he can be classified in the *veterano* group described above, was nonetheless antiessentialist. Placed in the CARA exhibition book, and written via a Chicano-Anglo collaboration, the essay can be read as a metacommentary on the organizational process of the exhibition and on the different voices and visions that vied for authority in determining CARA's representation of Chicano/a identity.

Generational and ideological differences notwithstanding, it is possible to deduce that the Chicanos/as on the CARA Advisory Team, veteranos and "new kids on the block" alike, wanted to bring the artistic expression of Chicanismo (i.e., the visual politics of el Movimiento) out of the archives and into the public's eye. What was the Wight Gallery's agenda? Let us begin by looking at its mission statement: "The goals of the Wight Art Gallery are to collect, preserve, display, interpret, and promote the research of art for the education of the UCLA audience, the Southern California region, and the art community in general."[42] If we bracket the regional references, we are left with the objectives of a mainstream art

museum, the traditional paradigm of responsibilities that Stephen Weil in *Rethinking the Museum* traces back to Joseph Veach Noble's essay in the April 1970 issue of *Museum News*.[43] Thus, despite its placement in a university setting, despite its educational ethos and its expressed commitments to innovation and diversity, the gallery represented the same place which, in 1972, had been tagged by Willie Herrón, Gronk, and Harry Gamboa, who had not yet arrived at their collective identity as ASCO. "[They] spray painted their signatures onto all the entrances to the Los Angeles County Museum of Art (LACMA) in reaction to the negative response of a museum curator to their query about the possibility of including Chicano art in museum exhibitions."[44]

Ironically, two years later, Los Four exhibited its *placas* at LACMA, a show organized by Jane Livingston (and crashed by ASCO). It was the first time Chicano art had been curated by and exhibited in a mainstream art museum; now displayed inside the master's house rather than across the entrances, spray-can graffiti became art rather than vandalism; such is the transformative and legitimizing power of the art world.

This anecdote is instructive because it sets the precedent for the paradoxical relationship between Chicano/a art and the mainstream institutions which it seeks both to resist and enlist. It also serves as an early example of the ambivalences and ambiguities that have haunted Chicano/a artists from the beginning of el Movimiento, the tensions between individual liberation and collective struggle, between loyalty to a movement and personal survival. The shadow of these tensions followed the organizational process of CARA, particularly at the ideological level.

Ideological Visions

In their collaborative essay "Compañeros and Partners: The CARA Project," Edith Tonelli and Alicia González, executive member of the National CARA Committee, outline the specific objectives of the exhibit:

the *documentation* of an underrecognized American art movement; an *expansion* of the audience for and the understanding of Chicano art and culture; . . . the *presentation of evidence for a reexamination and redefinition of American art and culture*; . . . [and] a reevaluation of the process for organizing museum presentations of artworks of living cultures (especially *those cultures not represented in museums* by a critical mass of professional personnel) so that the *organizational process reflects the spirit and values of the culture itself.*[45] (emphasis added)

Through Serpent and Eagle Eyes

103

Before we can determine whether the CARA exhibit lived up to the principles and intentions of its organizers, we need to deconstruct the language of these goals to discover the historical and political specificities at work not only in the statement, but also in the entire process of the exhibition's development.

In the segments I have emphasized above, we see the rhetoric of two movements—each historically specific and contradictory in its underlying premises to the other. The word "documentation" in anything related to people of Mexican origin is clearly loaded, bringing to mind issues of nationality, immigration, deportation, and border politics—all major concerns of el Movimiento. Apart from these manifestly political issues that constitute a significant part of Chicano history and that were, thus, to be represented in this historical exhibit, there is also the more implicit and underlying issue of identity, specifically Chicano identity, which is "Other" or *alien* (a relative word to documentation) to the so-called national identity. One of the purposes of the CARA exhibit was to document Chicano/a existence (as rendered by the Chicano Art Movement); another was to apply the differences inherent in Chicano/a identity, primarily the differences in "spirit and values" (see fourth goal above), to the organizational process of the exhibition. Obvious here is the distinction being made between two cultures and two identities, an affirmation of differences that evokes the separatist ideology of the student arm of the Chicano Civil Rights Movement and that, coincidentally, echoes the *veterano* belief that "La Raza should be recognized by its uniqueness . . . and the differences should be separated from the dominant culture." [46]

The Chicano Civil Rights Movement, as we saw in the previous chapter, arose as a form of resistance to cultural hegemony and melting pot ideologies. Like the Black Movement, the Women's Movement, and the American Indian Movement, el Movimiento was one of the several shifting faultlines that yanked at the core of the "American mind" and shattered the myth of "one nation indivisible under God" or *e pluribus unum*. Indeed, though it demanded equal civil and human rights for American citizens of Mexican descent, in its most radical expression el Movimiento was a separatist movement, claiming its own land, its own people, its own ideology, its own nationality, its own language and culture, its own heroes, its own flag. According to Ybarra-Frausto and Goldman:

A cultural nationalist philosophy, separatist in nature, was . . . developed in the early period by the youth and students of the [Chicano]

movement, and expressed most influentially in the utopian "El Plan Espiritual de Aztlán" (The Spiritual Plan of Aztlán). . . . Key points were a call for reclamation and control of lands stolen from Mexico (the U.S. Southwest), anti-Europeanism, an insistence on the importance and glory of the brown-skinned Indian heritage, and an emphasis on humanistic and nonmaterialistic culture and education.[47]

Other crucial concerns of el Movimiento were, in the words of veterano poet Tino Villanueva, "la justicia, la igualdad, la calidad de la vida, y . . . la conciencia entera de la dignidad personal"[48]—concerns common to all colonized peoples. In broad scope, then, these were the cultural politics that the CARA Advisory Committee sought to integrate into the organizational process of the exhibit. They sought to rectify the injustice of Chicano exclusion from mainstream representation in the art world. They sought the equal right of self-determination by controlling the structure and implementation of the exhibit's production. They sought to create historical awareness of the Chicano struggle for the quality of life, as well as to bear witness to the quality and scope of Chicano art and culture. And, finally, they sought to dignify Chicano consciousness with self-representation, opposing the ego- and ethnocentric tradition of museum curating.

But another movement of thought can be extrapolated from the statement of the exhibition's goals, and the premises of this movement are, I argue, fundamentally contradictory to the philosophy of el Movimiento. In seeking to expand "the audience for and the understanding of Chicano/a art and culture," in using the exhibit as a testimonial to the plurality of American identities and their effect on the dominant culture, a "presentation of evidence for a reexamination and redefinition of American art and culture," the Wight Art Gallery was creating a multicultural educational experience not only for Chicanos/as who had never seen themselves in a museum, but also for mainstream museum audiences who were suddenly finding "Others" represented under the aegis of multiculturalism.

Thus, although Elizabeth Shepherd asserts that the Wight Art Gallery "didn't do the show to promote multiculturalism," the fact that it had "curricular relevance" to the students and faculty of UCLA, and that it was also an educational experience for the larger community and the mainstream art world,[49] accentuates the multicultural motivation behind the exhibit. Moreover, CARA brought sorely needed "otherness" to several of the venues that it visited which, like the "Modern" in San Fran-

Through Serpent and Eagle Eyes

cisco and the El Paso Museum of Art, were finding themselves criticized by their communities and state arts' councils for their lack of ethnic representation.

One of the distinguishing features of the CARA exhibit was the production and distribution of comprehensive education packets for elementary and high school teachers who would bring their classes to visit the exhibit.[50] These packets, "made possible with the generous support" from the Anheuser-Busch Companies and the Rockefeller Foundation, were distributed by each site that CARA visited. In this community outreach, it was hoped "that the exhibit and accompanying educational program [would] contribute immensely to the appreciation and understanding of Chicano culture in this country."[51] This country, then, as acknowledged in the previous quotation, knows little, at best, of Chicano culture; thus, the CARA exhibit, with the support of mainstream capital and a three-year touring agenda, was meant to bring Chicano culture to the awareness of "this country." Indeed, this is multiculturalism at its best. How, then, you might ask, does multiculturalism contradict el Movimiento, when both advocate the rights and the visibility of cultural Others? The complexities of this question will be explored in more depth in the last chapter, but it is necessary, here, to give a brief overview of the different multiculturalisms, or multicultural narratives, at work at the time of CARA's cross-country tour.

In "White Terror and Oppositional Agency: Towards a Critical Multiculturalism," Peter McLaren traces several different forms of multiculturalism, which he labels conservative/corporate, liberal, left-liberal, and critical/resistance.[52] This taxonomy of the different ways in which multiculturalism can be managed culturally to construct and accommodate difference helps respond to the implicit paradox in the question above. Just as there is no such thing as a monolithic theory of difference, so too must we acknowledge that there is no monolithic meaning of multiculturalism, despite the fact that the word is bandied about as if there were only one set of assumptions behind it. As McLaren's essay (and its companions in the volume *Multiculturalism: A Critical Reader*) effectively illustrates,[53] a position based on the assumption of *sameness* (e.g., regardless of where we come from we all share the same culture, the same language, and the same history) will not value *difference*.

As David Theo Goldberg points out:

Identity is generally conceived in [the identity/difference] conceptual framework [of multiculturalism] as a bond: as the affinity and

affiliation that associates those so identified, that extends to them a common sense or space of unified sameness. . . . Identity can sustain fascist social movements as readily as emancipatory ones, and difference may license genocide almost as easily as it does celebration.[54]

In McLaren's categorization, those who subscribe to the notion of identity as sameness are the conservative and liberal multiculturalists who, respectively, want to adopt or include ethnic minorities in the dominant culture via assimilation. Not interested in diversity *per se*, these multiculturalists seek to whitewash difference, make us all "Americans," the "love it or leave it" mentality.

Those who adopt a position that exoticizes or romanticizes *difference*, as left-liberals do when they mourn the lack of culture (read "color") in their own lives, or as producers of consumer goods do when they jump on the multicultural bandwagon to extend their markets, what the Chicago Cultural Studies Group calls "the Benetton effect,"[55] will nonetheless see an "us/them" dichotomy between themselves and those whom they esteem as *different*. Built on what Frances Aparicio calls a "tolerance for difference," this brand of multicultural logic eschews the analysis of power relations and fosters instead "cheerleading efforts" and "exercises in touristic voyeurism."[56] Like liberals, then, left-liberals tend to overlook the role that culture and history play in the construction of difference. This largely depoliticized position values the authenticity of diverse experience but fails to problematize or even locate the ideological, historical, and cultural origins and conflicts of that experience.

Arguing for the value of homogeneity and the universal "truths" that bind a community together, what McLaren labels conservative multiculturalists "pay only lip service to the cognitive equality of all races and charge unsuccessful minorities with having 'culturally deprived backgrounds' and a 'lack of strong family-oriented values.'"[57] Other features that distinguish conservative/corporate multiculturalists are their pronounced belief in a national language, English-Only, and their unstated commitment to white supremacy. Among these corporate representatives who "use the term 'diversity' to cover up the ideology of assimilation that undergirds [their] position,"[58] McLaren names Lynne Cheney. Need we wonder, then, that the CARA organizers' three requests for funding from the NEH under Cheney's leadership were consistently denied? Or that the rejection was couched in a need to examine some abstract "bigger picture" that could accommodate the conservative view of multiculturalism which the organizers of the exhibition, from their own perspective

Through Serpent and Eagle Eyes

107

of *affirmation and resistance*, were not willing to do? Critical multiculturalists, says McLaren—and it is in this category that we must locate the Movimiento radicals behind CARA—go beyond recognizing or celebrating difference and argue instead for a semiotic reexamination of historical, cultural, and ideological differences necessary to achieve social justice.

Here is where the CARA organizers ran into the most ideological trouble. Even before the proposals for funding were submitted and during the full four-year tenure of the developmental process, the different multicultural workers sitting in the Advisory Board meetings and in the several committees that organized the exhibition had to sort out what guiding logic, what voice, would prevail in the design and implementation of the show.

"Voice," says Steven Lavine, "has emerged as a crucial issue in the design of exhibitions." [59] If the exhibition is a historically interpretive one like CARA, its main voice, its authority, comes from the historians and academics whose scholarship was used to create CARA's interpretation of the Chicano Movement that gave rise to the exhibit. As Judy Baca, Marcos Sanchez-Tranquilino, Holly Barnet-Sanchez, Rene Yáñez, and Edith Tonelli discovered at an early meeting of the Selection Committee, however, there is a difference between *research* and *recall*. Research implies the existence of Chicano/a art historians, publications, and archival collections of Chicano/a art, but as Baca pointed out to her committee members, "one of the things the Chicano Movement has suffered from incredibly is the lack of historians, lack of documentation." [60] Baca's point that the organizers would have to rely on recall more than research—that is, on the organizers' own memories of the last twenty years—to construct the history of the Chicano Art Movement was met with resistance from Edith Tonelli, representing the voice of the Wight Gallery, who wanted "a broader perspective than what any individual person can remember." [61]

In the end, the view of Chicano/a history that shaped and prevailed in the exhibit is not one of recuperation and expansion of the boundaries of history, but rather one of chronology and narrative (that is, old-style history, not the New Historicism of Chicana feminists, for example). Nonetheless, it stands to reason that CARA re-presents the voice, or, more accurately, the multiple voices of Movimiento historians, artists, activists, and Chicano academics. Those academic voices, however, traditionally filtered by the curator of an exhibit, in a show that resisted the curatorial approach had to be filtered through the visions of the different organizers, some of whom were actively engaged in the making of that history, some of whom were recording that history as it was being made, and some of

whom learned about that history in college or through research. Not surprisingly, this process resulted in controversy, confrontation, and struggle as much within the organizational structure of the exhibition as within the mainstream art world in which the show was packaged.

The organizational conflicts did not stop once CARA was installed and began to travel. Another layer of voices and visions came into play, not least of which were those of the institutions that had agreed to show the exhibit. Largely due to the differences between the curatorial "voice" of traditional museum practices and the consensual "voices" that not only organized CARA but also insisted on remaining in control of the show's integrity throughout the life of its tour, frictions sparked over modifications that some of the venues wanted to make in design and installation that they felt would better suit their interests or the needs of their audiences.

At the San Francisco Museum of Modern Art (SFMMA), for example, the official CARA logo was replaced by Amado Peña's *Mestizo* (Figure 19), a graphic that, in the opinion of key CARA organizers, depoliticized and ahistoricized the exhibition with its connotations of an innocuous southwestern art. Moreover, seven days before CARA was scheduled to open at the SFMMA, the exhibitions coordinator submitted a list to the Wight Gallery of materials that "the Modern" was considering eliminating from the show. Among the items on the list of exclusions were the artists' quotes about what a Chicano is, the photo mural of the United Farm Workers' march to Sacramento in 1966, the timeline panels, the interpretive stations, and the artists' round table video.[62]

Upon being informed of these arbitrary changes, Marcos Sanchez-Tranquilino and Holly Barnet-Sanchez sent a four-page, single-spaced missive to John Lane, the director of SFMMA, condemning the exclusions, reminding him of the museum's contractual obligation to discuss any changes to the exhibition with the organizing committee, without whose approval those changes could not be effected, and pointing out that the politics of self-representation at the core of CARA's organizational process had been undermined, beginning with the SFMMA's decision to exclude the CARA logo.[63]

We can tell you that it took many committee meetings to agree on the logo and accompanying graphics so that their significance became absolutely clear and necessary to the non-Chicano staff of the Wight Art Gallery. THE LOGO AND ACCOMPANYING GRAPHICS WERE DESIGNED FROM A CHICANO PERSPECTIVE AND NOT TO

Through Serpent and Eagle Eyes

109

APPEAL EXCLUSIVELY OR NECESSARILY TO ANGLO MUSEUM PRO-
FESSIONALS OR COMMUNITIES.[64]

Although the director of the museum denied even considering the prospect of editing the interpretive materials, stating that "from the outset [the SFMMA] recognized the crucial role that information establishing cultural and historical context would play in contributing to the public's understanding" and asking the project coordinators to issue a retraction of their "reproach based on hearsay,"[65] CARA opened at its San Francisco venue with a logo designed and chosen by the SFMMA, under banners proclaiming "A Celebration of Chicano Art,"[66] without the explicit title of the exhibition, without the artists' quotes about labeling themselves "Chicano," without the arched photo mural that signified the protest ethos of the exhibit (see Figure 1), and without the introductory panel of the historical timelines.

"The Modern" was not the only venue that effected interpretive changes in CARA; in fact, part of its justification for the changes it did make was based on the fact that an earlier venue (the Denver Art Museum) had also altered the design of the show. But, as the project coordinators pointed out, this was achieved without permission, was inadmissible, and reflected a cavalier disregard for the collective vision that had organized the exhibit, a vision that was represented by the eyes of the logo.

Yet another institution, the Smithsonian's National Museum of American Art (NMAA), had a problem with the CARA logo. According to Andrew Connors, the curatorial associate at the NMAA responsible for shepherding the show through the museum, the logo was both alienating and visually unappealing for Smithsonian audiences:

People in the East don't know what Chicano art is, they have no idea what a Chicano is. If you tell them, "come to an exhibit of Chicano art" without giving them an image there is nothing to attract them. . . . There are so many acronyms in Washington and so much visual information vying for people's attention that something like that [CARA] would not grab anybody's attention. . . . If you told somebody that they should see the C-A-R-A exhibition, they would think that it was some government agency. . . . So we had to work very hard to get permission [to change the image] for the poster and for the invitation. . . . Luckily we did a good job with it so that [the

committee] ultimately approved the product. But it was a real battle to get permission to do that.[67]

What these conflicts of voice and vision between the organizers of the show and the sponsoring venues represent is a rift in the rules of the exhibition-making game. Viewing the art of exhibition as a field involving three players—the maker of the object, the exhibitor, and the viewer of both the object and the exhibition—Michael Baxandall offers a succinct method for understanding insider/outsider dynamics in mainstream museums. Because the kind of exhibition that Baxandall is writing about in "Exhibiting Intention: Some Preconditions of the Visual Display of Culturally Purposeful Objects" is an ethnographic one—a display of objects representing an "Other" culture—he envisions the first player, the maker of the object, as an insider to her/his own culture (the culture on display) and an outsider to the culture represented by the museum. The exhibitor, of course, is an insider to museum culture and an outsider to the culture on display. And the viewer, at least what Baxandall envisions as the traditional viewer, "an adult member of a developed society" who "has a sense of the museum as treasure house, educational instrument, secular temple, and the rest,"[68] is an outsider both to museum culture and to the "Other" culture about which he or she has come to learn. Because of his/her membership in the "developed society" which sponsors ethnographic exhibitions, however, the viewer is as much an insider to the dominant culture as the exhibitor.

Thus the viewer occupies both the insider and the outsider perspectives, and it is the exhibitor's job to mediate between the viewer and the maker, to interpret the maker's intention to the viewer, through the device of the object label. "And I use the word *label* here to denote the elements of naming, information, and exposition the exhibitor makes available to the viewer in whatever form: a label is not just a piece of card, but includes the briefing given in the catalogue entry and even selection or lighting that aims to make a point."[69]

With this in mind, we can say that both the San Francisco "Modern" and the National Museum of American Art, in arbitrarily deciding to alter the CARA logo, sought to interpret for their respective audiences the intention of the CARA artists, which as exhibitors they had a right and a duty to do. But because CARA came packaged to represent the collective voices and visions of its multifaceted organizing committees, the traditional rules of the exhibition-making game did not apply. Here, then, is

CHICANO ART: RESISTANCE AND AFFIRMATION

Figure 39. CARA exhibition logo, designed by Willie Herrón and Patrice Roberts. Photograph provided courtesy of the Wight Art Gallery. Reproduced by permission of Willie Herrón.

the rift I mentioned above, for the exhibitors of these mainstream institutions who found their authority challenged by outsiders realized that there was a fourth player in the game of this particular exhibition, composed of essential Chicanos/as and American Me's, and this one considered itself the captain of the team, the one in control of both the content of the show and the means of representation.

Indeed, the CARA organizers called the bluff on the multicultural rhetoric of the mainstream museum, which was eager to incorporate "outsiders" into the display halls (especially when that meant extra funding for the museum from state and federal agencies), but not so willing to accept or apply "outsider" views on the theory and praxis of exhibition-making. In insisting on retaining jurisdiction over the interpretive apparatus of the exhibition, the CARA organizers dislodged the museum's colonizing tendency to name and define "Others" in its own terms, for, as Ivan Karp reminds us, "what is at stake in struggles for control over objects and the modes of exhibiting them, finally, is the articulation of identity." [70]

Eye-conography and Identity

Several images in the CARA exhibition are emblematic of the story behind the face. Using the human eye as the central motif, these images are metanarratives that reflect back upon the master narratives (and the conflicts between them) that created the show, the multiple tensions between margin/center, identity/difference, and insider/outsider which are at the core of CARA's cultural politics.

The first visual element created for the exhibition was its logo, those cryptically disembodied eyes staring through the acronym CARA. We are told in the preface to the exhibition book that "the eyes of the CARA face—its visible gaze that reflects back on its viewer—conceptually embody the reflexive nature of [the] entire planning and implementation process."[71] The organizational process of the exhibit fluctuated between collaboration and confrontation—between Chicanos and Chicanas, artists and art scholars, activists and academics, Raza representatives and Anglo museum staff, essentialists and "Americans," Movimiento politics and multicultural rhetoric, veteranos and "new kids on the block." No singular subjectivity gazed through the eyes of that multidimensional face. It was neither an insider nor an outsider vision, but a postmodern fragmentation and fusion of both.

I argue that, in keeping with the idea of liminal identities and with the double consciousness which the exhibition sought to personify,[72] the eyes of the logo represent a culturally schizophrenic vision. Lest this be confused with a pathological assessment, let me qualify my strictly cultural application of the terms. Culture, as defined by Webster's and as it applies to my use of the term "cultural schizophrenia," means "the customary beliefs, social forms, and material traits of a racial, religious, or social group." Schizophrenia signifies, apart from its clinical definition of mental disorder, "the presence of mutually contradictory or antagonistic parts or qualities." Integrating these denotations, then, we can say that cultural schizophrenia is the presence of mutually contradictory or antagonistic beliefs, social forms, and material traits in any group whose racial, religious, or social components are a hybrid of two or more cultures (also known as mestizaje). An organizing committee imbued with all of the differences previously discussed in the case of the CARA organizers is negotiating an equivalent process of mestizaje as a group dealing with cultural/racial differences; these differences, or mutually contradictory qualities, are then brought to bear upon the combined vision of that group. Even

the way in which the logo was created suggests the cultural and generational splits inherent in the organizational process:

> [It] is important to note that there was no immediate agreement on whose eyes to use—those of a man? a woman? a famous Chicano or Chicana?—even though they were planned to be stylized. In the end, the CARA design team, Willie Herrón and Patrice Roberts, came up with a brilliant solution. Herrón superimposed images of the eyes of his twin sister over images of his own, and used elements of both.[73]

Perhaps the eyes offer the viewer "twin" perspectives: the oppositional, vigilant stare of the "essential" Chicano described earlier and the composed, reflexive gaze of the American citizen.

The implicit message in the essentialist stare is defiance: Chicano art is watching you; you are the "Other" in this domain, *ése;* "we" are here and "you" are there; you do not interpret us, we interpret ourselves; I see you seeing me; you are in the process of being seen even as you pretend to do the looking. This is both affirmation of who I am and resistance of who you make me out to be. The implicit message in the American gaze, on the other hand, is equality: I am one of you; I have every right to be here. Your house is my house, too. I affirm my Americanness and resist your construction of me as "Other" and outsider.

But, if the eyes of the logo represent in part the "I" of Chicano identity—a pronoun that, as we have already seen, has several referents—and that I/eye has shifted from the object to the subject position, who are "we" or "they" in the context of the mainstream museum? Obviously, "we" and "they" occupy the same place in the chain of signification; only the signifier changes the meaning between "insider" and "outsider." González and Tonelli say that the logo "subtly emphasizes the shift between the observer and the observed."[74] If the observer is a white male art historian, for example, he is an insider to museum politics and an outsider to Chicanismo; if the observer is a *veterano/a* of el Movimiento, however, then he/she is an insider to Chicanismo and an outsider to museum politics. The logo, therefore, represents both the "insider" and the "outsider," a subject position that is always changing relative to the domain of discourse in which that positioning is taking place.

Self and Other, insider and outsider, the observer and the observed: these are the paradoxes contained in the CARA logo (and, by extension, in the CARA exhibit), accentuated by the distance between one's knowl-

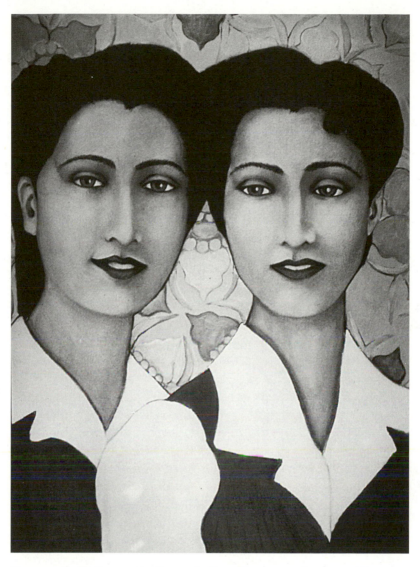

Figure 40. Cecilia Concepción Alvarez, *Las Cuatas Diego*, 1979, oil on canvas. Reproduced by permission of the artist.

edge of the other. The CARA organizers sought to bridge the distance between insider and outsider by following a three-pronged strategy: (1) opening the doors of Chicano/a culture and inviting "outsiders" to peruse the premises (thus reversing traditional roles), (2) applying the proverbial mi *casa es su casa* approach to the organizational process of the

exhibit, and (3) accommodating the Chicano Art Movement's visual history of el Movimiento to a mainstream exhibition format.

As a national art show displaying the syncretism of Chicano/a and mainstream art practices and popular cultures, CARA participated as an insider in the *casa* of the mainstream art world by occupying space in the housing community of the art museum. In this instance, mi *casa* **sí** *es su casa;* the possessive pronouns here refer to mainstream culture as the host (mi *casa*) and to the CARA exhibit as its guest (*su casa*). If we reverse the referents, however, we see that the proverb does not work both ways: if we configure the CARA exhibit as the host, and the mainstream viewers of the show as the guest/s, then mi *casa* **no** *es su casa* because the show was by and about Chicanos/as, historically *personas non gratas* in the art world with a legacy of invisibility to rub in the viewer's face (see Figure 5). Rather than welcoming or accommodating the viewer, the watchful eyes of the logo (which are the eyes, finally, of the organizing committee) and the acronym CARA bring home the idea of a colonized culture that, vis-à-vis an art exhibit, is "making [its own] face/making [its own] soul,"[75] Gloria Anzaldúa's metaphor for constructing identity.

In "Culture and Representation," Ivan Karp discusses the political ramifications of ethnic representation in mainstream exhibition venues and boils the curatorial process down to the issue of identity.[76] If, indeed, a museum exhibition is a representation of identity, as Karp argues, and that representation is created by the curatorial vision behind the exhibit—and if, as in the case of CARA, the curatorial vision is composed of inter- and intracultural differences that have at their core differing and deferring ideologies about what it means to be Chicano/a and what it means to be an artist—then the CARA exhibit, as a representation informed by those different ideologies, necessarily depicts the multiple views of identity and the power negotiations inherent in the curatorial visions that made CARA. Thus, the CARA exhibit is a representation not of a monolithic identity that calls itself "Chicano," but of contradictory, conflicting, multifaceted identities signified by the twin eyes of the logo. Perhaps, through the process of negotiating the multiplicity of differences that characterized the project from its inception, the CARA organizers achieved a synthesis of serpent and eagle vision; for, as Anzaldúa says, "At some point on our way to a new consciousness, we will have to leave the opposite bank, the split between the two mortal combatants somehow healed so that we are on both shores at once, and at once, see through serpent and eagle eyes."[77]

If we see the CARA exhibit as a self-portrait of Chicanismo, and the logo as the eyes of that portrait, who or what is the viewer really viewing? In discussing the self-portraiture of Frida Kahlo, Claudia Schaefer states: "The eyes—being both observer and observed, looking outward yet into a mirror—are always gazing at themselves, as does the artist for the creation of her self-portrait, to discover the identity being presented to the public and to look simultaneously at the observer."[78] My suggestion here is that, like the bedridden Frida Kahlo, who painted images of herself by reproducing her reflection in the mirrors that hung above her bed,[79] what the viewer sees in the CARA exhibit is a reflection of the organizers themselves, whose visions and politics of representation are reproduced and reflected back in the "mirrors" of the eye-conography of the artwork.

In this complex construction of identity, however, did the CARA exhibition makers practice the politics of self-representation that they preached? If the collaborative process—despite its conflicts and tensions—can be said to be democratic, and one of the most fundamental tenets of democracy is the equitable representation of the constituency which it serves, then it stands to reason that the politics of representation inherent in the democratic process of the exhibition's development should strive not only to document the presence of an underrepresented and "underrecognized American art movement" in the mainstream art world,[80] but also to represent all of the members who were active in that art movement. If CARA sought to rectify the injustice of Chicano/a exclusion from mainstream representation in the art world, did it do so equitably across gender lines or did the nationalist/essentialist politics of Chicanismo perpetuate its own exclusions?

From looking at the catalog, one would think that, in fact, feminist visions were not just reserved for the next to the last room in the exhibition. The opening section of the catalog contains forty-nine color plates, twenty of which are works done by women, and seven of these come from the "Feminist Visions" section. Let us go to that room now and scrutinize the gender and identity politics of CARA.

3 CHAPTER

Out of the House, the Halo, and the Whore's Mask:

The Mirror of Malinchismo

Gender Politics

"If Chicano art has been considered a long neglected entity within the realm of 'Art History,' certainly the attention given to the women artists of la Raza is a long time coming," wrote Sybil Venegas in the special *la mujer* issue of *Chisméarte* in 1977.[1] Thirteen years later, did the CARA exhibition give Chicana artists the attention they deserve? According to several reviewers, it did: "Chicana artists are well represented throughout the exhibition," said Eva Sperling Cockcroft in *Art in America*.[2] "The real triumph of the disenfranchised in the exhibit," said Michael Ennis in *Texas Monthly*, " . . . is the emergence from obscurity of Chicana artists."[3] Indeed, one of the exhibition guidelines set forth by the CARA National Advisory Committee at its first planning meeting in 1986 was that "there must be an awareness of the gender issues in all aspects of the exhibition, in both process and product."[4]

A basic quantitative analysis of the show, however, reveals that approximately a hundred more Chicano artists than Chicanas were represented. If we examine the ten sections of the exhibit according to the number of works de-

119

Figure 41. Installation shot. Entrance to "Feminist Visions" room. CARA: Chicano
Art: Resistance and Affirmation, exhibition held at UCLA's Wight Art Gallery,
September 9–December 9, 1990. Photograph provided courtesy of the Wight
Art Gallery.

picted and the number of male artists and female artists represented in
each section we find a glaring inequality. Of the fourteen pieces in the
"Cultural Icons" room, one was done by a woman; of the ten in "Civil
Liberties," again one by a woman; of the twenty-seven in "Urban Im-
ages," you guessed correctly, one by a woman. Of the fifty-four mural
images projected, only seven were done exclusively by women or wom-
en's collectives. Of the three *grupos* selected for special recognition within
the Chicano Art Movement, not one of them had women's concerns and
particular oppressions primary to their agendas. In fact, the inequity re-
vealed by this quantitative analysis is qualitatively reinforced when we
juxtapose, later in this chapter, what I call the three "men's rooms" or
grupo installations in the show with the "Feminist Visions" room or W.C.
(for Women's Closet).

Although Chicana artist collectives like las Mujeres Muralistas from San
Francisco exist in the history of the Chicano Art Movement, the CARA
organizers chose to highlight only ASCO, the Royal Chicano Air Force,

Table 1. Quantitative Analysis of the
CARA Exhibition by Gender

Section	Number of Works	Male/Female
La Causa	4	3/1
Cultural Icons	14	13/1
Civil Liberties	10	9/1
Urban Images	27	26/1
Murals (slide show)*	54	47/7
Grupo installations*	3	3/0
Regional Expressions	34	24/10
Reclaiming the Past	10	7/3
Feminist Visions	14	0/14
Redefining American Art	14	8/6

*Several of the murals displayed in the slide show were done by collectives whose members included both men and women; the seven murals done exclusively by women or women's collectives account for seven of the fifty-four mural images shown in the slides. Similarly, the grupo installations line does not reveal the number of men and women since all three of the grupos had at least one female member; rather, the number refers to the number of grupos presented and the dominant gender of each grupo.

and Los Four.[5] Las Mujeres Muralistas originally consisted of three Chicanas, Patricia Rodríguez, Graciela Carrillo, and Irene Pérez, and a Venezuelan, Consuelo Méndez. Others joined the group later, among them Ester Hernández. At the time that Venegas's article was published in Chismeárte in 1977, Mujeres had done eleven murals, nearly all of them in the Mission District in San Francisco.[6]

According to Yolanda M. López, one of the foremothers of Chicana art,[7] Mujeres was an extremely important group for the empowerment of Chicanas in el Movimiento, for they challenged the sexist and stereotypical notions within the Chicano Art Movement that women were physically not able and politically not "meant" to create murals, to build and climb scaffolding, to be on public display and withstand the comments of passersby.[8] Precisely to mitigate these limiting, sexist assumptions, Judith Baca produced Woman's Manual: How to Assemble Scaffolding, which, Shifra Goldman tells us, "was intended to help remedy women's socialization," by instructing women artists on the logistics of "working outdoors on a large scale . . . and knowing how to handle tools and successfully construct such large objects as one- or two-story scaffolds."[9]

Out of the House

121

In "Quest for Identity: Profile of Two Chicana Muralists," Amalia Mesa-Bains describes the revisionary narrative and impact of las Mujeres Muralistas:

> The images of their murals . . . expressed a pan-American aesthetic where highly visible images of women and emphasis on ceremony, celebration, caretaking, harvest and a continental terrain worked toward the creation of a new mythology. The power of the murals relied on precisely that widely held memory of the everyday which allowed the work of Mujeres Muralistas to provide a recollective function for a broad community during a historic period of time.[10]

The question is not so much why an important group such as las Mujeres Muralistas was not itself recollected by the organizers of the first major national exhibition of Chicano/a art or given the same special recognition within CARA as the other *grupos*, but, rather, what this exclusion says about the sexual politics of the Chicano Art Movement, which was then replayed by the CARA exhibit.

In a patriarchy, says Kate Millett, sexual politics denotes a relationship between those in power (men) and their subordinates (women).[11] Exploring and exploding this differential has been the *modus operandi* of Anglo/European feminist theory; however, is that the only theory, or vision, of the "Feminist Visions" section in CARA? Is gender the only parameter for discussing a feminist identity politics? Ana Nieto Gómez, Martha Cotera, Francisca Flores, Elena Flores, and all of the other early *feministas* of the Chicano Movement as well as their Chicana/Latina *hermanas* in the 1980s and 1990s would say absolutely not: to privilege gender over class and race is to perpetuate racism and ruling class values. To ignore gender, however, in the struggle for civil and human rights is to perpetuate the objectification and abuse of women.

Let me pause here to clarify the distinction between identity politics and politics of identity, since these are two popular terms in feminist discourse whose meaning, though similar, should not be collapsed into one definition. A politics of identity (also known as politics of location) is the individual process or motivation by which a woman constructs her own definition of her identity, based on identifying with and differing from social/racial/sexual constructions of her gender. Identity politics, on the other hand, is a kind of party-line, a philosophy of race/class/gender differences that constitutes a particular group's sense of community and public action.

CARA's Politics of Representation

122

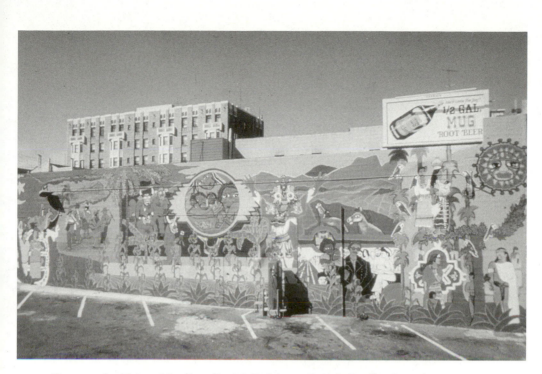

Figure 42. Las Mujeres Muralistas (Patricia Rodríguez, Graciela Carrillo, Consuelo Méndez, and Irene Pérez), *Latinoamérica*, 1974, mural. Mission District, San Francisco, California (not extant). Photograph provided courtesy of the Social and Public Art Resource Center (SPARC). Reproduced by permission of Irene Pérez.

After thirty years of conflict, contradiction, and hard work, feminists have devised several *feminisms*: some, like liberal feminism, Marxist feminism, and radical feminism, grew out of the predominantly Anglo/European and middle-class "women's liberation" movement of the late sixties. Collectively labeled "white" feminism—in both its liberal and radical wings—this school has been traditionally concerned with gender difference, positing woman's subjectivity primarily in relation and opposition to men or patriarchal institutions. What has now come to be known as Third World feminism arose from Third World women's critiques of the class- and color-blindness of "women's lib." Third World feminists accuse white feminists of gender-bias and inherent racism and insist that colonialism and slavery be used as frameworks to examine gender and power relations. Lesbian feminism and separatist feminism blossomed from heated debates between straight and queer women about sexuality as another determining factor in a woman's politics of identity. Chicana feminism is Third World–identified in its concerns over class and color as

key nodes of subjectivity and oppression, but it also occurs in the context of entrenched Catholicism, a colonized history, and a First World economy; and so issues of language and culture, of nationality and citizenship, of autonomy and choice, all play significant roles in Chicana identity. In the realm of sexuality (including the politics of reproductive rights, enforced sterilization, and sexual orientation) Chicana feminists take a share of what Norma Alarcón calls "the gender standpoint epistemology."[12] Chicana lesbian feminists, whose theoretical writings have most impacted the field of Chicana/o Studies, exhort us to push the gender question further and analyze the dissonance between ethnic and sexual identity. What began as a discourse about gender difference has evolved in three decades into a plurality of identity politics and multiple strategies of political action that address the needs and interests of more than just white women and help us to discern and counteract the essentialism, gender oppression, monolithic stereotyping, and heterosexual privilege that still emerge as bylaws in the land of the almighty 'Apá (Father).

Clearly, then, we cannot rely on just one school of feminism for our analysis of the gender politics in the CARA exhibit. We must use the tri-faceted mirror of Anglo/European, Third World, and Chicana feminisms to help us deconstruct the overt and oblique gender messages in the Women's Closet. Furthermore, through a strategy of appropriation and subversion, this intersection of the three identity politics can help us visualize a new theory of resistance to all of the inequities named above.[13]

Like the work-dazed characters that populated *Animal Farm*, Chicana feminists learned as early as the seventies that something was wrong with the revolution. The workers in George Orwell's bleak fable are the animals who till the fields and produce the meat and poultry of the farm. The state is represented by the farmer and the other humans in the story. Subsisting on meager portions of food, working outrageous hours, and living in crowded and filthy conditions, the animals revolt against the farmer and successfully manage to wrest control of their lives away from human hands. The human hand, in fact, like walking on two legs, is vilified as the cause of the animals' misery; upon winning the battle, they immediately decide that no animal will ever adopt human ways. Freed from the farmer's domination, the animals establish their own government and seize the means of production. Following the ideals of a socialist order, each animal contributes its unique talents to the operating of Animal Farm, and they all share equally in the fruits of their labor (or so they think). Gradually, however, the greediness of the pigs becomes apparent. They work less than the other animals, the pigs rationalize, because they

think more, and because they think more, they get to govern the farm, and because they have to govern, they need to consume more food. Eventually, the lofty goals of the revolution are undermined, as the pigs become more and more human in their behavior and morality. In a shocking final scene the animals realize that greed and capitalism are once again in control of Animal Farm, and the newest rule for everyone to memorize is that "some animals are more equal than others."

The cryptic irony of this message is particularly useful in understanding discrepancies between feminist and Chicano identity politics. Although the nationalist mentality upon which much of the politics of el Movimiento was founded continues to believe that the label "Chicana feminist" is a contradiction in terms, it is perfectly possible for a woman to subscribe to the identity politics of Chicanismo and at the same time adopt a feminist politics of identity. In the Chicano Art Movement, for example, Chicana artists like Judith F. Baca and Yolanda M. López upheld the Marxist ideologies of el Movimiento that focused on class and worker solidarity as central to liberation and defended the indigenista and mestizo values of Chicanismo which proudly affirmed a racially inscribed identity of resistance; they were also deeply concerned with gender inequalities and issues of autonomy and sexual and vocational self-fulfillment.

The fact that there were more pieces by male artists than by mujeres in the CARA exhibition is consistent, no doubt, with the fact that, in the early years of el Movimiento, more men were plying their artistic vocation than women. But if art-making was considered a legitimate and powerful form of activism during the Movement, weren't Chicanas involved in the dual process of resistance and affirmation through art? Or were their contributions being undermined, ignored, or coopted by the machos who had appointed themselves the leaders of la Causa Chicana? Were women and men resisting and affirming the same oppressions? Yes and no. Indeed, Chicana artists, like their male counterparts, were resisting class and race oppression and affirming their differences as colonized subjects with their own cultural, historical, and linguistic identity. But some of the Chicanas were also resisting another form of oppression, internal to the Movement, and for this resistance they were labeled by the patriarchs and their female allies traitors to the Chicano Movement.

In "The Role of the Chicana within the Student Movement," Sonia López tells us that, though Chicanas were active from the inception of the Movement, they were generally relegated to traditional roles played by women in society. It was the realization of this oppressive situation and their secondary status within the Movement which led many Chicanas to

Out of the House

125

initiate a process by which they could begin to resolve the inconsistencies between male/female roles.[14]

What these women were seeing, to modify Orwell's warning, was that "some members of the Movement were more equal than others," and the process they were initiating for their liberation (even though some resisted the word) was feminism.

Adelitas and Malinches

Thirty years after the initial struggles of el Movimiento, and nearly at the cusp of the twenty-first century, what have Chicanos in general done to ameliorate the fact that "some members of the Movement are more equal than others?" What strategies have been devised within the tenets of Chicanismo to redress the vicious cycle of men's internalized oppression? Armando Rendón, author of *Chicano Manifesto*, acknowledges the following: "The Chicano macho has to concede that he has usually relegated la mujer to the kitchen or to having kids and has never allowed her to express herself. Perhaps it is true, as some Chicanas say, that the Chicano passes on to his woman the frustrations and mierda (shit) that befall him during the day" (emphasis added).[15] Indeed, in the early chauvinist years of "el" Movimiento, Chicanas were granted one of two patriarchally defined identities. They were either "Adelitas," depicted in the popular Mexican revolutionary song as loyal supporters and followers of their men (as we see in Figure 18), or "Malinches," Eve-like traitors of *la Causa*, perniciously pursuing their own individual interests.[16] Both terms derived from male interpretations of history and served male fantasies of women. Though historically both Malinches and Adelitas are constructed as "loose women," women who have stepped outside the boundaries of their gender to dictate their own sexual destiny, what we see in the Malinche/Adelita dichotomy is the difference, respectively, between the bad whore, who sells her body to outsiders, and the good whore, who offers her body for the sake of *la Causa*.

Rendón tells us that Chicano identity was "symbolized by cries of Viva la raza! Viva la causa! And by the concepts of Chicanismo, el Quinto Sol, and by the psychological as well as the seminal birthplace of Aztlán."[17] It was up to "la mujer" to perpetuate the cause and the race by populating Aztlán with little Emilianos and Panchos, Adelitas and Valentinas. There was no room in that scheme for feminists, lesbians, or queers. Anyone who had an agenda beyond race and class could not be a "real" Chicano, for, as Rendón explains, "The essence of cultural nationalism is the full

acceptance of this fact, that we are oppressed because of the color of our skin and because of the nature of our being, and that as a consequence, inevitably, our sole means of preservation and equality before all men is in that color and in that raza." [18]

Rendón encouraged Chicanos to "allow" their daughters and sisters to go to college and thereby halt the disturbing trend among those "hijos de Cuauhtemoc" who were marrying Anglo women they met at school. "Because [Chicanas] lack the opportunity of other women who take higher education for granted," Rendón's argument ran, "they are excluded from the best setting for catching a promising young Chicano." [19] Getting a *macho*, then, rather than getting an education, was the primary reason to encourage Chicanas to go to college.

Chicanas, "real" Chicanas, only lived for two things: for their men and families and for the struggle. The few images of women that we see in Luis Valdéz's documentary depiction of Corky Gonzales's I *Am Joaquín*, for example, show us either bullet-decked *soldaderas* or bereaved, rebozo-wrapped mothers. In a San Antonio alternative newspaper called *El Rebozo*, edited by two Chicanas, we find the following explanation for the paper's title: "The traditional garment of the Mexican woman symbolizes the three roles of the Chicana . . . 'la señorita,' feminine, yet humble . . . 'la revolucionaria,' ready to fight for la causa . . . 'la madre,' radiant with life." [20] Still distributed in San Antonio, *El Rebozo* has been a part of Tejana/o popular culture nearly as long as I *Am Joaquín* has been considered the quintessential Chicano poem, clearly demonstrating that the cycle of women's internalized oppression persists, for patriarchy functions in insidious ways; despite a quarter-century of struggle for liberation, *El Rebozo*'s audience, many of them young Chicanas, still believe and espouse the ideology of their own subjugation. Humble virgins, radiant mothers, or ferociously devoted revolutionaries—these (and the ever-present "loose woman") are the same roles that women of la Raza have been assigned since they heard the first *grito* of Chicano Power.

Like their Mexican counterparts, Chicano men assign three attributes to the feminine gender: motherhood, virginity, and prostitution. During the Chicano Civil Rights Movement, *mujeres* were valued, mainly, for their biological contributions to the struggle: they could provide nourishment, comfort, and sexual release for the men and future revolutionaries and workers for *la Causa*. *Mujeres* were seen, in fact, as the carriers of the culture, and their own revolutionary role was circumscribed by their procreative function.

To be an "Adelita" (or a Loyalist, as was the popular term) a Chicana

Out of the House

127

could not adopt feminism as a strategy for liberation. Ana Nieto Gómez, one of our early *feministas*, was told by the male leadership of the Movement that Chicanas like her were "anti-family, anti-cultural, anti-man, and therefore anti-Chicano."[21] *Feministas*, it was believed by the *macho* leadership of the Chicano Movement and their female advocates, were white middle-class "wannabes," men-haters, lesbians, and threats to the beliefs and values of *la familia*. Chicanas who adopted feminist ideologies, who fought against gender oppression within el Movimiento as well as class and race oppression against the dominant culture, were considered "Malinches," untrustworthy "vendidas," politically if not sexually selling their bodies and souls to the white oppressors, thereby destroying the most basic bonds of Chicanismo: the patriarchal bonds of *la familia* and *carnalismo*. In fact, the *feministas* were not betraying anything except the gender and sexual inequities that prevailed in the Chicano Movement; in other words, to return to *Animal Farm* for a moment, they were denouncing the greediness of the pigs. The problem, as Emma Pérez succinctly puts it, is that "before the revolution, political Marxist men refuse to give up their *power*, during the revolution, men refuse to give up their *power*, after the revolution, men refuse to give up their *power*. . . . Social, political, economic and yes, sexual power."[22]

As evidenced by a recent publication that charts the evolution of Chicana/o Studies since 1968, Chicanos continue to be threatened by the activism and scholarship of Chicana feminists, particularly Chicana lesbian feminists. Calling us "adversarial" to the true goals of Chicanismo and "gender nationalists" who not only attack but also debunk the hard work of our male colleagues, engaging in confrontation rather than accommodation, the author argues that we are "moving away from [read: betraying] the community" with our alienating gender politics. He explains in a footnote that Chicana feminists have redefined the traditional notion of "community" and reduced it to signify "single females, or single-parent families led by females, who are poor and abused. There is very little vibrancy in that community beyond the mother-daughter relationship."[23] It is a testament to the insular legacy of patriarchy that, at the cusp of the twenty-first century, we still find Chicano academics who cannot see beyond their one-dimensional definition of what constitutes Chicano community and whose myopic nostalgia for the dualisms of a social scientific methodology persists in construing women's identity in strictly relational terms: as "single females" (i.e., unmarried, divorced, widowed) and as mothers or daughters. Those single-female, mother/daughter studies, especially those that condemn male abuse of power, by the

way, lack sociological resonance with the "real" Chicano community. The author locates four institutions in California as "recent hotbeds of feminist discourse,"[24] actively engaged in "dividing" the discipline of Chicana/o Studies. On Chicano Farm, it seems, the females are not supposed to be queer or autonomous subjects; their job is to lay and brood and nest while the cocks and the pigs work out the revolution.

A gendered analysis of the *solar* of Chicano/a popular culture shows that, aside from resistance, affirmation, *mestizaje*, self-determination, and the myth of Aztlán, two other deep-seated beliefs that have buttressed Chicanismo, sexism and its first cousin heterosexism, are also amply portrayed in the CARA exhibit.

Back to the W.C.

"Feminist Visions" contains fourteen pieces, all done by women, of course, implicitly stating that in the Chicano Art Movement only *las mujeres* were concerned with achieving a feminist consciousness. Moreover, its placement as the second to the last room in the exhibit, sandwiched between the traditional history of "Reclaiming the Past" and the individualized future of "Redefining American Art," has the effect not only of ghettoizing the work of Yolanda M. López, Ester Hernández, Isabel Castro, Barbara Carrasco, Juana Alicia, Celia Muñoz, and Celia Rodríguez,[25] but also of perpetuating the Chicano nationalist message that women are the cultural and biological links between yesterday and tomorrow, between tradition and change. This message is reinforced by the reproductive imagery that predominates in the section. There are, for example, three allusions to babies: Celia Rodríguez's shadowy *Llorona* portrays a cloaked figure with outstretched claws drifting over a white bundle in a cradle; Juana Alicia's *Xochiquetzal* depicts a pregnant woman on a hospital gurney, her fetus visible through her translucent belly, about to be operated on by death-masked doctors but protected by the Aztec goddess of love and procreation.

Barbara Carrasco's *Pregnant Woman in a Ball of Yarn* shows a naked woman bound and gagged by the yarn of motherhood; as the artist herself described it: "[the lithograph] portrays an oppressed pregnant woman trapped by the fear of fighting her oppressors."[26] Isabel Castro's photographs depict "Chicanas who have had to survive familial and social repression, including forced sterilization,"[27] yet another, if negative, reference to reproduction.

The pages of Celia Muñoz's mixed-media book *Which Came First? Enlight-*

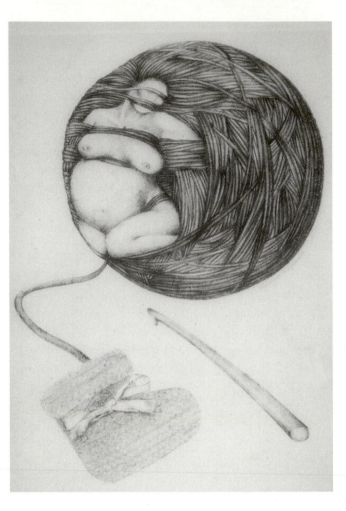

Figure 43. Barbara Carrasco, *Pregnant Woman in a Ball of Yarn*, 1978, lithograph. Reproduced by permission of the artist.

enment (visible in the installation shot in Figure 41) associate the learning of English with the proverbial chicken and egg question by conjugating the verb "to lay" in five sentences, each written in what looks like a child's grade school tablet. While the sentences change, the recurring image in the series is a photograph of five eggs arranged in a row above each painstakingly written sentence. Subliminally, and in the context of all of those images of pregnancy and motherhood, the piece, which is primarily a critique of the educational system that crams English down our throats, forcing us to forget which of our mother tongues came first, loses some of its revisionary narrative and the eggs become a visual refrain for the reproductive message.

Figure 44. Isabel Castro, *Women under Fire*, 1979, color Xerox. Collection of Robert S. Rems. Reproduced by permission of the artist.

"Feminist Visions" is supposed to display Chicana feminist reinscriptions of female iconography as well as feminist critiques of social issues affecting Chicanos/as. Although individually each piece questions and challenges traditional roles, models, and behaviors ascribed to Chicanas in Chicano patriarchy, the artwork ends up being grouped together and used by the curatorial agenda to serve and reproduce the sexist ideology of el Movimiento. Thus, the viewer's intertextual associations are limited to a singular discourse.

It can be argued, of course, that the motifs and images of these fourteen pieces fit into the tradition in feminist art and literature of celebrating the body and using the body as text and metaphor for lived experience. In-

deed, one of the first goals of the feminist art movement of the 1970s was, in the words of Judy Chicago, "to transform our circumstances into our subject matter . . . to use them to reveal the whole nature of the human condition."[28] This focus on "circumstantial identity" led feminist artists to the work of decolonizing the female body by transforming it into an active speaking subject rather than a passive object of display and male gratification.[29] In this particular vein, the circumstances of women's lives included the life-affirming aspects of sexuality—menstruation, orgasm, self-love, birth—as well as the difficult issue of abortion and the inhumanity of rape and battery. Thus, images of women's bodies, particularly the genitals, became prolific expressions of feminist ideology. Pregnant bellies, breasts, vaginas, menstrual blood, orifices, apertures, and lush images of nature were seen as manifestations of the creative essence of women's lives. If biology is destiny, as Freud would have it, then the message of the first wave of feminist art was that the way women were to control their destiny and thereby achieve autonomy and independence in the art world was to proudly claim and display their biology and so defy the misogynistic mores of patriarchy that label women's issues as taboo or unworthy of "fine art."

In "'Portraying Ourselves': Contemporary Chicana Artists," Shifra Goldman traces the contact points between feminist ideology and Chicanismo and finds that, indeed, the themes of women and children which pervaded much of the artwork of Chicanas were seen as both a product of and a metaphor for female creativity.

> If there are unifying characteristics [among Chicana artists], they include the overwhelming concern with images of women, their condition, and their environment. Many works are directly or indirectly autobiographical; a certain number deal with sexuality. Another common denominator that has emerged is the tendency to use organic rather than geometric form: the rounded corner, the flowing line, the potlike shape shared by clay vessels, the pregnant body, and the adobe fireplace.[30]

We can argue, then, that motherhood, regeneration, and female ancestry constituted what could be called a Chicana aesthetic in the early years of the Chicano Art Movement that shared certain formal and ideological characteristics with what came to be known as "cunt art" in feminist circles.[31] Coupled with iconography from Catholic ritual and pre-Columbian mythology and stressing the political vantage point of the

working class, this Chicana aesthetic could, in fact, be the predominant vision of the "Feminist Visions" room and not necessarily reflect the essentialist discourse of the Selection Committee. Open as I am to that reading, however, the art of this room cannot be taken out of context. If, indeed, Chicana artists were adopting a political essentialism meant specifically to problematize the cultural essentialism of Chicanismo,[32] what Gayatri Spivak would call "strategic essentiali[zing],"[33] do the other images of and by women in the show deploy the same strategy, or can we trace the crumbs of a sexist discourse underlying the exhibition?

To answer this question we must step outside of the W.C. for a moment and examine other rooms in the show. Let us walk, first, around the corner to look at César Martínez's La Fulana/The Other Woman in the final section of CARA and then back to an earlier room, to analyze the images chosen to portray women in the barrio.

La Fulana, along with John Valadez's The Wedding (see Figure 30, discussed in Chapter 1) and the mother and children scenes of Carmen Lomas Garza's Camas para Sueños and Virgen de los Lagos are among the last images of Chicanas that the viewer sees before leaving the exhibit. In Valadez's piece, womanhood is depicted as a relational identity: the younger woman, dressed in the symbol of female purity, is someone's overprotected daughter and someone else's virginal wife-to-be; seated on the train of the bride's dress, the older woman is someone's overbearing mother and omnipresent future mother-in-law. In Carmen Lomas Garza's two pieces, mothers nurture their children's dream lives and religious faith, respectively. In La Fulana, "she's" la otra, a sexual allusion to the lover of a married man.

Michael Ennis says in his review of CARA in Texas Monthly that La Fulana "evokes the scorching sultriness, the vulnerability, and the weariness of a barrio temptress."[34] This image, as the reviewer's comments confirm, endorses one of the most deep-seated and pernicious mainstream stereotypes of Latina women. Though its intent is to leave the viewer with the impression that Chicano/a art is "redefining American identities," the last room in the exhibition clearly demonstrates that gender identities have not been redefined in Chicano/a culture, and we can still rely on the mother/virgin/whore archetypes to represent the women of el Movimiento.

The "Urban Images" section, whose principal hero is the Pachuco, contains twenty-seven pieces, at least fifteen of which depict either the Pachuco in his zoot suit or some derivation of Pachuco culture. As we saw in Chapter 1, through la Causa and the Chicano Art Movement, the Pachuco has become one of the most important icons of Chicano (stress

Figure 45. César A. Martínez, *La Fulana (The Other Woman)*, 1985, acrylic on canvas. Reproduced by permission of the artist.

the 0) resistance. When women appear in the "Urban Images" room, all except one (which I will focus on later) are shown either as members of a patriarchal institution like a family, a heterosexual couple, or a beauty pageant or, as we see in Daniel Gálvez's painting *Home Girl #1*, as male representations of women that signify not *mujer* culture in the barrio, but the presence of Chicanismo projected onto the female body like a tattoo or the stamp on a T-shirt.

What we see in Gálvez's portrayal of a Homegirl is not the girl herself, but the Homeboy's sexual desire for her, the fact that "lowriders do it [implicitly to them] low and slow." But the Homegirl is more than just

Figure 46. Judith Francisca Baca, *Las Tres Marías*, 1976, mixed media. Photograph provided courtesy of the Wight Art Gallery. Reproduced by permission of the artist.

the receiver of the Homeboy's attention; she is, like the Chevy painted across her breasts, owned, manipulated, and altered by the Homeboy to reflect his style and his world. She is, in short, an *espejismo*, an optical illusion of the macho image looking at himself in a female body.[35] Only two pieces in the "Urban Images" section can be said to commemorate women *per se*: Harry Gamboa's black and white photograph of Chicana artist Patssi Valdéz and Judy Baca's mixed-media triptych *Las Tres Marías*, the only one of twenty-seven pieces in the section done by a woman, which portrays and reflects Pachuca/Chola culture.

Espejismos in *Las Tres Marías*

The "Urban Images" room of the CARA exhibit is described in the catalog as a representation of daily life in the barrio: "portray[ing] community landmarks and events, such as panaderías (bakeries), tortillerías (tortilla factories), quinceañeras (girls' coming-of-age celebrations), and concursos de reina (beauty pageants)."[36] One of those community institutions not named in the catalog besides the neighborhood *cantina* is the *costurería* or dressmaker's shop, usually the front room of the *costurera's* house or apartment. It is the *costurera* who makes your *quinceañera* dress, recycles it into your prom dress, stitches your wedding gown and the gowns of your ladies-in-waiting. Your mother or grandmother goes with you to the *costurera*, and maybe a sister or a cousin or your best friend. Invested in the most meaningful events of your social life, more than a woman's world, the *costurería* is a woman's ritual, a ceremony of your socialization as a heterosexual female. Indispensable to the dressmaking trade is the three-paneled mirror, and this is the form that Judy Baca adopts for her *Las Tres Marías*, used originally as a performance piece in 1976.

Each of the three panels is 68" x 16" and 2½" deep, mounted on a platform to render life-sized depth to the images. The back of the triptych is stylized as velour-upholstered seats in a lowrider. The two side panels are Masonite over wood. On the proper left panel Baca has painted a Pachuca from the 1940s: tight black skirt, narrowing at the knees, wide patent-leather belt, tucked-in white blouse with rolled-up sleeves and a butterfly imprinted on one side, a scarf tied around the neck, low-heeled buckle shoes, and an ankle bracelet. The Pachuca's hair is done up in the Homegirl style of the day, with razor blades tucked into her curls; her eyebrows are plucked into a high arch, her lips and nails glow bright red. Standing with her weight on her right leg, right hip thrust sideways, her head cocked slightly back, she is taking a drag off a cigarette and is

just about to take the cigarette out of her mouth between her index and middle fingers. In her other hand, held down below her hip, she holds a long-tailed comb, reminiscent of the Pachuco's filero. Though she seems to be looking sideways, her heavily lined eyes are angled obliquely toward the viewer. Tattooed on the fingers of her left hand are letters that spell LOCA, a barrio designation for Cholas and Pachucas.

In the proper right panel, Baca has painted a 1970s Chola. Like the Pachuca thirty years earlier, the Chola is a city girl, street-wise, defiant, dangerous, the feminine version of the Cholo or Homeboy. Despite her thickly lined eyes, though, Baca's Chola is an almost boylike figure, in baggy black pants, black "zombie slippers,"[37] a loose black pullover with the sleeves pushed up to her elbows, hands deep in her pockets. Her hair, parted in the center, hangs flat against her shoulders. Barely visible on the inside of her right arm is the LOCA tattoo. If we compare Baca's Chola with Daniel Gálvez's Home Girl # 1, we note the same masculinized stance, but in Gálvez's Homegirl we also see an attention to makeup, coiffure, and fashion that is more consonant with Baca's Pachuca. In other words, a more intentionally "feminine" sexuality is connoted in the images of the Pachuca and the Homegirl. Baca could well be making a distinction between the flashier dress styles of the Pachuco/Pachuca generation and the ganglike uniformity of the more contemporary Cholo generation as well as between (at least) two kinds of female identity. Baca's middle figure, however, ultimately determines the politics of identity implicit in the piece.

The middle panel is a mirror. More than reflecting the viewer's image, the mirror incorporates the viewer into the text of Las Tres Marías. Stephen Greenblatt argues that a strong work of art should evoke a mixture of "resonance" and "wonder" in the viewer:

> By resonance I mean the power of the displayed object to reach out beyond its formal boundaries to a larger world, to evoke in the viewer the complex, dynamic cultural forces from which it has emerged and for which it may be taken by a viewer to stand. By wonder I mean the power of the displayed object to stop the viewer in his or her tracks, to convey an arresting sense of uniqueness, to evoke an exalted attention.[38]

Indeed, one piece that stops you in your tracks is Las Tres Marías. You are arrested by your own image. A minute ago you were standing in a museum looking at multiple representations of Chicanismo and suddenly

Out of the House

137

you are looking at yourself in a dressmaker's mirror. Boundaries have shifted. If you are a mainstream viewer (remember: the CARA exhibit is, finally, a mainstream exhibit), the optical illusion has for a moment de-centered you by placing you between two images of la otra, thus remov-ing the distance between the observer and the observed. The text accom-panying the piece states that the triptych is meant to visually interrogate the virgin/mother/whore paradigm that patriarchal cultures impose on women. If so, does that mean you represent one of those stereotypes? Which one? Where are you?

Amalia Mesa-Bains interprets Las Tres Marías as an installation piece that

plays on the multiple roles that the pachuca of 1940s . . . and the chola or ruca of the 1970s . . . have assumed over time. This piece, whose title recalls the Three Marys of the crucifixion, sets up a good woman/bad woman satire by positioning a mirror so that it cap-tures the viewer in the center of these extremes.[39]

A Pachuco or a Cholo looking into the mirror of Baca's triptych would find affinity and recognition in the figures of the Pachuca and the Chola; what he would probably overlook, however, is the fact that his own im-age, centralized between the two female images, is the creator of the vir-gin/mother/whore stereotype in which he finds himself reflected. The fa-mous slogan of Chicano/a resistance—Chicano Power!—was, indeed, about Chican-O. As Angie Chabram notes her essay "I Throw Punches for My Race, But I Don't Want to Be a Man: Writing Us—Chica-nos (Girl, Us)/ Chicanas—into the Movement Script,"

if Chicanas wished to receive the authorizing signature of predomi-nant movement discourses and figure within the record of Mexican practices of resistance in the U.S., then they had to embody them-selves as males, adopt traditional family relations, and dwell only on their racial and/or ethnic oppression. Yet even this type of definition, which implies affirming oneself through the symbolic construction of an other, was deceptive, since Chicano nationalism was also predi-cated on the necessity of mimesis: a one-to-one correspondence be-tween the subject and its reflection in mirror-like duplication.[40]

Through mimesis, says Chabram, Chicanos succeeded in marginalizing their Chicana counterparts. One of the messages of Las Tres Marías, then,

could be directed at the male "saviors" of the Movement who claimed the glory for themselves, while *las mujeres*, as usual, did the cleaning up, the lying down, the nurturing, the weeping. But the more pertinent message of the piece is directed at a female audience. The question is, how does that message change according to the differences that each female viewer brings to that middle image?

In the reproduction of the triptych that appears in the CARA catalog, the viewer photographed in the middle is the artist herself. Interestingly, the model for the Pachuca side of the triptych was also Judy Baca—or rather, photographs of Baca taken in 1974 by Donna Deitch, well-known among feminist film critics as the director of *Desert Hearts* (1985), a lesbian coming-out story set in 1950s Nevada. We have already established that *Las Tres Marías* is a subversive text because it undermines prescriptive gender codes in Chicano/Mexicano culture. Another reading of *Las Tres Marías* implies defiance of what Adrienne Rich calls "compulsory heterosexuality." While appropriating the dressmaker's mirror, symbol of heterosexual socialization, the artist presents the female viewer with the option of a gay (more masculinized) or a straight (more feminized) identity. Of course, sexual identities are never that clear-cut. If the viewer is a white lesbian of the Monique Wittig school that believes lesbians are not women, she may repudiate the heterosexual appearance of the Pachuca and at the same time feel alienated from the Chola's racial attributes. If the viewer is a Chicana lesbian of the butch/femme school, she will identify with the butch Chola and desire the femme Pachuca (or vice versa). If the viewer is a closeted lesbian she may overlook the entire issue of sexuality and focus instead on locating herself on the generational continuum of *Las Tres Marías*. And finally, if the viewer is a staunch "Hispanic" rather than a Chicana, she may not see or want to recognize herself in the mirror at all.

Implicit in the virgin/mother/whore trilogy of oppressions represented by the three Marys of the Crucifixion are the images of La Virgen de Guadalupe, La Llorona, and La Malinche—the female trinity of Chicana identification that artists like Judy Baca, Yolanda López, and Ester Hernández have reappropriated to their own ends. As already mentioned, one of the first and most enduring icons of Chicano popular culture is the image of the Mexican Virgin of Guadalupe, re-visioned and re-presented in the "Feminist Visions" room as a symbol of female empowerment rather than feminine submission. In the etching *La Virgen de Guadalupe Defendiendo los Derechos de los Xicanos*, Ester Hernández depicts the Virgin as a karate

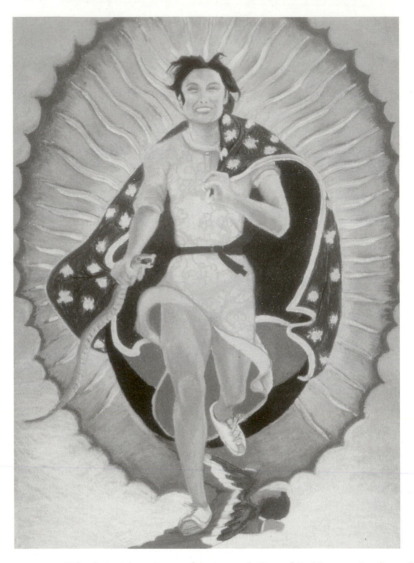

Figure 47. Yolanda M. López, *Portrait of the Artist as the Virgin of Guadalupe*, 1978, oil pastel on paper. Reproduced by permission of the artist.

black-belt kicking at the invisible oppressor, be that Uncle Sam or the self-indulgent and overbearing Diego Riveras of the Chicano Art Movement (see Figure 58). Yolanda M. López's *Portrait of the Artist as the Virgen de Guadalupe* depicts the Virgin as a marathon runner with muscular thighs and calves, wearing white track shoes and holding the serpent in

CARA's Politics of Representation

140

her hand like a staff of power. Crushed underfoot is the angel, described by López as a middle-aged agent of patriarchy, whose wings are red, white, and blue.

A self-declared iconoclast, López explained in a talk delivered at the University of California, Irvine, that she depicted this Lupita[41] as "jumping off the crescent moon, jumping off the pedestal she's been given by Chicanos."[42] Both Hernández's and López's portrayals of the Guadalupana alter the passive femininity of the traditional image to communicate feminist empowerment through change and physical action.

A Chicana reinscription of La Virgen not shown in CARA, perhaps because it was created after 1985 (the cutoff date of the show), and which has an overtly lesbian tone, is Ester Hernández's serigraph La Ofrenda, used on the cover of Carla Trujillo's groundbreaking anthology Chicana Lesbians: The Girls Our Mothers Warned Us About (first edition). La Ofrenda depicts the traditional Guadalupe image as a tattoo on a Latina's back. The offering connoted in the serigraph's title is the rose presented by a woman's hand emerging from the lower left-hand corner of the piece; the rose does not so much honor the Virgin as it honors the woman who bears the Guadalupe image on her body and thus, by association, represents the object of the unseen woman's devotion. The rose is also symbolic of the gift-giver's sexuality.

Hernández's Libertad etching, one of the earliest images of Chicana feminist art, however, is included in "Feminist Visions" and is a reinterpretation of the motherland symbol, with whom the legendary Llorona has sometimes been equated by both Chicano and Chicana poets.[43] In this work, Hernández again appropriates and subverts a cultural icon, not from her Mexican heritage, but from mainstream U.S. culture, to extend Chicano/a consciousness, emblematized by the word "Aztlán," to the East Coast, where one of the most traditional symbols of U.S. nationality is located. Here the Statue of Liberty's name has been changed to "Libertad," and the imposing figure from European mythology is transformed by a Chicana sculptor into a pre-Columbian goddess welcoming her gente to the New World of Aztlán. To further compound the irony, this etching was completed during the nation's bicentennial. In "A Conversation with Ester Hernández," the artist tells the interviewer, Theresa Harlan, the story behind the piece:

I did Libertad as an etching when I was in Fran Valesco's class [in the art department at the University of California, Berkeley] in 1976. I already had a drawing of it from 1975. The Statue of Liberty was

Out of the House

141

Figure 48. Ester Hernández, *Libertad*, 1976, etching. Reproduced by permission of the artist.

everything, the flag and Uncle Sam and all that. I did *Libertad* to show the indigenous roots of the Americas. Borders did not always exist, but migrations have always occurred. That was my American Bicentennial contribution.[44]

The political message of the piece is clear. Chicanos/as are not immigrants to the United States, nor were their Mexican forbears, nor their Native American ancestors who occupied the continent long before the Statue of Liberty—which, at the turn of the century, Rubén Darío interpreted as a symbol of "easy conquest"[45]—welcomed European immigrants to her colonial shores. For Hernández, the Statue of Liberty is a meaningless symbol unless its syncretic ethos, its indigenous core, its mestizaje, is discovered and recovered. Like La Malinche, then, the Statue of Libertad juxtaposes European and Native American ideologies of conquest and freedom. Although there are no pieces in CARA about La Malinche, I would like to suggest that this figure, Libertad, offers us a very powerful symbol of resistance not only to assimilation but also to patriarchal inscriptions of Aztlán.

Rather than the chaste virgin, the weeping mother, and the treacherous whore, La Lupita, La Llorona, and La Malinche are now configured as powerful icons of Chicana resistance to cultural hegemony and patriarchal domination. La Lupita can be a karate expert, a marathon runner, or a seamstress, and she can also represent a religious mestizaje that includes European Catholicism, New World santería, and indigenous American beliefs that go back as far as the Maya; La Llorona's weeping is now interpreted as an oppositional scream against patriarchal inscriptions of womanhood, and among Chicana lesbians she symbolizes defiance to compulsory heterosexuality; La Malinche, once the Mexican Eve accused of the downfall of the Aztec empire, is now an affirmation of la india, who lives, says Chicana poet Inés Hernández, inside "every single woman, Chicana/Mexicana/mestiza, who has refused unconditionally to accept any longer any form of oppression or violation of her self, whatever that source, and who has committed herself to a universal struggle for justice and dignity, as they say in the Indian community, for 'all our relations.'"[46] Hernández (the poet) argues that Chicana writers and artists are all daughters of La Malinche: "those women who have accepted their role as 'tongues' and demanded that their voices be heard."[47]

Following the lead of Mexican critic Octavio Paz, Chicano patriarchy continues to construct Malinche as La Chingada, the fucked one, and evokes her name to censure and malign mujeres who fail to conform to their prescribed roles and functions. But as I argue in my review of the literature of Chicana lesbians,

the binary choices allotted to Malinche are reductive. Even though Malinche was not a lesbian (as far as we know), the Chicana lesbian

Out of the House

143

is a Malinchista. As Chicana, she must interpret and negotiate the three cultures that spawned her, a spawning born of struggle, domination, and anger. As lesbiana, she is always engaged in the process of self-creation. Out of corn, water, and lime the tortillera makes the masa of her identity.[48]

As Adelaida del Castillo, Norma Alarcón, Cherríe Moraga, and Deena González have demonstrated,[49] a feminist re-vision of the male myth of La Malinche as traitor/sellout/whore can serve as a model for de-stereotyping the images of Chicanas and Chicana lesbians, who have become the latter-day Malinches of Chicano culture. In this postmodern age of shifting signifiers and signifieds, and in the same way that early feminist artists reclaimed the word "cunt" and that gay and lesbian discourses have reappropriated the word "queer" and invested it with the power of self-naming, Chicana lesbians can take "Malinchista" away from the oppressive and degrading signification of patriarchy. bell hooks believes that in order to resist hegemony from every front women of color must commit ourselves to "militant" resistance—a resistance rooted in the margins and on the homefront, not afraid of sacrifice, and enemy to the self-defeating practice of nihilism.[50] Indeed, Chicana historians, theorists, and writers have begun to transform the story of Malinche into an example of militant female resistance on the homefront of Chicanismo.

To be a Malinche is to be a traitor: to the essentializing, stereotypical, male-privileged gender codes of the race; thus, Malinche is a new mirror for Chicana posterity to look upon and in which to be reflected. From this mirror arises the vision of Malinchismo, a new theory of Chicana resistance. The Greek word theoria (the etymology of theory) originally meant an act of viewing, reflection, and observation, an imaginative contemplation of reality. As we contemplate our own images in this mirror, as we step out of the W.C., out of the halo, the house, and the whore's mask, let us reflect upon this: Chicanas are no longer espejismos, optical illusions of el Movimiento. There is a new aesthetics of affirmation and resistance, and one of its names is Malinchismo.

"The master's tools cannot dismantle the master's house," wrote Audre Lorde.[51] CARA was the first major national art exhibition to intervene in the master's house; nonetheless, it brought and used some of the master's tools, in this case, gender politics that were typically patriarchal, reflections of the madre/virgen/puta archetypes of Chicano/Mexicano popular culture. More than a commentary on the sexual politics of Chicano artists, this critique is ultimately about the selection process of the

exhibition, for it was the five-member Selection Committee—Edith To-nelli, Judy Baca, Rene Yáñez, Holly Barnet-Sanchez, and Marcos Sanchez-Tranquilino—and the nine regional committees—headed by Victor Sorell, Pedro Rodríguez, Tomás Ybarra-Frausto, Zulma Jiménez, David Avalos, Carlos Santistevan, Alicia González, Bernadette Rodríguez-LeFebre, and Amalia Mesa-Bains—who chose the imagery that would best represent the exhibit's interpretation of the Chicano Art Movement or rather, as we saw in Chapter 2, their own multifaceted and contradictory views of that interpretation. Though it is possible that these committees did not know the breadth of Chicana art, or even that the art produced by Chicanas during the twenty-year scope of the exhibition did, indeed, focus on issues of biological destiny, I tend to agree with Cherríe Moraga's view that a revisionary narrative about gender and sexuality was absent from the exhibit:

What was missing in [CARA] was the rage and revenge of women, the recognition that the violence of racism and misogyny has distorted our view of ourselves. What was missing was a portrait of sexuality for men and women independent of motherhood and machismo: images of the male body as violador *and* vulnerable, and of the female body as the site of woman-centered desire. There was no visible gay and lesbian response to our chicanidad that would challenge institutionalized and mindless heterosexual coupling; no break-down and shake-up of La Familia y La Iglesia; no portrait of our isolation, of machismo as monstruo, of la Indígena erased and muted in the body of la Chicana.[52]

A Trip to the Men's Rooms

Before leaving the Women's Closet in CARA, let me place it in a comparative context with the three freestanding "men's rooms," the *grupo* installations of the RCAF (or Royal Chicano Air Force) of Sacramento and Los Four and ASCO, both based in Los Angeles. The first thing that stands out about these installations is that both their outer and inner forms are reminiscent of domesticity and spirituality, domains traditionally assigned to women: the home and the home altar. With their doorways, stoops, windows, walls and roofs, the three "men's rooms" are *casitas* that on the inside appropriate the form of the home altar, a domestic space traditionally installed and cared for by women (see Figures 17 and 49).

In her dissertation, "Mexican-American Women's Home Altars: The

Out of the House

145

Figure 49. View from inside the RCAF *casita*. Installation that was part of CARA: Chicano Art: Resistance and Affirmation, exhibition held at UCLA's Wight Art Gallery, September 9–December 9, 1990. Photograph provided courtesy of the Wight Art Gallery.

Art of Relationship," Kay Turner sees the construction of altars as a form of resistance to "patriarchal alienation." "Deep within the interior of her home the woman's private altar has been a separate space dedicated to the fulfillment of her own ideology, an ideology given to the fruition of social relationships and opposed to alienation."[53] Paradoxically, of course, resistance to alienation takes the form of a "separate space," which, nonetheless, is devoted to promoting "social relationships" through the intercession of saints and spirits. Although it is essentializing to assume that women are more ideologically predisposed to discourse with the spiritual world than men, it is true that, for the most part, home altars are the domain of mothers and grandmothers in Mexican/Chicano/a culture. That the three artists' collectives honored in CARA have all chosen or been assigned the domestic form of an altar to represent themselves in the history of the Chicano Art Movement is more than another example of male appropriation of a space and a discourse traditionally manipulated by women; it signifies, I would argue, the canonization of these male-

dominant *grupos*, the fact that they (and no others, and certainly not any women's collectives) deserve to be memorialized as dearly departed ancestors or heroic pioneers of the Chicano Art Movement. I do not mean here to demean the important contributions of these three groups, which I will discuss below, only to suggest, through a semiotic analysis of the structure used to represent them in the show, that their reification epitomizes the male privilege underscoring the entire exhibition.

The Royal Chicano Air Force, originally named the Rebel Chicano Art Front, was organized in 1968 by California State University art professors José Montoya and Esteban Villa, along with Ricardo Favela, who was their student at the time. The RCAF was committed to integrating artistic production and political action within the Chicano community. Famous for popularizing two slogans in their art, *la locura lo cura* and *aquí estamos y no nos vamos*,[54] the RCAF encouraged Chicano artists to express their working-class sensibilities and indigenous claims to Aztlán. As the catalog of the exhibition informs us:

> Their aim for the community was creation of political self-consciousness, educational advancement, cultivation of the indigenous heritage, and its influence on present identity and art, and the retrieval of Chicano history and culture . . . [which they saw as] distinct from Mexican culture, while acknowledging the important connections between the two.[55]

Layered with photographs, posters, Movimiento buttons, pre-Colombian iconography, images of Pachucos and the Virgin of Guadalupe, feathers, dried corn, and children's art from one of the group's Barrio Arts programs—the RCAF installation documents the group's locura, a craziness of spirit reminiscent of shamanic transformation rituals in which a poverty- and crime-beleaguered community is transformed through active engagement in Chicano cultural production.

Los Four was the first Chicano artists' collective (indeed, the first Chicano artists) whose work was exhibited at the Los Angeles County Museum of Art, in 1974. The group included Carlos Almaraz,[56] Frank Romero, Gilbert "Magú" Luján, and Roberto de la Rocha. The "unofficial" fifth member of the group was Judithe Hernández, who collaborated on some of the group's projects. Like the RCAF, Los Four were committed to political art, but they also believed in "institutionalizing their efforts in order to establish an economic base. In 1975, the four members signed the charter for incorporation for the group."[57] Known for their spray-can

Out of the House

147

art which combined graffiti and icons drawn from Chicano popular culture—such as the lowrider, the crucifix, the Sacred Heart symbol, as well as pre-Colombian motifs—Los Four contributed a keenly politicized vision to the artistic production of el Movimiento.

The altar constructed against the bright yellow wall of the Los Four installation mimics the shape of an Aztec pyramid, each tier crammed with objects that signify both Chicano/a and California popular culture: model cars and airplanes, Mexican masks, *calaveras*, a toy slot machine, plastic palm trees, and *corazones*. Cases mounted along the side walls contain archival documents of the group's history: meeting notes, sketches, receipts, photographs, even bank statements showing the dwindling of the group's account, and other papers documenting their problems with funding and the difficulties in getting paid for their work (see Figure 17).

Another artists' collective that sprouted in Los Angeles was a multimedia, conceptual performance group that called itself ASCO (which means nausea in Spanish), composed of Harry Gamboa, Gronk, Willie Herrón, and Patssi Valdéz.[58] Rather than focusing on Chicano/a folklore and popular culture, ASCO sought to critique el Movimiento and strip it of its romantic nationalist agenda that, according to Marcos Sanchez-Tranquilino, failed to serve "the immediate needs of the Chicano community."[59] Chicano film scholar Chon Noriega, co-curator of *Revelaciones/ Revelations: Hispanic Art of Evanescence* at Cornell University in 1994,[60] says that "in street performance and conceptual art, ASCO provided a postmodern voice within the Chicano Art Movement, one that questioned the essential identity of cultural nationalism, but also the societal and institutional racism of Los Angeles."[61]

Indeed, the ASCO installation is arguably the most postmodern piece in the CARA exhibition. Combining the mainstream American icon of the television with the traditional Mexican icon of the altar, the border icon of the chain-link fence, and the cross-cultural icon of the wedding veil, and set against part of the *Black and White Mural* created by Gronk and Willie Herrón as a memorial to the Chicano Moratorium of 1970, the installation is, at first sight, an avalanche of confusion that requires knowledge of the history of the moratorium for its deconstruction.

In 1969, about 2,000 people organized by the Brown Berets demonstrated in East Los Angeles to protest the Vietnam War and the high percentage of Chicano military being killed in Southeast Asia. Another march of 6,000 people took place in February 1970. In August 1970, the National Moratorium Committee swelled the Los

Figure 50. Willie Herrón and Gronk, *The Black and White Mural*, 1973–1980 (also known as the *Moratorium Mural*), Estrada Courts Housing Project, East Los Angeles. Photograph provided courtesy of the Social and Public Art Resource Center (SPARC). Reproduced by permission of Willie Herrón.

Angeles demonstration to between 20,000 and 30,000 people. Attacked by sheriff's deputies, the march was dispersed with tear gas and, in a related incident, *Los Angeles Times* reporter, Rubén Salazar, was killed.[62]

The upper-right section of the *Black and White Mural* focusing on the woman's screaming face was used as the backdrop in the ASCO installation.

Two televisions sit behind the chain-link gate, both placed on a black circular platform that, in the blue radiation of the niche, resembles a lava rock. The platform is tilted, and the televisions appear to be sliding off, giving the impression of a collapsing altar. The chain-link fence keeps the viewer from entering the sacred space of the television, underscoring the distance between the observer and the observed, as well as the distance between two types of popular culture: the "safe" kind which is broadcast

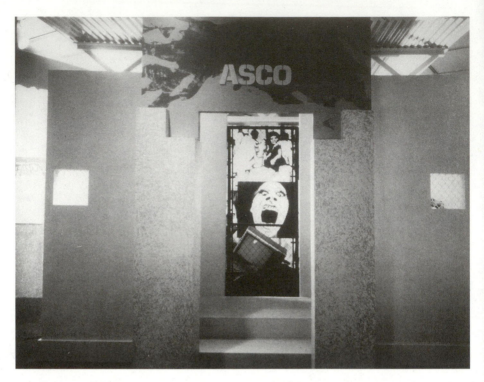

Figure 51. The ASCO *casita*. Installation that was part of CARA: Chicano Art: Resistance and Affirmation, exhibition held at UCLA's Wight Art Gallery, September 9–December 9, 1990. Photograph provided courtesy of the Wight Art Gallery.

on an interior screen and the "dangerous" kind occurring in the streets and memorialized by the images of pain and pandemonium in the *Black and White Mural*. Meanwhile, the "blind eye of the objective cultural voyeur" watches a talk show on one of the televisions,[63] called "A Date with the Artist." Most of the viewers whom I observed did not take the time to listen to the closed-circuit program and, instead, remarked on "how confusing" or "how inaccessible" the installation seemed to them. An analysis of "A Date with the Artist," however, reveals an incisive critique of the narcissism of American life and, at the same time, a parody of cultural schizophrenia.

The host of the show and the artist being interviewed are the same man—Gronk, one of the five members of ASCO. "I've known this man all my life," says Gronk the "host" as Gronk the "guest" smiles modestly. The bulk of the "interview" is comprised of clips from *The Devil Girl from Mars*, a black-and-white space movie of the early 1960s that supposedly

most influenced the "guest's" artistic career. A robot, a space ship, a nuclear explosion, an evil "alien" dressed in a polyester space suit, or, as the artist sees it, "a shower cap and shower curtain," appear on the screen. Since Chicanos/as are seen as part of the alien army invading the southern borders of the country, the images of the space movie send absurd messages to the viewer about alien invasion and cultural holocaust which mock the mainstream phobia of foreigners and "illegal aliens."

While the viewer figures out that the talk show is a mockery of television and movies, as well as a culturally schizophrenic dialogue between the artist and himself, or, rather, between a Chicano's artistic identity and his "other" persona as an alien, the images of the Black and White Mural in the background—the panicked faces of the protesters, the gas-masked police, the thorn-pierced heart of the Sacred Heart of Jesus—confront the viewer with his/her own ignorance of the event and immunity to violence against people of color.

What is the purpose of the white, ephemeral wedding veil draped in the corner of the niche?[64] On the one hand, it can be read as an ironic representation of the loss of innocence that comes with realizing that "democracy" is as much a farce as Gronk's "date with the artist," that freedom of speech and freedom of assembly are constitutional rights for the ethnicity in power but criminal activities for "Others." On the other hand, the veil, traditionally worn by women in a marriage ceremony as a symbol of the commodity to be exchanged between the bride's father and her future husband (her chastity), can be a signifier of the violation of constitutional rights. Given that the only ASCO members really represented by the installation are Gronk and Willie Herrón,[65] the veil can also signify absence; although ASCO may have questioned Chicano nationalism and institutional racism, and though the group, indeed, played with the notion of shifting sexual identities, a sustained questioning of gender inequities is conspicuously absent from their work. Indeed, as Shifra Goldman points out, Patssi Valdéz, the only full-time female member of the group, "in the early years, was often the 'target' of the men's actions, whether taped-up in a Super-8 or on a wall."[66]

Of all the pieces in the CARA exhibit that function as metanarratives behind the face, Marcos Raya's Through Frida's Eyes best conceptualizes the dynamics of power and gender inherent in the selection process, again, through the metaphor of vision and the use of eye-conography. It is also an allegory for the "insider"/"outsider" polemics at the heart of the cultural politics of the exhibition.

Out of the House

151

Figure 52. Marcos Raya, *Through Frida's Eyes*, 1984, acrylic on canvas. Collection of Dolores M. Díaz. Reproduced by permission of the artist.

Through Frida's Eyes: More Eye-Conography

As the title of the work indicates, the artist is looking through the eyes of Frida Kahlo, an "insider" view that supposedly reveals not only the objects of "Frida's" vision at that specific moment, but also the very nasal passages, gums, and eye sockets behind her face, the "frame," so to speak, of that vision. Inside the frame, in "Frida's" actual field of vision, we see two separate scenes, binary opposites composed with a meticulous attention to symmetry. The scene in "Frida's" left eye contains three male images—a picture of Lenin above a picture of Che Guevara and Diego Rivera walking through the doorway of the room in his dungarees and floppy hat (disregard the historical inaccuracy of the images for the moment). The compressed size of Diego and the pictures indicate their distance from "Frida." Beside the doorway is a large window looking onto

a lush garden; on the windowsill sits a pre-Columbian figure of a child with arms uplifted. Proportionately speaking, the idol seems enlarged while Diego appears reduced, though he is taking up all of the doorway, symbolically blocking Frida's passage out of the confines of her emotions.

The scene in "Frida's" right eye contains three images of Frida that balance out the male imagery in the left eye—two self-portraits, one with the Communist hammer and sickle painted on her body cast and a fetus curled inside her belly and another of Frida and her monkey, Fulang-Chang, looking back at the viewer; Diego's physical correspondence is Frida's naked body stretched out on the sarape-covered bed, while the pre-Columbian idol corresponds to a laughing skeleton that hangs near the footboard. The window and doorway on the left side are balanced by the two canvases on the right, thresholds to different worlds.

The yin/yang reciprocity of the imagery is obvious (even if left is masculine and right is feminine rather than vice versa). The left side represents the male world of movement, growth, continuance; the right side represents the female world of sexuality, introspection, death. Together, the two scenes compose the elements that make up "Frida's" life: her art, her politics, her relationship to Diego, her problems with her body, her loneliness, her preoccupation with death, her *indigenismo*, her bisexuality. There is, however, something not quite right with the vision, something off historical kilter. The clue comes with *el Che* (see Figure 13); the famous black and red image of *el Che* reproduced by Raya did not become a part of Latin American popular culture until the late 1950s and therefore could not have graced the walls of Frida's bedroom while she was alive. Lenin was there; so were Engels, Marx, Stalin, and Mao, lined up in the same frame and hung on the wall in front of her bed. So why has Raya placed Che in the picture? He has obviously visited or seen pictures of *la casa azul de Coyoacán*,[67] seen the *calaveras* hanging from the bedroom wall, the pre-Columbian figures lining the shelves in Frida's studio, the Communist heroes gazing back at the bedridden artist. Indeed, except for Che's image, the vision that Raya paints "through Frida's eyes" is almost realistic in the sense that it reproduces those objects that Frida probably did see from her vantage point on the bed. Clearly, *el Che* is not about Frida; the image serves as a linking device between the artist and his subject that establishes an affinity.

Now let us step away from the painting and analyze the affinities that Marcos Raya has painted between himself and Frida Kahlo. In "Histories of the Tribal and the Modern," James Clifford, through his analysis of art exhibits in New York City in 1984, specifically the Museum of Modern

Out of the House

153

Art's "Primitivism" in 20th Century Art: Affinity of the Tribal and the Modern,[68] critiques the notion that a kind of kinship, or affinity, exists between so-called tribal (meaning African) art and the art of Modernist painters such as Picasso. Rather than sharing common denominators, which is the premise of especially the MOMA show, Modernist art, says Clifford, has "discovered" African art and, as in all imperialist discoveries, conquered it for its own ends, thus demonstrating "the disquieting quality of modernism: its taste for appropriating or redeeming otherness, for constituting non-Western arts in its own image. . . . The affinities shown at MOMA are all on modernist terms" (emphasis added).[69]

Let us return with this idea in mind to Raya's Through Frida's Eyes. His exaggerated insider's perspective can be read in at least two ways: (1) it emphasizes common denominators or affinities between himself and Kahlo as artists and/or between Chicano and Mexican art, and (2) it accentuates the "otherness" of the subject for the artist in the face of these affinities; it is, in other words, a máscara, or más cara, more than a face, a mask through which Raya can express his own subjectivity. Indeed, what Raya sees "through Frida's eyes" are those elements that identify who he is; the objects of "Frida's" vision serve as props that identify Raya's own gendered reality as an artist of Mexican descent. El Che, Lenin, and Diego Rivera—the men themselves as well as the nationalist, socialist, and populist philosophies they stood for—were seminal (I use the word purposely) to the evolution of el Movimiento and its cultural extension, the Chicano Art Movement. By appropriating not only Frida's eyes, but also Frida's political and artistic views and merging them with his own, Marcos Raya can claim for himself an identity that is both "Other" and mirror to his own experience; he can, in fact, as Clifford says above, create Frida Kahlo "in [his] own image." Moreover, he can use the physical constraints of Frida's life to reinforce the nationalist idea that a woman's role in the revolution is to procreate—as the fetus in the belly signifies—more sons for la lucha.[70]

What does this say about the Selection Committee's "awareness of gender issues in all aspects of the exhibition, in both process and product?"[71] As already mentioned, Raya's painting occurs in the "Cultural Icons" room of the exhibit; because CARA calls itself an interpretive exhibition of the first twenty years of the Chicano Art Movement, it follows that the cultural icons section is a display of the icons that symbolized the struggles of el Movimiento from 1965 to 1985. There are fourteen pieces in the section, five of which show or allude to Frida Kahlo; the other cultural icons depicted are Emiliano Zapata (four pieces), the mestizo head (two

pieces), the Virgin of Guadalupe, the word "Aztlán," and Ricardo Flores Magón (one piece each). Why are there five "Frida" images and no Che Guevaras or Diego Riveras or *corazones* or *calaveras*, arguably more representative of the cultural politics of el Movimiento than Kahlo?

The first Chicano artist to use Frida's image in his work is Rupert García, whose 1975 silkscreen that appears in the CARA icons room was created "for the Galería de la Raza's 1975 collective calendar."[72] Frida's image, like that of *el Che*, Emiliano Zapata, and Ricardo Flores Magón, represented the connection that Chicano artists saw between the politics of el Movimiento and the liberation struggles of Latin America; but Frida also became an icon for the marginalized members of la Causa (i.e., Chicana artists). Interestingly, however, only one of the Frida pieces in the "Cultural Icons" section is done by a woman, Yreina Cervántez's *Homenaje a Frida Kahlo* (see Figure 22, described and analyzed in the Open House chapter). In fact, Cervántez is the only Chicana artist represented in the section. Why such a conspicuous lack of gender representation in this very significant room of the exhibit? Could it be that, as Alvina Quintana believes, "Chicano cultural productions moved closer to legitimacy by developing ideological systems which represented predominantly masculine interpretations of history and culture?"[73] Were the five images of Kahlo used to represent the female gender, thus masking the absence of Chicana subjectivity for representational presence? How was Frida Kahlo "used" by the curatorial agenda of the exhibit (for it is curating, finally, that informs the work of the selection process)? What did Kahlo's image offer to the overall vision of the exhibit that it had once offered to Chicana artists?

Clearly the Selection Committee saw in Frida Kahlo the very embodiment of resistance and affirmation, the two underlying motifs of the exhibit. Through prolific artistic representations of her body, Kahlo resisted giving in to the physical and emotional pain that constantly threatened to engulf her and transformed this pain into disturbing portraits of an oppressed and yet creative spirit. In the process, she affirmed her identity as an artist and a survivor of physical pain, emotional strife, and political struggle, as well as her claim to a fulfilling life. As Claudia Schaefer says, "the painted 'Frida' suffers, therefore she is; and each time [Kahlo] conjures up another portrait of this pain she reaffirms that identity."[74]

In Kahlo, Chicana artists such as Yreina Cervántez, Graciela Carrillo, Barbara Carrasco, Carmen Lomas Garza, and Amalia Mesa-Bains found a model of their own struggles within Anglo racism and Chicano patriarchy, for as Sybil Venegas said in 1977, and as Goldman and Ybarra-Frausto

echoed in 1990, el Movimiento was deeply sexist. "The Chicano Movement sought to end oppression—discrimination, racism, and poverty—and Chicanas supported that goal unequivocally; *the movement did not, however, propose basic changes in male-female relations or the status of women*" (emphasis added).[75] That the National Selection Committee privileged Frida Kahlo as a "Cultural Icon" of el Movimiento is commendable (if not altogether accurate) and consistent with CARA's practice of honoring its Mexican predecessors in the political art world; but the committee also privileged the male renditions of Kahlo rather than giving the space to those Chicana artists who saw Frida as an icon of their own struggles and liberation through art. Kahlo's appropriation as a cultural icon by the privileged members of the Chicano Art Movement speaks to the perpetuation of sexist male-female relations that give men the right to take what they want away from women and, as Marcos Raya's painting demonstrates, to use that which women have claimed to serve their own gendered vision.

Perhaps, though, we can effect a subversive or at least a more refreshing reading of the piece that may or may not exculpate the Selection Committee. What if we find another affinity projected in the image of a male artist in a woman's mask, assuming that woman's vision and, by extension, subjectivity? What if, by shrinking Rivera, Lenin, and Che and magnifying the presence of Frida Kahlo, the piece invites a radical interpretation of sexual politics? One reviewer who found Raya's piece "stunning . . . skilled, imaginative, and as sophisticated as any representative of the contemporary European art movements" patently assumed the sex-change suggested in the image: "What *she* sees ranges from an ape to heroes of the Mexican revolution."[76] The *she* in question is, first, the artist who has donned the mask of Frida's vision, but also the viewer who is positioned by the piece not as an observer but as a surrogate for the artist. *She* can also represent the Selection Committee. Thus, artist, viewer, and curator become Frida Kahlo, assume a subjectivity that is not their own and that is, moreover, located in a female body, in a woman's politics of location. The piece is, indeed, open to a transgendered interpretation.

Was Marcos Raya in fact establishing this other affinity between himself and Kahlo or, as I said above, simply projecting his own vision and identity onto the canvas by appropriating Kahlo's iconography? Perhaps the answer to this question is less important than the fact that the ambiguity offers the nonheterosexual viewer the opportunity to make her/his own subversive interpretation of the piece based on her/his own politics of identity and inclinations. As John Fiske believes, "a reading, like a text, cannot of itself be essentially resistant or conformist; it is its use by a so-

cially situated reader that determines its politics."[77] Reception, in other words, determines meaning; and reception, as we shall soon see, is no simple matter. The interpretation of a Chicano/Latino gay man who fetishizes Frida Kahlo the way that some white gay men fetishize Marilyn Monroe would, I warrant, be substantially different from that of a Chicana lesbian who cannot find herself anywhere in the exhibit except in the mirror of Judy Baca's *Las Tres Marías* and who, moreover, knows that one of the explicit objectives of the exhibition was to ensure a conscious sensitivity to the politics of gender and yet finds that Chicanas—no matter what their sexual identity—were marginalized once again.

By juxtaposing feminist and nationalist agendas, gay male and lesbian perspectives, the men's rooms and the Women's Closet, I have further divided CARA's "insider"/"outsider" polemics. The Malinche or feminist position operates as an outsider to the dominant codes of Chicanismo, the context of the exhibit. In "Encoding, Decoding," Stuart Hall says that dominant codes are those meanings that are assigned to a text or an event by the producers of that event.[78] Although Hall is talking about television and the way that messages are encoded through and decoded from a televised program by its creators and consumers, his theories about the construction of meaning, as we shall see in the following chapter, apply to other forms of cultural production.

Thus, the dominant codes of the CARA exhibit are those assigned by its organizers, which, clearly, have not been framed by a feminist viewpoint. Placing myself on the margins of Chicanismo, I have performed an oppositional reading of the exhibit by "detotaliz[ing] the message in the preferred [or dominant] code in order to retotalize the message within some alternative framework of reference."[79] How have others read or decoded the exhibit? How was CARA received nationwide by its audience of over 300,000 viewers?[80]

PART THREE PUBLIC RECEPTION

Figure 53. Jaime Hernández, "*Chicano Art*" *at the Bronx Museum*, 1993, drawing. Reproduced by permission of the artist.

CHAPTER 4

"Between the Ghetto

and the Melting Pot":

Popular Hegemony

I loved this exhibit. It's like looking in a mirror. It's really seeing the heart of my people.[1]

Reading this [comment] book one realizes how popular this show is, but what about the non-politicized Mexican-Americans, the traditional craftspeople of the Southwest?[2]

Chicano is a bad word.[3]

"CARA" proves that the issue of quality in art will not go away. Some commentators are insisting these days that quality is a code word for the judgmental domination of white males. Nonsense.[4]

In its "Goings On about Town" section, the May 3, 1993, issue of the *New Yorker* published a microreview of the CARA exhibit, illustrated by the graphic in Figure 53. The anonymous reviewer says that Chicano art appears to live "in the shadow" of the revolutionary art created by "*los tres grandes*," Orozco, Siqueiros, and Rivera, but nonetheless praises several of the artists in CARA "who manage to be both political

and inventive," namely Luis Jiménez, Yolanda M. López, Celia Muñoz, and Eduardo Carrillo, all of whom are cast as "real" artists, whose work can be labeled according to traditional categories: sculpture, portraiture, Conceptual art, and Magic Realism. The reviewer is especially impressed by the slide-show of Chicano murals, whose "size enhances their ability to provide a dynamic self-image to whole disenfranchised communities."[5] Employing what has come to be known as politically correct language (i.e., "disenfranchised communities," "revolutionary art," and "exploited labor force"), the review says little about CARA that could offend the artists or the organizers of the exhibit; the graphic, however, signed "Xaime '93," sends the opposite message. Known for the political wryness of its cartoons, the *New Yorker* gets away with this message without provoking any irate letters to the editor from its predominantly white readership. But what if the same drawing appeared in *Hispanic* magazine's review of CARA or illustrated the reviews in *UCLA Today* or the *Los Angeles Times*? How would the context change the meaning of the message as well as the audience's response to both the drawing and the exhibition?

Cultural critics familiar with Stuart Hall's "three hypothetical positions from which decodings of a televisual discourse may be constructed" know that he is referring to three ways of reading and understanding a cultural text: the dominant, the negotiated, and the oppositional.[6] A dominant reading occurs when the viewer "decodes the message in terms of the reference code in which it has been encoded."[7] In the case of the graphic above, we can say that the reference code is the white, upper-middle-class producers of the *New Yorker* magazine; a dominant or "preferred" reading of the *New Yorker's* wry message about the CARA exhibit is that the show, or perhaps the Bronx Museum that was the sponsoring venue, is (chuckle, chuckle) full of criminals posing as artists or as subjects of art. A negotiated reading occurs when the viewer acknowledges and even, on an abstract level, adopts the message of the dominant code, but also contradicts that message by restricting or applying it to what Hall calls "situational logic." A negotiated response to Xaime's drawing would go something like this: Chicanos may not all be criminals or con-artists, but that's the primary association that comes to mind with the word "Chicano." A viewer who deconstructs and decontextualizes the dominant code and reinterprets the message through an alternative context—the drawing, commissioned from the Los Angeles-based artist Jaime Hernández expressly to illustrate the brief review of CARA, is an example of how internalized stereotypes continue to plague Chicano/Latino existence—is performing an oppositional reading of the image.

Hall's thesis is especially pertinent for reception theorists and ethnographic critics who monitor the multiplicity of audience responses to popular culture because it provides a convenient paradigm for labeling and categorizing reception and, as in the case of the Birmingham School of Cultural Theory, for showing "the ways in which particular subcultures [or alter-Native cultures] 'negotiate' the dominant culture, appropriating its objects and symbols to produce group unity and solidarity."[8] My use of Hall's theory in this chapter is not so much concerned with showing how Chicano/a culture negotiates Euro-American hegemony as with analyzing the way that the dominant culture negotiates Chicanismo, when Chicanismo is an invited guest of honor at the mainstream art world's multicultural party. Figure 53 shows one way in which the dominant culture mediated "a revolutionary culture's invasion of the pristine halls of an establishment institution":[9] through sarcasm, mockery, and condescension, but also through omission, as the review did not appear until a week before the show was scheduled to close at the Bronx Museum. What were other responses?

Public reception to the CARA exhibition can be traced in two domains of discourse—published reviews and viewer responses written (sometimes drawn) in the comment books of some of the venues. As of late 1993, the *Readers' Guide to Periodicals* did not list the CARA exhibit as a topic, despite the fact that since September 1990 over 150 reviews (not counting announcements, listings,[10] and articles on peripheral events) have been written about CARA nationwide.[11] Of these, a full 52 percent occurred in the local daily papers of each venue. Just over 20 percent appeared in the Spanish-language press, from daily newspapers to monthly journals. Eight reviews emerged in national periodicals like the *Washington Post* (2), *New York Times* (2), *New Yorker* (1), *Wall Street Journal* (1), *Village Voice* (1), and *Hispanic* (1). One review appeared in *Artweek*, another in *Museum News*, and the most comprehensive in *Art in America*. Of the alternative arts magazines, *New Art Examiner* printed a lengthy review, as well as a letter in the subsequent issue that was generated in response to the reviewer's comments. *Newsweek* made a passing reference to CARA in its review of the Los Angeles Festival: ". . . the opening of the big exhibition, [CARA], was delayed for three hours at UCLA while the wilting crowd pressed against the gallery's glass doors in the heat."[12] And the *Chronicle of Higher Education* published, not a review of CARA, but an excerpt from Shifra Goldman and Tomás Ybarra-Frausto's essay in the CARA catalog, with a listing of dates and names of the participating venues that were sponsoring the show.

Table 2. Published Reviews

Venue	Local			National				Arts			Total
	Daily	Weekly	Monthly	Spanish Language	News	Education	Other	Mainstream	Alternative	Regional	
Los Angeles 9/9–12/9, 1990	8	0	5	9	0	1	1	2	3	2	31
Denver 1/25–3/18, 1991	11	2	1	2	0	0	0	0	0	3	.19
Albuquerque 4/7–6/9, 1991	9	0	0	3	0	0	0	0	0	0	12
San Francisco 6/27–8/25, 1991	10	1	4	6	0	0	1	0	0	3	25
Fresno 9/21–11/24, 1991	4	0	0	0	0	0	0	0	0	0	4
Tucson 1/19–4/5, 1992	6	0	1	2	0	0	0	0	0	2	11
Washington, D.C. 5/5–7/26, 1992	10	0	0	9	2	0	0	1	0	0	22
El Paso 8/23–10/25, 1992	13	0	0	0	0	0	0	0	0	0	13
The Bronx 3/2–5/2, 1993	3	2	0	1	2	0	2	0	0	0	10
San Antonio 5/29–8/1, 1993 (incl.)	3	0	1	0	0	0	0	0	0	0	4
Total	77	5	12	32	4	1	4	3	3	10	151

Before we can analyze these responses in any systematic way, we have to understand the analytical apparatus through which they will be interpreted. Hall's theory of reception is rooted squarely in the framework of Eurocentric hegemony. For Hall, hegemonic or dominant codes have been inscribed with institutionalized ideologies and are considered both legitimate and universal arbiters of meaning.[13] But if we say that hegemony is one framework in which hegemonic codes are dominant, then it stands to reason that in another framework another set of codes will be dominant. If we hegemonize the theory, it has only a hegemonic application, and the only dominant or preferred readings we can discern are those that comply with the hegemonic code. In my view, a dominant reading is not necessarily synonymous with a hegemonic reading, since the latter operates within only the hegemonic framework. Although the word "dominant" implies power relations and social hierarchies, as I will demonstrate below, it can also simply signify a particular frame of reference with its own prevailing "truths."

If, for example, a viewer decodes the CARA exhibit within the terms of the Chicano Art Movement—that art is a legitimate medium for protesting injustices, effecting community empowerment, and expressing cultural pride—then the viewer is, as Hall says, "operating under the dominant code."[14] If a viewer accepts the validity of the abstract message of the dominant code (that exploitation is wrong, that individuals should feel good about their cultures), but disagrees with the idea that such a message should be transmitted in an art museum, then the viewer is performing a negotiated reading of CARA. When the show was installed in the Fresno Art Museum, it was critiqued by Chicano college students who objected to the show appearing in a "white museum."[15] This is another example of a negotiated response within the context of Chicanismo. A viewer who interprets the art of the exhibition only through the hegemonic codes of the mainstream art world and who, moreover, repudiates the message of Chicanismo is operating in the "oppositional" mode. In the latter example, hegemonic codes do not occupy the dominant space, for, as I said above, they contest the prevailing truths of the exhibit.

Lest I be accused of subverting the revolutionary meaning of the word "oppositional," let me qualify my application of it to the dominant culture. I do not mean to imply that mainstream hegemony can ever assume or achieve what Chela Sandoval calls "oppositional consciousness,"[16] since this is, by definition, a consciousness of the oppressed; rather, I am saying that the mainstream art world's resistance to the codes of Chicanismo as a dominant and legitimate frame of reference for the CARA

"Between the Ghetto and the Melting Pot"

exhibition is synonymous with a reactionary response, unwilling to cede legitimacy to any hegemony but its own.

I see three dominant frameworks in which to contextualize public reception to CARA: (1) the hegemonic framework, represented by the mainstream art world; (2) the "discovery" context of multiculturalism as enacted by the Quincentennial Commemoration; and (3) Chicanismo. In each context, the decodings outlined by Hall are going to occupy different positions. What may be considered a "preferred" reading in the context of the art world will be oppositional in the context of Chicanismo; likewise, what may be a negotiated reading in Chicanismo could be oppositional in the context of multiculturalism.

Not surprisingly, each framework generated its own dialectic, and four general criticisms emerged in the reviews. Mainstream art critics grumbled over the lack of artistic "quality" in the show, which they saw sacrificed to the "politically correct" agenda of multiculturalism. Multiculturalists applauded the show's educational and artistic value but were uneasy about the exhibit's terminology, which they felt offended or accosted mainstream audiences, even those members of the dominant culture who were striving to be sensitive to the issues of the Quincentennial. Chicanos/as and other Latinos/as, in general, felt empowered by the exhibit, but complained about regional underrepresentation and the overexposure of California artists; some were explicitly critical of the term "Chicano," which they saw as divisive, a political rather than a cultural or ethnic identity that excluded those who preferred to call themselves "Hispanic." Let us address each criticism within its own frame of reference.

Faces of "Quality"

"Did the quality of the artwork [in CARA] stand up to scrutiny?" asks Steven Rosen of the *Denver Post*. "If not, according to whose standards? The answers are not easy, for they involve the struggle by art museums to find relevance in a multicultural society." [17] The Quality debate in the art world is not new; nor is multiculturalism or pluralism or diversity in the arts a recently controversial development. When the Quality lens is fixed over the CARA exhibition, however, a whole series of issues previously untouched by the art world comes into focus: Chicano/a aesthetics, Chicano/a culture, the cultural politics behind the art, the organizational structure of the exhibit, and the historical relationship between the dominant culture and the Mexican-descended people in the United States. These issues are decidedly volatile, and the Quality question ends up pass-

ing judgment on an entire group of people, a way of life, a historical reality; hence, it too is packed with explosives that are either detonated or mitigated by hegemonic codes. Because hegemonic codes are, as Hall says, "imprinted" with "the institutional/political/ideological order," [18] they carry an air of legitimacy about them, a naturalness that is reproduced and reinforced by a fourth level of encoding that Hall calls the "professional code."

The professional code determines the techniques and practices of the particular profession responsible for transmitting the message of a text, and this applies as much to the television industry as to the art world (or any other profession that produces audiences and texts). Hall points out that, although professional codes are largely independent of the dominant or hegemonic codes, they "reproduce dominant definitions precisely by bracketing their hegemonic quality and operating instead with displaced professional codings which foreground such apparently neutral-technical questions as *visual quality* . . . [and] '*professionalism*'" (emphasis added).[19]

Thus, critics like William Wilson of the *Los Angeles Times*, Steven Rosen of the *Denver Post*, Paul Richard of the *Washington Post*, David Littlejohn of the *Wall Street Journal*, and Eric Gibson of the *Washington Times*, operating within the professional codes of the art world, all found CARA deficient in Quality—a dimension of excellence believed by the institutional art world to exist outside of ideology. Although artists of color and feminist artists have been calling for a revision of the Quality epistemology since the mid-sixties, it remains firmly rooted, as art historian Betty Ann Brown points out, in race, gender, and class privilege:

> Linked for centuries with the European concept of aesthetics, [quality] was bound in the 1960s to Clement Greenberg's formalist dictates. The concept of quality, as the exemplar of the elitist canon of the art world, has been used institutionally to exclude women and artists of color, particularly through the machinations of the curatorial process.[20]

But curators and other professionals in the art world are not the only ones who assert that Quality and aesthetics are neutral and universal concepts. In "Aesthetics and Cultural Studies," for example, Ian Hunter states that "the cultural studies movement conceives of itself as a critique of aesthetics."[21] The main charge that cultural studies makes against aesthetics, says Hunter, "is that it is wedded to a ('high cultural') canon of works expressing the taste and values of a particular class."[22] Moreover, this

"Between the Ghetto and the Melting Pot"

marriage between aesthetics and the interests of the ruling class is apoliticized, meaning it is assumed to be true, normal, and experiential: the way things are. Hunter disagrees with this view of aesthetics and goes to great lengths to prove that cultural studies has a limited understanding of how aesthetics functions outside of labor and politics; but he does acknowledge that "the practice of aesthetics has given rise to canons as privileged bodies of worked materials. . . . Such canons are, however [in Hunter's mind], intrinsically fissile." [23]

Hunter's premise is that, if viewed outside of the limits imposed by cultural studies (i.e., that it is an ideology which perpetuates the power relations of the status quo), aesthetics is simply "an ethic: an autonomous set of techniques and practices by which individuals continuously problematize their experience and conduct themselves as the subjects of an aesthetic existence." [24] Let us ignore the obvious flaw in Hunter's major premise—that it is cultural studies which imposes the limits to aesthetics—and examine this argument.

In true poststructuralist fashion, Hunter defines aesthetics by what it is not: it is not an ideology, it is an ethic; it is not just about labor and politics, it is about autonomy, individuality, and personal experience. In the context of a colonized culture such as Chicano/a culture, however, words like "autonomy," "individuality," and "personal experience" are not givens, are not just ethical concerns, but political issues of the sort that ignited the civil rights movements of the 1960s and 1970s. If aesthetics is just an ethic, a way in which to conduct or problematize one's behavior, is what Hunter conceives of as "a practice of the self" synonymous with the practice of proving one's citizenship to the Border Patrol? [25] If aesthetics arises from personal experience, can we say that colonization, dispossession, and historical amnesia constitute part of the repertoire of a Chicano aesthetic existence, out of which Chicanos and Chicanas carve their multifarious identities?

Hunter may be correct in assessing the possibilities of aesthetics as a generic experience, not monopolized by a class, race, or gender privilege; but his optimism cannot blind him to the fact that aesthetics is, in fact, an ideological construct, as exemplified by its very denotation. Etymologically, the word has a Greek root signifying "of sense perception." Aesthetics, then, originally meant that which could be perceived by the senses; it was an innocuous, generic experience (at least for those whose sense perceptions are not physically challenged). From that original denotation *Webster's* now gives us: "a philosophy, a science, and a theory of beauty, taste, and fine culture that is distinguished from that which is

simply pleasant, or moral, or utilitarian." The definition, quite clearly, is loaded with value judgments, fixed meanings, and binary opposites: beauty vs. pleasure, taste vs. morality, the culture of the refined, the noble, the leisure class vs. that of the practical, the common, the working class. With these dichotomies and value judgments so obviously and naturally embedded in the definition of aesthetics, any argument against the political nature of this "philosophy, science, or theory of art" is moot. There is no such thing as an apolitical or neutral aesthetics.

In her long tenure as an art critic, Lucy Lippard has found that aesthetic Quality is "identifiable only by those in power." [26] Indeed, for Lippard and others who question hegemony in the art world, Quality is an exclusionary tactic, a password meant to keep out those whose race, ethnicity, gender, and/or sexual orientation reflect a conflict of interests with white patriarchy; in short, Quality functions as a euphemism for racism, sexism, heterosexism, and ethnocentrism. [27] William Wilson, head art critic of the *Los Angeles Times* since 1978, would disagree with Lippard's assessment. In his view, "fostering quality in a disinterested way has been the goal of the arts across the centuries and cultures. . . . The only goal of the quest for quality is identifying expressive eloquence." [28]

Who gets to do the "identifying" is the question. One person's eloquence might be another's propaganda. The cultural assumptions that determine whose "taste" is to be considered "fine," whose eye gets to not only behold beauty but decide what beauty gets beheld, are the same ones that purport to judge a work of art by its supposedly neutral and universal "expressive eloquence."

One of the ways that Quality, or the lack thereof, is determined is by assessing the extent to which a work of art is concerned with *formal issues* rather than content. In "Political Correctness and Its Discontents," Steven Vincent writes that "many of today's politically engaged artists willfully downplay the formal qualities of their work in favor of its social content." [29] Indeed, Catherine Fox's brief review of CARA states that "too much of the work [in the exhibition] . . . privileges content over form or quality." [30] Writing in *Artforum* nearly twenty years earlier, Douglas Davis, video artist and art critic, asked "What Is Content?" [31] He determined that, after decades of being institutionally trained to avoid content in their work, to view it as a "corrupting agent" that requires them to lower their aesthetic standards in order to communicate *ideas*, artists (of the mainstream sort, anyway) are afraid of content and so either ignore it altogether or "handle [it] badly." Buttressed by the "formalist canon, which maintains that quality art achieves that status by ridding itself of impuri-

ties,"[32] the mainstream art world, thus, evolved its anticontent bias. What is content, then? Ideas, politics, history—anything that produces meaning and that, as Davis sees it, functions as a "link between the work of art and the outside world."[33]

According to the "Narrative Description" of the CARA project in its NEH proposals, CARA was organized primarily as an interpretive historical exhibition that would document the relationship between the Chicano Art Movement and the social circumstances of Chicanos/as during the twenty-year period between 1965 and 1985. Thus, it makes sense that content was a significant component of the artwork and of the entire exhibition. This overt oppositionality to the professional codes of the hegemonic art world, however, provoked responses like the following:

> I didn't feel many of the pieces met "masterpiece" criteria. Where enduring art challenges us in its style and content . . . the purpose of too much of this show's artwork was affirmation of its intended audience's values. As politics it was noble and stirring, but as art it was often just . . . politics.[34] (*Denver Post*)

> In reality [the show] is simply another attempt to cater to and/or pacify some political interest group, all at the expense (as always) of any real aesthetic standards. "CORA" [sic] as it is called . . . [has] precious little . . . that either elicits or rewards an extended gaze. . . .[35] (*Washington Times*)

> Its insistent ideologies coat this show like syrup. They stiffen your responses. . . . Is this good art? Is it bad art? You're not supposed to ask. To do so is to show yourself Eurocentric and elitist and out of it entirely.[36] (*Washington Post*)

But aesthetics is not the only way to judge an exhibit, as evidenced by William Wilson, David Littlejohn, and Bruce Nixon, whose quarrel with the Quality of the artwork is expressively eloquent about their own racial politics.

> The style of what we see [in CARA] is that of neighborhood art. . . . "CARA's" collective look becomes a simile of a *stay-with-the-gang subculture.* That works with the home folks but in a larger world, it's different. . . . Now *they* are in the Wight Gallery, which once housed a retrospective of Henri Matisse.[37] (*Los Angeles Times*; emphasis added)

[The artists in CARA] may derive emotional benefit from the symbols and rituals of a religion many have rejected; feel no profound connection to a "homeland" *their families have only recently left;* seek a new identity in the flashy artifacts of their current and unloved *economic masters;* and have to *break laws to get their paintings and signatures up on other people's walls.* . . . A few Chicano "graffiti artists" have made the leap from defacing buildings with flair and daring to a kind of inspired calligraphy on canvas, sanctioned by gallery shows.[38] (*Wall Street Journal*; emphasis added)

Bruce Nixon's review in *Artweek*, though attempting to analyze objectively both the strengths and the weaknesses of the show, finds "an analogy to tribal art here" because of CARA's reliance on cultural symbols "that are packed with significance for those who know how to recognize them," a practice that Nixon assesses as "clannish" and "insular." Nixon also criticizes CARA's "lack of self-scrutiny," its tendency to glorify Chicano existence without taking gang-related violence and drug traffic—so endemic to the Chicano community, he implies—into account.[39]

Clearly these critics have exceeded the professional codes of the art world. Their judgments about the formal standards of Quality that CARA supposedly fails to meet are far more than technical. They make paternalistic condescensions to "home folks" who suddenly find themselves in the "master's house," incriminate barrio existence, primitivize a people's cultural production, and refuse to acknowledge that Chicanos/as are not immigrants or foreigners. And yet these are preferred readings of the show based on institutional notions of "high art." The arguments made by Nixon, Littlejohn, and Wilson do not so much attempt to demonstrate all of the ways in which the artwork in CARA is more content-driven than form-oriented, more regional than universal, more "politically correct" than "art-for-art's-sake"; rather, they express the hidden face of the hegemonic code: institutionally sanctioned racism against, in this case, people of Mexican heritage.

Readers responded to these "preferred" readings of CARA in both oppositional and negotiated ways. Andrew Connors of the National Museum of American Art found that the Quality critics were approaching the exhibition as outsiders to Chicano/a culture unwilling to situate their remarks within a different framework for understanding aesthetics.

The reviews for this exhibition, the English-language reviews, have focused on the fact that there is . . . a lot of politics . . . but there is

"Between the Ghetto and the Melting Pot"

171

some good art in the show. . . . By saying that they mean, some of it fits our elitist sense of what good art is. None of those critics and most museum professionals are not willing to go to the community and say, what do you think is most important? Which of these works affects you most strongly? . . . [the community's] sense of aesthetics is different, not bad, not wrong, just different.[40]

María Acosta-Colón, executive director of the Mexican Museum in San Francisco, said of William Wilson's review in the Los Angeles Times:

Wilson misses the point of the CARA exhibition: it is precisely to call into question entrenched standards and to force us to consider its own origin and creative context. CARA jars our sensibilities and makes us think of new, powerful criteria for evaluating "great" art and pushes us toward new conceptions of the term American.[41]

In her review of CARA in New Art Examiner, Betty Ann Brown finds Wilson "emblematic of those writers who use formalist criteria to exclude anything beyond . . . the white male experience." She also contradicts Wilson's assessment of CARA's aesthetic merit, calling the exhibit "very worthy indeed" and the organizational process a "challenge" to conventional museum practices to be met with "questions that direct [art critics] to the bridge of differences between [their] preciously held preconceptions and the social position of the artist/imagemaker whose work [they] are viewing."[42] Nonetheless, she places responsibility for CARA on the shoulders of the Wight Gallery, thereby subsuming the collaborative nature of the organizational process. She also redefines art in vague language about art's relationship to its "sociopolitical matrix," proving, ergo, that CARA really is art.

Writing in response to Brown's oversights, Marcos Sanchez-Tranquilino finds that, while she tries to "challenge hegemonic premises of 'quality' art," Brown's redefinition of art is yet another "attempt to universalize experience." Moreover, her "reliance on quoting the traditionally privileged and empowered in the artworld" (i.e., Edith Tonelli), to the exclusion of the Chicano/a participants in the process, indicates for Sanchez-Tranquilino the extent to which mainstream critics are not equipped to understand the meaning of the collaborative organizational process involved in the making of CARA. It was not the Wight Gallery under the guidance of Edith Tonelli that produced the exhibit, he points out, but rather the "intercultural negotiations" between the gallery and the Chica-

nos/as on the Advisory Committee who "demanded to direct the planning of the exhibition from conception to implementation and did not come to sit at, but reversed the 'table of power' at [the] first planning meeting; otherwise the exhibition would not have proceeded."[43]

Indeed, this reversal of power relations, like the collaborative, intercultural process already discussed at length in Chapter 2, was another oppositional tactic set against the hegemonic codes of mainstream museum practices; within the framework of multiculturalism, however, this approach would be considered not oppositional but preferential, particularly in the sticky light of the Quincentennial. Let me pause here to explain the connection that I see between multiculturalism and the international commemoration of the Columbian detour in 1492.

Sailing to the Barrio: Chicano/a Art Gets "Discovered"

Multiculturalism was the "paradigm drama" of the eighties, which not only reflected a national pattern of thinking but was also an example of that thinking in action. Also known as the "diversity movement" and conceived of as a way to address the demographic changes rapidly coloring the nation's character, multiculturalism/diversity advocated more "minority" representation in every facet of American life, but particularly in educational and cultural institutions. Immediately co-opted by capitalism and distorted by right-wing cultural "purists" who saw diversification as the balkanization of the United States, the diversity movement succeeded in generating what Henry Louis Gates, Jr., calls "culture wars,"[44] a multifaceted debate about "American" identity, nationality, and "Otherness," which Gates sees as culminating in a "joint discovery of self and other."[45] Indeed, it was the notion of *discovery* that fueled the debates over the Quincentennial, a monumental event packaged as the "birth of a nation."

Organized by the power structures of both the "New" and the "Old" worlds, the Quincentennial was supposed to be a massive birthday party, the "New World" turning 500, the "Old World" celebrating the potency of its seed. Never mind that the youngest country (at least three centuries shy of its own quincentennial) had appropriated the name of the "discovered" continent as well as the economic control of the celebration. In the United States, the party was spearheaded by the Christopher Columbus Quincentenary Jubilee Commission, created by Congress in August 1984. Aside from the usual parades and mass mediated events that attend historic observances of this nature, plans for the Quincentennial festivities

"Between the Ghetto and the Melting Pot"

173

included a $5 million tour of replicas of the Niña, the Pinta, and the Santa María (built in Spain and paid for by Texaco);[46] the major traveling exhibition First Encounters: Spanish Explorations in the Caribbean and the United States, 1492–1570; two Hollywood films; a summer-long American folklife festival on the Washington Mall; a hundred-year retrospective on the World's Columbian Exposition; and even "the launching of a flotilla of spaceships to Mars."[47]

This last event coincided with the Where Next, Columbus? exhibition at the Smithsonian Institution's Air and Space Museum, which was sponsored by the kingdom of Spain and other Spanish agencies. I have transcribed nearly the full text that appears at the entrance to that exhibit, for it succinctly describes the state's ideological position vis-à-vis the Quincentennial's imperialist politics:

> Sailing across an uncharted sea 500 years ago, Christopher Columbus launched voyages of exploration and discovery that changed the world. No one in Europe or the Americas predicted the encounter of quite different cultures. Nobody imagined the resultant "New World." . . . Will we continue to explore the planets and stars? This exhibition examines our prospects for exploration and discovery of new worlds in space in the next 500 years. What are the challenges, choices, and consequences that we must consider as we make decisions about future exploration? (emphasis added)

The insider/outsider dynamics of the excerpt above are unmistakable. Who are we in this picture, except the children of colonizers on the threshhold of embarking upon similar colonizing enterprises into the "virgin" territories of space? We are the colonizers apostrophized in the exhibition's title, and we include everyone from the king of Spain and the commander-in-chief of the United States to the several million visitors who entered the Air and Space Museum in 1992 (and beyond). Hence, the Quincentennial is our celebration, the historical marking of our victory over the indigenous peoples of the "New World."

The commemoration of America's "discovery," seen within a Native American frame of reference, or, as Howard Zinn would say, told from the point of view of the conquered rather than the conquerors,[48] was not about discovery, progress, or civilization, but about imperialism, conquest, and genocide. Russell Means compared the Quincentennial jubilee to "celebrating Hitler's holocaust" and splashed a pint of "indigenous

blood" on the sail of the replica ship that was used in the First Encounters exhibit.[49] Ward Churchill, member of the Committee for American Indian History (CAIH) Advisory Board, found that "Columbus and [Heinrich] Himmler, nazi lebensraumpolitik and the 'settlement of the New World' bear more than casual resemblance to one another," citing Columbus's own diaries and letters as well as the writings of Bartolomé de las Casas as evidence of the systematic genocide with which Columbus was entrusted by the royal crown of Spain.[50]

> If there is one differentiation that may be valid, it is that while the specific enterprise Himmler represented ultimately failed and is now universally condemned, that represented by Columbus did not and is not. . . . The Columbian process is ongoing, as is witnessed by the fact that, today, his legacy is celebrated far and wide.[51]

Counter-Quincentennial groups formed in North, Central, and South America. Events organized to protest the ongoing legacy of the Columbian process included national and international walks, conferences, symposia, performances of poetry, theater, and music, counterimperialist traveling exhibitions such as Counter Colón-ialismo, congresses and gatherings of native peoples, and a protest and boycott of museums exhibiting First Encounters. Publications in every genre, too numerous to cite here, were generated in support of the Columbian protest, including the newsletters of the CAIH's Indigenous Thought and the Alliance for Cultural Democracy's Huracán: 500 Years of Resistance.

Indeed, the Quincentennial became such a heated controversy that by 1991 the NEH was reluctant to fund any more Quincentennial-related projects. Moreover, as Elazar Barkan tells, the "balance of power suddenly shifted in favor of the oppositional forces," resulting, surprisingly, in an eloquent silence on behalf of the mainstream. "The story of the Quincentenary for most Americans is one of averting it, of running away from Columbus, refusing to comment, write, or participate in any of these events. . . . Voting with their feet and their pockets, Americans overwhelmingly abstained."[52]

How does all of this help us analyze public reception of CARA within the framework of multiculturalism? We have to keep in mind that both the CARA exhibit and the Quincentennial were being organized and made their appearance during the paradigm drama of the diversity movement. The simultaneity was no coincidence. Ever-growing numbers of people of

color, including indigenous and immigrant populations, forced national awareness, or discovery, of ethnic "minority" majoritization. Multiculturalism was born. At the same time, however, as Shifra Goldman says,

> multiculturalist discourse coexisted with the most conservative/reactionary political agenda imaginable as the Reagan/Bush administrations increasingly signaled a return to 19th-century codes. . . . Racism, sexism, anti-semitism (against Jews and Arabs), ageism, homophobia, xenophobia, and censorship accompany joblessness, homelessness, and deepening poverty at home, and militarism and imperialism abroad.[53]

Meanwhile, the Quincentennial was getting organized, scheduled to make its grand arrival during an election year. If we grant that the Quincentennial's ethnocentric agenda represented the antithesis of diversity, that it can be construed, in fact, as one of the dominant ethnicity's most eloquent responses to the threats presented by multiculturalism, and if, furthermore, we grant that the CARA exhibit was pushed through the mainstream art world as a consequence of the multicultural agenda in the arts, then it stands to reason that CARA and the Quincentennial are antithetical. But one irreducible thread connects the Quincentennial and multiculturalism: the notion of "discovery," of encountering cultures that were already there but that had never existed in the consciousness of the discoverers. Multiculturalism "discovered" Chicano/a art as surely as Columbus "discovered" America.

What happens when CARA, rather than appearing adversarial to the racist, colonialist agendas of the Quincentennial, becomes part of the Smithsonian Institution's celebration of a cultural "eclosion," as depicted on the promotional card distributed at the Smithsonian Castle? The card, illustrated by Bryan Leister, depicts Columbus and Isabella (what happened to Ferdinand?) as the proprietors of the Smithsonian Castle. They are surrounded by images that represent the different exhibitions and events of the Quincentenary: a wild turkey and buffalo representing the *Amazonia* show at the National Zoo; stalks of corn representing the *Seeds of Change* show at the National Museum of Natural History; a trio of musicians—a jean-clad Native American on a drum, an Aztec Indian on a flute, and a Renaissance lady on a lute—representing *Music at the Times of Columbus*; a tiny reproduction of Yolanda M. López's running Virgin of Guadalupe, *Portrait of the Artist as a Marathon Runner*, with a male artist standing in front of it holding a paintbrush and palette, representing CARA at the

National Museum of American Art; and, up in the tower, two men using telescopic instruments of their respective centuries representing *Science in the Age of Columbus* at the Smithsonian Libraries. In the distance, behind the image of the castle, we see a longhouse, a totem pole, a New Mexican pueblo (the latter representing the *American Encounters* exhibition at the Museum of American History), the Aztec pyramids, Niagara Falls, the Grand Canyon, and, at the very top of the card, three tiny caravels heading, it seems, in the direction of U.S. shores, reinforcing the U.S.-centric version of the Columbus narrative. The title of the card, *An Eclosion*, signifies hatching from an egg; thus the Quincentenary events at the Smithsonian connoted different aspects of the hatching of American culture, all traced back to the genealogical loins of Christopher Columbus.

The Columbus Quincentenary Commemoration at the Smithsonian, we are told in the program of events, commemorated not Christopher Columbus *per se*, or even the five-hundredth anniversary of the Columbian voyage to the "New World," but, rather, "the biological change and the *encounters between cultures*" (emphasis added) that occurred as a result of that voyage and that highlighted "the experiences and contributions of all peoples who were affected by Columbus' voyage."[54] The most directly affected, of course, were the indigenous peoples upon whom Columbus and the other *conquistadores* who followed him wreaked their spiritual, physical, biological, and psychological havoc. Thus, although the Quincentenary did not officially celebrate the "discovery" of these Americans, laced as that word was with connotations of piracy and decimation, the events sponsored by the Smithsonian in honor of this historic occasion in effect "discovered" (i.e., appropriated) the cultural contributions of Native Americans and their descendants, namely Latinos/as and Chicanos/as.

The director of the Smithsonian Quincentenary was Alicia González, who was also on the CARA Executive Committee. When asked to participate in the planning phase of the CARA exhibition, González was already on board at the Smithsonian. In the context of the Quincentennial, González says that she "was very concerned about how peoples whose histories had not been previously recognized would be represented at [the Smithsonian] . . . and felt that Chicano artists and Chicano art merited an exhibition that would allow people to understand how the art had emerged and how it fit into the broader contexts of American art and art in the Americas."[55] Thus, once the logistics were worked out between the National Museum of American Art and the CARA organizers,[56] González placed CARA in the Smithsonian's program of events for the Quincentenary Commemoration. Indeed, according to Maggie Bertin, from the now-

defunct Office of the Assistant Provost for Education and Public Programs, there was an intrinsic link between the Quincentenary and the Latino initiative at the Smithsonian.[57] We can say, then, that CARA was received in Washington, D.C., within the "discovery" context of the Quincentennial.

We can construct an imaginary frame around CARA and call it the Quincentennial, which fits into an even larger frame called multiculturalism. We can further frame CARA within four separate but linked events that both directly and indirectly shaped how the exhibit was perceived/received in the nation's capital: the anniversary of the Mount Pleasant riots in Washington, D.C., the Rodney King uprisings in Los Angeles, the still-warm *West as America* controversy at the National Museum of American Art (NMAA), and *el cinco de mayo*—the Mexican/Chicano holiday that celebrates Mexico's resistance to French colonialism in the nineteenth century. *Cinco de mayo* was to be "Open House" day at the National Museum of American Art for *educators* to "view the [CARA] exhibition and review curriculum materials designed to complement the show."[58] It was not the official opening, just a day for teachers to get acquainted with CARA before bringing their students to the museum.

On May 5, 1992, the 130th anniversary of *el cinco de mayo*, Washington, D.C., was reflecting on the first anniversary of the Mount Pleasant "race riots" in which, according to an article in the *Washington Post*, "a black female police officer wounded a Hispanic man during a sidewalk confrontation," leading to an eruption of rage punctuated by torched police cars and looted stores through three neighborhoods of northwest Washington. The conclusion of the press was that "the shooting of Daniel Enrique Gómez became a symbol of what el pueblo Latino . . . and, later, other disenfranchised groups perceived as [racial] bias."[59]

On the anniversary of that event, and just nine days after the rebellion instigated by the acquittals in the Rodney King case broke out in Los Angeles, CARA opened at the National Museum of American Art. Both the Mount Pleasant and the Rodney King uprisings were racially charged dramas involving people of color and excessive police force that threw the country's coast-to-coast power inequities into bold relief against the Quincentennial's "rhetoric of celebration."[60] Moreover, CARA's opening came in the shadow of the extremely controversial revisionist interpretation of *The West as America* exhibit, which had been at the NMAA at the time of the Mount Pleasant unrest. "[CARA] came at an unfortunate time," said Andrew Connors, the curatorial coordinator for CARA. "Because of this *West as America* exhibition, our museum has been under very intense criticism for what certain senators have deemed our leftist agenda."[61]

Organized by William Truettner, the NMAA's curator of painting and sculpture, and described in the brochure of Quincentenary programs as an exhibit that "[would] critically examine popular misconceptions created by . . . images [of national expansion during the middle and late nineteenth century],"[62] The West as America provoked an overwhelmingly negative response from critics, viewers, historians, and Capitol Hill. In her New York Times article "When Museumgoers Talk Back to the Art," Celia McGee notes that "it eventually took four comment books to accommodate all the responses to The West as America. . . . People stood in line to attack or support the curators' message, sometimes for pages at a time."[63] Hank Burchard of the Washington Post called the show "a visceral shock [that] amounts to a jeremiad against American idealistic art and westward expansion, seen through a politically corrective lens."[64] Syndicated columnist Charles Krausthammer found the show "tendentious, dishonest, and . . . puerile," full of "ideological vulgarity," something that one would expect of a "Communist Party museum," but that, ironically, appeared "not a hundred yards from a plaster of Jefferson and the Lincoln portraits."[65] Daniel Boorstin, former Librarian of Congress, wrote in one of the exhibit's comment books that it was "a perverse, historically inaccurate, destructive exhibit."[66] Senator Ted Stevens of Alaska "accused exhibition organizers of promoting a leftist political agenda and threatened to curtail the Smithsonian's federal financing."[67]

It is, perhaps, doubtful that Senator Stevens knew the history of the cinco de mayo holiday, which, in another format, is a critique of precisely the same issues that The West as America was condemning: imperialism, colonialism, expansionism, dispossession. Now a popular media event meant to drum up business for beer companies and Tex-Mex food chains, cinco de mayo is losing its historical context, its ethos of resistance diluted by commercialism and historical amnesia. Nonetheless, it continues to be an important holiday in Chicano/a popular culture. That the NMAA scheduled a special for-teachers-only "Open House" on cinco de mayo, that the exhibit did not open to the public on that day (an audience that most likely would have been largely Latino), was, I believe, a strategy by the museum meant to contain CARA's political focus within the educational framework of multiculturalism and to deflect attention away from the museum on the anniversary of the Mount Pleasant rebellion. At any rate, CARA did not escape an oppositional response from Capitol Hill.

The first review of the show was published in the Washington Post on the day that CARA opened to the public. "The National Museum of American Art is trying to get your goat again, but go on over there anyway," writes

"Between the Ghetto and the Melting Pot"

179

Hank Burchard, who makes a direct comparison between CARA and its unpopular predecessor at the NMAA. "The in-your-face Chicano art on exhibit is so colorful, energetic and inventive that it should engage even the Anglos at whom many of the artists take aim. The exhibit's as provocative as 'The West as America' or any of the gallery's other recent diatribes against American culture. . . ."[68]

In a much less complimentary vein, Paul Richard's review in the Post, published two days after Burchard's, emphasizes the political ethos of CARA, certain to rankle any right-wing politician: "It's got class and gender politics, labor union politics, El Movimiento politics and other sorts as well. It's got the politics of art—both those that govern discourse in college art departments, and those that seem to govern the selection of exhibits at the National Museum. . . ."[69]

As is to be expected, these reviews only reignited the Alaskan senator's anger against the NMAA, despite the fact that the show lost much of its political flavor at this venue. Gone was the real "in-your-face" quality of the exhibit. Rather than adhering to the labyrinthine installation plan established at its UCLA venue by the organizing committee, a strategy for overwhelming the viewer with the abundant presence of Chicano/a art, the Washington audience passed through large sterile rooms viewing pieces surrounded by white space, meant to highlight the individual artistic merit of each piece. The columns that separated and described the different sections of the exhibit had gotten pushed up against the wall, the narrative structure embedded in their text swallowed by white space. The volume was turned down on the Through Walls video that at all the other venues had accompanied the murals display and that inundated the show every ten minutes with ¡Viva la Raza! and other Chicano movement gritos. Placed between the stark main galleries of the exhibition, in a dark room painted black, the murals flashed silently by, decontextualized and somber in their own private space. The voices in Through Walls that were meant to narrate the story of Chicano/a murals talked at the viewers in another room, disjointed and disconnected, nothing more than a passing documentary.

And there were other changes at the Washington venue that equally blunted the political message of the CARA organizers and that, by extension, affected public reception of the exhibit. One of these was the elimination of the CARA logo as the frontispiece of the show, which staff members at the NMAA interpreted as angry and alienating, as well as stereotypical, with connotations, through the image of the chain-link fence, of illegal border crossings. What the NMAA proposed as a substitution for

the logo was Carmen Lomas Garza's *Camas para Sueños*, which depicts two girls on the roof of a house looking at the full moon and the night sky and dreaming about the future while their mother literally prepares their bed inside, figuratively nurturing their dream lives. Connors's interpretation of Lomas Garza's image was the following:

> . . . it doesn't talk about issues, it doesn't talk about the pachucos, or resistance. It really only talks about affirmation. . . . Even Carmen Lomas Garza was initially unwilling to let us use it, because she said it did not represent the exhibition well, that it was not typical of the exhibition, and our point to her was that we had to get people into the exhibition first and then you can teach them, but if you don't get them in with an appealing image, you have no opportunity to teach them. . . . I think [the image] really implies a great deal of what this exhibition is about. . . . many people come away with [a historical] sense that this is where [Chicano/a] artists were at a particular time in history, and now there is an opportunity, a potential for opening doors into something for the future, and to have Carmen and her sister up there pointing to the stars, pointing to the future, I think is a very hopeful sign.[70]

Rather than being greeted by the reverse gaze of the logo, the destabilizing "we are watching you" attitude of those staring eyes, viewers in Washington were enticed into the exhibit by an image intended to emphasize the modernist values of a hopeful future for Mexican Americans rather than the postmodernist condition of a fragmented past. "What I wanted to bring to the museum," says Connors, "[was] the humanity behind [the Chicano art movement], not the angry politics, not these confusing, abstruse works of art."[71] The fact that the NMAA felt compelled to effect changes in the exhibit belies the abstruseness of these works; they were, it would seem, not difficult to comprehend at all. In the charged political context of the Quincentennial, Capitol Hill was breathing down the neck that the NMAA had once again stuck out for multiculturalism, and the museum pulled back by downplaying or decontextualizing CARA's political innuendos.

Interestingly, as critical as the staff at the NMAA was about there being too much text in the show, especially in the opening timeline, the most controversial of the changes that the NMAA proposed to the CARA organizers involved language. The museum wanted to tone down words like "genocide" and "manifest destiny," which they found too reminiscent of

"Between the Ghetto and the Melting Pot"

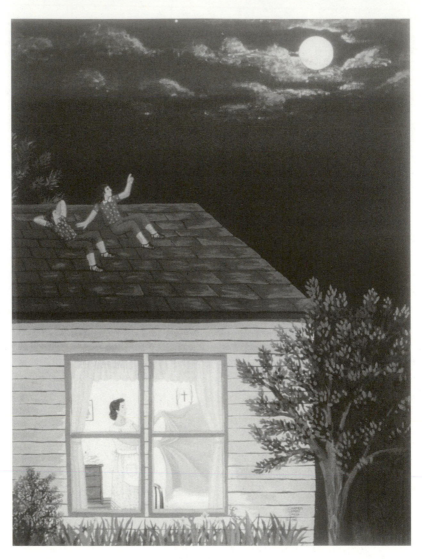

Figure 54. Carmen Lomas Garza, *Camas para Sueños*, 1985, gouache. Collection of the National Museum of American Art. Reproduced by permission of the artist.

the *West as America* scandal. The CARA committee did not allow this toning down of the exhibit's text, but the real controversy over language had to do with the museum's desire to "correct the Spanish."

> Our venue is the first venue for this exhibition in a city that has not had much of a Chicano population . . . so there was an understanding eventually after we harped on [the Spanish issue] for so long that

in the west you do things differently than you do in the east. We are an eastern museum. We need to do things the way our audience will be able to appreciate them. We felt that the Spanish was of a somewhat localized usage, primarily of southern California Chicano Spanish, and, because most of our visitors would not be Chicano, would not be from southern California, we wanted to make the Spanish more of a neutral Spanish. . . . We gradually built up an argument that we wanted to present the exhibition in the best way possible, not according to our standards, but according to factual and museological standards.[72]

Again, we return to the normalizing, "factual" professional code of the mainstream art world. In fact, one of the most strident criticisms that the Smithsonian made of the organizational process of CARA was that the academics behind the exhibition were not museum scholars and were apparently unaware of East Coast standards. Another criticism was that the CARA committee had

a great deal of control, and that alienates a museum community pretty quickly, especially a museum like ours that's been putting to-gether exhibitions for 160 years; with that much experience, the museum knows how to put exhibitions together and to have a group say you can't show our show that way is not a great way to make friends. But the exhibition was not about making friends, it was about getting across a message and a point of view and they suc-ceeded in that.[73]

To what extent, though, can we say that "they" succeeded in commu-nicating their intended message when that message was negotiated, in the Washington venue at least, through a hegemonic perspective, more con-cerned with protecting itself from the ire of Capitol Hill and with pro-moting the Quincentennial legacy of "encounters between cultures?" If the Chicano/a academics responsible for organizing CARA had too much control of their own show, what do we call it when a venue attempts to "legitimize" the exhibition by emphasizing, not that it was politics rather than art, but that it was, in fact, "art" and not politics, thereby completely altering the ethos of the exhibit? What does it mean that an institution, appealing to the professional code of "eastern" museology, standardizes the interpretive language of the exhibition? What, if not control, is being employed when a show of activist art is shown to the public as human

interest rather than political activism, as the story of individuals not of a historical movement, as the personal visions of "real people" in search of the American Dream rather than the collective statement of a minority group asserting its civil rights?

True, given the backlash created by *The West as America*, the NMAA would not have been able to show CARA without this alteration of the organizers' intentions, and the countless viewers who filled over 400 pages in the comment books at this venue would have been left without the impact of Chicano/a art in their lives; indeed, everyone responsible for pulling off CARA at the Smithsonian should be commended for withstanding the political pressures in bringing CARA to Washington, D.C., and for not allowing the criticisms and attacks the museum received during CARA's stay to dissuade them from pursuing Chicano/a art. The very fact that the museum could not present CARA as it was packaged by its organizers without risking its own survival, however, says more about the connection between censorship and federal funding than about the clash of museological standards or aesthetic visions. As Maggie Bertin, deputy director of the national campaign for the National Museum of the American Indian, commented at the IUP Latino Graduate Training Seminar in Qualitative Methodology in 1995: "Congress does not govern the Smithsonian, but if senators respond strongly and negatively to a particular exhibition sponsored by a Smithsonian museum, they can exert pressure on the museum and threaten to influence future funding for the Smithsonian."[74]

It should be noted for the record that of the sixteen museums that compose the Smithsonian, the NMAA owns a sizable collection of works by Latino artists, at least three of which were purchased from the CARA exhibition. Connors said:

> There's an artist that I've been trying to acquire for many years for the [NMAA]. But I just couldn't because he's a fairly expensive Chicano artist and our director and curator had never heard of him, and suddenly the CARA exhibition comes, they unpack the works, lean them up against the wall, and I bring the director [Elizabeth Broun] in to show her the works and give her some sort of preview and she was just knocked off her feet and said, "How can we get this painting?" and I said, well, I proposed this painting for acquisition three years ago.[75]

This painting was Frank Romero's *The Death of Rubén Salazar* (see Figure 8), for which the NMAA paid $49,500. Other works in the museum's collec-

tion that also came from the CARA exhibition include Emanuel Martínez's *Farm Workers' Altar* (see Figure 21) and Carmen Lomas Garza's *Camas para Sueños* (see Figure 54); Charles "Chaz" Bojórquez's *Placa/Roll Call* (see Figure 28) was donated as a gift by the artist.

According to the report filed by the Smithsonian Institution Task Force on Latino Issues, the NMAA "identifies 341 works by 92 Latino artists in the permanent collection"; it also notes that "the museum maintains a database identifying the ethnic origin of its works" and that "*Vaquero*, a sculpture by [Chicano artist] Luis Jiménez, has become the symbol of the Museum."[76] Elizabeth Broun, director of the NMAA, explains why Jiménez's piece receives such prominent exposure: "We believe this *Vaquero* sculpture makes many points that are key to our program: that American art began in the Hispanic Southwest, that Latinos are the most rapidly growing segment of the population, that the traditional American symbol of the cowboy began with Latinos in the Southwest."[77]

Moreover, the NMAA is "pursuing private funding for the new National Arts and Humanities Education Program with a significant Hispanic component and plans extensive outreach to Hispanic agencies in recruitment of docents."[78] For these reasons, the NMAA was singled out by the Task Force as one of the four museums "making a positive effort" to redress the lack of resources and exhibitions of Latino art at the Smithsonian. The report also stated that the Smithsonian's Quincentenary commemoration of which CARA was a part was "unique in being truly multicultural. [Its] message of *mestisaje* [sic] reflected the Spanish, African, Asian, and indigenous roots of the Americas, a model of multiculturalism which accurately reflects the American heritage and population."[79]

If "being truly multicultural" means negotiating rather than simply celebrating or acknowledging differences, then we can safely say that CARA's experience at the Smithsonian was a multicultural experience. In "Turning the Titanic: Can the Smithsonian Responsibly Face the Art of Non-Mainstream America?" (a paper he presented at the American Studies Association in 1993) Andrew Connors details the negotiations between the NMAA and the CARA organizers from both his perspective as a curator sensitive to the issues of self-representation by underrepresented artists and the perspective of a federally funded institution, historically unresponsive to the art of outsiders.[80] Negotiation, of course, implies compromise as well as conflict, neither of which were strangers to the CARA organizers.

Commenting on Connors's presentation, Professor Teresa McKenna, one of the three Executive Committee members of CARA and also a mem-

"Between the Ghetto and the Melting Pot"

ber of the catalog's Editorial Board, characterized the negotiation process with the Smithsonian as a "process of affront in terms of the language, in terms of the material of the art," which the committee found "very difficult to handle." I transcribe nearly the full text of her comments here because she represents the voice of the Executive Committee in response to the hegemonic codes imposed upon CARA, not only at the NMAA, but at every other venue that felt challenged by the oppositional stance of the exhibition.

> The vision of CARA was a vision that was Chicano, and it was civil rights oriented. . . . "Camas para sueños" was not the most political piece in the exhibition, and for us, [CARA] was a political exhibition . . . and so, therefore, that choice [to use Camas to represent the exhibition] was an affront to what CARA was all about. Yet at the same time, we thought it was very important for the Smithsonian to take CARA, not because it legitimized the art, but because it was the final transgressive move CARA could make. And so, we made some concessions. The Spanish, for example.
>
> Guess who had to go through it line by line to make sure that [the NMAA was] not reinterpreting what we had put out there? I was just thinking back on some of the corrections I made, [for example, the NMAA's] translation of White Fence to Blancos Ladrones [or white thieves]. . . . So, given those types of things, the Executive Committee and the whole organizing structure had to reassess constantly what kinds of losses we were accruing in terms of the integrity of the exhibition. . . . This type of chipping away at what the exhibition was about occurred over and over and over again. When we tried to place the exhibition in Spain, they wanted to put it in the ethnography museum, as artifacts, you see. In order to teach them about Chicano culture. We weren't teaching anybody. We were trying to show a history of the Chicano civil rights movement. . . . We decided not to send [CARA] to Spain because we could not make that concession. . . . For us, the whole conception of the exhibition had to do with its origins, it was a way of recuperating and recollecting a whole history that was told politically through its art because the Chicano Civil Rights Movement was not just about recollection, but about activism. . . . And we wanted people to understand that that civil rights movement was not ended, but actually in process. Part of the process was the activism of the exhibition, itself. To get it into the Smithsonian was a major coup. But it was also a major coup to get it in Denver, in San Francisco, in San Antonio.[81] (emphasis added)

Despite all of the NMAA's best intentions to change or subdue the controversial content of CARA, viewers were not so easily led down the path of "discovery" that characterizes both the Quincentennial agenda and multicultural pluralism. A visitor from Australia wrote that "Chicano [sic] is another example of a suppressed American 'minority' fighting white American bigotry and racism."[82] Speaking directly to the CARA organizers through the vehicle of the comment book, another viewer at the NMAA expressed heartfelt kudos:

> I am happy that your struggle was not watered down because of its place in a mainstream art museum. Thank you for having the courage to know this must be told and the persistence to find the way to tell it. Every person of color and white person in America should see this exhibit. Long live la Raza!

We know that CARA was a popular political exhibition, intended, in its oppositionality to elitist mainstream art codes and through its extensive outreach programming, to speak, not to tourists or art critics, primarily, but to its own community, described in both the tabloid brochure and the exhibition book as la plebe.[83] Through viewer commentary and local reviews, la plebe spoke back and performed their own dominant, negotiated, and oppositional responses.

All of the venues that participated in the CARA tour generated reviews; not all of them, however, had comment books in which viewers could express their opinions about the show,[84] perhaps because, as Celia McGee sees them, "comment books are the latest weapon in a struggle to change the relationship between art and audience, and to redefine the role of exhibitions and museums."[85] Here, then, is the third context in which to read public reception of CARA: the "outsider" frame of reference that we know as Chicanismo. Let us turn now to those individual voices that responded to the collective face of Chicano/a art.[86]

Chicanismo: Voices of la plebe

Stemming from the Latin plebeius, meaning "of the common people" and translated into English as "plebeian," la plebe stands for the working-class community of Chicanos/as who seldom, if at all, have been represented in their local museums. La plebe, then, was the primary audience of the exhibit. It was la plebe's collective face which CARA attempted to mirror, historicize, and portray. What did la plebe say in response?

The comment books and other viewer commentary on the exhibition revealed that la plebe's response was ultimately one of affirmation and gratitude, with the majority of comments fitting into the "preferred" category within the framework of Chicanismo. "Wonderful way to retain our history and culture," wrote one viewer at the Denver Art Museum. "It brings back a lot of great memories. I hope my children and their children will have this as a training tool in the future." [87] Two main problems, however, cast what would have been "preferred" readings of the exhibit into the "negotiated" category, and these echoed two of the criticisms made consistently in the local reviews: lack of regional representation and discomfort about the identity politics expressed by the term "Chicano."

"Despite the community-oriented approach to curating and the number of artists in the show," writes Dan Goddard of the San Antonio Express, "CARA has been criticized in all 10 cities it has toured . . . for leaving artists out." [88] Other reviewers were more specific:

Zoot suits and pachucos were born in El Paso's Segundo Barrio. San Antonio had the first Chicano arts group. But visit the [CARA] exhibit in cities other than El Paso, and you'd think all of that happened in California. [89] (El Paso Times)

What the exhibit lacks, perhaps, is more representation of Colorado artists. The muralists of Pueblo, San Luis, Grand Junction, and Brighton are not there. Organizations like the United Mexican American Students, Chicanos United for Action, La Gente, and the Brown Berets also are missing. [90] (Pueblo Chieftain)

"I enjoyed the show," said a visitor at the Albuquerque Museum of Art. "Maybe next time there will be more artists from all parts of New Mexico. Forget about the small politics." A man from Taos found CARA an "excellent spectrum of representation, but so few [artists] from New Mexico itself." [91]

The second criticism revolved around the issue of names and labels, an "insider" issue to Chicanismo as controversial in the postmodern 1990s as it has always been for the culturally schizophrenic descendants of the U.S.-Mexican War, who, as products of an ethnocentric and xenophobic educational system that robs them of their cultural history, enact the divide and conquer mentality of colonialism. Thus, those who call themselves Hispanics, Mexican Americans, Americans, and Mexicans, though

they may share the same cultural history as Chicanos/as, repudiate the term's class, color, and political affiliations.

La confusión de términos sirve para erguir más fronteras entre gente que comparte la misma sangre, y esas fronteras, con la ayuda de la amnesia histórica que provoca la cultura dominante a través de su sistema educativo, fragmentan tanto a la conciencia individual como al destino colectivo del pueblo chicano.[92]

This is a semiotic argument. The denotation of the word "Chicano," according to *Webster's*, is an "American of Mexican descent." Sterilized of its connotations, the term should be applicable to all Americans of Mexican descent no matter what they call themselves. However, those performing a negotiated reading of CARA based on the issue of self-definition were not those who identified themselves as Chicanos/as, but those who were applying what Stuart Hall calls "situational logic" to the connotative meaning of the word, for "it is at the connotative level of the sign," says Hall, "that situational ideologies alter and transform signification."[93]

Amado Peña's silkscreen *Chicano Gothic*, which opens the "Urban Images" section of CARA, offers perhaps the best visual interpretation of the connotative meaning of "Chicano" that assimilationist Hispanics, upwardly mobile Mexican Americans, and color-conscious Mexicans rejected as not reflective of their own experience.

Two dark-skinned *vatos*, drinks in hand, one in a sweater and a psychedelic tie, the other in his brown beret, both of them wearing buttons that show their political inclinations and solidarity with the United Farm Workers, proudly pose in front of a tortilla factory in the barrio. Like a bright community bulletin board, the facade of the *tortillería* announces the kinds of food sold inside the shop and is also inscribed with the names of Chicano gangs and a c/s (or *con safos*) sign that connotes graffiti and taggers (those who paint or tag graffiti on walls). No Hispanic conscientiously shedding his or her ethnicity in order to melt into the Great American pot, no Mexican American striving to disassociate him/herself from the gang-ridden connotations of the barrio or from the cyclical nightmare of the fields, no colonized Mexican still discriminating against the dark Indian inside him/her would accept "Chicano" as a term for self-definition. Only in the framework of Chicanismo would the splitting of this semiotic hair make sense.

"Between the Ghetto and the Melting Pot"

Figure 55. Amado M. Peña, Jr., *Chicano Gothic*, 1974, silkscreen. Collection of the Texas Union Chicano Culture Committee. Reproduced by permission of the artist.

As the review in *Texas Monthly* points out, "political correctness" does not only apply to the national discourse of multiculturalism, but can also have a strictly regional or cultural interpretation; what may be perfectly correct for some Americans of Mexican descent may send others into paroxysms of shame, revulsion, or indignation.

The term "Chicano" itself probably doesn't measure up to current standards of political correctness. Derived from *mexicano*, it is a derisive name for an unskilled Mexican worker (split the difference between "nigger" and "Okie," and you get the sense of it) . . . [it] remains deeply offensive to many Mexican Americans.[94]

Even in cities with a majority Mexican-American population such as Albuquerque and El Paso, the sponsoring venues wanted to eliminate the word "Chicano" from the title of the exhibition. James Moore, director of the Albuquerque Museum of Art, said that the "Chicano" signifier was his primary concern in bringing the show to a community that largely identifies itself as Spanish or "Hispano/a."

In New Mexico, particularly in the Northern part of the state, there are people whose genealogies stretch back to the colonial period. And I know from my own in-laws, that there are people here to whom the word "Chicano" is like a four-letter word. . . . They think of themselves as Spanish. No matter how much there's been a history of inter-marriage and . . . mestizo culture (although it's never called a mestizo culture), there is a lot of energy given over to the maintenance of the European tradition. . . . And in this particular neighborhood in Albuquerque [where the museum is located], the old town neighborhood, or Los Griegos out in North Valley, there is a very strong Hispanic mentality, which is very different from Martínez Town or Barelas or San José. . . . And so, Albuquerque has a very diverse Spanish-speaking population.[95]

Needless to say, the CARA organizers would not even contemplate removing "Chicano" from the exhibit's title and in fact "insisted that the term be part of the requirements for exhibiting,"[96] since not only was the term a signifier of self-identity and pride, but also the Chicano Art Movement was a recognized, if underrepresented, movement within the national art world.[97] Interestingly, although Moore "anticipated some flack" from the

"Between the Ghetto and the Melting Pot"

191

Hispanos/as in Albuquerque around the "Chicano" signifier, he "was pleased that there wasn't anything overt that surfaced."[98]

A viewer at the Albuquerque venue remembered his/her "early days in New Mexico [when] the term 'Chicano' was unacceptable," but noted that "some progress has been made at long last." A self-designated Chicano artist from Santa Fe stated that there were "too much [sic] Mexican, non-Chicano images in the show."

A viewer in Washington, D.C., admitted that "he had mixed feelings about the exhibit. It covers the popular art developed by the 'minority' group—Chicanos," but he feared that CARA would "help to further stereotype other people in the U.S. known as the 'Latinos.'" Another Washington visitor said that CARA was "the first exhibit of Chicano/Latino art" he had seen and added that he felt "shamed by how little I know of this culture. For example, should I say Hispanic? Or Chicano? Or Latino? Or none of the above?" A third Washington viewer underscored an internal contradiction of the exhibition: "[the] Smithsonian is an oppressor much like the one this exhibit talks about that the Chicano must free himself of."

And there were reactionary readings as well, recoded in a frame of reference completely outside of Chicanismo. A woman who saw the show in Albuquerque felt uneasy about how the exhibit portrayed "Spanish" Americans: "I feel this exhibit was very hard to explain to children. Alot [sic] of it had things I wouldn't want my children to see. It makes Spanish people look immoral." In Tucson, a viewer expressed her dis-ease through denial: "I thought it was a very different type of art from anything I've seen. It was Mexican-American. I wasn't disappointed, but I could live without any of it."[99] At the National Museum of American Art, a woman argued against the separatist vision of the exhibit, calling for the cultural homogenization of the melting pot.

> It's fine to know one's heritage, but it is also fine to celebrate being an *American*. I saw very little of the pride of Mexican Americans in this unique country that allows both protest and celebration that individuals feel. Border patrol people are doing a job—protecting the integrity of our border. Police are doing a job—trying to keep public peace. We need to recognize each other and work together as Americans.[100]

Another comment from a viewer at the NMAA, signed "a concerned Cuban American," emphatically disagrees with CARA's cultural politics:

Shockingly, I found the first two rooms of the exhibit to be over-whelmingly totalitarian. The repetition of the UFW eagle, the ham-mer and sickle, the same few themes—all were evocative more of a show of dead Soviet (or soon, hopefully, Castro's Cuban) art than an art of liberation. This art bespeaks to me much more that of a leftist, educated elite than of the Chicano people themselves, similar to that of communist regimes. I found its affirmation, at a time of rejoicing else-where in the world over the fall of communism surprising. Chicanos, sí, Communist totalitarians, no. (emphasis in the original)

Much more common, however, were the dominant or preferred read-ings: expressions of gratitude and joy, amazement and pride, most of them signed with their writers' names and places of origin. Some wrote poems of resistance, others drew pictures of affirmation (see Appendix A). Still others engaged in a dialectic with each other. The two comments above, for example, generated several responses. One woman pointed out to the writer of the first comment that "the S.S. guards in the concentra-tion camps" were also doing a job. Another asked, "How can we be American when the people of America continue to vote [for] and support people whose intentions are to destroy anything and anyone who does not represent their idea of America?" [101] Writing in response to the second comment, an unidentified viewer disagreed that "workers who urged consumers to boycott grapes [were] part of the elite," yet granted that "consumers who take the workers seriously" might be of the elite class; still, he/she asked if they should be "dismissed for that reason." Next to this comment another viewer wrote, "OK, a white guy."

A staff member at the El Paso museum said that, prior to CARA's visit, many of the city's residents did not even know El Paso had a museum and that those who did know of the museum's existence had not been there since the mandatory sixth-grade field trip. "I guess our museum is not the best kept secret in town anymore!" [102] said a Chicano viewer in El Paso. Another El Pasoan wrote of CARA's effect on her cultural memory and self-esteem:

The exhibit gave me a sense of pride in where I come from and where my race/heritage is going in America. I finally found an ex-hibit that I could relate to personally, for in those masterpieces I saw my friends, my grandparents and the stereotypes as well as the truths of the Chicano way of life.

Viewers from other cultures expressed solidarity with the exhibit's political message, such as the visitor from England who filled an entire page with his appreciative response. Stating that he had entered CARA "without knowledge or preconceptions and came out very moved and a lot less prejudiced towards non-English speaking Americans," he was also impressed by the artistic quality and breadth of talent displayed in the show and declared CARA the best show in the Smithsonian. Aside from Hispanicizing CARA, his closing comments express a political message that echoes the dominant codes of Chicanismo:

As Hispanics grow in number in America, I dearly hope that their culture is not lost, and their freedom of expression stifled, both by the government seeking to Americanise them and by the Hispanics themselves seeking to participate in all that is grotesque in American culture and Mass Consumerism, because from what I have seen in this exhibition, such a loss would be tragic in the extreme.

One particularly lyrical response, also at the Washington venue, was written by a man from San José, California, who, by employing two radically different voices in a postmodern combination of I Am Joaquín and Hunger of Memory, effectively demonstrates two extremes of Chicano consciousness:

I am a child of the sixties.
I walked the grape boycott picket lines, I marched
in the history-making Chicano War Moratorium in L.A.
I worked the fields as a farmworker, I cringed
as my father was belittled by the "patrón."
I decorated my college dorm room with
"Viva la Causa!" posters and wore that
brown beret and army jacket with pride.
As an attorney, elected school board member, and
now part of the "establishment," I am
happy to see that my childhood—our childhood
and my history—our history—merits
consideration and inclusion in this
august museum.

I would like to close with two more voices of la plebe. Both were recorded in the comment books of the NMAA. The first echoes the funda-

mental concern of the CARA organizers, who after five years of planning the exhibition and three years of monitoring the public reception to the art and the arguments of the show found themselves occupying the *nepantla* state not between resistance and affirmation, as both of those are actions from the margin, but rather between affirmation and assimilation, between the two native eyes/I's of Chicanismo and the mainstream art world.

> Is it possible to participate equally in the culture of your conqueror without losing or denying your own cultural heritage? Is there a place in between the ghetto and the melting pot? God, I hope so. (¿Es posible participar igualmente en la cultura de su conquistador sin perder su propia herencia cultural? Hay un lugar entre el barrio y el "melting pot?" Espero que sí.) D.C., San Francisco[103]

The other comment was written on the Fourth of July, 1992, and evokes the power of what he or she calls *hegemonía popular* or "popular hegemony" as the most enduring form of resistance to oppression and domination:

> ¿Qué hacer en este país en un 4 de julio, con esos desfiles tan facistas [sic] a unos cuantos pasos de aquí? ¿Cómo soportar esos jubilosos gritos de "freedom" y "democracy" y todas esas cosas que dicen aquí sin pensarlo? Hoy 4 de julio, un día cualquiera, he sentido la fuerza de todo aquello que los opresores se empeñan en tapar. No podrán hacerlo. No lo han hecho. La hegemonía popular está aquí. Habla por sí sola.[104]

For Antonio Gramsci, *hegemony* was not necessarily synonymous with the ideology of the ruling class, for, as Raymond Williams explains, hegemony is much more pervasive than ideology:

> Hegemony supposes the existence of something which is truly total, which is not merely secondary or super-structural, like the weak sense of ideology, but which is lived at such a depth . . . deeply saturating the consciousness of a society. . . . It thus constitutes a sense of reality for most people in the society.[105]

Ideology is used in the service of hegemony as a way of incorporating, through institutions like the school, the family, the church, the industry, through social events such as the Quincentennial and the Fourth of July,

through the process of "the selective tradition,"[106] that which the dominant culture wants to label "reality," "truth," and "common sense." What, then, is *hegemonía popular* or popular hegemony? It is, first of all, a contradiction in terms, for the popular can never achieve the effective domination of the ruling class. In the interstices of that contradiction, however, lies the power that the writer of the comment above sees as speaking for itself, and that power, I argue, is *alter-Native* popular culture: not only the power of resistance but, more significantly in terms of cultural survival, the power of production.

For Stuart Hall and John Fiske, popular culture itself is contradictory. Hall says that popular culture is "rooted in popular experience and available for expropriation [and commodification] at one and the same time."[107] Fiske clarifies the contradiction: "On the one hand [popular culture] is industrialized—its commodities produced and distributed by a profit-motivated industry. . . . But on the other hand, it is of the people, and the people's interests are not those of the industry."[108]

If the interests of the ruling class are to dominate, and to establish systems and practices by which to make that domination appear as natural, as total and irreducible as reality itself, the interests of the popular are to negotiate that domination. Let me reiterate here the contradictory nature of "the popular," which, as Fiske points out, means both "of the people" and of the "forces of domination" against which the popular is a reaction.[109] Popular hegemony, then, is composed, first of all, of those systems and practices by which subordinated groups react against and resist the social and economic domination of the ruling class, a reality of resistance, so to speak, that is a by-product of domination in the same way that the margins are a by-product of the center.

In the context of an alter-Native culture, however, popular hegemony is more than a by-product of domination, since the interests of *la plebe* are not only to negotiate and react against social and economic domination, but also to continue creating an autonomous, autochthonous alter-Native culture, a separate hegemony (i.e., reality) that is not only reactive but also productive, subversive, and different. One of those systems of resistance and production in Chicano/a popular culture was the CARA exhibition. In the words of Chicano artist José Montoya, "the show has proven that we didn't succumb. Our professors in the art schools were telling us to leave our *sarapes, plumas,* and politics at home. Our creativity won out."[110]

Rather than interpreting the Chicano Civil Rights Movement, the CARA exhibition reenacted el Movimiento on the stage of the mainstream art world. Not even 4 percent of CARA's reviews appeared in national art

journals. In fact, if we total the number of reviews published in the national press—including art journals and other periodicals—we come up with exactly 10 percent. Would it be wrong to say, based on these percentages, that the primary frame of reference was local rather than national, that the dominant code of the exhibit was not the mainstream art world but the popular hegemony of la Raza? The local and regional reviews, the comment books, and the pages of newsprint or typing paper that were used to capture la plebe's reception to CARA in both English and Spanish are popular texts, full of contradictions, pleasures, and antagonisms that document a three-year-long dialectic, national in scope but local in impact, between Chicanismo and the dominant culture.

If CARA proved anything at all it was the extent to which mainstream museums—be they municipal, private, or public institutions—are resistant to change and redefinition. Museologist Stephen Weil believes that, regardless of the differences that exist in museums, whether they vary by discipline, by collections, by scale, by facilities, by context, by funding, or by history,

> common to all . . . should be the notion that the primary and central relationship of museology is between the museum and its visitors and other clients—not between the museum and its collection. . . . The question we must ultimately ask ourselves is this: do our museums make a real difference in, and do they have a positive impact on, the lives of other people?[111] (emphasis added)

Without ever using the word "multiculturalism," Weil, an "insider" to museum politics, is calling for the diversification of museums, for the inclusion of cultural "Others" in the audience which can only come about by incorporating "outsiders" within both the museum's educational and curatorial functions. I have emphasized the word "other" in Weil's statement because it is a simple acknowledgment of the "insider"/ "outsider" dichotomy which museums take for granted and which the CARA exhibit turned on its head. For the three years of CARA's touring schedule, hundreds of thousands of viewers across the country found themselves in a space that was both alien and familiar, a space "between the ghetto and the melting pot," while Chicano/a art occupied the master's house.

Conclusion:

The Mutation

of Multiculturalism

Multicultural is the hip word of the late 1980s. Everybody agrees it is politically correct. Few know what it really means.
—Guillermo Gómez-Peña, *Warrior for Gringostroika*

Splitting the Multicultural Hair

The principal issue at the heart of the conflicts that CARA encountered and engendered in the mainstream art world was the insider/outsider polemic. Because of this, CARA was paradigmatic of the most volatile issue swirling around the "culture wars" of the 1980s: multiculturalism. CARA signified an important symbolic victory in la Raza's centuries-old legacy of struggle and survival in the United States; however, an exhibition like CARA exclusively about "outsiders" and composed by a collaborative effort of "outsiders" and "insiders" could not have happened, and indeed did not happen, at any other moment in the nation's cultural history than in the midst of the multicultural paradigm drama. But multiculturalism has become a signifier of many meanings. The assumptions that lie behind the application of the term help clarify some of the ambiguity; those who assume multiculturalism to be about identity, that is to say, *sameness*, are in truth advocating for assimilation and the era-

199

sure of differences; those who assume multiculturalism to be about difference see it as a vehicle by which to promote and celebrate diversity. Before we can see how the fate of CARA is linked to the history of multiculturalism, then, we must look at some of the ways in which multiculturalism has been applied in the culture industry.

For literary critic Frances Aparicio, whose critique of academic multiculturalism stems from her full-throttled commitment to the ideal it represents, true multiculturalism, or rather multiculturalism that is true to its word, is "collective work across racial, gender, and socioeconomic lines that will lead towards social change."[1] More than mere acceptance or celebration of difference, more than adding a few "colored" voices to a syllabus or a curriculum, more than simply accommodating demographic changes, this multicultural work, for academics, anyway, involves a recognition of privilege—be that class, as in Aparicio's case, or race or gender or sexuality—as well as acknowledgment of the conflicts that intersect our differences and that, in many instances, account for power inequities within academia.

As it has been defined, implemented, and contained (in the academy), multiculturalism (as diversity and as tolerance for difference) bypasses these sites of conflict; instead, it has focused on the "individual" as the problematic site and has tried to "correct"—thus the "politically correct" label—discriminatory behavior and verbalizations of prejudice.[2] Aparicio argues that multiculturalism has become a way of protecting white privilege, primarily, as well as the privilege of academics. Celebrating diversity does not necessarily mean analyzing power relations, much less doing anything to assuage power differentials. If the way to "correct" the problem of exclusion is acceptance, and acceptance is acted out only through representation, then representation poses two problems for Aparicio: (1) difference becomes exoticized, fetishized, and consumed, and (2) conflicts do not get recognized or resolved. Thus, white scholars are free to glorify difference and cannibalize others in their desire to prove how "politically correct" they are. For Aparicio this is a form of objectification without the benefit of social change, a pitfall for all scholars, not just white ones, who fail to recognize their privileges.

For Gloria Anzaldúa, Chicana lesbian poet, cultural worker, and author of the concept of "mestiza consciousness,"[3] multiculturalism is nothing but "a euphemism for the imperializing and now defunct 'melting pot,'"[4] and, particularly in the realm of feminist theory, another way in which white women objectify and further marginalize women of color. "Some white people who take up multicultural and cultural plurality is-

Conclusion

200

sues mean well," says Anzaldúa, "but often they push to the fringes once more the very cultures and ethnic groups about whom they want to disseminate knowledge."[5] To combat this colonizing tendency within feminist theory, Anzaldúa encourages women of color to devise our own multicultural theories that analyze power relations and deconstruct experience from the inside out.

Echoing Anzaldúa's view of multiculturalism as a euphemism for the status quo, Catherine Lord, who, as chair of the Art Department at the University of California, Irvine, bridges the academy and the art world, finds multiculturalism to be a big farce and a red herring, "a cover for business as usual,"[6] in the conservative mainstream art world and a way of promoting the same small group of "Others" who have been deemed interesting and safe by the cultural guardians.

Robin Cembalest, an associate editor of *ARTnews*, would disagree with Catherine Lord, believing instead that multiculturalism is actually catalyzing some changes in the art world, born of "a lot of soul searching" and the desire to reflect demographic diversity in the United States.[7] Indeed, Cembalest finds that museums such as the Getty, the National Gallery of Art, the Corcoran, and the Museum of Contemporary Art, among others across the country, are all doing their part to broaden notions of "Quality" and to represent hyphenated identities by implementing exhibitions of ethnic art at both national and local levels and making efforts to reach their communities of color.[8]

Is the fact that since 1990 more exhibitions of ethnic art have been hosted in mainstream museums evidence of an authentic desire to alter power dynamics in the art world, and thus effect social change, or, using Aparicio's terminology, is this simply multicultural cannibalism on behalf of privileged museum workers who have jumped on the trendy postmodern bandwagon of "representation?" One way of answering this question would be to return to Cultural Studies theory and analyze the machinations of hegemony.

In "Base and Superstructure in Marxist Cultural Theory," Raymond Williams classifies culture into three categories: the dominant, the residual, and the emergent. He defines the dominant as "a central system of practices, meanings, and values" that constitute social hegemony or, rather, what a society thinks of as reality itself. What makes the dominant culture hegemonic, that is, what comprises that society's sense of reality, is its effectiveness at incorporating this "central system of practices, meanings, and values" into the programs and processes of social, educational, religious, and political institutions; in short, the incorporation of

the hegemonic view of reality becomes natural, normal, moral, and desirable, thus effectively dominating other views and other systems and creating one *corporate* experience camouflaged, in the United States, anyway, by the trope of the *individual*.

Williams classifies those practices that resist incorporation into two categories: the alternative and the oppositional.[9] "There is a simple theoretical distinction between alternative and oppositional, that is to say between someone who simply finds a different way to live and wishes to be left alone with it, and someone who finds a different way to live and wants to change the society in its light."[10] Oppositional and alternative cultures can be further subdivided into two forms, those that Williams calls "residual" and "emergent." As its name implies, a "residual" culture is based on the "residue—cultural as well as social—of some previous social formation."[11] According to Williams, this residue can be found in enclaves of religious difference or in rural groups, for example, whose collective experiences and values differ substantially from those of the dominant culture; alternative residual cultures eventually become incorporated while oppositional residual cultures typically exist at enough distance from the dominant culture not to pose a significant threat to the status quo.

While residual cultures are based on the sediment of an older culture—as is the case, for example, in immigrant and dispossessed cultures (particularly the first generation in each)—emergent cultures, those whose meanings, values, and practices are in the process of being politicized as precisely nonimmigrant and nonforeigner, that is, as native or citizen, are "new" to the dominant culture (i.e., undiscovered). Their newness targets them as prime candidates for early incorporation, before their particularities become ensconced in either an alternative or an oppositional character; however, emergent cultures can also signify a potential challenge to hegemony if they remain unwilling to be effectively dominated or contained.

Both immigrant and citizen cultures have their oppositional and alternative groups, those who want to effect social change for their group and those who do not resist incorporation and, in fact, want to become more like the dominant group and leave their own group behind. Though Williams gives few examples to illustrate his theoretical distinctions, we can make our own illustration by comparing two groups of Mexican Americans, both stemming from the same emergent *native* culture, but one working to effect social change (Chicanos/as) and the other focused on upward mobility and access to the mainstream (Hispanics). We saw the

former come to action in the 1960s when marginalized communities were emerging into political awareness and refusing to submit to the racial, ethnic, and gender idioms of the dominant culture. Proudly displaying their oppositional mettle, and joining other emergent cultures such as the Black Power, the Women's Rights, and the Anti-War activists—all equally rankled by the ruling ideologies of the day—these groups formed a critical mass of protesters that took the dominant culture by storm. Of course, the powers of incorporation are both patient and persistent— thirty years later, we find that not only have some Hippies become Yuppies, but some Chicanos would now be better described as Chuppies.

Hegemonic incorporation of the "Hispanic" emergent culture was achieved in part by shifting federal policies to the advantage of the Mexican-American middle class and in part by employing a linguistic apparatus: the bureaucratic institutionalization of the label "Hispanic." Acuña explains the label's attraction for this alternative emergent culture:

> The term "Hispanic" appealed to this new wave of middle-class Mexican Americans. It was much more in line with their class biases and aspirations. The new Hispanic, in search of appointments and markets, liked the term "Hispanic" because it packaged the Mexican American, the Puerto Rican, Cuban, and other Latin Americans in one innocuous wrapper. . . . The media eagerly accepted the term. . . . Through repetition, the press and TV made the term a household word.[12]

Though equally discriminated against as Chicanos/as, equally connoted as "Other" with Spanish surnames and/or mestizo phenotypes (e.g., Richard Rodríguez), Hispanics strive toward a middle-class citizenship that ultimately removes them from la Raza and assimilates them to the social and political objectives of white Americans. Seeking access to the mainstream, these Mexican Americans, or "brokers" as Acuña prefers to call them, constitute the rising Republican middle class, wooed by Richard Nixon as early as the 1970s, whose party-line is the "Republicanization of Mexican-America."[13] It is from these ranks and their Latino/a counterparts that California's racist anti-immigrant bill, Proposition 187, received the most support in 1994. Such is the effectiveness of incorporation.

In terms of the art world, Raymond Williams's conceptualization of cultural dynamics helps explain how residual and emergent cultures get incorporated under the pretense of "access." If we substitute the mainstream museum for the dominant culture and the art of outsiders for

residual and emergent cultures,[14] we can see how this *corporate* accommodation of and resistance to difference comes into play. "Access to the mainstream," says Luis Camnitzer, "really means a mainstreaming of the artist,"[15] a process that involves the market as the primary site of incorporation. Because the politics of a capitalist market are also those of the state, it stands to reason that effective incorporation can only be achieved through the state. Art has always depended on the patronage of the state for its survival and preservation, but the patronage of the state requires (now and throughout history, either overtly or covertly) that the art promote the ideals of the state. In postrevolutionary Mexico, for example, the ideals of the new government repudiated Eurocentricity and reified Mexican nationalism, *indigenismo,* and the popular sector. Thus, the art sponsored by the Mexican government in the 1920s—the murals of *los tres grandes,* especially—corroborated and taught aspects of this revolutionary ideology.[16]

Similarly, in the multicultural eighties of U.S. history, prior to the NEA debacle, the ideals of the state paid lip service to the politics of diversity in order to accommodate the very real issue of a demographically altered citizenry. Federal and state funding for the arts, then, prioritized the art of difference. Art shows and films about ethnic "Others" proliferated in the exhibition and screening agendas of mainstream museums and movie houses. The art of emergent cultures was "discovered" by the hegemonic art world (dominant culture) and put on display. Thus display was one form of incorporation. Funding was another. To be included in the exhibition agendas of the multicultural moment or the Quincentenary celebration was yet another strategy of incorporation. Suddenly, artists like Carmen Lomas Garza, Gronk, Frank Romero, Luis Jiménez, Rupert García, and Carlos Almaraz found their work shown and collected by major mainstream museums.[17] In this way they "emerged" safely into the status quo, representing the cultural pluralism of the United States. Tomás Ybarra-Frausto finds that "pluralism—a right-wing synonym for multiculturalism—is a mainstream accommodationist strategy, a classification that permissively allows a sort of supermarketlike array of choices among styles, techniques, and contents. While stemming from a democratic impulse to validate and recognize diversity, pluralism serves also to commodify art, disarm alternative representations, and deflect antagonisms."[18] Thus, the illusion of access or acceptance effectively contains and diffuses oppositionality.

If it is true, as Aparicio, Anzaldúa, and Lord stipulate, that multiculturalism has been incorporated by the dominant culture and that, in turn,

Conclusion

204

multiculturalism is now being used to incorporate those emergent and residual cultures that are beginning to challenge, at least demographically, white hegemony, then it is possible to trace cultural signs of this corporate multiculturalism (see Chapter 2 for a taxonomy of multiculturalisms, of which the corporate, or conservative, view is at one end of the spectrum).

Guillermo Gómez-Peña finds that Disney World is an apt metaphor for the way that multiculturalism has been incorporated into the weaponry of cultural hegemony, functioning as it does like Esperanto, an artificial world language composed of common symbols, or, as in the Disney tradition, cultural stereotypes,[19] that make it easy for technology and capitalism to commercialize the racial and ethnic differences that multiculturalism is meant to champion.[20] This strategy, of course, is nothing new in the culture industry. In films and cartoons of the fifties and sixties, for example, bilingualism was used to reinforce Latino stereotypes,[21] such as the wily wetback (Speedy González), the indolent thief (Frito Bandito), the pidgin-tongued Pancho (of Cisco Kid fame), and the illiterate fool (the Lone Ranger's devoted Indian assistant Tonto, Spanish for Idiot). It's a small world, after all.[22] Indeed, popular culture offers us several good examples of the ease with which multiculturalism becomes incorporated into the weaponry of cultural hegemony, but none, I think, does so more effectively for the late twentieth century than the Teenage Mutant Ninja Turtles.

Turtle Power

Let me reiterate my definition of multiculturalism as close encounters of the Third World kind (see the Preface), for the Ninja Turtles emerged from the manholes of obscurity at the same time that "a full one quarter of the annual growth of the U.S. population [was] the result of immigration, and the vast majority of these immigrants [was] both nonwhite and non-European."[23] In 1984, Kevin Eastman and Peter Laird, young freelance cartoonists rejected by a mainstream comics company, created their own company, Mirage Studios, and self-published the first issue of *Teenage Mutant Ninja Turtles*, an intertextual parody of martial arts and mutant superhero comics.[24] Nine months after its first press run of 3,000 copies, *Turtles* was in its third printing, a run of 35,000 copies. Since then, "Mirage Studios has licensed [*Teenage Mutant Ninja Turtles*] to everyone in the known universe,"[25] resulting in a Saturday morning cartoon series, a 93-minute feature film and two sequels, videos, Burger King promotions, Nintendo games, lunchboxes, playwear, bed linen, watches, skateboards,

Halloween costumes, piñatas, etc.[26] With all of the other quirky superhero characters available in mainstream popular culture, what was it about the Turtles that seized not just children, obviously, but all those tax-paying adults who bought the products and the tickets to the films? What messages did the culture industry encode on the green backs of those heroes that were received loud and clear by the public that, until they were upstaged by the Power Rangers, loyally supported them?

What the Turtles ultimately represent, despite the intentions of Eastman and Laird, is the mainstream fear of and desire to control that rising tide of immigration from the Third World. The Teenage Mutant Ninja Turtles, as we shall see momentarily, not only epitomize the racial, cultural, and political changes that Third World immigration is breeding in the United States, but they also demonstrate the effects of the New American Melting Pot, nuclear technology. Trivia: the Ninja Turtles are mutants because of their experience in the literal subcultural world of New York City; eating radioactive waste in the sewers caused once normal little reptiles to change into Ninja warriors. Rather than dying, they are empowered by the dregs of nuclear technology and become the guardian angels of the sewer, endowed with the names of Renaissance painters: Michelangelo, Donatello, Leonardo, and Rafael (Americanized to Mikey, Donny, Leo, and Raf). Despite their foreign appearance, they are all-American heroes. They play language games punctuated with urban teenage diction: "Hey, Dude!" "Awesome!" "Totally weird!" They like to hang out, skateboard, watch television, and patronize Domino's Pizza. Best of all, they defend white women and protect inner-city youth against the corruptive influences of an invading Japanese superpower.

The Ninjas do not operate on their own, however. They were, in fact, named and trained (fathered, if you will) by Splinter, a rat who immigrated to New York City from Japan with the Ninja master or *sensei* Hamato Yoshi. When the *sensei* is killed by his evil nemesis in America, the rat is forced to inhabit the sewers of the city. "When we were forced to come to New York," says Splinter, "I found myself without a home, wandering the sewers." Though Japan is not in the Third World, technically speaking, Splinter's undocumented immigration (signified by his lowly incarnation and underground tenancy) makes him an illegal alien or, to use Border Patrol lingo, an OTM (Other Than Mexican).[27] His alienness is further reinforced by his own mutation: though he speaks and thinks like a Ninja master, he is still half-rat, half-human.[28]

Apart from their underground citizenship and their unprecedented infiltration into popular culture, other important features of the Ninjas are

Conclusion

206

their pronounced, alien-green otherness, their invisibility to the public world ("the art of Ninja," Splinter tells his pupils, is "the art of invisibility," and their "domain is the shadow"), their blend of ethnic accents (Valley Boy, Jewish Bronx, Asian-Latino), and their homelessness.[29] True, the Turtles' home is the sewer, and simulated reality has endowed their abode with all the comforts of modern living (color TV, computer, stereo, pizza, and greenbacks); but the Turtles live in the sewer because, like the homeless, the poor, and the undocumented, they are not even second-class citizens, but subalterns who need to mind their place.[30]

What happens when immigrants from the Third World, escaping their native countries because of political, economic, and/or environmental terrorism (all connected in some way to the First World), emerge from the sewers (in fact, for some the sewer is the place wherein to enact that rite of passage)[31] and into the lanes and boulevards of inner city U.S.A., with street names like Assimilation, Melting Pot, and English-Only? Quite clearly, they experience culture shock, torn between the protective shells of their particular identities and languages and the overwhelming process of "Americanization."

The acculturation process, however, did not begin when the immigrants surfaced from their respective manholes into the First World; rather, it began back in their homelands through the colonizing tactics of the mass media and popular culture. Thus, U.S. films, magazines, music, television, advertising, and popular iconography constituted the technological goop upon which their conceptions of "America" were fed, the effective medium through which their internalized images of themselves were formed. As Raf says upon leaving the movie Critters, a film about cultural "Others" like himself, "where do they get this stuff?" They, of course, is a self-referential allusion to the producers of popular culture, who almost magically transform immigrants into evil aliens or cute critters or powerful warriors. During the 1980s, what became increasingly and (for some sectors of the dominant culture) alarmingly apparent, however, was that immigrants were not the only ones changing. American life, culture, arts, education, politics, even the language—everything was mutating: Cowabunga!

In this moment of mutual mutation, multiculturalism both flourished and floundered. It flourished, primarily, in the urban schools, as educators and administrators saw increasing need to address the multiple and multiplying ethnic "Others" sitting in their classrooms.[32] But, whereas multiculturalism succeeded in opening some deeply ensconced borders in the curricula of primary and secondary education, it floundered on the

Conclusion

207

college level under the insidious designation "Politically Correct" teaching. The backlash against this so-called Political Correctness (or P.C.) is felt across the board on college campuses, from administrative decisions about hiring and/or retaining teachers with too much of a "political" bent to fraternity parties involving mock lynchings, gang rape, and the memorizing of misogynistic, racist lyrics like those in "Lupe's Song," transcribed below. The backlash is especially flagrant in the prolific number of books and articles published in the nineties that decry P.C.'s "invasion" of constitutional rights, freedom of expression primary among them. According to this logic, the dissemination of a fraternity ode like "Lupe's Song" should not be construed as a reactionary response to the antiracist and antisexist concerns promoted by multiculturalism, but simply as a lyric in the fraternity repertoire. To attack "Lupe's Song" is to impinge upon the fraternity members' civil rights and to slight their "Greek" culture.

Lupe

Twas down in Cunt Valley, where Red Rivers flow
Where cocksuckers flourish and maidenheads grow,
Twas here I met Lupe, the girl I adore
My hot fucking, cocksucking Mexican whore.[33]

On the art front, the backlash is best illustrated by the abolition of the National Endowment for the Arts. Appalled by the new art being displayed under the banners of multiculturalism—images of erect phalluses, of HIV-positive men cutting each other up onstage, of crucifixes soaking in urine, of women with pierced nipples and clitorises making love to each other, of children with exposed genitals, of blacks and Hispanics and Asians all clamoring against racism and discrimination—the guardians of the Republican "new world order" launched a so-called morality crusade against multiculturalism, targeting the work of gay and lesbian artists but implicating all alter-Native "outsiders" in the art world.

A revivified nativism has emerged, this time not directed against swarthy immigrants and the threat they pose to so-called American values. No, this time the threat is native-born; the foreign "other" . . . has been replaced by homosexuals from San Francisco and lower Manhattan; by photographers and writers from Philadelphia and

Chicago; by women everywhere; by bicoastal broadcasters and moviemakers; by Hispanic artists from the Lower East Side and Houston, and of course, by blacks, the country's perennial outsiders.[34] (emphasis added)

Although the conservatives—in the name of Christian morality and family values—won the fight against artistic freedom and freedom of expression, what these debates between "obscenity" and "censorship" ultimately foregrounded was the extent to which those in power construct the meaning and politics of art, merit, value, quality, and excellence. The age-old question "What is art?" was brought into clear relief as conservatives legislated against the constitutional rights of individual artists, judging and condemning those visions that did not comply with the official view of art. This, more than any multicultural agenda, made it obvious that, as Janet Wolff says, "'what is art?' is centrally a question about what is taken to be art by society, or by certain of its key members."[35] Art, in other words, is what those in power want it to be. What was deemed "not art" by the right-wing politicians guarding the master's house was not worthy of being funded by public, taxpayer monies. Though supposedly "taxpayer" represents the entire citizenry of the country, in fact, it was a select group of taxpayers represented by Jesse Helms and Ted Stevens, among others, that got to decide "what is art?" and who deserves to be funded. "For the NEA has the power not only to support creative efforts, but also, by doing so selectively, to indicate the parameters within which 'serious' art can fall and the issues it can address."[36] Given this example, it would be difficult to argue that art is not a product of politics, history, and ideology.[37]

Clearly, multiculturalism can work both for and against those it is meant to protect. For Stuart Hall this can only be contextualized within the contradictions of global postmodernism:

[If] the global postmodern represents an ambiguous opening to difference and to the margins and makes a certain kind of decentering of the Western narrative a likely possibility, it is matched, from the very heartland of cultural politics, by the backlash: the aggressive resistance to difference; the attempt to restore the canon of Western civilization; the assault, direct and indirect, on multiculturalism; the return to grand narratives of history, language, and literature (the three great supporting pillars of national identity and national culture).[38]

I would add "art" as the fourth great pillar sustaining the master's house. Indeed, the art world has proven to be the most unyielding of those pillars. Unlike history, literature, and language, which are all democratic in the sense that they are "available to the broad masses of the people," [39] the art world is the last bastion of the cultural elite, guarded jealously by legions of art critics, artists, museum professionals, agents, and collectors, all doing everything in their power to preserve traditional standards of "Quality" and the value of the artwork on the market (synonymous in many cases). In the 1980s, says Timothy Luke, "the art markets emerged as highly organized exchanges whose volume, prices, and overall direction were monitored with the precision of global markets for pork bellies, gold bullion, or winter wheat." [40]

Despite Ivan Karp and Steven Lavine's belief that museums are abandoning their old stance as "temples" of a monolithic culture and adopting a newer stance as "forums" for different cultures, [41] asking the aristocrats in control of the art world to move over and make room for multiculturalism is still, for some, a heretical proposition. For others, it is downright ridiculous, a good joke on behalf of mediocre "wannabes" who wouldn't know real art if it poked them in the face. "[The] audience of traditional museum consumers," says Elaine Heumann Gurian, "does not wish to have others join their company, as that would disrupt their notion of their own superiority and their right to an exclusive domain." [42] Outsiders are welcome in the mainstream art world as long as they don't take up too much space and remain within the safety zones of representation. As a viewer at the Albuquerque venue noticed, "since most of the works [in CARA] are labeled Collection of Artist may I safely assume the big museums aren't collecting them yet?" [43]

Hazel Carby's critique of multiculturalism as a strategy by which to substitute political activism against racism and desegregation for a safely textualized and commodified product (e.g., literature by and about people of color) can be applied, I think, quite easily to the housing community of the mainstream museum. Carby believes multiculturalism to be a "discourse about race" studied and constructed by ethnic studies programs across the country and particularly profitable to the publishing industry. She blames the paradigm of "difference" for objectifying cultural "Others" and for failing to question the power dynamics between the dominant culture, represented by the segregated neighborhoods of academia and white suburbia, and people of color, who occupy the inner cities: ". . . at what point do theories of 'difference,' as they in-

form academic practices, become totally compatible with, rather than a threat to, the rigid frameworks of segregation and ghettoization at work throughout our society?"[44]

Carby's question points candidly to the practice of substituting representation for presence, encouraging exclusionary policies that only serve to entrench dominant ideologies about the place of insiders and outsiders in the social structure. Hence, exhibitions of Chicano/a and Latino/a, African-American, Native-American, and Asian-American art figure into the exhibition agendas of traditionally "white" museums like the Met, the Whitney, the "Modern," and the Hirshhorn, but the predominant color of the staff or the administration or the board of trustees does not change.

In his critique of the Hispanic Art in the United States exhibit, Timothy Luke shows the symbolic workings of multiculturalism, which he sees as a mainstream strategy for controlling and diffusing the demands of the civil rights years:

When the many different movements for civil rights, ethnic pride, women's liberation, and anti-war resistance confronted the American state in the 1960s and 1970s with new claims about popular needs, the state's leadership quickly put the tools of symbolic politics into action . . . to give the appearance that something significant was being done in reaction to mass demands without doing anything significant. One aspect of this revolution in governance through symbolic means was "discovering" and "appreciating" the art of such aggrieved "outsider" groups to develop their sense of pride as well as a larger recognition of their cultural attainments on the margins of mainstream society. . . . In the main, it "worked" as a strategy of both containment and deterrence.[45] (emphasis added)

To return to the question posed in Chapter 3 about the two contradictory ideologies running like the woof and the warp of the CARA exhibition, we can conclude that the distinction between the symbolic and the historical is the fundamental difference between multicultural and Movimiento politics. While the historical motive aimed at documenting the presence of Chicanos and Chicanas within the whitewashed bungalow of "American" culture and "American" history, the symbolic approach was motivated by the "discovery" discourse of multiculturalism that only reinforced the "otherness" of Chicanos/as within mainstream culture. The Chicano Civil Rights Movement from whence the politics of the Chica-

Conclusion

no/a organizers of CARA derive was an authentic action from the margins of mainstream culture; on the other hand, multiculturalism, like the Ninja Turtles, has mutated into a lucrative enterprise, incorporating exhibitions like CARA into what Marcos Sanchez-Tranquilino calls "a multicultural programming circus act."[46] Rather than engaging questions of exclusion and ethnocentrism, rather than recognizing and resolving power differentials, rather than simply diversifying museum collections and exhibition programs, multiculturalism becomes a way of patronizing the arts of ethnic outsiders, an ethnographic method by which to collect, represent, and incorporate "Others."

In "Political Correctness and Its Discontents," art critic Steven Vincent describes multiculturalism's effect on the mainstream art world:

> What is "multiculturalism" in the arts? Simply put, it is the attempt (some would say long overdue) to broaden—or in some cases, supplant—the art world's traditional bias toward white, male, European artists in museums and galleries, with an increased emphasis on women, gays and lesbians and Third World artists, as well as American "artists of color." *The perception powering this movement is simple: America is becoming an increasingly politicized, ethnically diverse society,* and art and art institutions must reflect these changes—even if it means, in some cases, sacrificing notions of quality and the ideal of a "color-blind" society.[47] (emphasis added)

It is perhaps necessary to clarify that the definition of color-blind is not that you cannot see colors, but rather that you confuse colors of the same general tone. For mainstream U.S. society, color-blindness is an "ideal" because it suggests the blurring of all racial, ethnic, cultural, and linguistic differences; it is, in other words, a comfortable and convenient impairment, as well as a mainstream strategy for the continued invisibilization of "Others." How uncomfortable and unpleasant it must be when "Others" refuse to remain invisible and force the proprietors of the art world not only to look at them but to open the door. The question is, does multiculturalism really open doors for artists of color or does it simply serve a curatorial agenda, a funding requirement, an affirmative action quota? Or, as Malaquías Montoya and Lezlie Salkowitz-Montoya saw it in 1980, is this open-door policy in the arts yet another form of hegemonic incorporation, a way of redefining Chicano/a identities rather than, as the title to the final section of the CARA exhibit implies, redefining American art?

Conclusion

El Lavadero, or Everything Comes Out in the Wash

Before closing, I would like to revisit the *solar* of Chicano/a popular culture both to make a final point about the metaphor of the house and to examine the last room in the CARA exhibition in an effort to answer the questions posed above. Although it can be argued that the image of the house, whatever its architecture, is a signifier of a unity that both essentializes and fails to represent the diversity that exists among Chicanos/as, I want to argue for the common space, the space shared by all Chicanos/as, no matter what we call ourselves and where our roots are planted. That common space can be summarized as history, and even more specifically as colonialism, dispossession, and *mestizaje*. This is what Hispanics, Chicanos/as, Mexicans, and Mexican Americans have in common, the core of *sameness* that anchors all of our differences. That common space— represented by the patio in the *solar*—is our identity because it is the one place in which all of us are the same. Our differences, both collective and individual (in terms of race, gender, sexuality, class, language, region, religion, etc.), branch out from this common space, separate off into rooms and corridors that are nonetheless attached to a collective history of Mexicans in the United States, of alter-Natives in the landbase known as the Southwest. And it is that history, finally, that moves like the air and light of the patio into the different spaces of the *solar*. Thus, the *solar* is no more unified than the self that inhabits the body, and yet, like the body, it is bounded by geography, by history, and by the social, cultural, and ideological locations of its inhabitants.

As we wend our way toward the "exit" sign, I would like to pause in the last room of the *solar*, at the stone sink and washboard, otherwise known as the *lavadero*, and quickly scrub at the fabric of the assumptions underlying "Redefining American Art," for it is in this final room of the exhibition that we are shown the new face, the future, of Chicano/a art. What we see first is that, as is characteristic of the entire exhibition, the section is a "mixed bag" of artists and iconography: we see some *veteranos*, some "new kids on the block," some feminists, some realists, some abstractionists, some conceptualists, some Movimiento icons, some icons of mainstream culture. With the exception of John Valadez and Diane Gamboa, all of the artists exhibited in this room have had other work in the exhibition, be that an individual piece (or pieces) or a collective installation. Three of the artists in the section were original members of Los Four, the first Chicano artists to be exhibited by a major mainstream institution in the seventies (LACMA).[48] Two were members of the irreverent ASCO.[49]

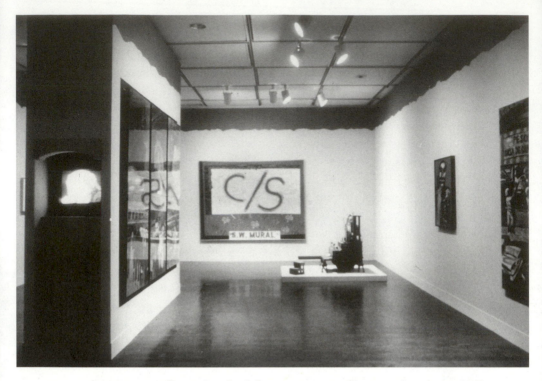

Figure 56. Installation shot. "Redefining American Art" room with *Artists' Round Table* video. CARA: Chicano Art: Resistance and Affirmation, exhibition held at UCLA's Wight Art Gallery, September 9–December 9, 1990. Photograph provided courtesy of the Wight Art Gallery.

One was a member of Mujeres Muralistas.[50] At least two have had major retrospectives of their own work.[51] Indeed, all of these artists now command a national and international audience.

One of the more strident criticisms of CARA from within the framework of Chicanismo echoed Malaquías Montoya's critique of the transformation he saw happening in the work of Chicano/a artists during the Reagan/Bush decade, changing from "a people's art" and "an art of protest and liberation" to an "art of validation" that was seeking to be legitimized by the very institutions and criteria which the artists of el Movimiento had set out to oppose.[52]

In another framework, the same criticism was made, directed specifically at the last section of the exhibition. From her perspective as a mainstream art critic reviewing CARA for an alternative art journal, Betty Brown wondered if "Redefining American Art" was "a concession to tra-

Conclusion

214

ditional curatorial/art historical standards? If so, it appears to contradict the premise of the rest of the show."[53] Sanchez-Tranquilino, whose duties as a project coordinator (along with Holly Barnet-Sanchez) also included serving on the Selection Committee, clarified for Brown and the readers of the New Art Examiner that "the last section asserts a redefinition of American art from a Chicano perspective . . . American art begins to be redefined at the moment Chicano art or any other art representing a resistance to the American art canon emerges" (emphasis in the original).[54]

In the narrative description of the NEH proposals, however, wherein "Redefining American Art" receives an attention not devoted to any of the other rooms in the show, the opposite message comes across. In fact, those documents suggest that it was the express purpose of the organizers to explain and reiterate for the sake of a mainstream funding agency not conversant in Chicanismo that, for all of its oppositionality and history of marginalization, Chicano/a art was fundamentally an "American" art, indigenous to the United States. The organizers were not, I think, trying to draw comparisons between Chicano/a art and the art of Native Americans. Rather, they wanted the review panel to understand the same point that Cheech Marín's character in Born in East L.A. kept trying to prove to another set of gatekeepers: "I'm an American citizen, you idiots!"

As U.S. citizens, then, the artists, academics, art historians, administrators, and activists involved in the making of CARA were American; therefore, according to the logic of the proposals, the exhibit itself needed to be seen as an exhibition of American art rather than as an ethnographic representation of cultural "Others." In underlining that point, the organizers of the show were seeking funding, to be sure, but they were also making several assertions: that Chicano/a art was the autochthonous expression of an alter-Native American culture; that Chicano/a art had earned the wherewithal and the credentials to define itself on its own terms; that Chicano/a art, because of the impact that artists such as those showcased in the last section were having on the national and international art scene, was beginning to redefine the meaning of American art.

Not only does [the work of Carmen Lomas Garza, Frank Romero, Rupert García, and Gronk] begin to be accepted within the structure of mainstream American art, but also it challenges both the notion of a unified and continuing movement, and the assumption that art by Chicanos (or any other self-defined cultural group) can or should remain separate and distinct from the larger context of (or other forms of) American art.[55]

Conclusion

215

Figure 57. Patssi Valdéz, *Downtown Los Angeles*, 1983, hand-colored photocollage, 3 panels. Collection of Christin and Günter Joetze (Vienna, Austria). Reproduced by permission of the artist.

This is a direct contradiction to what Sanchez-Tranquilino says in his response to Betty Brown, in which he states unequivocally that "contrary to [her] suspicions, [the CARA organizers] were not trying to validate [the art or the artists of the final section] by associating them within the 'broader field' [as Brown calls it in her review] of American art." [56] Were they or weren't they? Let us see what comes out in the wash.

The organizers ended the show with the work of artists who had "made it" in the art world, artists who can count major retrospectives of their work in mainstream institutions as part of their repertoire, artists whose work can now be found in public and private collections. Half of the pieces in this final section are no longer owned by the artists; one of these, Patssi Valdéz's postmodern triptych on urban life, *Downtown Los Angeles*, is in a European collection.

Conclusion

216

Representing not so much el Movimiento as the artists themselves, their individual trajectories through the art world, the work in the last section seems to promote two "American" ideas—the notions of individualism and progress. One way of reading the fourteen pieces in "Redefining American Art" is that Chicano/a art emerged out of the turbulent period of el Movimiento with a personal vision, communicated not so much now through the public art forms of poster, mural, and performance, but through more traditional, more private artistic media such as oil, pastel, acrylic, gouache, and photocollage.

Nonetheless, Chicano/a art has not ceased to be politically or culturally motivated, as even the more traditional pieces like Lomas Garza's family vignettes, Frank Romero's *The Death of Rubén Salazar*, and Mel Casas's rendering of the Cholo sign *con/safos* (pictured in the installation shot in Figure 56) are very clearly rooted in Chicanismo and/or the rituals of la Raza. The section also includes two screenprints and two mixed-media pieces reminiscent of the "old school," that is, *rasquache* lowrider and *calavera* art, as well as political commentary about U.S. intervention on the border and in Latin America. And, for the feminists in the art world, a poetic piece about the absence of subjectivity and the tenuous fabric of a socially constructed gender rendered as a paper-towel prom dress hangs in a quiet corner.

The point of the final section seems to be not that Chicano/a artists have forsaken their political work for a personal vision, but that the personal has both political and aesthetic dimensions, that the individual behind the vision is both a Chicano or Chicana and an artist of national and international stature. Thus, "Redefining American Art" offered viewers the individual and personal expressions of important American artists whose work had to be contextualized within a retrospective of the Chicano Art Movement; moreover, the section emphasized the "diversity of artistic expression that emerge[d] in the early 1980s."[57] Individualism and diversity, two mainstream concerns in the multiculturalized contemporary art world, were the guiding lights of this final section, and this, the implicit message seems to say, is the future of Chicano/a art.

CARA's intervention in the mainstream art museum, the house of "high" culture, can be interpreted in at least two contradictory ways: that the old categories are indeed breaking down and the postmodern values of different subjectivities and multiple realities are revolutionizing the cultural arena or that the apparatuses of the postmodern are being employed by hegemony to accommodate and diffuse those differences before any real ruptures in the social order can occur. The question, finally,

Conclusion

217

for the purposes of this study, anyway, is not have Chicano/a artists gone mainstream, sold out, or lost their ethos of resistance, but, rather, how will the inclusion of Chicano/a art in mainstream exhibitions, collections, and institutions affect the cultural politics of la Raza? How will the artists in CARA, as cultural brokers for la plebe, contribute to changing the status of Chicanos/as as second-class citizens in the master's house? To what extent can we say that the CARA exhibition will help in redefining not just the mainstream art world, but the quality of life for Chicanos and Chicanas across the country? As more Chicano/a artists become recognized figures in the art world, will their work, their message, their commitments change according to the demands of the market rather than the needs of the community? Tomás Ybarra-Frausto does not think so.

> They change not because a museum starts buying their work, but because they're onto another phase of their inquietud and their expression, and as long as they do that, I don't think there's any possibility of containment. Containment only happens when you stop creating and keep producing. I think most of our artists are still creating rather than just producing. They're work is not commodified, they still have too many stories to tell.[58]

In "Death on the Border: A Eulogy to Border Art," Guillermo Gómez-Peña tells the story of the appropriation of the Border Art Movement by European and Euro-American filmmakers, journalists, and artists who leapt on the bandwagon of the new Latino Boom: a twentieth-century version of the "discovery" of Latin America. The Border Arts Workshop/ Taller de Arte Fronterizo, initiated in 1984 as "a binational collective that combined critical writing, site-specific performance, media and public art with direct political action . . . on both sides of the border,"[59] iconographed la frontera as both a geographical and a conceptual site of cross-cultural exchange. The original members of BAW/TAF sought "dialog," a utopic collaboration mediated through art "between artists, activists and intellectuals from Mexico and the U.S."[60] The notion of "dialogue" was oppositional to the separatist mainstream discourses of nationality and citizenship and was thus a form of resistance to these dominant ideologies.

By 1989, Gómez-Peña laments, the BAW/TAF had become an institutionally funded and manipulated private club of mediocre and opportunistic artists who, "instead of turning the margins into the center, [brought] the center to the margins,"[61] by commodifying the border.

Conclusion

218

Gómez-Peña's description of the changes wrought on the Border Art Movement can be seen as a microcosmic repetition, a late-twentieth-century version, of one of the oldest rituals in the life of the American continent; what began as an "open-house" policy ended as invasion, colonization, and conquest.

Although we can question Gómez-Peña's own contribution to that invasion of la frontera by privileged non-fronterizos who exploited the border as their own conceptual laboratory, his account of a vision appropriated by "outsiders" and transformed into precisely the opposite of its original intentions serves as a metaexample of the fate of multiculturalism. Like the BAW/TAF, CARA brought mainstream attention to the margins of U.S. culture; its goal was to represent and articulate Chicano/a identity from the inside out and also to antagonize, to be in the face of its "discoverers" at the same time that it was a guest in the master's house. CARA may have benefited opportunistically from the multicultural agenda, but it turned out to be much more than a sampling of diversity, for the exhibition also brought the margins to the center, drawing la Raza into the art museum in unprecedented numbers.

"Chicano exhibit draws 4,000 on first day," reads a headline in the El Paso Herald Post.[62] Evidently not expecting a large turnout for the CARA opening, the El Paso Museum of Art offered one punchbowl of lemonade and a tray of cookies as refreshments for the audience. The El Paso Times relates that, "for the first time in the museum's 32-year history, guards asked people to wait for the crowds in the galleries to thin out."[63] Some visitors waited up to fifty minutes in the August heat, distracted from their thirst by the Ballet Folklórico and the mariachis that had been commissioned to entertain the audience and by the lowriders parked alongside the museum, on display as local examples of Chicano art "on wheels."

Noting that El Paso is 70 percent "Hispanic," an editorial in the El Paso Times published during CARA's visit states that "at last, the El Paso Museum of Art is fulfilling its promise, which is to depict the lives, struggles, and times of the people it serves" (emphasis added).[64] Even here, though, the brochure handed out for the exhibit did not display the CARA logo. The full name of the show appeared in tiny letters at the bottom of the front page; at the top of the page, over a detail from Frank Romero's Death of Rubén Salazar, the brochure reads **"Interpretations of Hispanic Reality."** Upon unfolding the five-page brochure, the viewer discovers full-color reproductions of five different paintings in the show and again the misnomer "Interpretations of Hispanic Reality."

Conclusion

219

Hearkening back to the Hispanic Art show curated by Beardsley and Livingston, which underscored the "Hispanic" label and the traditional medium of painting, the brochure completely decontextualized CARA from its political and resistant ethos. The logo that appears on the back of the brochure and on the T-shirts at this venue bears no sign of the acronym CARA, no eyes peering out at the viewer in defiant reflection of the colonizing gaze. Altered completely, the new logo shows a curled snake with a paintbrush for a tail. As that graphic suggests, and despite the lowrider parade that served as preamble to the opening, at the El Paso Museum of Art, Chicanos/as—the very subjects of the show—can be erased, brushed over, and refigured as "Hispanics."

In the same vein, a report submitted in 1994 by the Smithsonian Institution Task Force on Latino Issues finds the Smithsonian—described therein as "the largest museum complex in the world" and "premier cultural institution in the United States"—guilty of "willful neglect towards the estimated 25 million Latinos in the United States" in all aspects: governance, personnel, collections, exhibitions, research, and programs.[65] Whether on the eastern seaboard or in the heart of Aztlán, whether it's a municipal museum erasing its major constituency or a federal museum neglecting 25 million Americans, we have to understand that, like all social movements from the margins, multiculturalism was destined to fail. The fact that it did fail, however, and that it generated the vicious backlash that it did signals its potential to challenge hegemonic assumptions, practices, policies, interpretations, and categories of analysis.

Multiculturalism may not have altered power dynamics in the mainstream art world, and it ultimately may have mutated into an ethnographic method or a primary instrument of incorporation by the producers of cultural and social hegemony. What it did achieve, however, was twofold. First, multiculturalism facilitated the entry of outsiders into the hallowed halls of the mainstream museum. Their presence—as both makers and viewers—destabilized the art world, at first expanding and then closing the borders of access. Before that closing came, before some artists found themselves caught like wetbacks in the backward flow of the mainstream, before the language of the left was appropriated by the slogans of the right, exhibitions like CARA permeated the master's house, leaving behind flagrant evidence of their alter-Native existence in catalogs, reviews, newspaper articles, comment books, and the history books of their sponsoring museums.[66]

Herein was its second achievement. More than access to the mainstream, multiculturalism created a new way for alter-Native cultures to

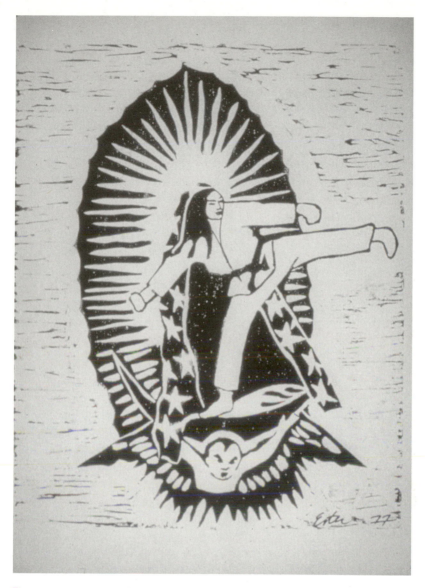

Figure 58. Ester Hernández, *La Virgen de Guadalupe Defendiendo los Derechos de los Xicanos*, 1975, etching and aquatint. Reproduced by permission of the artist.

see and be seen. As John Berger notes, in the act of seeing "the eye of the *other* combines with our own eye to make it fully credible that we are part of the visible world" (emphasis added).[67] We see each other, therefore we both know the other exists. Through its logo and the recurrent eye imagery that stands out as the most prevalent leitmotif of the show, CARA

reversed the ethnographic gaze. Through the paradigm drama of multiculturalism CARA brought Chicanos and Chicanas out of the Ninja Turtle realm of invisibility. As the viewer at the Albuquerque Museum of Art wrote in the comment book: "Finally, we (Chicanos) can see our culture, not only on the outside, but on display [inside] where others can learn and appreciate who we are today and why." The response CARA received from all sides—from the critics who could not stop writing about it to the Chicano/a and Latino/a audiences who came by the thousands at each of the venues—proved that, more than being a transgression into the boundaries of the art world, CARA was decisively a kick in the face of the mainstream cultural canon.

Appendix A

Selected Viewer Comments

For the most part all the comments have been transcribed exactly as they were written; a few punctuation, spelling, and tense errors were corrected.

Excerpts from the Albuquerque Museum of Art Comment Books (provided courtesy of James Moore)

The most comprehensive Chicano Art Exhibit I have ever experienced! ¡Felicidades! ¿Que pasó con los paños? [What happened to the handkerchief art?] E. S. B., Las Cruces, Nuevo Mexico.

Very disturbing! Ugly and beautiful at the same time!

Very valuable—Should travel to more places in U.S. D. D.

Not a complete representation of what the true hispanic heritage brought to us at this period. Too much concentration on pachuco ideas, values, and accepted classification of a people by so called white people. More emphasis should have been given to the love, innocence, and true hardships

of a people trying to survive without being given everything on a silver platter because they are "Chicano" and have hardships instead of trying to work by educating oneself. D. K. M.

I felt that this was an excellent exhibition. It has emotions that run from sadness to laughter. A collection of artists that challenges the "Anglo art establishment" in terms of breadth, depth, and talent. This makes me very proud to be a Chicano. Unfortunately this museum does not normally showcase some of the great Chicano artists that live in this community. A. C. B.

Beautiful and passionate. An exhibit which opened my eyes further to the richness and depth of Chicano culture. It makes me wish I were Chicano in many ways just so I could appreciate the art and experience fully. I want more! S.

Having been involved in the Chicano Movement, I know now that all was worth it. Although we still have a long way to go. F. L.

Gracias, por los recuerdos de mis labores cuando joven. Trabajando a estilo animal sirvió no tanto al amo, sino para serme más fuerte y orgullosa de mis raíces. ¡Sigamos adelante! [Thank you for the memories of all the labors of my youth. Working like an animal served not so much the master but to make me stronger and prouder of my roots. Let us continue forward!] D. A.

Trae muchos recuerdos y alienta el corazón . . . qué bueno—se necesita más de esto. [This brings many memories and feeds the heart. This is good, we need more of this.] X. T.

Please separate the mural slide and video presentations. Otherwise very informative and thoughtful exhibit.

¡Incredible! I can think of a lot of stuff I should have saved! I have something I'd like to donate. Please contact me.—C. I.

¡Qué Bueno! Dynamic, visually exciting, explorative. Congrats to opening up and validating a hidden and neglected world.

A very powerful exhibit. Hope it will be the vanguard of more Chicano exhibitions. Thank you. J. and A.

La realidad no es siempre bella—sino también triste. Así es la vida del Chicano/Chicana. ¡Adelante! ¡Muchas gracias! ¡Bien Hecho! [Reality is not always pretty, but also sad. That's life for the Chicano/Chicana. Forward! Thank you! Well done!] R.

¡Muy Good!

CARA Tribute
Brown hands create / White faces wait / Souls and ayes / Someone cries / Artists paint / U.S.A. ain't mine. H. P.

Why do they make everything so morbid or/and sad?

I enjoy the sophistication of some pieces and the innocence of others. Every piece has a serious individual study of each artist's opinions.

Not an exhibit or display, this is an experience! Extremely well done and well organized. B. C.

I'm finally glad to see hispanics' cultural art work, instead of non-hispanics trying to copy them . . . it's about time . . . T. M.

Very impressive: I am a Chicano: I felt my emotions rise and fall when I encountered the different works of art. The exhibit touched my heart. I saw myself, my parents, and grandparents in the art. Art truly is the expression of a people's soul. Thanks. R. P.

BRAVO! What a great show—so much life, color, depth and inspiration to me. We need this recognition. Thank-you to the museum and the artists for this wonderful exhibition. Que Viva. L. F. M.

¡Al fín! No estoy loca, nomás Chicana—bueno pues, poca loca. Finally an exhibit that we define by ourselves, for ourselves, and for others to see who we are. A very positive thing has been done here. Mil Gracias y porqué nadie más de Nuevo Méjico? [Finally! I'm not crazy, just Chicana—well, a little crazy. A thousand thanks, and why no one else from New Mexico?] S. S.

I feel that by the fact that it is a <u>Chicano</u> exhibit only and there are no inter-mixtures of other equally talented artists I felt this exhibit was a bit of justified prejudice. Other than that I <u>loved</u> the exhibit, would happily come again, and I was even moved by a few of the excerpts. S. C. L.

Waste of Space. F. C. S.

<u>VIVA LA BORDER PATROL</u>
Where fences divide misunderstandings flourish. I feel that the Chicano people will never be equal to the white people. We didn't force them to come here and yet they complain. They could have stayed in Mexico. There will always be a fence dividing America and Mexico that won't change. They have a bad reputation. They made it that way. J. L.

Response to above comment:
Intolerance! Where is this immigrant from? No, Spanish people forced their way into a land already occupied by others—Native Americans! Where fences divide misunderstandings flourish. One earth, one humanity. C. H. L.

Response to previous comments:
After reading some of the racist comments on the previous pages, I will vow to fight racism and verbalize it in my comedy act. G. G., stand-up comic.

I liked the show, but if I were the curator I would try to acquire pieces from Chicana artists that show the beauty of the culture and people. H. L.

Very moving, thought-provoking and beautiful. Video on murals could have lower volume so one does not have to hear it thru whole exhibit. Also video with slide projections could be separated more—I found it overwhelming.

Powerful exhibit. Beautiful and tough. Send it to Eastern cities!

I loved this exhibit. The people creating this art are so colorful! It's beautiful!! M. G. G.

Thank you for bringing our lives back—We remember all the sacrifice and pain we have endured to reach peace, justice and spiritual healing

through our art—I feel my art, I feel my family's art and most of all I feel the art of other Chicanos/Chicanas. G. B. G., Albuquerque, N.M.

I found the exhibit to be profoundly moving and informative. It reacquainted me with a part of my history I had somehow "misplaced." I will be back, so there is much to reacquaint myself with! D. M.

I'm glad 2 see that this form of art is appreciated instead of looked down at. Nice set up. Keep up the art, 4 it will <u>never</u> die! O. M. C.

Viva la Raza! Inspiring to see so many mediums in art form. Todo muy bello! M. L.

About time!! How about that!! T. C. K.

Fantastic! Great! Very informative. Do <u>More.</u>

We really enjoyed the exhibit "Chicano Art." The photographs were unique especially. Although, more Chicano publications would have helped the exhibit. Overall it was amusing, and interesting especially the religious art. Thank you and we look forward on seeing more "Chicano Art." C. M.

I can recall my early days in New Mexico—the term "Chicano" was unacceptable. Some progress has been made at long last. P. R.

Very interesting. Different. Very Colorful. Beautifully Displayed. "Congratulations." D. J. K., Connecticut

This exhibit provides opportunity to experience cultural diversity through various art forms. It also provides the viewer with information on social and cultural issues that have been present in the past, present and into the future. C. T., New Mexico

We liked it. Interesting/enlightening to non-Chicanos. D. G. and T. F., New Mexico

¡Fabuloso! Want all budding artists to see this one—love the strong, unabashedly clear imagery.

Wonderful, very fresh art. Enjoyed it immensely. The Pottery Group, Santa Fe.

Wonderful. A real education for a white girl. M. E.

For those of us who lived the Chicano movement I thank the exhibitors. Powerful and moving. J. E.

The Best Chicano exhibit I've ever seen. It's about time something like this came out. Keep up the good work. Viva La Raza. R. S.

It was stirring to see pride in our race exhibited with such moving art. O. V.

As an anglo this exhibition has helped me to understand what it is that I feel uncomfortable about. I have always recognized that the emotional hispanic culture (emotion vs. reason) is uncomfortable for me but now I know it is because their culture brings out what I fear or hate in myself from my own culture! Maybe this is what divides us all—we are at different levels, if only we could all be at the same level at the same time. But then, would we learn anything new about ourselves and each other. Perhaps this is our strength rather than our weakness. C. S.

This is one of the best exhibits. It made me think. I've been here every weekend since you opened it.

I love this exhibit—it brings many memories and foretells a future of our people. E. O. S.

Miguel Gandert's photo is clearly non chicano. In Albuquerque the Juanito gang is a rival of Chicano's and is composed of Mexican youths from Juárez. You put too much Mexican non chicano images in the show. I really enjoyed it. X. L., Albuquerque, N.M.

Radical. P. G.

"Totaly Choloish Man?" [sic]

I enjoyed the show, maybe next time there will be more artists from all parts of New Mexico. Forget about the small politics. D. F.

Everyone in this country needs to be proud of who they are. But remember one thing we all are Americans!!

Why, if we are all Americans, cannot we also be Hispanic, Afr., Asian, Native, as well? Are we so limited by that label that we must deny our uniqueness?

Excerpts from the National Museum of American Art Comment Books (provided courtesy of Andrew Connors)

Como Hispano, mi corazón y mi amor va hacia ustedes. [As a Hispanic, my heart and love go out to you.] ¡Viva Méjico! ¡Viva Puerto Rico! ¡Viva la Raza! E. O. L., Ponce, Puerto Rico.

This exhibition has definitely been an eye-opening and conscious-raising experience. No other art work has captured my heart and soul like Chicano art. My prayers, gratefulness and respect go to those who have used their time and talent for "La Causa" so that the younger generation further acknowledges our culture's values. Thank you all for making me more proud of my culture.—El Pueblo Unido Jamás Será Vencido [A united community will never be defeated]—Adiós, Y. H., raised in L.A., C.A.

The exhibit was excellent. I enjoyed the political statements. More exhibits like this one are needed throughout the country. I'd like to thank the silent heroes of the exhibit: the workers that put it together, the funders that gave money, and the committees that included and excluded art. I urge all of you in continuing your efforts. It helps us who need our minds reminded of the past, our present and our future. Siempre con cariño y respeto. [Always with love and respect.] A. B. B.

In response to Paul Richard's review of your show, art always reflects politics. This show reveals the vision of a culture. Thanks to the NMAA for supporting it. It may open the eyes of the politically unconscious. R. M.

From a Chicana from East Los Angeles: There's a lot of controversy or call it confusion about identity terms. No matter what you call yourself, we must educate the children ourselves because only EDUCATION and VOTING will get us ahead. I have, I guess you could say somewhat "assimilated," I go to a pretty prestigious college, but never will I deny my cul-

ture, my background because that's what gives me strength, courage and las ganas [the desire] to move ahead and help my raza. I hope all Chicanos and Chicanas do the same! ¡Viva La Raza! D. L.

These past few days I have spent at the Festival of American Folklife on the mall. I met a man who creates pictures on handkerchiefs—Paño art I believe it is called. He told the people that he learned to do it during 6 months of solitary confinement in prison. His patience and skill and creative ability was such an inspiration to me. I wanted to learn more about Chicano Art. (This man was from New Mexico.) Then I saw the art work on the first floor on Folk Art—and I knew that Everyone has artistic talent that could be expressed if only he or she would believe in themselves. And then I viewed your exhibit and I saw the Greatness of your heritage, the Power of your message and the beauty of your culture and art. I feel overwhelmed by it all—and I feel inspired to create my own art—in my own humble way. I wish to inspire my students who are mostly Cambodian to express their inner most feelings. Down with television images, Ninjas, Batman, etc. We must not allow our children to feed into the greediness of "American Culture." Thank you so much and God Bless all of you. M. S.

From a young Chicano from Oakland, Califas. "Born in violence and baptized in oppression." In an era of sweeping changes, an era where white hegemonic institutions are called into question, an era of white political instability and blatant injustices, it is pertinent for our "gente" to rally together once again, to persevere and surpass our long-ago gains during the '60s and implement a "new" institution, a "new" government that will listen and aid our people—our "RAZA." It's time to awaken the "SLEEPING GIANT." We are a proud and powerful people, we have the masses, we have the determination to change the existing political oppression of our people. "¡RAZA!" Hear me now—VOTE!

The two hours spent here today has left a definite positive self-awareness I had lost. Thanks so much for that re-kindling. V. T., Wichita, Kansas.

This exhibit was very enlightening and has a very powerful meaning. I give my deepest respects to those who participated in making the exhibit. I hope they are publicly recognized in a positive way. My favorite exhibit is Snow Queen. S. M. S.

Do Bongs! Patricia, Chicago

¡Viva el espíritu! La Arte! [Long live the spirit! Art!] Thanks for a great exhibit and one waited for a long time. R. G.

As a grad student in museum education, this show is a great example of everything we've talked about. Accountability, blend of mediums, audio-visual, books!!

Suggestions—feedback: Just reading through the comments really tells all. Fabulous job! Keep up the good work! S. V.

I'm torn between wanting to write in affirmation/celebration of "La Causa" and wanting to merely sign my name in solidarity—as though this were one messy verbose petition for change. I hope to be a white ally "en La Causa." K.

America must celebrate all her peoples and their heritages. This exhibit is an important inclusion. I'm a person of color, African-American, glad to see this perspective.

I am an artist married to a Chicano—this exhibit brings my understand-ing and sensitivity even closer. K. G.

My Dad is a Chicano and he's been made fun of and has been treated different. J. G.

Gracias Andrew Connors for the fine works of presentation. "Artes guada-lupanos de Aztlán" S. L.

Thank you Andrew Connors for bringing meaning to what I did not un-derstand alone. L. L. S., New Mexico

Thanks. It takes an exhibition like this one to communicate the will to survive in no other way do I think can people understand each other than through art. R. F. B., San Francisco

Art is powerful. The paintings were powerful. Will we ever be one "na-tion" under our gods? We pray to God. Amen—P. N.

¡MIL GRACIAS! [A thousand thanks!] I missed this exhibition in L.A. Came 3,000 miles to see it here. A. M. G.

After seeing these expressions of my people I feel I understand the movement and struggle a little better. Thanks. J. S.

Re: The work of Carmen Lomas Garza. The artist was born in the Rio Grande Valley in Texas, yet she is listed as a Californian. Even though she lives in San Francisco, I think her Tejana roots ought to be noted. Otherwise, a fantastic exhibit. E. A., Austin, Texas

From El Paso, Texas, to witness a friend's work. I find a disturbing, enlightening tribute to the peoples of my new home. S. K.

This art exhibit seems to me to be a perfect model of integrating the personal, political, and cultural. Very moving and inspirational. Do our children have access to this? How empowering it could be for them. K. S., Washington, D.C./Austin, Texas

It is with tears of joy that I view a culture rejoicing in what is truly beautiful—themselves. As an African-American, I not only understand, but I stand along side you!! M. C.

The Chicano/Hispano/Latino experience is you and I. For our origins include a mixture of all the "types" that are "Americans." This show, especially in conjunction with the "encounters" exhibit on New Mexico and its cycles of Resistance, Conquests and ReConquests proves that the Smithsonian has the intellectual courage to provide a mirror for self examination. ¡Bien hecho! El Manito de Santa Fe [Well done! The brother from Santa Fe], O. R.

This should make the Anglo begin to think about the rejection he has had for the Chicano and what they have accomplished in spite of it. Viva la raza.

I saw this exhibit last year in San Francisco and loved it then. Now, in its expanded form, it's even better. A great way to approach 7/4 weekend— celebrating the nation's cultures and raising the issues that are problematic.

To be born Mexicano is a blessing. For I know who I am. I object to slavery but I find myself with chains. I hate crime but my brothers are killing each other. I believe in God and La Virgen but my prayers are not answered. Why!! Does success mean to be white? NO!! Success means to be Proud. Pride in my self, in who I am, in what I believe, in where I come

from. Carnal (Brother), believe in yourself in the bronze reflection of the mirror. Our Quinto Sol (Fifth Sun) is here, rise to the occasion. L. G.

I am Asian American and I found this exhibit . . . powerful and necessary! I am excited that the very format of the exhibit was such a collaborative process of Chicano reinterpretation of self and community. I feel that this exhibit . . . is a model for other communities of color—to present ourselves by ourselves! A note of idea: one theme which occurred over and over was the Movimiento's coalition with other people of color on issues of immigration, etc. An exhibit on the Asian American movement and People of Color (called Third World People's) condition . . . and artistic groups would be very powerful! Is anyone working on it? T. D., Virginia

All in all the exhibit was good. Would have liked to see images of other parts of our culture—where was Pancho Villa, el rancho, our traditional foods, y la musica Norteña or Tejana (Tex-Mex music). But again it's a rewarding experience. Outside of the murals of San Antonio, I've never seen such a vast, impressive collection of the Chicano art. This exhibit should travel to all the Chicano cities—San Antonio, Brownsville, El Paso, Laredo, etc. It will help our community remember how far we've come and how much more we have ahead. Never be ashamed, don't apologize to anyone. R. L., San Antonio, Tejas

Power is not given so I decided to take it! You punk-ass racist I'm the person you love to hate. West Side Locotes L.A. Rioteer.

Very disappointed. There are so many great Chicano artists and art, why were these picked? Except for a few selections the art is only political emotion. It makes one think all Chicano art is raw which is not the case.

Response to the above comment:
A critic is a person who knows the price of everything and the value of nothing. And to add insult to injury you don't sign your name C/S. A. B. B.

Response to the above comment:
And you don't give credit for this quote from Oscar Wilde, an Anglo!

I disagree with the preceding hostile comments. This is a powerful show—wonderful diversity of media, styles, subjects (tone, too)—a good survey. Thanks for it.—an Anglo visitor (female, 45)

Chicano Culture is foreign to me. After seeing this show it is more so and somewhat disturbing. Will Latins add to the unity of our country? Enrich it? Support it? I hope so. Worried.

Let's just appreciate each individually—but struggle unified. E.

To quote Los Quatro [sic] from the exhibit "aren't we taking ourselves too seriously—after all, no one on Mars even knows we exist" (or something like that). Lighten up. R.

To be governed is to be enslaved. Therefore: To abolish slavery we must abolish government.—Libertarian Anarchist Alliance

This is a wonderful show/experience—thanks to the Smithsonian for supporting it. U.S. museums/galleries need to show more work like this that comes from different experiences in the U.S. and has developed different aesthetics to express the bicultural/bilingual or X of being Chicana/o in a subtly or overtly oppressive, racist culture. Beauty coming out of pain— is that too political? L. P.

Thank you D.C. for introducing the "white" culture to me. I now know who I am and I'm ready to go back home—to my real family.

¡Ya era tiempo en este museo! [It was about time in this museum!]

The whole point is that there are different groups among Latinos and this is called the Chicano—not Latino—exhibit. Let's not criticize. E.

Coming to see creative expressions of resistance has uplifted me and re-affirmed my conviction for social progress. This exhibit is potent and serves the community at the same time that it brings people to see different ways art can originate. I myself have never seen some of the materials and forms used in elements of this exhibit. I also think you should have more of these objects featured in the gift shop, such as Sun Mad Raisins postcards!

A very good and provocative show. . . . we want to collect Hispanic and Chicano art.

¡El respeto al ajeno es la paz! [Having respect for that which is foreign to us creates peace!] (Benito Juárez). M. M.

Response to above comment:
What was actually said was: "El respeto al derecho ajeno es la paz" (Benito Juárez). Respect for the rights of others is peace! S. K.

Fue realmente fantástico al haber conocido un lugar como este, sobre todo ver que en cualquier lugar del mundo puedes encontrar algo de tu patria. Gracias. [It was truly fantastic to have experienced a place like this, especially to see that in any place in the world you can find something of your own country. Thank you.] F. N.

Andy, Your comments on opposite page are inspiring to a fellow Anglo schmuck, but talk about participating in all that is grotesque in American culture, what about these chrome-dripping low-rider mobiles? Everyone needs to have their sense of identity, but these cars are Detroit gas-guzzlers and an insult to Chicano peasant and noble Aztec roots. S. L., Washington, D.C.

¡No chinguen con nosotros! "No vengo a ver si puedo; Sino porque puedo vengo." [Don't fuck with us! "I come not to see if I can, but because I can I come."] M., Chicano Caucus, Columbia University, New York

Excerpts from Comments Printed in the El Paso Times

Immense talent! Beautiful exposition of history of the Chicano movement through creative art of the first order. E. B., Las Cruces, N.M.

It's about time! This is really great. E. B., New York

El Paso is a mixed culture city, although rich in Mexican/Hispanic traditions, we don't really think about the beautiful art that is just at our hands' reach. This exhibit makes me proud to be Hispanic of Mexican descent and especially proud of El Paso. Viva La Raza! J. E., El Paso

I believe the CARA exhibit says to El Pasoans that we have a lot to be proud about from the workers in the chile fields to the graffiti artists. Everything Chicanos did is noteworthy. This exhibit will open a great many eyes outside of the Chicanos and hopefully they also will be able to appreciate the work shown here. A. G., El Paso

Appendix A

235

Magnificent—Chicanismo is alive and well. May the city of El Paso continue supporting similar events. Not until I left this wonderful city did I realize how important the cultural aspects such as our art would draw me back. This exhibit makes me homesick, and I just wish I could stay and enjoy it a bit longer. Hats off to the museum curator responsible for bringing this exhibit to the Sun City. Houston wasn't so lively! L. M., Houston

The exhibit says to El Pasoans: "The Hispanics by their sweat made and built El Paso and with our taxes this place was built for all to see." E. O., El Paso

The CARA exhibit is truly an accurate description or assemblage of Mexican cultural artistic expression. El Paso's high percentage of "Chicanos" could not be a better place for such an array of art. Art expressed both in language and in canvas. I think the exhibit is a physical value that should remain among the various forms of art. Thanks to all the artists who contributed to a heartfelt memory. F. J. R., Jr., El Paso

Superb! El Movimiento is not dead! Social and racial oppression has increased. Take a ride through the Chicano barrios of Aztlán—see the graffiti, see the anger, see the remaking of the 21st Century Chicano artists. Viva La Raza! Chicano Power! A. L., Houston

This is an amazing show, and since it's right here on the border it should be mandatory for all people, but especially students from kindergarten to Ph.D. candidates. One depressing aspect of this show for me, however, was that I would predict how some reactions to it would be dismissive, as in, "it's political, not art." So degraded is "our" (as U.S. citizens) concept of my culture and everyday life that when the "obviousness" of our lives as they are always lived in and through politics (to the locations of where we live and why we live there) is pointed out, some act as if a grand heresy has occurred. Art has always been political and both categories—
art and politics—are too huge to be contained by conventional understandings. We as Chicana/Chicano people should not be afraid of our politics; Chicana/Chicano artists demonstrate that imagination is the key to our liberation. D. T. C., Brownsville, TX

Alberto Ledesma, viewer response to CARA (given to the author, ink on napkin)

The CARA exhibit helped me understand a little bit more as to what my background is. All these years, I have been told that I was a Mexican-American and most of my cultural background was passed on but it was never made clear to me what I really was. This exhibit helped me understand why my parents are the way they are. Thanks for opening my eyes and helping me not be ashamed of who I am and what my background is. R. V. O., El Paso

I am filled with anger and frustration at the way my ancestors have been treated. As my cultural awareness increases, I become more confused and enraged at the perpetual lies, deceit and lack of consideration by my country on other cultures. Although things are getting better, these policies persist. We must all continue, in our own unique way, to change and make things better for those people yet to arrive, just like those people prior to me. E. R. O., El Paso

Please bring more of this to El Paso! M. A. M., El Paso

We want more! G. M., El Paso

Appendix A

237

Appendix B

The Organizational Structure of

the CARA Exhibition

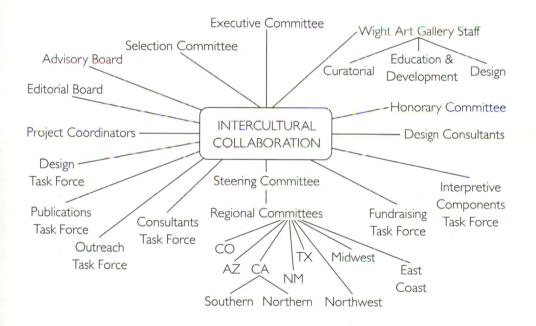

Notes

Pre-Face/Pre-CARA

1. Alicia Gaspar de Alba, "Literary Wetback," in *Infinite Divisions: An Anthology of Chicana Literature*, ed. Tey Diana Rebolledo and Eliana S. Rivero, 289.

2. The Spanish equivalent of consciousness-raising, a moment of personal and political epiphany.

3. Alice Walker, "The Unglamorous But Worthwhile Duties of the Black Revolutionary Artist, or of the Black Writer Who Simply Works and Writes," in *In Search of Our Mothers' Gardens: Womanist Prose*, 130–138.

4. Becky W. Thompson and Sangeeta Tyagi, "The Politics of Inclusion: Reskilling the Academy," in *Beyond a Dream Deferred: Multicultural Education and the Politics of Excellence*, ed. Becky W. Thompson and Sangeeta Tyagi, 97.

5. *Mi casa no es su casa* was a slogan of the Chicano Movement that subverted the popular adage by underscoring the fact that Chicanos were no longer willing to accommodate or facilitate their own colonization. I used this revised form of the adage as the title for my doctoral dissertation in American Studies in 1994 and Marcos Sanchez-Tranquilino used it as the title for his master's thesis in Art History in 1991. See my "Mi Casa [No] Es Su Casa: The Cultural Politics of the *Chicano Art: Resistance and Affirmation, 1965–1985* Exhibition" (University of New Mexico,

1994) and Sanchez-Tranquilino's "Mi Casa No Es Su Casa: Chicano Murals and Barrio Calligraphy as Systems of Signification at Estrada Courts, 1972– 1978" (University of California, Los Angeles, 1991). Although Sanchez-Tranquilino and I are both writing about Chicano art, and we have both adopted the antiaccommodationist stance of the slogan, I had not read or even heard of his work prior to arriving at this idea for the title of my dissertation. Moreover, given our disciplinary differences, our use of the conceptual *casa* is also completely different. While he is literally talking about a housing project and specifically about the artwork painted on the outer walls of those houses, I am referring to an allegorical house which represents popular culture and using the art of the CARA exhibition to represent the material culture and popular objects and images of that house.

6. Gloria Anzaldúa, "Haciendo caras, una entrada/An Introduction," in *Haciendo Caras/Making Face, Making Soul: Creative and Critical Perspectives by Women of Color*, xv.

7. A word about my use of the terms "Chicano," "Chicana," and "Chicano/a": I use "Chicano" to refer specifically to men or to the "official" name of both the Chicano Civil Rights Movement and the Chicano Art Movement. "Chicana" refers specifically to women, unless used in Spanish, in which case its feminine application is grammatical and not exclusively pertinent to women. "Chicano/a" encompasses everything else: Chicano/a culture, Chicano/a art (not the Movement), Chicano/a history, etc. When I want to underscore pluralities, I say "Chicanos" and "Chicanas." Chicanismo is the philosophical "ism" that names the politics and beliefs of el Movimiento, a male-dominant, male-identified ideology not limited to Chicanos. Chicanisma applies only to Chicana feminist constructions of identity politics.

8. This is my own comment, written in the comment book of the Albuquerque Museum of Art the first time I saw the show.

A Theoretical Introduction

An earlier version of the Introduction was published as "The Alter-Native Grain: Theorizing Chicano/a Popular Culture," in *Culture and Difference: Critical Perspectives on the Bicultural Experience in the United States*, ed. Antonia Darder, 103–122.

1. The original touring schedule did not include El Paso. CARA was supposed to travel to Madrid, Spain, and also to Mexico City, but problems in funding as well as ideological differences about the kind of museum in which to house CARA, an art museum or an anthropological one, diminished the international scope of CARA's tour.

2. Quotations taken from the board.

3. See "The Plan of Delano," in the CARA Education Packet, grades 7–12, CARA Archives, Armand Hammer Museum, UCLA.

4. Because murals are a public art, painted on the walls of housing projects, stores, and other buildings in the barrio, the only way to represent this most popular facet of Chicano art in the CARA exhibit was in a documentary format. At most of the sites, the video replayed every ten minutes in conjunction with the slide projection of the murals, although several of the venues— among them, Washington, D.C., and San Antonio—commissioned a Latino or Chicano artist to create a mural in the foyer of the museum.

5. A comparative analysis between the "Feminist Visions" section and the three separate "Grupos y Centros" installations will reveal the gender politics of the exhibit. See Chapter 3.

6. See Simon During's historical overview of cultural studies in the "Introduction" to The Cultural Studies Reader, ed. Simon During, 1–25.

7. Jacinto Quirarte, "Exhibitions of Chicano Art: 1965 to the Present," in the CARA exhibition book, 175.

8. See John Beardsley and Jane Livingston, Hispanic Art in the United States: Thirty Contemporary Painters and Sculptors, exhibition book, with an essay by Octavio Paz (New York: Abbeville Press, 1987). See also The Latin American Spirit: Art and Artists in the United States, 1920–1970, exhibition book, with essays by Luis R. Cancel, Jacinto Quirarte, Marimar Benítez, Nelly Perazzo, Lowery S. Sims, Eva Cockcroft, Félix Angel, and Carla Stellweg (New York: Harry N. Abrams, Publishers, 1988). See also Mexico: Splendors of Thirty Centuries, exhibition book, introduction by Octavio Paz (New York: Bullfinch Press, 1990).

9. Quirarte, "Exhibitions," 166.

10. For a listing of these exhibitions, see Quirarte's chronology in ibid., 163–178.

11. Ibid., 170.

12. Mestizaje means social, cultural, and biological hybridity; la Raza means the race (i.e., the "bronze" race, born of the mestizaje created by European, African, and Native American mixing in colonial Latin America). For an analysis of mestizaje in pan-American art, see Lucy R. Lippard's chapter "Mixing," in Mixed Blessings: New Art in a Multicultural America.

13. Judy Seigel, introduction, in Mutiny and the Mainstream: Talk That Changed Art, 1975–1990, ed. Judy Seigel, ix.

14. Ibid.

15. Ibid., xviii.

16. For a more detailed treatment of rasquachismo, see Ybarra-Frausto's essay "Rasquachismo: A Chicano Sensibility," in the exhibition catalog Chicano Aesthetics: Rasquachismo, 5–8. The artwork in the catalog provides good examples of the rasquache inclination, which is an artistic recycling of material culture with a vernacular Chicanesque (Chicano + baroque) flair.

17. See Chela Sandoval, "U.S. Third World Feminism: The Theory and Method of Oppositional Consciousness in the Postmodern World," *Genders* 10 (Spring 1991): 1–24.

18. Tania Modleski, "The Terror of Pleasure: The Contemporary Horror Film and Postmodern Theory," in *Studies in Entertainment: Critical Approaches to Mass Culture*, ed. Tania Modleski, 158.

19. Ibid.

20. John Fiske, *Understanding Popular Culture*, 49.

21. Tomás Ybarra-Frausto, "The Chicano Movement/The Movement of Chicano Art," in *Exhibiting Cultures: The Poetics and Politics of Museum Display*, ed. Ivan Karp and Steven D. Lavine, 133–134.

22. Ybarra-Frausto, "Rasquachismo," 5.

23. Celeste Olalquiaga, *Megalopolis: Contemporary Cultural Sensibilities*, 42.

24. Ibid., 45.

25. Ibid., 48.

26. Jerald R. Green, "Mexico's *Taller de Gráfica Popular*, Part I," *Latin American Art* 4, no. 2 (1992): 65.

27. Translation: "The caricaturist uses irony like a critic. He/she makes fun of everything, overcomes everything. He/she makes note of the contrasts between beauty and ugliness, between truth and falsehood. . . . When necessary, he/she reaches the point of cruelty, tragedy. But irony is only destructive and negative on the surface, for what it destroys is that which is false and ridiculous. Irony represents the effort we make to triumph over all of that which opposes our spiritual ascension toward the infinite." José G. Zuno, *Orozco y la ironía plástica*, cited in *Historia de las artes plásticas en la revolución mexicana*, vol. 1, 151.

28. Michael Schudson, "The New Validation of Popular Culture: Sense and Sentimentality in Academia," *Critical Studies in Mass Communications* 4 (1987): 51.

29. Customs, ways, practices.

30. See Rodolfo Acuña, *Occupied America: A History of Chicanos*, 141–197.

31. Tania Modleski, *Feminism without Women: Culture and Criticism in a "Postfeminist" Age*, 38.

32. Dick Hebdige, "From Culture to Hegemony," in *The Cultural Studies Reader*, ed. Simon During, 366–367.

33. Ibid., 361.

34. Dick Hebdige, *Subculture: The Meaning of Style*, 132.

35. Henry Nash Smith, *Virgin Land: The American West as Symbol and Myth*, 11.

36. I am using "mind" as a synecdoche rather than a metaphor. I am not attempting to totalize "the Chicano mind," but to extract the differences in cultural myths, values, and practices between the Chicano Art Movement and the mainstream art world.

37. See Gene Wise, "'Paradigm Dramas' in American Studies: A Cultural

and Institutional History of the Movement," *American Quarterly* 31, no. 3 (1979): 293–337.

38. Ibid., 297.

39. Literally, the fifth sun. According to the Aztec calendar, every new sun portended the end of the old world, cataclysmic changes, doomsday. When the Spaniards arrived in Tenochtitlan, bearing the Columbian legacy of "discovery" and decimation with them, the fifth sun was rising. It is depicted on the calendar stone as the central orifice from which the fifth world would emerge. The legend seems particularly prophetic in the age of multiculturalism.

40. A native of El Paso, Rubén Salazar coined one of the most popular definitions of the term "Chicano" as "a Mexican American with a non-Anglo image of himself." See Rubén Salazar, "Who Is a Chicano? And What Is It the Chicanos Want?" *Los Angeles Times*, part 2 (February 6, 1970): 7.

41. This is an allusion to Proposition 187, the racist, anti-immigrant law proposed by Governor Pete Wilson that passed resoundingly in the state of California in 1994 and was repealed as unconstitutional by a federal appeals court in 1996.

42. See the "Narrative Description" of the CARA project in the third NEH proposal, in the Holly Barnet-Sanchez and Marcos Sanchez-Tranquilino Papers, Special Collections, Stanford University Libraries.

43. Timothy Luke, *Shows of Force: Power, Politics, and Ideology in Art Exhibitions*, 3.

44. See Janet Wolff, *Aesthetics and the Sociology of Art*.

45. Ibid., 27.

46. Luis Camnitzer, "Access to the Mainstream," *New Art Examiner* (June 1987): 20.

47. See "Preface" to *Chicano Art: Resistance and Affirmation, 1965–1985*, exhibition book, ed. Richard Griswold del Castillo, Teresa McKenna, and Yvonne Yarbro-Bejarano, 32 (hereafter called the CARA exhibition book).

48. Renato Rosaldo, *Culture and Truth: The Remaking of Social Analysis*, 19.

49. Ibid.

50. See Renato Rosaldo, "From the Door of His Tent: The Fieldworker and the Inquisitor," in *Writing Culture: The Poetics and Politics of Ethnography*, ed. James Clifford and George E. Marcus, 77–97.

51. Coco Fusco, "Passionate Irreverence: The Cultural Politics of Identity," in the 1993 *Biennial Exhibition* catalog, ed. Elizabeth Sussman, 79.

52. Wise, "'Paradigm Dramas' in American Studies: A Cultural and Institutional History of the Movement," 297. This is the period from 1950 to 1965. It was founded upon a "consensus on the nature of American experience," represented by individualism and the Puritan "founding fathers" of the nation, as well as on "a methodological consensus on ways to study that experience," which occupied Americanist scholars from 1929 to 1950.

This founding phase of the discipline culminated in the myth-symbol-image school, whose methodology involved, primarily, literary analysis and inductive reasoning, and it was to the "master narratives" of American literature that these scholars turned to extrapolate the meaning of "the" American identity. For a more sustained discussion of methods in American Studies, see the following publications, arranged in chronological order of publication: Henry Nash Smith, "Can 'American Studies' Develop a Method?" *American Quarterly* 9, no. 2 (Summer 1957): 197–208; Leo Marx, "American Studies— A Defense of an Unscientific Method," *New Literary History* 1 (October 1969): 75–90; Bruce Kublick, "Myth and Symbol in American Studies," *American Quarterly* 24, no. 4 (October 1972): 435–450; Jay Mechling, Robert Merideth, and David Wilson, "American Culture Studies: The Discipline and the Curriculum," *American Quarterly* 25, no. 4 (October 1973): 463–489; Robert Sklar, "American Studies and the Realities of America," *American Quarterly* 27, no. 3 (August 1975): 245–262; Jay Mechling, "If They Can Build a Square Tomato: Notes toward a Holistic Approach to Regional Studies," *Prospects: An Annual of American Cultural Studies* 4 (1979): 59–78; Betty Chmaj, "A Decade of Déja Vu," *American Quarterly* 31, no. 3 (1979): 358–364; John Ibson, "Virgin Land or Virgin Mary? Studying the Ethnicity of White Americans," *American Quarterly* 33, no. 3 (Bibliography issue, 1981): 284–308; Michael Cowan, "Boundary as Center: Inventing an American Studies Culture," *Prospects: An Annual of American Cultural Studies* 12 (1987): 1–20; Linda Kerber, "Diversity and Transformation of American Studies," *American Quarterly* 41 (1989): 415– 431; Allen F. Davis, "The Politics of American Studies," *American Quarterly* 42, no. 3 (September 1990): 353–374; Elaine Tyler May, "'The Radical Roots of American Studies': Presidential Address to the American Studies Association, November 9, 1995," *American Quarterly* 48, no. 2 (June 1996): 179–200.

53. See Wise, "'Paradigm Dramas' in American Studies: A Cultural and Institutional History of the Movement," 306–307.

54. Ibid., 312.

55. Ibid., 314.

56. Kerber, "Diversity and Transformation," 421.

57. The new scholarship that emerged in the areas of popular culture, women's studies, and reflexive cultural studies created the need for new journals and associations. *American Quarterly*, founded in 1949, had dominated as the "voice of the discipline" for nearly twenty years. The *Journal of Popular Culture* was founded in 1967. The Popular Culture Association formed in 1968. *Signs: A Feminist Journal* and *Prospects: An Annual of American Studies* were founded in 1975.

58. See Deena J. González, "On Outside-Insiders," an unpublished article presented at the 1994 American Historical Association Conference in San Francisco.

59. Rosaldo, *Culture and Truth*, 34–45.

60. Ibid., 41.

61. "There is no doubt that the greatest and purest discovery is that in which a child becomes aware of himself as a person." See "*Recuerdo, Descubrimiento y Voluntad en el Proceso Imaginativo Literario*/Remembering, Discovery and Volition in the Literary Imaginative Process," in *Tomás Rivera: The Complete Works*, ed. Julian Olivares, 359–370.

62. Renato Rosaldo, "After Objectivism," in *The Cultural Studies Reader*, ed. Simon During, 108. Here Rosaldo is referring to Américo Paredes's "diagnosis . . . that most ethnographic writing on Mexicans and Chicanos has failed to grasp significant variations in the tone of cultural events" (108). Paredes's implication is that an ethnographer native to Mexican or Chicano culture would at least be aware of those variations necessary for accurate interpretation.

63. Ibid., 109.

64. Ana M. López, "Are All Latins from Manhattan? Hollywood, Ethnography, and Cultural Colonialism," in *Unspeakable Images: Ethnicity and the American Cinema*, ed. Lester D. Friedman, 404.

65. Ibid., 405.

66. See Jane Livingston and John Beardsley, "The Poetics and Politics of Hispanic Art: A New Perspective," in *Exhibiting Cultures*, ed. Karp and Lavine, 104–120.

67. Ibid., 116.

68. See Robert Stam, "Bakhtin, Polyphony, and Ethnic/Racial Representation," in *Unspeakable Images: Ethnicity and the American Cinema*, ed. Lester D. Friedman, 251–276.

69. Rosaldo, "After Objectivism," 108.

70. See Svetlana Alpers, "The Museum as a Way of Seeing," in *Exhibiting Cultures*, ed. Karp and Lavine, 25–32.

71. James Clifford, "On Collecting Art and Culture," in *The Predicament of Culture: Twentieth-Century Ethnography, Literature, and Art*, 152.

1. The Solar of Chicano/a Popular Culture

1. Houston A. Baker, Jr., "Of Ramadas and Multiculturalism," President's Column, *MLA Newsletter* (Summer 1992): 2.

2. See Christopher D. Geist and Jack Nachbar, eds., *The Popular Culture Reader*, 3rd edition. See also Jack Nachbar and Kevin Lause, eds., *Popular Culture: An Introductory Text*. This text is basically the fourth edition of the text cited above, except for the difference in one of the editors and a few different essays. It is organized around the same "house" heuristic.

3. Ray B. Browne, "Popular Culture—New Notes Toward a Definition," in *The Popular Culture Reader*, 13.

4. The term "restrictive covenants" refers to housing restrictions imposed upon people of color (i.e., legally sanctioned segregation). In Clare-

mont, California, for example, restrictive covenants were in effect until 1972. Although they have been legally abolished, restrictive clauses continue to appear on housing documents in Claremont, sometimes with a line running through them on the contract.

5. See Geist and Nachbar, *The Popular Culture Reader*, 1–11.

6. Nachbar and Lause, *Popular Culture*, 22.

7. The way the idiom has been inverted here suggests an "outsider's" perspective which, in effect, is deriding the expression by asserting its ideological differences (e.g., community vs. private property). To restructure the sentence as "my *casa* may be your *casa*, amigo, but your house ain't my house" changes the perspective to that of an "insider," which is not the point of the sentence.

8. Jack Solomon, *The Signs of Our Time: The Secret Meanings of Everyday Life*, 97.

9. Ibid., 101.

10. Frederick Jackson Turner, "The Significance of the Frontier in American History," in *The Early Writings of Frederick Jackson Turner, with a List of All His Works*, compiled by Everett E. Edwards and with an introduction by Fulmer Mood, 187.

11. Baker, "Of Ramadas and Multiculturalism," 3.

12. "The difference between a hacienda and a modest dwelling were actually minimal. Each consisted of a string of rooms in single file; in one instance the rooms extended around four sides of an open court, in the other in a straight line or bent into an **L**- or **U**-shape": Bainbridge Bunting, *Early Architecture of New Mexico* (Albuquerque: University of New Mexico Press, 1976), 63.

13. Geist and Nachbar, *The Popular Culture Reader*, 5.

14. Nachbar and Lause, "Introduction," in *Popular Culture*, 22.

15. Eva Sperling Cockcroft and Holly Barnet-Sanchez, eds., *Signs from the Heart: California Chicano Murals*, 5.

16. Let me reiterate the definition of this term, as expressed by Shifra Goldman and Tomás Ybarra-Frausto: "Chicanismo involved a radicalization of politics. It engaged and made attractive the issues of national identity, dignity, self-worth, pride, uniqueness, and cultural rebirth." See their "Introduction" to *Arte Chicano: A Comprehensive Annotated Bibliography of Chicano Art, 1965–1981*, 35.

17. Geist and Nachbar, *The Popular Culture Reader*, 5.

18. Tomás Ybarra-Frausto, "Arte Chicano: Images of a Community," in *Signs from the Heart*, ed. Cockcroft and Barnet-Sanchez, 56, 57.

19. John R. Chávez, *The Lost Land: The Chicano Image of the Southwest*, 106.

20. See David Montejano, *Anglos and Mexicans in the Making of Texas, 1836–1986*.

21. Marcos Sanchez-Tranquilino, "Murales del Movimiento: Chicano Murals and the Discourses of Art and Americanization," in *Signs from the Heart*, ed. Cockcroft and Barnet-Sanchez, 86.

22. Oscar Zeta Acosta, *The Revolt of the Cockroach People*.

23. Goldman and Ybarra-Frausto, *Arte Chicano*, 39–40.

24. See the CARA tabloid brochure generated at the Wight Gallery venue, 1, CARA Archives, UCLA.

25. See Carey McWilliams, "The Fantasy Heritage," in *North from Mexico: The Spanish-Speaking People of the United States*, 43–53.

26. Chávez, *The Lost Land*, 130.

27. See Teresa Córdova, "Roots and Resistance: The Emergent Writings of Twenty Years of Chicana Feminist Struggle," in *Handbook of Hispanic Cultures in the United States: Sociology*, ed. Félix Padilla (Houston: Arte Publico Press, 1992), 175–202.

28. Deena J. González, "Speaking Secrets: Living Chicana Theory," forthcoming in *Living Chicana Theory*, ed. Carla Trujillo.

29. bell hooks, "Black Vernacular: Architecture as Cultural Practice," in *Art on My Mind: Visual Politics*, 149.

30. bell hooks, "Architecture in Black Life: Talking Space with LaVerne Wells-Bowie," in *Art on My Mind*, 152–162.

31. See ibid., 161.

32. Nachbar and Lause, *Popular Culture*, 24.

33. Professor Ray Padilla, of the University of Arizona, believes that the Virgin of Guadalupe symbolizes what he calls "the great compromise" between the conquering religion and the native one. The compromise, says Padilla, is more than syncretism; through the artifice of "conversion" the native religions continue to unfold in the context of the Guadalupana/Marian societies of Mexico. Personal conversation, July 1993.

34. CARA brochure, UCLA, 16.

35. Ibid.

36. See the CARA exhibition book, 239, 241.

37. As one of the main protagonists of the Mexican revolution in 1910, Emiliano Zapata represents Mexican nationalism, the restoration of Mexican land and resources to its indigenous inhabitants, and the liberation of the underclass; as such, he is idolized by Chicano nationalists also seeking the liberation of working-class Chicanos and the recuperation of their national patrimony, called Aztlán. Pancho Villa, the other protagonist of the Revolution (from *el norte*, whereas Zapata was from the south), is only mentioned briefly in the Historical Timeline and does not appear in the Chicano Hall of heroes/icons in the exhibition.

38. Chávez died in his sleep in the home of a friend in San Luis, Arizona, on April 22, 1993. He had spent two days testifying in Yuma County Superior Court in response to a lawsuit launched against the UFW by a Salinas-based vegetable grower. The grower, Bruce Church, Inc., "had won a $5.4-million judgment against the UFW for alleged damage done by boycotts. On appeal,

the case was sent back to the trial court." According to a friend, the 66-year-old Cesar had been fasting for three days. See "Chavez Died Near Birthplace of Property Lost in Depression," *Los Angeles Times* (April 24, 1993), 23.

39. Geist and Nachbar, *The Popular Culture Reader*, 206.

40. Rupert García's image on the cover was used in this calendar for Galería de la Raza, 1975.

41. Geist and Nachbar, *The Popular Culture Reader*, 206.

42. For a literary rendering of this hero by a Chicana, see Sandra Cisneros, "Eyes of Zapata," in *Woman Hollering Creek and Other Stories* (New York: Random House, 1991), 85–113.

43. This is a reference to Mariano Azuela's classic *Los de Abajo*, considered by critics to be "the" novel of the Mexican Revolution. Originally published in 1915 in El Paso, Texas, it can be considered one of the early Chicano novels; though Azuela was a Mexican national, the novel was published before the erection of a border between the two countries.

44. Chávez, *The Lost Land*, 77.

45. CARA brochure, 16.

46. Quoted in "Cesar Chavez, Founder of the UFW, Dies at 66," in the *Los Angeles Times* (April 24, 1993), 1.

47. The altar now belongs to the collection of the National Museum of American Art, where it will be housed after CARA completes its tour. It was in the Bronx Museum at the time of César's death on April 22, 1993; ironically, funds were not available to ship it back to California for the funeral services.

48. As in the expression *cerrar con broche de oro* or to close with a golden brooch, a definitive gesture of closure.

49. See "For the Final Time They March for Chavez," *Los Angeles Times* (April 30, 1993), sec. A: 1.

50. As the prototypical *peladito* or Mexican wise guy/little tramp, Cantinflas can be seen to belong to the repertoire of Chicano/a popular culture, for it is from the *peladito* that contemporary Chicano comedians like Cheech Marín and performance artists like Guillermo Gómez-Peña derive their *rasquache* brand of humor.

51. From the funeral oration given by Andrés Iduarte at Frida's cremation, quoted in Hayden Herrera, *Frida: A Biography of Frida Kahlo*, 437.

52. Veronkia Cáslavská, "Why Frida Kahlo Painted Herself," translation of "Porqué Se Pintaba Frida Kahlo," by Martha Zamora, *Imagine: International Chicano Poetry Journal* 2, no. 1 (Summer 1985): 14.

53. Ibid., 16.

54. Cervántez's image could also be read as a representation of Frida's cremation, described in Herrera's *Frida* thus: "at the moment when Frida entered the furnace, the intense heat made her sit up, and her blazing hair stood out

from her face in an aureole. Siqueiros said that when the flames ignited her hair, her face appeared as if smiling in the center of a large sunflower" (438).

55. Ibid., 109.

56. Michael Cutler Stone, "Bajito y suavecito [Low and Slow]: Low Riding and the 'Class' of Class," Studies in Latin American Popular Culture 9 (1990): 85.

57. Ibid., 87.

58. George Lipsitz, Time Passages: Collective Memory and American Popular Culture, 153.

59. Literally, a Hispanicized version of "clique," defined by Webster's as a small, exclusive group of people. Clica or klika is now the preferred insider word over "gang."

60. Brenda Jo Bright, "Remappings: Los Angeles Low Riders," in Looking High and Low: Art and Cultural Identity, ed. Brenda Jo Bright and Liza Bakewell, 90.

61. Ibid. I find the ethnographic assumptions behind this outsider interpretation quite problematic. Their differences notwithstanding, it must be noted that lowriders come from the same barrios as gang-bangers. Bright's distinction between these two Chicano urban youth groups seems to reify the car over the ghetto, the individual over the group. Is Bright suggesting that social activity centered around a car lends Chicano youth both physical and class mobility, whereas social activity centered around the neighborhood keeps one locked in class and place? Perhaps these issues are addressed in the broader dissertation-length study.

62. Ibid., 108.

63. Quoted in Stone, "Bajito y suavecito," 103.

64. Geist and Nachbar, The Popular Culture Reader, 97.

65. Susannah Cassedy, "The High Art of Lowriding," Museum News (July/August 1992): 28.

66. Ibid., 29.

67. This had already been done in the Hispanic Art in the United States exhibit; see photo of Gilbert Luján's Our Family Car in Beardsley and Livingston, Hispanic Art in the United States: Thirty Contemporary Painters and Sculptors, 102–103. A lowrider parade, however, did initiate CARA's opening at the El Paso Museum of Art, and at the Albuquerque Museum of Art lowriders were part of a larger car show exhibited outside the museum during CARA's visit.

68. From a scene in Zoot Suit, directed by Luis Valdéz, 1981.

69. George I. Sánchez, "Pachucos in the Making," Common Ground 4 (1943–1944): 13–20. For more analyses of pachuquismo and the riots, see Emory S. Bogardus, "Gangs of Mexican-American Youth," Sociology and Social Research 23 (September–October 1943): 55–66; Beatrice Griffith, "The Pachuco Patois," Common Ground 7 (1946–1947): 77–84; McWilliams, North from Mexico, 233–251; and Acuña, Occupied America: A History of Chicanos, 254–259.

70. Mauricio Mazón, The Zoot Suit Riots: The Psychology of Symbolic Annihilation, 8.

71. Ibid., 7–8.

72. Luis Valdéz, "Once Again, Meet the Zoot Suiters," *Los Angeles Times* (August 13, 1978): part V, 3.

73. Ibid.

74. See the opening scene of the film *Malcolm X*, in which the young, fashion-conscious Malcolm (played by Denzel Washington) and his close friend (played by Spike Lee) sport colorful zoot suits on the streets of Harlem. Indeed, as Fritz Redl pointed out in his 1943 article "Zoot Suits: An Interpretation," zoot suiters were a motley crew, though in Detroit, Michigan, the zoot suit was considered to be a "Negro" phenomenon. Redl states that "*racially* the phenomenon is not confined to the Negroes. In Detroit there are white zoot suit groups, especially among some of the Italians. However, it does seem to be true that the majority of zoot suiters are Negroes." See *Survey Midmonthly* 79, no. 10 (October 1943): 259–262. According to a *New York Times* article, the first zoot suit was called a "Killer Diller" and was worn first by a busboy named Clyde Duncan in Gainesville, Georgia. Briefly outlining the rise of the zoot suit fad, the author of the article, Meyer Berger, asserts that "in New York City, Harlem is the zoot suit center. High school age children from all parts of the city go to Harlem for them. Prices range from $18 to $75." See "Zoot Suit Originated in Georgia: Bus Boy Ordered First One in '40," *New York Times* (June 11, 1943).

75. What follows is an abridged listing of primary sources tracing the so-called Zoot Suit Riots in several national periodicals from June 5 to June 13, 1943. I would like to thank my student Leslie Smith for her research and reproduction of these sources as part of her coursework in my class on "Barrio Popular Culture," Pomona College, 1994.

In the *Los Angeles Times*: "Zoot Suiters Learn Lesson in Fights with Servicemen" (June 7, 1943); "Riot Alarm Sent Out in Zoot War" (June 8, 1943); "City, Navy Clamp Lid on Zoot-Suit Warfare" (June 9, 1943); "Zoot Girls Use Knife in Attack as 'War' Eases," "Watts Pastor Blames Riots on Fifth Column," "Mexico Not Expected to File Protest over Zoot War Here" and "Grand Jury Investigation Promised" (June 11, 1943); "Calm Rules; Warren Acts to End Strife" and "Punishment for All Urged in Zoot War" (June 13, 1943).

In the *Los Angeles Examiner*: "Sailors Hunt Zoot-Suiters, 2 in Hospital" (June 5, 1943); "WAR ON ZOOT SUITS, Shore Patrol Goes after Navy Men, Navy Men Go after the 'Pachucos,'" "Zooters Will Lose Lagoon," "Civilians Also Blamed for Street Fights" (June 9, 1943).

In the *San Francisco Chronicle*: "Servicemen Denude L.A. Zoot Suiters" (June 8, 1943); "Zoot War Still On: Policeman Is Run Down as Riots Spread," "Why Zoots? Psychiatrist Says Youths Unable to Get in Service Seek Attention" (June 10, 1943); "The Zoot Warfare: More about 'Near Anarchy' in L.A. Area," "On the Bay Front of the Zoot War" (June 11, 1943); "Public Hear-

ings on Riots Will Begin in L.A. Today," "S.F. Gas Station Operator Is Attacked by Zooters" (June 12, 1943).

In the *New York Times*: "Los Angeles Barred to Sailors by Navy to Stem Zoot-Suit Riots" (June 9, 1943); "Zoot Suit Originated in Georgia: Bus Boy Ordered First One in '40," "Seek Basic Causes of Zoot Suit Fray" (June 11, 1943); "Army Takes a Hand in Zoot Suit Fray" (June 12, 1943); "Los Angeles Group Insists Riots Halt" (June 13, 1943).

76. Geist and Nachbar, *The Popular Culture Reader*, 155.

77. See Raymund Paredes, "The Origin of Anti-Mexican Sentiment in the United States," *New Scholar* 6 (1977): 130−165. Paredes contends that English-Spanish animosity actually started in Europe in the Middle Ages and followed the English and Spanish diaspora to their colonies in the New World. Thus, when Anglo-Americans and Spanish-Mexicans clashed in Texas in the nineteenth century, their hostilities were fueled as much by their historical animosity toward each other as by the struggle for control of the Mexican northern territories.

78. Américo Paredes, *"With His Pistol in His Hand": A Border Ballad and Its Hero*, 15−16.

79. Geist and Nachbar, *The Popular Culture Reader*, 156.

80. See Dan Luckenbill, *The Pachuco Era: Catalog of an Exhibit* (Los Angeles: University Research Library, Department of Special Collections, UCLA, 1990). For a more popular treatment of Pachuco issues see the films *Zoot Suit* (Luis Valdéz, 1981) and *American Me* (Edward James Olmos, 1992).

81. See Gary Hoppenstand, "Yellow Devil Doctors and Opium Dens: A Survey of the Yellow Peril Stereotypes in Mass Media Entertainment," in Geist and Nachbar, *The Popular Culture Reader*, 176−185.

82. Ibid., 176.

83. Ibid.

84. Mazón, *The Zoot Suit Riots*, 22.

85. Hoppenstand, "Yellow Devil Doctors," 183.

86. Mazón, *The Zoot Suit Riots*, 1.

87. One of the text descriptions in the show states that "José Montoya was instrumental in the revival of the image of the Pachuco and Pachuca (Mexican-American zoot-suiter) as a symbol of resistance and affirmation."

88. From the text accompanying the photograph.

89. From the text accompanying the piece.

90. Geist and Nachbar, *The Popular Culture Reader*, 263.

91. Ibid., 267.

92. Lourdes Portillo, director, *La Ofrenda: The Days of the Dead*, 1988.

93. Ybarra-Frausto, "The Chicano Movement," 132.

94. Tomás Ybarra-Frausto, "Sanctums of the Spirit: The *Altares* of Amalia Mesa-Bains," essay for the *Grotto of the Virgins* exhibition catalog, 4, 6.

95. For a thorough deconstruction of *An Ofrenda for Dolores del Río*, see Jennifer Gonzales's article "Rhetoric of the Object: Material Memory and the Artwork of Amalia Mesa-Bains," *Visual Anthropology Review* 9, no. 1 (Spring 1993): 82–91.

96. From the text description accompanying the piece.

97. See George Hadley-García, *Hollywood Hispano: Los latinos en las películas*, 31. Translation: "had not had to struggle in order to triumph, for they were aristocrats who tried cinema as a diversion."

98. For all of their popularity, Dolores del Río and her fellow "Hispanic Hollywood" actors, although they did not suffer the physical travails of immigration and deportation, nonetheless had to contend with institutionalized racism and themselves enact racist roles. According to Ybarra-Frausto in his essay on the altars of Amalia Mesa-Bains, Dolores del Río was "the first Mexican superstar [to break] the racial taboos of mainstream Hollywood" ("Sanctums of the Spirit"). Rather than break the taboos, however, her class and light-skinned privilege allowed her to play roles outside of the stereotypical *señorita*, thus conflating race with class.

99. See Acuña, "The Building of the Southwest: Mexican Labor, 1900–1930," in *Occupied America*, 141–197.

100. See Acuña, *Occupied America*, 158.

101. See Hadley-García, *Hollywood Hispano*, 35.

102. Philip Brookman, "Conversations at Cafe Mestizo: The Public Art of David Avalos," essay in the exhibition catalog *Cafe Mestizo*, 16.

103. From the text accompanying the piece.

104. Gloria Anzaldúa, *Borderlands/La Frontera: The New Mestiza*, 11.

105. Geist and Nachbar, *The Popular Culture Reader*, 265.

106. Ramón "Tianguis" Pérez, *Diary of an Undocumented Immigrant*, trans. Dick J. Reavis, 9.

107. See Debbie Nathan, "The Eyes of Texas Are upon You," in *Women and Other Aliens: Essays from the U.S.-Mexico Border*, 17–34.

108. Geist and Nachbar, *The Popular Culture Reader*, 265.

109. Gloria Anzaldúa, "Border Arte: Nepantla, El lugar de la frontera," in *La Frontera/The Border: Art about the Mexico/United States Border Experience*, exhibition book (San Diego: Centro Cultural de la Raza and Museum of Contemporary Art, 1993), 110.

110. The chain-link fence, rendered in lavender against a bright yellow background, is a recurrent motif in the CARA exhibit, as well as in the catalog and in other ephemera of the exhibition. The chain-link fence is, in fact, so central a metaphor that it serves as the background for the CARA logo.

111. "Operation Blockade," the El Paso Border Patrol's latest campaign against undocumented immigrants, has approximately 450 agents patrolling twenty miles of the El Paso–Juárez border around the clock. In 1994 Janet

Reno, attorney general of the United States, not only commended the efficacy of the blockade, but also added to the Border Patrol's budget.

112. Geist and Nachbar, *The Popular Culture Reader*, 265.

113. Antonio Burciaga, *Drink Cultura: Chicanismo*, 26.

114. A contemporary example of this popular ritual is the UCLA hunger strike of 1992, engaged in by Chicano/a students and faculty to protest the lack of a Chicana and Chicano Studies *department* at that institution.

115. From the text accompanying the piece.

116. Cited in Eleanor Heartney, "Ceremonial Art," *Sculpture* (September/October 1992): 32.

117. Elizabeth Martínez, ed., *500 Años del Pueblo Chicano/500 Years of Chicano History in Pictures*, 113.

118. Chandra Mukerji and Michael Schudson, eds., *Rethinking Popular Culture: Contemporary Perspectives in Cultural Studies*, 36.

2. *Through Serpent and Eagle Eyes*

1. Alicia González and Edith Tonelli, "*Compañeros* and Partners: The CARA Project," in *Museums and Communities: The Politics of Public Culture*, ed. Ivan Karp, Christine Mullen Kreamer, and Steven D. Lavine, 274.

2. See Gloria Ohland, "CARA," *L.A. Weekly* (September 14–20, 1990).

3. See Shifra Goldman's letter to Edith Tonelli and Cecelia Klein, dated October 30, 1983, CARA Archives, UCLA.

4. See Edith Tonelli's letter to Suzanne Jaimson, director of the Santa Fe Council for the Arts, dated May 5, 1984, CARA Archives, UCLA.

5. González and Tonelli, "*Compañeros* and Partners," 274.

6. Ibid., 275.

7. Ibid.

8. See Thomas H. Wilson's letter to Edith Tonelli, dated May 18, 1989, CARA Archives, UCLA.

9. Ibid.

10. See the Executive Board's letter to Lynne Cheney, dated December 16, 1989, CARA Archives, UCLA.

11. See Edith Tonelli's memo to the Executive Committee, dated January 30, 1990, CARA Archives, UCLA.

12. See the budget sheets of the three NEH proposals, CARA Archives, UCLA.

13. See the letter from Suzi Jones to Edith Tonelli, dated November 21, 1990, CARA Archives, UCLA.

14. Quoted in Carole S. Vance, "Issues and Commentary: The War on Culture," *Art in America* 77 (September 1989): 41.

15. Elizabeth Shepherd, telephone interview, February 24, 1994.

16. See "Arte ChicaNews," *National Chicano Art Exhibition Planning Newsletter*, no. 3 (Fall 1987), CARA Archives, UCLA.

17. See the minutes of the meeting, CARA Archives, UCLA.

18. See "Preface," in CARA exhibition book, 27–32.

19. See the minutes to the first meeting, distributed at the second planning meeting, July 21, 1987, CARA Archives, UCLA.

20. See the Wight Gallery's press release on CARA, September, 1990, CARA Archives, UCLA.

21. An Honorary Committee, headed by Edward James Olmos, was selected to help in the fundraising process. Other prominent members included César Chávez, Dolores Huerta, Linda Ronstadt, Los Lobos, Carlos Santana, Ricardo Montalban, Martin Sheen, Luis Valdéz, Luis Leal, Rodolfo Acuña, Rudolfo Anaya, Arturo Madrid, Bert Corona, Gloria Molina, and the mayors and Mexican consuls of nine of the cities that CARA ended up visiting.

22. Ybarra-Frausto resigned from the committee due to a conflict of interests; he was also the associate director for Arts and Humanities at the Rockefeller Foundation, to whom the CARA organizers had applied for funding.

23. Tomás Ybarra-Frausto, personal interview, Los Angeles, California, March 5, 1993.

24. Marcos Sanchez-Tranquilino, telephone conversation, February 13, 1993.

25. Ibid.

26. González and Tonelli, "*Compañeros* and Partners," 276–277.

27. Members of the Advisory Committee included Alicia González, director of the Smithsonian Institution's Quincentenary Programs; José González, artist; Lidia Mendoza-Huante, arts administrator; Amalia Mesa-Bains, artist and teacher; Victor Ochoa, artist and arts administrator; Pedro Rodríguez, artist and arts administrator; Bernadette Rodríguez-LeFebre, artist; Carlos Santistevan, artist; Tomás Ybarra-Frausto, academic and arts administrator; Victor Sorell, art historian; Teresa McKenna, academic; Richard Griswold del Castillo, academic; Rene Yáñez, artist and arts administrator; Yvonne Yarbro-Bejarano, academic; Shifra Goldman, art historian; Jacinto Quirarte, art historian; Mario Barrera, academic; Ramón Favela, art historian; Cecelia F. Klein, art historian; José Montoya, artist; Jesús Treviño, filmmaker; Sid White, arts administrator; Judith Baca, artist and teacher; Raymund Paredes, academic; David E. Hayes-Bautista, academic; Steven Loza, academic; Guillermo Hernández, academic; Edith Villareal, playwright; Robert Gárfias, academic; Eduardo Carrillo, artist and academic; Tomás Atencio, academic; Patricia Rodríguez, artist; Zulma Jiménez, arts administrator; David Avalos, artist; Ken Brecher, arts administrator; Richard Chabran, research coordinator.

28. See Acuña, "The Age of the Brokers: The New Hispanics," in *Occupied*

America, 363–412. Acuña explains the attraction of Marxism for Chicano activists.

29. See Ramón Favela's letter, dated November 28, 1986, CARA Archives, UCLA.

30. See Holly Barnet-Sanchez's letter to José Montoya, dated April 28, 1988, CARA Archives, UCLA.

31. Malaquías Montoya and Lezlie Salkowitz-Montoya, "A Critical Perspective on the State of Chicano Art," *Cambio Cultural* (July 1991): 12. The article was originally published in *Metamorfosis: Northwest Chicano Magazine of Literature Art and Culture* 3, no. 1 (Spring/Summer 1980), Cultura Popular issue. For a rebuttal to the Salkowitz/Montoya arguments, see Shifra Goldman, "Response: Another Opinion on the State of Chicano Art," *Metamorfosis: Northwest Chicano Magazine of Literature Art and Culture* 3 and 4, no. 1 (1980/1981): 2–7.

32. José Montoya, personal statement, *Imagine: International Chicano Poetry Journal*, Arte Chicano issue, 3, nos. 1–2 (Summer–Winter 1986): 144.

33. Montoya and Salkowitz-Montoya, "A Critical Perspective on the State of Chicano Art," 10.

34. See José Montoya, "El Louie," in *Literatura Chicana: Texto y contexto/Chicano Literature: Text and Context*, ed. Antonia Castañeda Shular, Tomás Ybarra-Frausto, and Joseph Sommers, 173–176.

35. Jacinto Quirarte, CARA exhibition book, 167.

36. Cited in ibid., 167.

37. Carmen Lomas Garza, telephone interview, February 1, 1994.

38. Her Hirshhorn show was entitled "Directions D.C." and was on view from November 18, 1995, through February 18, 1996. For the exhibition catalogs of her other retrospectives, see *Carmen Lomas Garza: Pedacito de mi corazón*, essay by Amalia Mesa-Bains (Austin: Laguna Gloria Art Museum, 1991), and *Carmen Lomas Garza: Lo Real Maravilloso/The Marvelous/The Real*, with essays by Terecita Romo and Tomás Ybarra-Frausto (San Francisco: Mexican Museum, 1987).

39. Pedro Rodríguez, personal interview, San Antonio, Texas, July 13, 1992.

40. See Gloria Anzaldúa, "La conciencia de la mestiza:/Towards a New Consciousness," in *Borderlands/La Frontera*, 77–98.

41. Marcos Sanchez-Tranquilino and John Tagg, "The Pachuco's Flayed Hide: The Museum, Identity, and Buenas Garras," in CARA exhibition book, 103.

42. From the third NEH proposal, CARA Archives, UCLA.

43. Stephen Weil, *Rethinking the Museum and other Meditations*, 57.

44. Harry Gamboa, Jr., "In the City of Angels, Chameleons, and Phantoms: Asco, a Case Study of Chicano Art in Urban Tones (or Asco was a Four-Member Word)," in CARA exhibition book, 125.

45. González and Tonelli, "Compañeros and Partners," 265.

46. Montoya and Salkowitz-Montoya, "A Critical Perspective on the State of Chicano Art," 7.

47. Goldman and Ybarra-Frausto, Arte Chicano, 32–33.

48. Tino Villanueva, "Prólogo," in Chicanos (selección), 18. Translation: "justice, equality, the quality of life, and . . . the full consciousness of personal dignity."

49. Shepherd, telephone interview.

50. The Wight Art Gallery's Community Development and Education department, headed by Cindi Dale, prepared two comprehensive education packets: one adjusted for grades K–6 reading level, the other for grades 7–12. To help students interpret the exhibition and relate it to their own lives, both packets contained a glossary of words in the exhibition, a synopsis of the exhibition's historical timelines, and summaries of the section descriptions, along with activities such as mural-making, altar-making, puzzles, and other vocabulary exercises. Each packet also came with a set of slides, useful for analysis, discussion, and illustration of the interpretive material. Packets were sent to all of the venues, who then distributed them to selected teachers in local schools.

51. From the "CARA Exhibition Sponsor's Statement" generated by Anheuser-Busch. In this statement, the well-known beer company presents itself as not only a patron of the arts, but a patron of ethnic (specifically "Hispanic") arts, going so far as to quote Pablo Picasso: "The arts are that which wash away from the soul the dust of everyday life." The implicit message, of course, is that beer is that which helps wash down that dust, but also that art is a higher, cleaner realm of experience than everyday life.

52. Peter McLaren, "White Terror and Oppositional Agency: Towards a Critical Multiculturalism," in Multiculturalism: A Critical Reader, ed. David Theo Goldberg, 45–74.

53. Although all of the essays in Multiculturalism: A Critical Reader provide illuminating views on the process and praxis of multiculturalism, both culturally and within the academy, for critical deconstructions of multiculturalism, see Goldberg, the Chicago Cultural Studies Group, Wallace, Giroux, and Turner. See also Mapping Multiculturalism, ed. Avery F. Gordon and Christopher Newfield.

54. David Theo Goldberg, "Introduction: Multicultural Conditions," in Multiculturalism, 12.

55. "Critical Multiculturalism," in Multiculturalism, 115. For a more detailed account of the "Benetton effect," see Henry A. Giroux, "Consuming Social Change: The United Colors of Benetton," in Disturbing Pleasures: Learning Popular Culture, 3–24.

56. Frances Aparicio, "On Multiculturalism and Privilege: A Latina Perspective," American Quarterly 46, no. 4 (December 1994): 584.

57. McLaren, "White Terror and Oppositional Agency: Towards a Critical Multiculturalism," 48.

58. Ibid., 49.

59. Steven D. Lavine, "Museum Practices," in *Exhibiting Cultures*, ed. Karp and Lavine, 151.

60. From the taped recording of the meeting, 5/9/87, CARA Archives, UCLA.

61. Ibid.

62. See letter from Marcos Sanchez-Tranquilino and Holly Barnet-Sanchez to John R. Lane, director of the San Francisco Museum of Modern Art, July 14, 1991, Barnet-Sanchez and Sanchez-Tranquilino Papers, Special Collections, Stanford University Libraries.

63. Ibid.

64. Sanchez-Tranquilino and Barnet-Sanchez, June 17, 1991, Barnet-Sanchez and Sanchez-Tranquilino Papers, Special Collections, Stanford University Libraries. Capitalized section in the original.

65. See letter from John R. Lane to Sanchez-Tranquilino and Barnet-Sanchez, July 9, 1991, Barnet-Sanchez and Sanchez-Tranquilino Papers, Special Collections, Stanford University Libraries.

66. The banners were originally going to depict children's art, effectively infantilizing the show with "seemingly welcome and innocuous art." See Marcos and Holly's letter of July 14, 1991.

67. Andrew Connors, personal interview, June 14, 1992.

68. Michael Baxandall, "Exhibiting Intention: Some Preconditions of the Visual Display of Culturally Purposeful Objects," in *Exhibiting Cultures*, ed. Karp and Lavine, 33–41.

69. Ibid., 37.

70. Ivan Karp, "Culture and Representation," in *Exhibiting Cultures*, ed. Karp and Lavine, 15.

71. "Preface: The CARA Exhibition," in CARA exhibition book, 27.

72. The organizers called this concept the Chicano Janus. See "Intellectual Content" of the third grant proposal to the NEH. "Like that of Janus, the Greek deity, Chicano identity was based on an ability as well as a need to monitor, investigate, and function simultaneously in more than one direction. . . . This bicultural analogy of the ability or necessity to look in two directions at once becomes crucial for encompassing the extensive array of historical and cultural conjunctions in which Chicano art looked continuously and simultaneously in at itself and out at the larger society" (7), Barnet-Sanchez and Sanchez-Tranquilino Papers, Special Collections, Stanford University Libraries.

73. González and Tonelli, "*Compañeros* and Partners," 263.

74. Ibid.

75. See Anzaldúa, "Haciendo caras," xv–xxviii.

76. Karp, "Culture and Representation," 15.

77. Anzaldúa, Borderlands, 78–79.

78. Claudia Schaefer, Textured Lives: Women, Art, and Representation in Modern Mexico, 16.

79. Schaefer explains that "the majority of [Kahlo's] self-portraits are done from the waist up" because possibly this view was "the most natural scope of perception for a prone invalid reproducing the images of her body from a mirror. One is reminded in particular of the mirrors suspended above her bed in Coyoacán during her frequent bouts of illness and recuperation" (ibid., 19).

80. See González and Tonelli, "Compañeros and Partners," 265.

3. Out of the House, the Halo, and the Whore's Mask

1. Sybil Venegas, "Conditions for Producing Chicana Art," ChisméArte 1, no. 4 (Fall/Winter 1977): 2.

2. Eva Sperling Cockcroft, "Chicano Identities," Art in America (June 1992): 85–91.

3. Michael Ennis, "Moving Pictures," rev. of CARA, Texas Monthly (July 1993): 56.

4. From the list of the exhibition's objectives, drawn up at the first planning meeting, November 1986, CARA Archives.

5. Slides of two murals by Mujeres Muralistas, Latinoamérica and Para El Mercado, were part of the slide show representing the murals of the movement.

6. See Sybil Venegas, "The Artists and Their Work: The Role of the Chicana Artist," ChisméArte 1, no. 4 (Fall/Winter 1977): 3, 5.

7. Though Yolanda deplores this designation, I call her a foremother of Chicana art because, as she herself has stated, "In 1969 I consciously declared myself a Chicana artist, without knowing anything about what that meant, fully realizing that it was an act of invention." Because Yolanda was at the forefront of that act of self-invention as a woman of Mexican descent in a time when the only parameters for understanding Chicano identity were nationalist, sexist, and patriarchal, she had no models to emulate and no mentors of Chicanisma. She carved her aesthetics of empowerment in a deliberate and lonely course of political awareness. Today she is a mentor and a model, not only for Chicana artists, but for all Chicanas committed to the struggle for race, class, and gender liberation through the free expression of the self.

8. Yolanda M. López, personal interview, San Francisco, California, January 1994.

9. Shifra Goldman, "Mujeres de California: Latin American Women Artists," in Dimensions of the Americas: Art and Social Change in Latin America and the United States, 215.

10. Amalia Mesa-Bains, "Quest for Identity: Profile of Two Chicana Muralists," in *Signs from the Heart*, ed. Cockcroft and Barnet-Sanchez, 76.

11. See Kate Millett, *Sexual Politics*.

12. Norma Alarcón, "The Theoretical Subject(s) of *This Bridge Called My Back* and Anglo-American Feminism," in *Criticism in the Borderlands: Studies in Chicano Literature, Culture, and Ideology*, ed. Héctor Calderón and José David Saldívar, 32.

13. For a fundamental grounding in theories of gender subversion, white privilege, and critiques of essentialism, see Simone de Beauvoir, *The Second Sex*, trans. H. M. Parshley (New York: Bantam Books, 1970); Adrienne Rich, "Compulsory Heterosexuality and Lesbian Existence," *Signs* 5 (Summer 1980): 631–660; Monique Wittig, "One Is Not Born a Woman," *Feminist Issues* (Winter 1981): 47–54; Aída Hurtado, "Relating to Privilege: Seduction and Rejection in the Subordination of White Women and Women of Color," *Signs* 5 (Autumn 1989): 833–855; Chandra Mohanty, "Under Western Eyes: Feminist Scholarship and Colonial Discourses," in *Third World Women and the Politics of Feminism*, ed. Chandra Talpade Mohanty, Ann Russo, and Lourdes Torres, 51–80; Angela Davis, *Women, Race, and Class* (New York: Random House, 1981); Chela Sandoval, "Feminism and Racism: A Report on the 1981 National Women's Studies Association Conference," in *All the Women Are White, All the Blacks Are Men, But Some of Us Are Brave*, ed. Gloria T. Hull, Patricia Bell Scott, and Barbara Smith (Westbury, N.Y.: Feminist Press, 1982); Gloria Anzaldúa, "La conciencia de la mestiza: Towards a New Consciousness," in *Borderlands/La Frontera*, 77–98; Emma Pérez, "Sexuality and Discourse: Notes from a Chicana Survivor," in *Chicana Lesbians: The Girls Our Mothers Warned Us About*, ed. Carla Trujillo, 159–184; Angie Chabram-Dernersesian, "I Throw Punches for My Race, But I Don't Want to Be a Man: Writing Us—Chica-nos (Girl, Us)/Chicanas—into the Movement Script," in *Cultural Studies*, ed. Lawrence Grossberg, Cary Nelson, and Paula Treichler, 81–95; and Deena J. González, "Chicana Identity Matters," in *Culture and Difference: Critical Perspectives on the Bicultural Experience in the United States*, ed. Antonia Darder, 41–53.

14. Sonia López, "The Role of the Chicana within the Student Movement," in *Essays on la Mujer*, ed. Rosaura Sánchez and Rosa Martínez Cruz (Los Angeles: UCLA Chicano Studies Research Center Publications, 1977), 16–29.

15. Armando Rendón, *Chicano Manifesto*, 187.

16. Mayan interpreter for Hernán Cortés during the Conquest of Mexico, who later bore a child by Cortés believed to be one of the first mestizos. In Chicanismo, the term *malinche* applied generically to both men and women who were perceived as betraying la Raza. According to Rendón, "malinches are worse characters and more dangerous than the Tio Tacos, the Chicanismo euphemism for Uncle Tom. The Tio Taco may stand in the way of progress only out of fear or misplaced self-importance. In the service of the gringo, malinches attack their own brothers, betray our dignity and manhood, cause jealousies and misunderstandings among us, and actually seek to retard

the advance of the Chicanos, if it benefits themselves—while the gringo watches" (97). Interestingly, while the masculine-gendered euphemism for traitor, Tío Taco or Uncle Tom, is forgiven on psychological grounds, the feminine-gendered Malinche, equated as she is with the historical Doña Marina, described by Rendón as "Cortez' concubine . . . interpreter and informer against her own people" (96), is afforded no psychological justification for her actions.

17. Ibid., 3.

18. Ibid., 181.

19. Ibid., 188.

20. Andrea Gómez and Sylvia Gonzales, editorial, El Rebozo, San Antonio, Texas, July 1995.

21. Quoted in Córdova, "Roots and Resistance," 175.

22. Emma Pérez, "Sexuality and Discourse: Notes from a Chicana Survivor," in Chicana Lesbians: The Girls Our Mothers Warned Us About, ed. Carla Trujillo, 160.

23. Ignacio M. García, "Chicano Studies since 'El Plan de Santa Barbara,'" in Chicanas/Chicanos at the Crossroads: Social, Economic, and Political Change, ed. David R. Maciel and Isidro D. Ortiz. See fn. 27 on 202.

24. Ibid., fn. 24 on 202. As a resident Chicana lesbian of one of these "hotbeds of feminist discourse," I feel honored to be included in the company of such notable feministas as Vilma Ortiz, Camille Guerín-Gonzales, Sonia Saldívar-Hull, and Judy Baca (UCLA), Deena J. González and Lourdes Argüelles (the Claremont Colleges), Yolanda Broyles-González, Chela Sandoval, and, until 1995, Antonia Castañeda (University of California at Santa Barbara), Norma Alarcón and Carla Trujillo (University of California at Santa Barbara).

25. Judy Baca is also included in this section, but her work appears prominently in two other sections of the exhibit, the Murals display and the "Urban Images" room.

26. Quoted in Shifra Goldman, "'Portraying Ourselves': Contemporary Chicana Artists," in Feminist Art Criticism, ed. Arlene Raven, Cassandra Langer, and Joanna Frueh, 205.

27. From the wall copy accompanying the piece.

28. Quoted in "Introduction: Feminism and Art in the Twentieth Century," catalog essay by Norma Broude and Mary D. Garrard, in The Power of Feminist Art: The American Movement of the 1970s, History and Impact, 22.

29. Ibid.

30. Goldman, "'Portraying Ourselves,'" 195.

31. Coined by Miriam Schapiro and Judy Chicago in the early seventies, the term "cunt art," like "Black Power," "Chicano Power," and "Queer Nation," radically revised a derogatory label from an insider's perspective.

32. Broude and Garrard explain the difference between these terms: "Cul-

tural essentialism, roughly equivalent to what is today called socially constructed femininity, is society's gender-stereotyped conditioning of women's self-image and experience. . . . Although it was not so named, cultural essentialism was recognized in the early 1970s as the problem to which *political* essentialism—the deliberate celebration of culturally essentialist forms—offered a solution" ("Introduction," 25).

33. See Gayatri Chakravorty Spivak, "Practical Politics of the Open End," in *The Post-Colonial Critic: Interviews, Strategies, Dialogues*, edited by Sarah Harasym, 95–112. Spivak contends that "it is not possible not to be an essentialist [and so] one can self-consciously use this irreducible moment of essentialism as part of one's strategy" since, "no representation can take place without essentialism" (109). See also "The Problem of Cultural Self-Representation" in the same volume, wherein she argues that essentializing is indispensable to deconstructive practice. Because the critic is "going to essentialize anyway," Spivak argues that the critic can look at essentialism strategically, "not as descriptions of the way things are, but as something that one must adopt to produce a critique of anything" (51).

34. Ennis, "Moving Pictures," 56.

35. The Larousse dictionary of the Spanish language defines *espejismo* as "ilusión óptica, imagen engañosa. Por la cual objetos lejanos parecen estar cerca" (mirage: optical illusion, deceptive image. In which a distant object appears to be nearby).

36. See "Catalog of the Exhibition," in CARA exhibition book, 256.

37. Sanchez-Tranquilino and Tagg, "The Pachuco's Flayed Hide: The Museum, Identity, and Buenas Garras," 100.

38. Stephen Greenblatt, "Resonance and Wonder," in *Exhibiting Cultures*, ed. Karp and Lavine, 42.

39. Amalia Mesa-Bains, "El Mundo Femenino: Chicana Artists of the Movement—A Commentary on Development and Production," in CARA exhibition book, 133.

40. Chabram-Dernersesian, "I Throw Punches for My Race, But I Don't Want to Be a Man," 83.

41. Diminutive of Guadalupe, reference to the Virgin.

42. Yolanda M. López, untitled, unpublished paper delivered at the Culture and Society in Dialogue: Issues in Chicana Scholarship Conference at University of California, Irvine, May 14, 1993.

43. La Llorona is the mythic weeping woman of Mexican and Chicano/a popular culture, said to have drowned her children in exchange for eternal life and cursed for eternity to wander riverbanks and ditches crying out for her children. In some interpretations of the legend, La Llorona signifies the loss of Tenochtitlan at the hands of the Spanish *conquistadores* and also the loss of Aztlán at the hands of Anglo imperialists. For poetic treatments of the legend, see Alurista, "must be the season of the witch," in *Voices of Aztlán*:

Chicano Literature of Today, ed. Dorothy E. Harth and Lewis M. Baldwin (New York: New American Library, 1974), 179, Alicia Gaspar de Alba, "Malinchista: A Myth Revised," in Three Times a Woman: Chicana Poetry (Tempe: Bilingual Press, 1989), 16–17, and Naomi Quiñonez, "La Llorona," in Sueño de Colibri/Hummingbird Dream (Los Angeles: West End Press, 1985), 8–9. For a critical perspective, see Tey Diana Rebolledo, "From Coatlicue to La Llorona: Literary Myths and Archetypes," in Women Singing in the Snow: A Cultural Analysis of Chicana Literature (Tucson: University of Arizona Press, 1995), 49–81.

44. See the brochure to her exhibition, The Art of Provocation: Ester Hernández, A Retrospective, held from October 10 to November 17, 1995, at the C. N. Gorman Museum of the Native American Studies Department at the University of California, Davis.

45. See Rubén Darío's 1903 poem "To Roosevelt," in Selected Poems, trans. Lysander Kemp, 69–70.

46. Inés Hernández, "An Open Letter to Chicanas: On the Power and Politics of Origin," in Without Discovery: A Native Response to Columbus, ed. Ray González (Seattle: Broken Moon Press, 1992), 161.

47. Ibid., 160.

48. Alicia Gaspar de Alba, "Tortillerismo: Work by Chicana Lesbians," Signs: Journal of Women in Culture and Society 18, no. 4 (Summer 1993): 962 (special issue on "Theorizing Lesbian Experience"). Tortillera is a Latin American colloquialism for lesbian.

49. See Adelaida del Castillo, "Malintzin Tenepal: A Preliminary Look into a New Perspective," in Essays on la Mujer, ed. Rosaura Sánchez and Rosa Martínez Cruz, 124–149; Norma Alarcón, "Chicana's Feminist Literature: A Re-Vision through Malintzin/or Malintzin: Putting Flesh Back on the Object," in This Bridge Called My Back: Writings by Radical Women of Color, ed. Cherríe Moraga and Gloria Anzaldúa (New York: Kitchen Table/Women of Color Press, 1981), 182–190; Cherríe Moraga, "A Long Line of Vendidas," in Loving in the War Years: Lo que nunca pasó por sus labios (Boston: South End Press, 1983), 90–144; Deena J. González, "Encountering Columbus," in Chicano Studies: Critical Connection between Research and Community, ed. Téresa Córdova (n.p.: National Association for Chicano Studies, 1992), 13–19, and "Chicana Identity Matters," in Culture and Difference: Critical Perspectives on the Bicultural Experience in the United States, ed. Antonia Darder, 45–53.

50. See bell hooks, Yearning: Race, Gender, and Cultural Politics.

51. See Audre Lorde, "The Master's Tools Will Not Dismantle the Master's House," in Sister/Outsider: Essays and Speeches, 110–113.

52. Cherríe Moraga, "En busca de la fuerza femenina," in The Last Generation: Prose and Poetry, 71–72.

53. See Kay Turner, "Mexican-American Women's Altars: The Art of Relationship."

54. "Craziness cures" and "We're here and we're not leaving."

55. See "Catalogue of the Exhibition," in CARA book, 290.

56. Carlos Almaraz died of an AIDS-related condition on December 11, 1988.

57. See "Catalogue of the Exhibition," in CARA book, 288.

58. Harry's sister, Diane Gamboa, occasionally participated in the group's activities.

59. Sanchez-Tranquilino, "Murales," 98.

60. Revelaciones was an exhibition of site-specific installations held at Cornell University's Herbert F. Johnson Museum of Art from November 6 to December 19, 1993. The exhibit included an installation by Gronk, one of the founders of ASCO.

61. Chon Noriega, "Installed in America," curatorial essay in Revelaciones/Revelations: Hispanic Art of Evanescence, unbound exhibition catalog.

62. Shifra M. Goldman, "How, Why, Where, and When It All Happened: Chicano Murals in California," in Signs from the Heart, ed. Cockcroft and Barnet-Sanchez, 44.

63. Taken from ASCO's personal statement in Imagine: International Chicano Poetry Journal, Arte Chicano issue, 3, nos. 1–2 (Summer–Winter 1986): 64.

64. Patssi Valdéz's slides were supposed to be projected upon the veil, thus representing her contribution to the installation, but the images did not show up clearly.

65. "I had absolutely nothing to do with it," states Harry Gamboa, founding member of ASCO. Gamboa's original idea for the installation consisted of a documentary 10-minute video that, as he states in his proposal for the project, "would effectively present many of the visual aspects of the creations . . . the concepts, events, and personalities" of the collective (see CARA Archives, Wight Art Gallery, UCLA). Due to personal conflicts between Gamboa and the other three members of ASCO, the documentary was never produced, and Gamboa distanced himself from the installation altogether. Personal conversation with the artist, Los Angeles, January, 1994.

66. Goldman, "Mujeres de California," 227.

67. The blue house of Coyoacán: Frida Kahlo's house in Coyoacán, a suburb of Mexico City, painted a royal blue on the outside.

68. See James Clifford, "Histories of the Tribal and the Modern," in The Predicament of Culture: Twentieth-Century Ethnography, Literature, and Art.

69. Ibid., 193, 195.

70. As a result of the bus accident that left Frida sterile, she became obsessed with the illusion of childbearing and depicted herself as pregnant in several paintings.

71. From the minutes of the first meeting, CARA Archives.

72. See Rupert García: Prints and Posters, 1967–1990/Grabados y afiches 1967–1990, exhibition catalog, 53.

73. Alvina Quintana, "Politics, Representation, and the Emergence of a Chicana Aesthetic," Cultural Studies 4, no. 3 (October 1990): 258, special issue: "Chicana/o Cultural Representations: Reframing Alternative Critical Discourses," ed. Rosa Linda Fregoso and Angie Chabram, assisted by Lawrence Grossberg.

74. Claudia Schaefer, Textured Lives, 15.

75. Goldman and Ybarra-Frausto, "The Political and Social Contexts of Chicano Art," in CARA exhibition book, 90.

76. Alfred Kay, "Chicano Exhibit Embodies History," Marin Independent Journal (July 4, 1991): n. pag., media packet, CARA Archives, UCLA.

77. Fiske, Understanding Popular Culture, 45.

78. See Hall, "Encoding, Decoding," in The Cultural Studies Reader, ed. Simon During, 90–103.

79. Ibid., 103.

80. See letter from Elizabeth Shepherd, curator of the Wight Gallery, to Yolanda M. López, dated November 8, 1993, in which she cites the following statistics that mark the impact of CARA's three-year tour in the culture industry: "1) over 300,000 people attended the exhibition, 2) 7,376 copies of the catalogue have been distributed, 3) over 10,000 Kindergarten–12th grade public school curriculum packets and over 1,000 exhibition videotapes have been distributed nationwide, 4) [the Gallery has] been overwhelmed by requests for photographs from publishers who want to include images from CARA in their forthcoming publications, 5) CARA is the subject of a University of New Mexico student's doctoral dissertation." Personal archives, Yolanda M. López.

4. "Between the Ghetto and the Melting Pot"

1. From the CARA comment book of the Albuquerque Museum of Art.

2. From the CARA comment books of the National Museum of American Art.

3. From the CARA comment book of the Albuquerque Museum of Art.

4. William Wilson, "Chicano Show Mixes Advocacy, Aesthetics," Los Angeles Times (September 12, 1990): F7.

5. See the New Yorker (May 3, 1993): 17.

6. Hall, "Encoding," 100.

7. Ibid., 101.

8. Modleski, Studies in Entertainment, xi.

9. Chiori Santiago, rev. of CARA, "La Raza Goes Uptown," San Francisco Weekly (June 26, 1991): 13.

10. During its stay at the Wight Gallery, listings and announcements of the exhibit appeared in Artweek, the Los Angeles Times, Hispanic Business, L.A. Maga-

zine, *La Opinión, Image, Hispanic, Artscene, Arts Quarterly, Art of California, L.A. West, UCLA Magazine, AHA! Hispanic Arts News, Hollywood Reporter,* and *Elle.*

11. Table 2 breaks the reviews down into local, national, and arts periodicals. The *Washington Post* and the *New York Times* have been counted as both local and national papers; therefore, the reviews of CARA published therein are counted in both the local/daily and the national/news categories. Similarly, the *New Yorker* and *Village Voice* were both tagged as local weekly and national "other" (i.e., literary, cultural) publications. The actual totals for the Washington, D.C., and New York venues were 20 and 6, respectively. The listing of reviews for the San Antonio venue was incomplete at the time of this writing.

12. See Peter Plagens (with Lynda Wright), "Multiculturalism or Bust, Gang," rev. of Los Angeles Festival, *Newsweek* (September 24, 1990): 68.

13. "The definition of a hegemonic viewpoint," says Hall, "is (a) that it defines within its terms the mental horizon, the universe, of possible meanings, of a whole sector of relations in a society or culture; and (b) that it carries with it the stamp of legitimacy—it appears coterminous with what is 'natural,' 'inevitable,' 'taken for granted' about the social order" ("Encoding," 102).

14. Ibid., 101.

15. See "Chicano Art on Display," rev. of CARA, *Bakersfield Californian* (November 3, 1991): F1.

16. See Sandoval, "U.S. Third World Feminism."

17. Steven Rosen, "'Chicano Art' Show Had Political Thrust," rev. of CARA, *Denver Post* (March 24, 1991): n. pag., media packet, CARA Archives, UCLA.

18. Hall, "Encoding," 98.

19. Ibid., 100.

20. Betty Ann Brown, "A Community's Self-Portrait," rev. of CARA, *New Art Examiner* (December 1990): 20.

21. Ian Hunter, "Aesthetics and Cultural Studies," in *Cultural Studies*, ed. Lawrence Grossberg, Cary Nelson, and Paula Treichler, 347.

22. Ibid., 356.

23. Ibid.

24. Ibid., 358.

25. Ibid., 359. Hunter says that aesthetics must be located within a "history of the means by which individuals have come to form themselves as the subjects of various kinds of experience and action and to endow their lives with particular kinds of significance and shape" (359).

26. Lucy R. Lippard, *Mixed Blessings: New Art in a Multicultural America*, 7.

27. See ibid.

28. William Wilson, "Stop the Art World and Let 1990 Off," *Los Angeles Times* (December 23, 1990): F1.

29. Steven Vincent, "Political Correctness and Its Discontents," *Art and Auction* (June 1992): 86.

30. Catherine Fox, "You've Got to Have Art, Washington's Mall Has It All," *Atlanta Journal/Atlanta Constitution* (May 27, 1992): E8.

31. See Douglas Davis, "What Is Content?" reprinted in *Artculture: Essays on the Post-Modern*, 44–55.

32. Ibid., 49.

33. Ibid., 54.

34. Rosen, "'Chicano Art' Show Had Political Thrust," n. pag., media packet, CARA Archives, UCLA.

35. Eric Gibson, "Politically Correct 'Chicano' Is a Radical Dud," rev. of CARA, *Washington Times* (June 21, 1992): D8.

36. Paul Richard, "The Colors of Struggle: The Politicized Palette of 'Chicano Art,'" rev. of CARA, *Washington Post* (May 10, 1992): G1.

37. William Wilson, "Advocacy, Aesthetics," *Los Angeles Times* (September 12, 1990): F7.

38. David Littlejohn, "Art in Service of Revolution," rev. of CARA, *Wall Street Journal* (August 29, 1991): A10.

39. See Bruce Nixon, "Art with an Historic Mission," rev. of CARA, *Artweek* (September 27, 1990): 1.

40. Andrew Connors, personal interview, June 15, 1992.

41. María Acosta-Colón, "Chicano Art: Time for a New Aesthetic," letter to the editor/rev. of CARA, *Los Angeles Times* (September 24, 1990): F3.

42. Brown, "A Community's Self-Portrait," 24.

43. Marcos Sanchez-Tranquilino, letter to the editor, *New Art Examiner* (April 1991): 3.

44. See Henry Louis Gates, Jr., *Loose Canons: Notes on the Culture Wars*.

45. Ibid., xv.

46. See Dan Nicolai, "Columbus Commission on the Rocks," *Huracán: 500 Years of Resistance* 2, nos. 1–2 (Summer 1991), for the outcome of the caravel story, the upshot of which is that Texaco did not meet its end of the contract.

47. Editorial, *Huracán: 500 Years of Resistance* 2, nos. 1–2 (Summer 1991): 12.

48. See Howard Zinn, *A People's History of the United States*.

49. See "Exploding the Columbus Myth! De-Celebration in the News," *Indigenous Thought* 1, no. 1 (January–February 1991): 1.

50. See Ward Churchill, "Deconstructing the Columbus Myth: Was the 'Great Discoverer' Italian or Spanish, Nazi or Jew?" *Indigenous Thought* 1, nos. 2–3 (March–June 1991): 28A–31A.

51. Ibid., 29A.

52. Elazar Barkan, "Producing Columbus: American Identity and the Quincentenary," in *The Columbian Quincentenary: A Reappraisal*, exhibition catalog, 5.

53. Shifra Goldman, "How Latin American Artists in the U.S. View Art,

Politics, and Ethnicity in a Supposedly Multicultural World," in *Beyond Walls and Wars: Art, Politics, and Multiculturalism,* ed. Kim Levin, 69.

54. See "Columbus Quincentenary Commemoration 1492–1992 at the Smithsonian Institution," 1. This program of events was a two-color, 35-page publication available to the public.

55. Alicia González, "*Compañeros* and Partners," in *Museums and Communities,* ed. Ivan Karp, Christine Mullen Kreamer, and Steven D. Lavine, 269. Dr. González declined giving an interview for this research, except to describe the issues that CARA brought to the Smithsonian as "minefields."

56. Part of the logistics was the amount of time it took for the CARA organizers to submit slides to the NMAA, without which the museum could not accept the show. "It was almost a year and a half of waiting for slides and checklists," said Andrew Connors. "There were a bunch of other exhibitions that we were trying to schedule at the same time. So, unfortunately, there was a decision made at the administrative level, without consulting those of us interested in the project, that we were no longer able to consider the CARA show. . . . Obviously, that set off a minefield. We were besieged with letters. I was very pleased that each one of those letters came in. It was more fuel for my fire" (Connors, interview).

57. Maggie Bertin, "The Latino Working Committee: The Challenge of Cultural Representation in a Large Museum," lecture presented at the Inter-University Program for Latino Research, Latino Graduate Training Seminar in Qualitative Methodology—Interpreting Latino Cultures: Research and Museums, June 18, 1995. Unfortunately, due to the controversies generated in Washington, D.C., by the Quincentenary in 1992, the Smithsonian experienced what Bertin called "brown flight" from that institution in 1993. It would seem that the Latino initiative at the Smithsonian was doomed by its association with the Quincentennial.

58. See the NMAA's program of events related to CARA.

59. Christine Spolar, "D.C. Police, Hispanics Reach Out," *Washington Post* (May 4, 1992): A1. See also Rubén Castañeda and Al Kamen, "Roots Were East Side's Riot Shield: Established Hispanic Neighborhoods Mobilize to Avert L.A. Violence," *Washington Post* (May 5, 1992), sec. A: 1, 11; Gabriel Escobar, "A Year after Unrest, D.C. Hispanics Remain United Despite Diversity," *Washington Post* (May 3, 1992), sec. A: 1, 22–23; Nell Henderson, "Power at Ballot Box Eludes D.C. Hispanics: Task Force Attempts to Bridge the Gap," *Washington Post* (May 5, 1992), sec. A: 1+; Sari Horwitz, "A School Vies for Attention from City," *Washington Post* (May 5, 1992), sec. A: 16–17.

60. See González, "Encountering Columbus," 19.

61. Connors, interview.

62. "Columbus Quincentenary Commemoration," 7.

63. Celia McGee, "When Museumgoers Talk Back to the Art," *New York Times* (April 25, 1993): sec. 2: 38.

64. Hank Burchard, "How the West Was Rewritten," rev. of *West as America* exhibit, *Washington Post* (March 15, 1991): 1. See also Robert Hughes, "How the West Was Spun," *Time* (May 13, 1991): 79–80, and Stephen May, "Rethinking Western Art: A Revisionist Exhibition Stirs Controversy," *Southwest Art* (October 1991): 100–109.

65. Charles Krausthammer, "Smithsonian Exhibit Takes Revisionism Back to the Frontier," *Albuquerque Journal* (June 4, 1991): n. pag.

66. Quoted in ibid.

67. Quoted in Alan Wallach, "Revisionism Has Transformed Art History, But Not Museums," rev. of *West as America* exhibit, *Chronicle of Higher Education* (January 22, 1992): B2.

68. Hank Burchard, "Celebrating Chicano Art," rev. of CARA, *Washington Post* (May 8, 1992): n. pag, media packet, CARA Archives, UCLA.

69. Paul Richard, "The Colors of Struggle," G1.

70. Connors, interview.

71. Ibid.

72. Ibid. There were examples of factual errors that were corrected. In one of the historical panels, for example, Juan Diego was described as a mestizo, when he was, in fact, an Indian. Also the IWW was identified as the International Workers of the World rather than the Industrial Workers of the World.

73. Ibid.

74. Bertin, "The Latino Working Committee."

75. Connors, interview.

76. *Willful Neglect: The Smithsonian Institution and U.S. Latinos*, a report of the Smithsonian Institution Task Force on Latino Issues, Washington, D.C., May 1994, 26.

77. See Elizabeth Broun's response in the "Detailed Appendices," in ibid.

78. *Willful Neglect*, 37.

79. Ibid., 30.

80. This paper was presented on the Faces of Quality: The CARA Exhibit panel I organized at the American Studies Association Convention, Boston, Massachusetts, November 1993.

81. Taped recording of Professor McKenna's comments, American Studies Association Convention, Boston, Massachusetts, November 1993.

82. All comments about the Washington, D.C., show are taken from the National Museum of American Art's comment books. Thanks to Andrew Connors for providing copies and to Elizabeth Broun for permitting me to use them here.

83. "The art must maintain its *locura* (creative fury), and retain the beauty of the *plebe* or working class from which it springs" ("Preface" to the CARA exhibition book, 29).

84. Of the sites that I visited, only the Albuquerque Museum of Art and

the National Museum of American Art in Washington, D.C., provided comment books; the El Paso Times had response sheets that viewers could fill out and deposit in a box, from which the paper printed selected responses. Tucson offered viewers a forum for comments, some of which were reprinted in the Tucson Citizen. In Denver, viewers were given sheets of newsprint on which to express their reactions.

85. McGee, "When Museumgoers Talk Back to the Art," sec. 2: 37.

86. I have contextualized all of the viewer comments (including the ones I quote directly as well as the ones transcribed in Appendix A and all of those which for various reasons I could not access), as well as many of the local reviews, especially the ones published in the Spanish-language press, in the framework of Chicanismo.

87. Quoted in Linda Terhune, "Colors of Protest: Denver Art Exhibit Gives an Inside Look into Chicano Culture," rev. of CARA, Colorado Springs Gazette Telegraph (February 15, 1991): E1.

88. Dan R. Goddard, "CARA: It's Part Politics, Part Journalism, All Community Pride," rev. of CARA, San Antonio Express (May 30, 1993): 4F.

89. Robert Nelson, "Art Exhibit to Emphasize Local Talent," rev. of CARA, El Paso Times, "El Tiempo" (August 21, 1992): 8.

90. Juan Espinosa, untitled rev. of CARA, Pueblo Chieftain (February 10, 1991): 2D.

91. All comments about the Albuquerque show have been taken from the Albuquerque Museum of Art's comment books. Thanks to director James Moore for providing copies and permitting me to use them here.

92. See Alicia Gaspar de Alba, "El pueblo que pierde su memoria pierde su destino: Un análisis de la esquizofrenia cultural en el pueblo chicano," in Palabras de allá y de acá: Memoria del sexto encuentro nacional de escritores en la frontera norte de México, ed. Ricardo Aguilar, 226. Translation: "The confusion created by all of these different labels only serves to erect more borders between people who share the same blood, and those borders, with the help of historical amnesia—provoked by the dominant culture's educational system—fragment the individual consciousness as much as the collective destiny of Chicanos/as."

93. Hall, "Encoding," 97.

94. Ennis, "Moving Pictures," 52.

95. James Moore, personal interview, October 9, 1992.

96. Albert Noyer, "Chicano Art: Anger, Humor and Love from the Barrio," rev. of CARA, East Mountain Telegraph (April 18, 1991): 10.

97. We will see what happened in the El Paso venue in the last chapter.

98. Moore, interview.

99. Quoted in Alva B. Torres, "CARA Draws Raves from Museumgoers" (February 4, 1992), n. pag., media packet, CARA Archives, UCLA.

100. From the NMAA comment books.

101. From the NMAA comment books.

102. All El Paso comments are cited in "CARA Exhibit Stirs Souls, Emotions," El Paso Times (September 8, 1992): 5D.

103. From the NMAA comment books.

104. From the NMAA comment books. Translation: "What to do in this country on the fourth of July with those fascist parades passing just a few steps away from here? How to withstand those joyous cries of 'freedom' and 'democracy' that they issue here without thinking? Today, the fourth of July, a day like any other, I have felt the power of all of that which the oppressors insist on hiding. They cannot do so. They have not done so. Popular hegemony is here. It speaks for itself."

105. Raymond Williams, "Base and Superstructure in Marxist Cultural Theory," in Rethinking Popular Culture, ed. Mukerji and Schudson, 412–413.

106. The "selective tradition," says Williams, is "that which, within the terms of an effective dominant culture, is always passed off as 'the tradition,' 'the significant past.' But always the selectivity is the point; the way in which from a whole possible area of past and present, certain meanings and practices are chosen for emphasis, certain other meanings and practices are neglected and excluded. Even more crucially, some of these meanings and practices are reinterpreted, diluted, or put into forms which support or at least do not contradict other elements within the effective dominant culture" (ibid., 414).

107. Stuart Hall, "What Is This 'Black' in Black Popular Culture?" in Black Popular Culture, a project by Michelle Wallace, ed. Gina Dent, 26.

108. Fiske, Understanding Popular Culture, 23.

109. Ibid., 45.

110. Quoted in Rubén Hernández, "California: Chicano Art Exhibition," rev. of CARA, Hispanic (November 1990): 58.

111. Weil, Rethinking the Museum, 56.

Conclusion: The Mutation of Multiculturalism

1. Aparicio, "On Multiculturalism and Privilege," 582.

2. Ibid., 578.

3. See Chapter 7 in Gloria Anzaldúa, Borderlands/La Frontera: The New Mestiza.

4. Anzaldúa, Haciendo Caras, xxii.

5. Ibid., xxi.

6. Catherine Lord, "Bleached, Straightened, and Fixed: The Cooptation of Cultural Pluralism," New Art Examiner (February 1991): 27.

7. Robin Cembalest, "Goodbye, Columbus?" ARTnews (October 1991): 104–109. She cites demographic statistics for Los Angeles in 1990 which

show that 38 percent of Angelenos were white, 36 percent were Latino, 15 percent were African American, and 12 percent were Asian American.

8. Indeed, the 1980s and early 1990s saw a plethora of ethnic exhibitions touring mainstream venues in the United States, with titles such as Mira! The Canadian Club Hispanic Art Tour; Expresiones Hispanas—The 1988/1989 Coors National Hispanic Art Exhibit and Tour; The Border/La Frontera; Free within Ourselves; Mistaken Identities; Shared Visions: Native American Painters and Sculptors in the Twentieth Century; Ante América/Regarding America; The View from Within: Japanese American Art from the Internment Camps, 1942–1945; Black Male: Representations of Masculinity in Contemporary American Art; Myth and Magic: Oaxaca Past and Present; and Parallels and Divergence: One Heritage, Two Paths, an exhibition that was to run concurrently with Mexico: Thirty Centuries of Splendors in Los Angeles and with CARA in Washington, D.C. (their juxtaposition meant to explore the relationship between Chicano art and the art of Latin America). For citations of other multicultural exhibitions see note 8 in the Introduction and notes 51 and 66 in this chapter.

9. Williams's concept of "alternative" cultures is not to be confused or conflated with my construction of the alter-Native, discussed at length in Chapter 1.

10. Williams, "Base and Superstructure," 416.

11. Ibid., 415.

12. Acuña, Occupied America, 379.

13. See Acuña's chapter "The Age of the Brokers: The New Hispanics," in Occupied America, 378.

14. For discussions on the presence of self-trained artists, folk-artists, artists of color, women artists, and others collectively deemed "outsiders" in the mainstream art world, see The Artist Outsider: Creativity and the Boundaries of Culture, ed. Michael D. Hall and Eugene W. Metcalf, Jr. (Washington, D.C.: Smithsonian Institution Press, 1994). See also the September 1994 issue of New Art Examiner, particularly "Speakeasy" by Russell Bowman, "Self-Taught Ethics: Regarding Culture" by Randall Morris, and "Voices: Nine Views on 'Outsider' Art from Those Who Make It, Show It, Collect It, and Write about It."

15. Camnitzer, "Access to the Mainstream," 22.

16. See Shifra Goldman, "Mexican Muralism: Its Influence in Latin America and the United States," in Dimensions of the Americas, 101–117.

17. While all of this discovering was going on in the art world and culture industry, the Smithsonian Institution was offering its associates significant discounts on two "entertaining and educational" study tours that had been organized in conjunction with the Columbus Quincentenary in 1992. These "Voyages to the New World Aboard the Sea Cloud" took place on a 359-foot, square-rigged, four-masted tall ship. The first cruise, from October 17 to November 5, was called "The Atlantic Crossing," and would trace, in the swords of the Smithsonian's press release, "Christopher Columbus' 1492 route across the Atlantic Ocean, with stops at the Canary Islands and the Ba-

hamas." The second, "The Bahamas to Hispaniola" cruise, from November 4 to November 14, would follow "the route described in Columbus' logbook, cruising past Cuba and ending in the charming colonial capital of Santo Domingo, which was founded by Columbus' brother in 1496." In this way, Smithsonian Associates were given the opportunity to "experience the thrill" of conquering the Caribbean all over again. See the "Detailed Appendices" to *Willful Neglect: The Smithsonian Institution and U.S. Latinos.*

18. Ybarra-Frausto, "The Chicano Movement/The Movement of Chicano Art," in *Exhibiting Cultures*, ed. Karp and Lavine, 145–146.

19. The root of "Esperantic" is Esperanto, defined in *Webster's Third New International Dictionary* as 1. "an artificial international language based as far as possible upon words common to the Chief European languages," and 2. "a usu. artificial language or set of symbols common to or designed to be common to a widely diverse and esp. international group." The Walt Disney corporation continues to traffic in these symbols, with such racist films as *Aladdin, The Lion King, Pocahontas,* and *The Indian in the Cupboard.*

20. See Gómez-Peña, "The Multicultural Paradigm," 52.

21. In schools, bilingual education—one of the principal struggles and goals of el Movimiento—became a means by which to help children assimilate to the dominant culture, teaching them mainstream values and beliefs in their native language. In the case of Mexican-American children, the mainstream values and beliefs they were assimilating included bigotry toward Mexicans and rejection of the Spanish language. Even in those cases where students retained their native language, what was being reinforced was not their native culture, but their own alienation from the dominant culture.

22. This is the famous Disneyland slogan.

23. Edmund Barry Gaither, "'Hey! That's Mine': Thoughts on Pluralism and American Museums," in *Museums and Communities: The Politics of Public Culture,* ed. Ivan Karp, Christine Mullen Kreamer, and Steven D. Lavine, 56.

24. See Harlan Ellison's introduction to the Special Deluxe Edition of the first issue, *Teenage Mutant Ninja Turtles* 1, no. 1 (August 1992): n. pag.

25. Ibid.

26. Ellison says that "as of the middle of May [1992]," the feature film, released by New Line Cinema, had made $109,585,273.77, "having cost a reputed mere 12 million to make." Merchandising of the Ninjas has exceeded $650 million, $150 million more than Batman.

27. See Cheech Marín's *Born in East L.A.* (1987).

28. Like Speedy González, Splinter is a projection of the dominant culture's phobia of ethnic Others who, like irrepressible rodents, are seen as "invading" the economic borders and infesting the cultural purity of the United States. Thus, Splinter is the late-twentieth-century version of the "sneaky [Oriental] rat" epitomized by the yellow peril stereotype of the 1940s. The

racist sentiments in all of this are cleverly masked by "cartoon" characters, who carry the mainstream message across to the children who view them.

29. For images of real-life underground dwellers, see Margaret Morton, The Tunnel: The Underground Homeless of New York City. These "mole-people," as they are called, live in a forsaken subway tunnel under Manhattan's Riverside Park. Composed mainly of homeless Vietnam veterans, addicts, and survivors of dysfunctional families, this subterranean community is entirely powerless, unlike its Ninja Turtle counterparts.

30. In a scene in the first film, the Turtles are dropped off in front of their manhole in a rainstorm. Riding in the back of the white man's truck, Raphael says "Now I know what it's like to travel without a green card." For a detailed analysis of this popular construction of immigrants as aliens, see Charles Ramírez Berg, "Immigrants, Aliens, and Extraterrestrials: Science Fiction's Alien 'Other' as (among Other Things) New Hispanic Imagery," CineAction! (Fall 1989): 3–17.

31. See the films El Norte (1987), directed by Gregory Nava, and The Border (1981), directed by Tony Richardson.

32. For a review of the literature of multicultural education, see Christine E. Sleeter and Carl A. Grant, "An Analysis of Multicultural Education in the United States," Harvard Educational Review 57, no. 4 (November 1987): 421–444. This review focuses on five specific approaches to pedagogy and methodology that would fit under the rubric "multicultural." To differentiate among the several meanings of "multicultural education," Sleeter and Grant devise the following categories: (1) "teaching the culturally different," an approach that resembles bilingual education in its goal of eventual assimilation; (2) "human relations," an approach that aims to teach children how to negotiate cultural and racial differences for the sake of getting along, both with one another and within society; (3) "single group studies," an approach that concentrates on the experiences of a particular ethnic group that is not white; (4) "multicultural education," an approach that advocates for differences and does not encourage assimilation; and, finally, (5) "education that is multicultural and social reconstructionist," an approach that employs the methodology of multicultural education for the purpose of preparing students for social action against institutionalized ethnocentrism, racism, and sexism. See also William M. Chace, "The Real CHALLENGE of Multiculturalism," Education Digest (May 1991): 35–36; James S. Coleman, "A Quiet Threat to Academic Freedom," National Review (March 18, 1991): 28, 30–33; María de la Luz Reyes and John J. Halcón, "Racism in Academia: The Old Wolf Revisited," Harvard Educational Review 58, no. 3 (August 1988): 299–313; Lisa D. Delpit, "The Silenced Dialogue: Power and Pedagogy in Educating Other People's Children," Harvard Educational Review 58, no. 3 (August 1988): 280–298.

33. First verse. From the manual of the Theta Xi fraternity at UCLA.

34. Stephen Salisbury, "Wild in the Streets: Sex, Cities, and the NEA," *American Poetry Review* 21 (November–December 1992): 11–18.

35. Janet Wolff, *Aesthetics and the Sociology of Art*, 12.

36. Calvin Reid, "Beyond Mourning," *Art in America* 78, no. 4 (April 1990): 51–57.

37. For more detailed accounts of the NEA saga, see Carole S. Vance, "Issues and Commentary: The War on Culture," *Art in America* 77 (September 1989): 39–43, "Misunderstanding Obscenity," *Art in America* 78 (May 1990): 49–55, "Issues and Commentary I: Reagan's Revenge: Restructuring the NEA," *Art in America* 78 (November 1990); Douglas Davis, "Art and Contradiction: Helms, Censorship, and the Serpent," *Art in America* 78, no. 5 (May 1990): 55–59; Peggy Phelan, "Money Talks, Again," *Drama Review* 35, no. 3 (Fall 1991): 131–141; Maurice Berger, "Too Shocking to Show?" *Art in America* 80, no. 7 (July 1992): 37–39; Dante Ramos, "Jane's Addiction: Can Ms. Alexander Save the NEA?" *New Republic* 212, nos. 2–3 (January 9, 1995): 23–25; Lynda Hart, "Karen Finley's Dirty Work: Censorship, Homophobia, and the NEA," *Genders* 14 (Fall 1992): 1–15; Calvin Reid, "Court Rejection of NEA 'Decency Standard' Viewed as 'Breakthrough,'" *Publishers Weekly* 239, no. 27 (June 15, 1992): 8–10; Timothy Cone, "Limited Partnership: The NEA and the Arts," *Arts Magazine* 64 (November 1989): 13–14; Brian Wallis, "Issues and Commentary II: Bush's Compromise: A Newer Form of Censorship," *Art in America* 78 (November 1990): 57–63, 210; Samuel Lipman, "Backward and Downward with the Arts," *Commentary* 89 (May 1990): 23–26; Leonardo Shapiro, "The Tip of the Iceberg: Creativity and Repression in the U.S.," *Performing Arts Journal* 13 (September 1991): 25–41; David Bosworth, "Hard Being Good: Reaganomics, Free Expression, and Federal Funding of the Arts," *Georgia Review* 45 (Fall 1991): 441–462; Maurice Berger, "Democracy, Inc.: On the NEA," *Artforum* 31 (September 1992): 10–11; Maurice Berger and Ronald Felman, "The Future of the National Endowment for the Arts," *Artforum* 31 (January 1993): 72–73.

38. Stuart Hall, "What Is This 'Black,'" 25.

39. From the meaning of "democratic," in *Merriam-Webster's Collegiate Dictionary*, 10th ed.

40. Luke, *Shows of Force*, 3.

41. See Karp and Lavine, "Introduction: Museums and Multiculturalism," in *Exhibiting Cultures*, 1–9. "Twenty years ago it still was credible to assert the possibility of the temple role, but now few serious museum practitioners would claim that a museum could be anything but a forum (although exhibitions themselves often have failed to reflect this changed view)" (3–4).

42. Elaine Heumann Gurian, "Noodling around with Exhibition Opportunities," in *Exhibiting Cultures*, ed. Karp and Lavine, 177.

43. From the Albuquerque comment book.

44. Hazel Carby, "The Multicultural Wars," in Black Popular Culture, a project by Michele Wallace, ed. Gina Dent, 193.

45. Luke, Shows of Force, 178–179.

46. Quoted in Santiago, "La Raza Goes Uptown," 4.

47. Steven Vincent, "Political Correctness and Its Discontents," Art and Auction (June 1992): 114.

48. Frank Romero, Gilbert "Magú" Luján, and Carlos Almaraz.

49. Gronk and Patssi Valdéz.

50. Ester Hernández.

51. See The Art of Rupert García: A Survey Exhibition, exhibition catalog, text by Ramón Favela (San Francisco: Chronicle Books and Mexican Museum, 1986); Rupert García: Prints and Posters, 1967–1990; Carmen Lomas Garza: Lo Real Maravilloso/The Marvelous/The Real; Carmen Lomas Garza: Pedacito de mi corazón, exhibition catalog, essay by Amalia Mesa-Bains (Austin: Laguna Gloria Art Museum, 1991).

52. See Montoya and Salkowitz-Montoya, "A Critical Perspective on the State of Chicano Art."

53. Brown, "A Community's Self-Portrait," 22.

54. See Sanchez-Tranquilino, letter to the editor, 3.

55. See "Narrative Content" in the third NEH proposal, CARA Archives, UCLA.

56. Sanchez-Tranquilino, letter, 3.

57. See "Narrative Content" in the third NEH proposal, CARA Archives, UCLA.

58. Tomás Ybarra-Frausto, personal interview, March 5, 1993.

59. Guillermo Gómez-Peña, "Death on the Border: A Eulogy to Border Art," High Performance (Spring 1991): 8.

60. Ibid.

61. Ibid., 9.

62. See Robbie Farley-Villalobos, "Chicano Exhibit Draws 4,000 on First Day: Lowriders and Dancers Lead Off Emotional Museum Experience," El Paso Herald Post (August 24, 1992), sec. B: 1. Prior to CARA, the largest opening crowd at the El Paso Museum was 800 viewers for The Latin American Spirit in 1988.

63. See Renee Ramírez, "Crowd for Chicano Exhibit Is New Museum of Art Record," El Paso Times (August 24, 1992), sec. B: 1+.

64. See "CARA Fosters Recognition of Chicano Culture," El Paso Times editorial, n.d., n. pag., media packet, CARA Archives, UCLA.

65. See Willful Neglect: The Smithsonian Institution and U.S. Latinos.

66. Since CARA, the art world has seen several exhibitions of Chicano/a art, including single-artist retrospectives like Gronk! A Living Survey, 1973–1993 (organized by the Mexican Museum in San Francisco), Man on Fire/El Hombre en Llamas: Luis Jiménez (organized by the Albuquerque Museum of Art), and

Emanuel Martínez: A Retrospective (organized by Museo de las Américas in Denver, Colorado) and traveling exhibitions like *Art of the Other Mexico: Sources and Meanings* (organized by the Mexican Fine Arts Center Museum in Chicago) and *Across the Street: Self-Help Graphics and Chicano Art in Los Angeles* (organized by the Laguna Art Museum in Laguna Beach, California, and Self-Help Graphics in Los Angeles). Also, from 1992 to 1996, the Mexican Museum in San Francisco presented a series of four traveling exhibitions on Chicano/a art. The series is entitled *Redefining the Aesthetic: Toward a New Vision of American Culture* and was sponsored by the Lila Wallace–Reader's Digest Fund. The four shows were *The Chicano Codices: Encountering Art of the Americas*, curated by Marcos Sanchez-Tranquilino; *Ceremony of Spirit: Nature and Memory in Contemporary Latino Art*, curated by Amalia Mesa-Bains; *Xicano Progeny: Investigative Agents, Executive Council, and Other Representatives from the Sovereign State of Aztlán*, curated by Armando Rascón; and *From the West: Chicano Narrative Photography*, curated by Chon A. Noriega.

67. John Berger, *Ways of Seeing* (New York: Penguin Books, 1973), 9.

Bibliography

Reviews of the CARA Exhibition

Los Angeles: September 9–December 9, 1990

Acosta-Colón, María. "Chicano Art: Time for a New Aesthetic." *Los Angeles Times* (Sept. 24, 1990), sec. F: 3.

"Afirmación, resistencia y magia: Muestra nacional de Arte Chicano se inaugura en L.A." *Vecinos del Valle* (Sept. 5, 1990): 1, 32.

"Arte Chicano: resistencia y afirmación." *Vecinos del Valle* (Sept. 5, 1990): 1, 32.

"Arte y Resistencia." *La Gente de Aztlán* 21, no. 1 (Oct. 1990): 14.

Brown, Betty Ann. "A Community's Self-Portrait." *New Art Examiner* (Dec. 1990): 20–24.

———. Letter. *New Art Examiner* (Apr. 1991): 4–5.

"CARA Goes on the Road." *UCLA Art Council Newsletter* (Oct. 1990). Media clipping packet, compiled by Vivian Mayer, CARA exhibition archives, UCLA (henceforth cited as media packet).

"CARA Opens at Wight Gallery." *UCLA Art Council Newsletter* (Oct. 1990). Media packet.

"Chicano Art: Resistance and Affirmation." *UCLA Magazine* (Summer 1990): 39.

"Chicano Art: Resistance and Affirmation, 1965–1985." *Art of California* (Sept. 1990). Media packet.

Dunitz, Robin J. "Drawing on a Cultural Movement." *Westways* (Sept. 1990): 24.

Fusco, Coco. "Arte Chicano: Resistencia y Afirmación." *MAS* (Summer 1990): 75.

Garfield, Donald. "This Chicano Art Show Bristles with Politics and Pride." *Museum News* (Nov./Dec. 1990): 26–27.

Garza, Gerard. "Chicano Visions." *Los Angeles Times Calendar* (Aug. 26, 1990): 7+.

Hernández, Rubén. "California: Chicano Art Exhibition." *Hispanic* (Nov. 1990): 58, 60.

Márquez, Letisia. "Chicano Art Exhibit at Wight Art Gallery to Close Soon." *Daily Bruin Local News* (Dec. 6, 1990): 7, 23.

Mayer, Vivian. "Chicano Art: Resistance and Affirmation." *Intercambios* (Spring 1991). Media packet.

———. "Wight Exhibit Is First to Focus Exclusively on Chicano Art." *UCLA Today* (Nov. 1990): 3.

Nixon, Bruce. "Art with an Historic Mission." *Artweek* (Sept. 27, 1990): 1+.

Ohland, Gloria. "CARA." *L.A. Weekly* (Sept. 1990): 14–20.

Pierce, Rebecca. "The Quiet Storm: Art Show at UCLA's Wight Gallery Traces Chicano Struggles." *Spirit* (Sept. 1990). Media packet.

Pincus, Robert L. "Vivid Chicano Point of View at UCLA Exhibit." *San Diego Union* (Sept. 23, 1990), sec. E: 1+.

Ramos, Lydia. "Touring Retrospective Examines Chicano Art/Movimiento Chicano Visto a Través del Arte." *Los Angeles Times/Nuestro Tiempo* (Aug. 30, 1990): 12.

"Record Crowd Welcomes CARA." UCLA Art Council Newsletter (Oct. 1990). Media packet.

Rugoff, Ralph. "Resisting Modernism: Chicano Art: Retro Progressive or Progressive Retro?" *L.A. Weekly* (Oct. 5–11, 1990): 43–44.

Ruvalcaba, Carlos. "La mayor 'Cara' del arte chicano en UCLA." *Panorama Dominical* (Oct. 14, 1990): 8.

———. "Un festival de arte digno de los angelinos." *La Opinión* (Sept. 9, 1990): 6–7.

Sanchez-Tranquilino, Marcos. Letter. *New Art Examiner* (Apr. 1991): 3.

Schifrin, Dan. "Movimiento: Celebrating Two Decades of Social, Cultural, and Political Change, the Chicano Community Veers from Tradition to Affirm Their Artistic Vision." *UCLA Daily Bruin* (Sept. 24–27, 1990): 1–2.

Snow, Shauna. "Deep in the Heart of Chicana Art." *Los Angeles Times* (Nov. 7, 1992), sec. F: 1.

"Transformations in the World of Chicano Art." *Chronicle of Higher Education* (Dec. 5, 1990), sec. B: 64.

"UCLA Wight Gallery Presents 'Chicano Art: Resistance and Affirmation, 1965–1985.'" *La prensa de San Diego* (July 27, 1990). Media packet.

Wilson, William. "Chicano Show Mixes Advocacy, Aesthetics." *Los Angeles Times* (Sept. 12, 1990), sec. F: 1+.

———. "Stop the Art World and Let 1990 Off." *Los Angeles Times* (Dec. 23, 1990): 87, 89.

Zavala, Antonio, "Chicano Art: 20 Years of Uphill Battle for La Raza." *Lawndale News* (Aug. 23, 1990). Media packet.

Denver: January 25–March 18, 1991

Brown, Nyal M. "Chicano Art—Testament to the Chicano Movement." *La Voz* (Jan. 30, 1991): 9.

"CARA Exhibit Explores Chicano Culture." *Denver Catholic Register* (Feb. 6, 1991). Media packet.

"Chicano Art Exhibit on View." *Denver Herald-Dispatch* (Feb. 21, 1991). Media packet.

"Chicano Exhibit Explores Art of Civil Rights Movement." *Denver Spectrum* (Jan. 1991). Media packet.

"Chicano Exhibit Explores Art of Civil Rights Movement." *Sterling Journal-Advocate* (Feb. 5, 1991). Media packet.

"Chicano Murals Shown in Denver." *SLV Midweek* (Jan. 5, 1991). Media packet.

Clegg, Nancy. "The Art of Politics." *Westword* (Feb. 6–12, 1991): 30.

de Cossío, Francisco González. "Cara—Chicano Art Exhibit a Product of Southwest History." *La Voz* (Feb. 6, 1991). Media packet.

Dickinson, Carol. "Pride and Power." *Rocky Mountain News* (Jan. 27, 1991): 75+.

Espinoza, Juan. "CARA." *Pueblo Chieftain* (Feb. 10, 1991), sec. D: 1+.

"Face to Face with Chicano Art." *On and Off the Wall: Denver Art Museum Newsletter* (Jan./Feb. 1991): 4–5.

Hornby, Bill. "A New Era Dawns on Chicano Art." *Denver Post* (Jan. 31, 1991), sec. B: 7.

Johnson, Richard. "Art Experts Maintain a Low Profile." *Denver Post* (Mar. 4, 1991), sec. E: 1+.

Motian-Meadows, Mary. "Chicano Art: Resistance and Affirmation." *Muse: Colorado's Journal of the Arts* (Dec./Jan. 1990): 1, 3.

Romero, Tomás. "The Birth of a Multicultural City." *Denver Post* (Mar. 13, 1991), sec. B: 7.

———. "Chicano Art Visions: El Espíritu de La Raza." *Denver Post* (Jan. 23, 1991), sec. B: 7.

Rosen, Steven. " 'Chicano Art' Show Had Political Thrust." *Denver Post* (Mar. 24, 1991), sec. E: 3.

———. "History Viewed in Chicano Art." *Denver Post* (Jan. 25, 1991), sec. E: 1+.

Terhune, Linda. "Colors of Protest: Denver Art Exhibit Gives an Inside Look

into Chicano Culture." *Colorado Springs Gazette Telegraph* (Feb. 15, 1991), sec. E: 1.

Albuquerque: April 7–June 9, 1991

Armas, José. "CARA Is Base to Compare Other Chicano Art Shows." *Albuquerque Journal* (May 26, 1991). Media packet.

———. "Recent Lectures, Exhibits Celebrate Rich Hispanic Culture." *Albuquerque Journal* (Apr. 28, 1991), sec. B: 3.

"Arte Chicano en Albuquerque." *El Hispano News* (Apr. 5–11, 1991): 1.

Clark, William. "Beauty from the Barrio." *Albuquerque Journal* (Apr. 7, 1991), sec. F: 1+.

Hernández-Ramos, Sara. "Exhibición de Arte Chicano." *El Hispano News* (Apr. 12–18, 1991). Media packet.

Neese, Della. "Chicano Art Featured in Exhibit." *New Mexico Daily Lobo* (Apr. 11, 1991). Media packet.

Noyer, Albert. "Chicano Art: Anger, Humor and Love from the Barrio." *East Mountain Telegraph* (Apr. 18, 1991): 10.

Reed, Mollie, Jr. "Nuevo Icons: Exhibit Mixes Pop Culture with Traditional Works." *Albuquerque Tribune* (Apr. 9, 1991). Media packet.

Romero, Alex G. "Chicano Exhibit Communicates Struggle for Identity." Editorial. *Albuquerque Tribune* (n.d.). Media packet.

Ron, Ricardo. "Ser Chicano es poseer una conciencia crítica." *El Mensajero* (May 29–June 4, 1991): 1, 4.

Sierra, Christine. "Art Show Distills Cultural Pride, Defiance, Endurance." *Albuquerque Tribune* (May 2, 1991). Media packet.

Spring, Robin. "The Chicano Experience: History as Art." *Voice* (Apr. 3, 1991). Media packet.

San Francisco: June 27–August 25, 1991

"Arte Chicano: resistencia y afirmación." *El Mensajero* (June 12–18, 1991): 2+.

Baker, Kenneth. "'Chicano Art' Hits Town." *San Francisco Chronicle* (June 27, 1991), sec. E: 1.

Bonetti, David. "Exhibit Celebrates La Raza." *San Francisco Examiner* (July 5, 1991), sec. D: 1+.

Burkhart, Dorothy. "Huge, Exuberant Exhibit Celebrates Chicano Culture." *San Jose Mercury News* (July 5, 1991). Media packet.

"A Celebration of Chicano Art." *Morena* (Aug. 1991): 7.

"Chicano Art: Resistance and Affirmation." *Azure* (June/July 1991). Media packet.

"Chicano Art: Resistance and Affirmation." *Cambio Cultural* (July 1991): 7.

Bibliography

282

Fink, Rita. "Chicano MOMA Show: History in the Making." Morena (Aug. 1991). Media packet.

Fowler, Carol. "Artists Find the Pulse of Chicano Life." Contra Costa Times (July 11, 1991), sec. F: 1+.

Goldman, Shifra, and Ybarra-Frausto, Tomás. "Arte Chicano: origen social y político." El Mensajero (June 26–July 2, 1991): 9.

Kay, Alfred. "Chicano Artists Share Visions of Power." Sacramento Bee (July 7, 1991), Encore: 6.

———. "Chicano Art Sizzles with Power." Press Democrat, Santa Rosa (July 14, 1991). Media packet.

———. "Chicano Exhibit Embodies History." Marin County Independent Journal (July 4, 1991). Media packet.

Littlejohn, David. "Art in Service of Revolution." Wall Street Journal (Aug. 29, 1991), sec. A: 10.

Martínez, Victor. "¿Es CARA una bendición?" Tecolote (July 15–Aug. 15, 1991): 4+.

Pepper, Margot. "Resistance and Affirmation: The Chicano Movement Had a Short History, But the Pieces in the Touring 'Chicano Art' Exhibit Attest That El Movimiento's Message Is Still Politically Potent." San Francisco Bay Guardian (June 26, 1991): 33+.

Santiago, Chiori. "CARA: The Face of a Movement." El Andar (August 1991): 6+.

———. "La Raza Goes Uptown." San Francisco Weekly (June 26, 1991): 13.

Scott, Nancy. "Art with a Mission." San Francisco Examiner Image (June 23, 1991): 12+.

Stutzin, Leo. "Chicano Art Gets Spotlight." Modesto Bee (June 30, 1991), sec. D: 7.

"Summer of Festivities Highlights Chicano Art." San Francisco Chronicle (June 28, 1991), sec. F: 10.

"Una celebración de arte Chicano." El Bohemio News (July 12, 1991). Media packet.

"Una celebración del arte Chicano." El Mensajero (June 12–18, 1991): 2.

"Viva La Raza." El Mensajero (June 26–July 2, 1991): 8.

Fresno: September 21 –November 24, 1991

"Chicano Art on Display." Bakersfield Californian (Nov. 3, 1991), sec. F: 1+.

Hale, David. "The Art of 'La Causa': Bittersweet Images of Passion, Color." Fresno Bee (Oct. 13, 1991): 3+.

———. "Resistance and Affirmation: Multimedia Collection Offers Both History Lesson and Tribute to Chicano Art." Fresno Bee (Sept. 22, 1991): 11+.

Heredia, Rick. "Chicano Art on Display: Fresno Exhibit Reflects Struggle, Hope of Political Movement." Bakersfield Californian (Nov. 3, 1991), sec. F: 2+.

Tucson: January 19–April 5, 1992

"Arte Chicano en Tucson." El Imparcial (Feb. 25, 1992), sec. D: 4.

Cauthorn, Robert S. "Touring Exhibition Charts Origin, Politics of Heroic, Vital Works." Arizona Daily Star (Jan. 19, 1992), sec. E: 1+.

"Chicano Art Tells a Story/El arte chicano relata la historia." Desafío Bilingüe (n.d.). Media packet.

"Eight Arizonans in Chicano Art Exhibit." Phoenix Magazine (Jan. 1992). Media packet.

"Face to Face with Chicano Art." Preview (Winter 1992): 8+.

Johnson, Tina V. "Chicano Art." Desert Leaf (Mar. 1992): 19.

Lowe, Charlotte. "A Giant Leap for Chicano Art." Tucson Citizen (Jan. 16, 1992): 9+.

"Major Chicano Art Show to TMA." Dateline: Downtown (Jan. 1992). Media packet.

Stevens, Carolyn. "Chicano Art Portrays Past and Present Struggles/Arte refleja la historia chicano." El Independiente (Feb. 1992): 6.

Torres, Alva B. "CARA: An Exhibit Worthwhile to See." Tucson Citizen (Mar. 10, 1992). Media packet.

———. "CARA Draws Raves from Museum-goers." Tucson Citizen (Feb. 4, 1992). Media packet.

———. "CARA Exhibition: The Show of Shows." Tucson Citizen (Jan. 21, 1992). Media packet.

Washington, D.C.: May 8–July 26, 1992

"Arte Chicano: resistencia y afirmación, 1965–1985." El Hispano (May 1, 1992): 13.

"Arte Chicano en Washington." Impacto (Apr. 25, 1992). Media packet.

Benanti, Mary. "Chicano Art: Up Close." Gannett News Service. May 13, 1992.

———. "Smithsonian Opens Door to Chicano History." Gannett News Service. May 13, 1992.

Burchard, Hank. "Celebrating Chicano Art." Washington Post (May 8, 1992), sec. G: 1.

"Chicano Art—Resistance and Affirmation, 1965–1985." Gaceta Iberoamericana (May–June 1992). Media packet.

Cockcroft, Eva Sperling. "Chicano Identities." Art in America (June 1992): 84+.

"El Museo de Arte Americano presenta 'Arte Chicano.'" Crónica (May 1, 1992). Media packet.

"Festival of Color and Power." El Diario de la Nación (May 14, 1992). Media packet.

Fox, Catherine. "You've Got to Have Art, Washington's Mall Has It All." Atlanta Journal and Constitution (May 27, 1992), sec. E: 7.

Bibliography

284

Gibson, Eric. "Politically Correct 'Chicano' Is a Radical Dud." *Washington Times* (June 21, 1992), sec. D: 8.

Guerrero, Angélica. "Exhibición de arte chicano toma otra vez las salas del Instituto Smithsonian." FORO (May 22, 1992): 13+.

Kilian, Michael. "Life, Death, Love, and Politics: Chicano Exhibit Speaks with 'Voice of the People.'" *Chicago Tribune* (May 25, 1992), sec. C: 1+.

Richard, Paul. "The Colors of Struggle: The Politicized Palette of 'Chicano Art.'" *Washington Post* (May 10, 1992), sec. G: 1.

Roncal, Rafael. "El mapa de una vida: La cultura chicana: resistencia y afirmación." *El Pregonero* (May 14, 1992): 10+.

————. "Muestra integral del arte chicano se está exhibiendo en Washington." *El Pregonero* (May 7, 1992): 4.

Weil, Rex. "The Art of a Movement." *Washington City Paper* (June 12, 1992): 1.

Wilson, Janet. "Paintings Furnished with Allusions." *Washington Post* (May 23, 1992), sec. D: 2.

El Paso: August 25–October 25, 1992

Armijo, Phyllis. "An End to Stereotypes." *El Paso Times* (Aug. 23, 1992), sec. F: 1+.

"Art and Civil Rights Tied in Exhibit." *El Paso Times* (Aug. 21, 1992), El Tiempo: 7.

Benanti, Mary. "Chicano Art Multicultural Blend of Varied Backgrounds." *El Paso Times* (Aug. 21, 1992), El Tiempo: 7.

————. "Chicano Struggle Depicted in Artwork." *El Paso Times* (Aug. 21, 1992), El Tiempo: 8.

"CARA Exhibit Stirs Souls, Emotions." *El Paso Times* (Sept. 8, 1992), sec. D: 5.

"Chicano Arts on Display." Gannett News Service (Oct. 22, 1992).

Duarte, Pete. "Life of Culture, Conflicts." *El Paso Times* (Aug. 23, 1992), sec. F: 1+.

Farley-Villalobos, Robbie. "Lowriders and Dancers Lead Off Emotional Museum Experience." *El Paso Herald-Post* (Aug. 24, 1992), sec. B: 1+.

Nelson, Robert. "Art Exhibit to Emphasize Local Talent." *El Paso Times* (Aug. 21, 1992), El Tiempo: 8+.

————. "Art on Wheels Takes to the Street in Sunday's Lowrider Parade." *El Paso Times* (Aug. 21, 1992), El Tiempo: 9.

————. "Works by El Paso Artists Focus on Everyday Lives of Hispanics." *El Paso Times* (Aug. 23, 1992), sec. F: 2.

Ramírez, Renee. "Crowd for Chicano Exhibit Is New Museum of Art Record." *El Paso Times* (Aug. 24, 1992), sec. B: 1+.

Soriano, Irene. "Show Touches All People from All Backgrounds." *El Paso Times* (Aug. 23, 1992), sec. F: 1+.

The Bronx: March 2–May 2, 1993

Cotter, Holland. "Chicano Art: A Lustier Breed of Political Protest." *New York Times* (Apr. 4, 1993), late ed.: 37.

Fernández, Enrique. "Birth of La Raza." *Village Voice* (Apr. 6, 1993): 26.

Iverem, Esther. "Chicano Exhibit Transcends Social and Political Themes." *Newsday* (Mar. 16, 1993), city ed., part II: 51.

New Yorker. Untitled review. (May 3, 1993): 17.

Noriega, Chon. "Resistance and Affirmation." *Art/World* (Apr./May 1993): 4.

Zimmer, William. "Chicanos Define Themselves in a World of Mixed Messages." *New York Times* (Apr. 4, 1993), late ed., sec. 13WC: 24.

San Antonio: May 29–August 1, 1993

(Listings are incomplete for this venue.)

Burr, Ramiro. "Exhibit Draws Praise for Cultural Education: CARA Called a Communication." *San Antonio Express-News* (May 30, 1993), sec. F: 1+.

Ennis, Michael. "Moving Pictures." *Texas Monthly* (July 1992): 52+.

Goddard, Dan R. "CARA—Chicano Art: Resistance and Affirmation: It's Part Politics, Part Journalism, All Community Pride." *San Antonio Express News* (May 30, 1993), sec. F: 1+.

———. "Caravan of Lowriders to Kick Off Art Exhibit." *San Antonio Express News* (May 25, 1993). Media packet.

Archives, Collections, Personal Papers

Chicano Art: Resistance and Affirmation Exhibition Archives. Armand Hammer Museum, University of California, Los Angeles.

Chicano Art: Resistance and Affirmation Exhibition Comment Books. Albuquerque Museum of Art Archives, Albuquerque, New Mexico.

Chicano Art: Resistance and Affirmation Exhibition Comment Books. National Museum of American Art, Smithsonian Institution Archives, Washington, D.C.

Holly Barnet-Sanchez and Marcos Sanchez-Tranquilino Papers. Special Collections, Stanford University Libraries.

Yolanda M. López, personal papers.

Transcripts of Oral Sources

Barraza, Santa Contreras. Personal interview. San Antonio, Texas, July 16, 1992.

Cárdenas, Gilberto. Personal interview. Austin, Texas, July 12, 1992.

Connors, Andrew. Personal interview. Washington, D.C., June 15, 1992.

Gamboa, Harry, Jr. Conversation with the artist. Los Angeles, California, January 1994.

Lomas Garza, Carmen. Telephone interview. February 1, 1994.

López, Yolanda M. Personal interview. San Francisco, California, January 1994.

Martínez, César. Personal interview. San Antonio, Texas, July 16, 1992.

McKenna, Teresa. Transcript of comments on the CARA Exhibition Panel (Faces of Quality) presented at the American Studies Association Convention, Boston, Massachusetts, November 1993.

Moore, James. Personal interview. Albuquerque, New Mexico, October 9, 1992.

Nieves, Marysol. Personal interview. The Bronx, New York, May 1, 1993.

Pérez, Cynthia. Personal interview. Austin, Texas, July 12, 1992.

Rodríguez, Pedro. Personal interview. San Antonio, Texas, July 13, 1992.

Sanchez-Tranquilino, Marcos. Telephone conversation. February 13, 1993.

Shepherd, Elizabeth. Telephone interview. February 24, 1994.

Ybarra-Frausto, Tomás. Personal interview. Los Angeles, California, March 5, 1993.

Periodicals and Special Issues

ChisméArte: A Quarterly Publication of the Concilio de Arte Popular 1, no. 4 (Fall/Winter 1977). Special Issue: "La Mujer."

Community Murals Magazine (San Francisco) (Fall 1982).

CrossRoads: A Salute to Latinas in the Arts 31 (May 1993). Ed. Arnoldo García and Elizabeth Martínez. Oakland: Institute for Social and Economic Studies.

Cultural Studies (Oct. 1990). Special Issue: "Chicana/o Cultural Representations: Reframing Alternative Critical Discourses," ed. Rosa Linda Fregoso and Angie Chabram, assisted by Lawrence Grossberg.

Differences: A Journal of Feminist Cultural Studies (Summer 1991). Special Issue: "Queer Theory: Lesbian and Gay Sexualities."

Differences: A Journal of Feminist Cultural Studies (Fall 1992). Special Issue: "Trouble in the Archives."

Eastman, Kevin, and Peter Laird. Teenage Mutant Ninja Turtles 1, no. 1 (sixth printing, Aug. 1992). Northampton, Mass.: Mirage Publishing.

"Hispanic Culture Breaks Out of the Barrio." Time (July 11, 1988): 46–84. Special Issue.

Huracán: 500 Years of Resistance 2, nos. 1, 2. (Summer 1991). A Publication of the Alliance for Cultural Democracy. Minneapolis.

Imagine: International Chicano Poetry Journal 2, no. 1 (Summer 1985). Frida Kahlo issue.

Imagine: International Chicano Poetry Journal 3, nos. 1–2 (Summer–Winter 1986). Arte Chicano issue.

Indigenous Thought: A Networking Newsletter to Link Counter-Columbus Quincentenary Activities 1, no. 1 (Jan.–Feb. 1991); 1, nos. 2–3 (Mar.–June 1991). Gainesville, Fla.

Theses and Dissertations

Gaspar de Alba, Alicia. "Mi Casa [No] Es Su Casa: The Cultural Politics of the Chicano Art: Resistance and Affirmation, 1965–1985 Exhibition." Diss. University of New Mexico, 1994 (this dissertation received the Ralph Henry Gabriel Award for the Best Dissertation in American Studies for 1994).

Kosiba-Vargas, S. Zaneta. "Harry Gamboa and ASCO: The Emergence and Development of a Chicano Art Group, 1971–1987." Diss. University of Michigan, 1988.

Krauter, Ute Ulrike. "Popular Culture, Mass Media, and Chicano Identity: Three Literary Responses." M.A. thesis. University of New Mexico, December 1988.

Sanchez-Tranquilino, Marcos. "Mi Casa No Es Su Casa: Chicano Murals and Barrio Calligraphy as Systems of Signification at Estrada Courts, 1972–1978." M.A. thesis, University of California, Los Angeles, 1991.

Turner, Kay. "Mexican-American Women's Altars: The Art of Relationship." Diss. University of Texas at Austin, 1990.

Vargas, George. "Contemporary Latino Art in Michigan, the Midwest, and the Southwest." Diss. University of Michigan, 1988.

Secondary Sources Cited

Books

Acosta, Oscar Zeta. The Revolt of the Cockroach People. New York: Vintage Books, 1973.

Acuña, Rodolfo. Occupied America: A History of Chicanos. 3rd edition. New York: HarperCollins, 1988.

Anzaldúa, Gloria. Borderlands/La Frontera: The New Mestiza. San Francisco: spinsters/aunt lute, 1987.

———. Haciendo Caras/Making Face, Making Soul: Creative and Critical Perspectives by Women of Color. San Francisco: aunt lute foundation, 1990.

Bright, Brenda Jo, and Liza Bakewell, eds. Looking High and Low: Art and Cultural Identity. Tucson: University of Arizona Press, 1995.

Broude, Norma, and Mary D. Garrard, eds. The Power of Feminist Art: The American Movement of the 1970s, History and Impact. New York: Harry N. Abrams, 1994.

Bunting, Bainbridge. Early Architecture of New Mexico. Albuquerque: University of New Mexico Press, 1976.

Burciaga, Antonio. Drink Cultura: Chicanismo. Santa Barbara: Capra Press, 1993.

Castañeda Shular, Antonia, Tomás Ybarra-Frausto, and Joseph Sommers, eds. Literatura Chicana: Texto y contexto/Chicano Literature: Text and Context. Englewood Cliffs, N.J.: Prentice-Hall, 1972.

Chávez, John R. The Lost Land: The Chicano Image of the Southwest. Albuquerque: University of New Mexico Press, 1984.

Chicano Art: Resistance and Affirmation, 1965–1985. Exhibition book. Ed. Richard Griswold del Castillo, Teresa McKenna, and Yvonne Yarbro-Bejarano. Los Angeles: Wight Art Gallery, University of California, Los Angeles, 1991.

Clifford, James. The Predicament of Culture: Twentieth-Century Ethnography, Literature, and Art. Cambridge, Mass.: Harvard University Press, 1988.

Clifford, James, and George E. Marcus. Writing Culture: The Poetics and Politics of Ethnography. Berkeley: University of California Press, 1986.

Cockcroft, Eva Sperling, and Holly Barnet-Sanchez, eds. Signs from the Heart: California Chicano Murals. Venice, Calif.: Social and Public Art Resource Center, 1990.

Darío, Rubén. Selected Poems. Trans. Lysander Kemp. Austin: University of Texas Press, 1965.

Davis, Douglas. Artculture: Essays on the Post-Modern. New York: Harper and Row Publishers, 1977.

Dent, Gina, ed. Black Popular Culture. A project by Michelle Wallace. Seattle: Bay Press, 1992.

During, Simon, ed. The Cultural Studies Reader. New York: Routledge, 1993.

Fiske, John. Understanding Popular Culture. Boston: Unwin Hyman, 1989.

Friedman, Lester D., ed. Unspeakable Images: Ethnicity and the American Cinema. Chicago: University of Illinois Press, 1991.

Gates, Henry Louis, Jr. Loose Canons: Notes on the Culture Wars. New York: Oxford University Press, 1992.

Geist, Christopher D., and Jack Nachbar, eds. The Popular Culture Reader. 3rd ed. Bowling Green: Bowling Green University Popular Press, 1983.

Giroux, Henry A. Disturbing Pleasures: Learning Popular Culture. New York: Routledge, 1994.

Goldberg, David Theo, ed. Multiculturalism: A Critical Reader. Cambridge: Blackwell, 1994.

Goldman, Shifra. Dimensions of the Americas: Art and Social Change in Latin America and the United States. Chicago: University of Chicago Press, 1994.

Goldman, Shifra, and Tomás Ybarra-Frausto, eds. Arte Chicano: A Comprehensive Annotated Bibliography of Chicano Art, 1965–1981. Berkeley: University of California Press, 1985.

Gonzales, Rodolfo "Corky." I Am Joaquín/Yo Soy Joaquín: An Epic Poem. New York: Bantam, 1972.

Gordon, Avery F., and Christopher Newfield, eds. Mapping Multiculturalism. Minneapolis: University of Minnesota Press, 1996.

Grossberg, Lawrence, Cary Nelson, and Paula Treichler, eds. Cultural Studies. New York: Routledge, 1992.

Hadley-García, George. Hollywood Hispano: Los latinos en las películas. New York: Carol Publishing Group, 1991.

Hebdige, Dick. Subculture: The Meaning of Style. London: Methuen, 1979.

Herrera, Hayden. Frida: A Biography of Frida Kahlo. New York: Harper and Row Publishers, 1983.

hooks, bell. Art on My Mind: Visual Politics. New York: New Press, 1995.

————. Yearning: Race, Gender, and Cultural Politics. Boston: South End Press, 1990.

Jameson, Fredric. Postmodernism: Or, The Cultural Logic of Late Capitalism. Durham: Duke University Press, 1991.

Kanellos, Nicolás. A History of Hispanic Theater in the United States: Origins to 1940. Houston: Arte Publico Press, 1990.

Karp, Ivan, Christine Mullen Kreamer, and Steven D. Lavine, eds. Museums and Communities: The Politics of Public Culture. Washington, D.C.: Smithsonian Institution Press, 1992.

Karp, Ivan, and Steven D. Lavine, eds. Exhibiting Cultures: The Poetics and Politics of Museum Display. Washington, D.C.: Smithsonian Institution Press, 1991.

La Frontera/The Border: Art about the Mexico/United States Border Experience. San Diego: Centro Cultural de la Raza and Museum of Contemporary Art, 1993.

Lippard, Lucy R. Mixed Blessings: New Art in a Multicultural America. New York: Pantheon Books, 1990.

Lipsitz, George. Time Passages: Collective Memory and American Popular Culture. Minneapolis: University of Minnesota Press, 1990.

Lorde, Audre. Sister/Outsider: Essays and Speeches. Freedom, Calif.: Crossing Press, 1984.

Luke, Timothy. Shows of Force: Power, Politics, and Ideology in Art Exhibitions. Durham: Duke University Press, 1992.

Maciel, David R., and Isidro D. Ortiz, eds. Chicanas/Chicanos at the Crossroads: Social, Economic, and Political Change. Tucson: University of Arizona Press, 1996.

Martínez, Elizabeth, ed. 500 Años del Pueblo Chicano/500 Years of Chicano History in Pictures. Albuquerque: SouthWest Organizing Project (SWOP), 1992.

Mazón, Mauricio. The Zoot Suit Riots: The Psychology of Symbolic Annihilation. Austin: University of Texas Press, 1984.

McWilliams, Carey. North from Mexico: The Spanish-Speaking People of the United States. New York: Praeger, 1990 (originally published 1948).

Millett, Kate. Sexual Politics. New York: Avon, 1971.

Modleski, Tania. Feminism without Women: Culture and Criticism in a "Postfeminist" Age. New York: Routledge, 1991.

————, ed. Studies in Entertainment: Critical Approaches to Mass Culture. Bloomington: Indiana University Press, 1986.

Mohanty, Chandra Talpade, Ann Russo, and Lourdes Torres, eds. Third World

Women and the Politics of Feminism. Bloomington: Indiana University Press, 1991.

Montejano, David. *Anglos and Mexicans in the Making of Texas, 1836–1986.* Austin: University of Texas Press, 1987.

Mora, Pat. *Nepantla: Essays from the Land in the Middle.* Albuquerque: University of New Mexico Press, 1993.

Moraga, Cherríe. *The Last Generation: Prose and Poetry.* Boston: South End Press, 1993.

Morton, Margaret. *The Tunnel: The Underground Homeless of New York City.* New Haven: Yale University Press, 1996.

Mukerji, Chandra, and Michael Schudson, eds. *Rethinking Popular Culture: Contemporary Perspectives in Cultural Studies.* Berkeley and Los Angeles: University of California Press, 1991.

Nachbar, Jack, and Kevin Lause, eds. *Popular Culture: An Introductory Text.* Bowling Green: Bowling Green University Popular Press, 1992.

Nash Smith, Henry. *Virgin Land: The American West as Symbol and Myth.* Cambridge, Mass.: Harvard University Press, 1950.

Nathan, Debbie. *Women and Other Aliens: Essays from the U.S.-Mexico Border.* El Paso: Cinco Puntos Press, 1991.

Olalquiaga, Celeste. *Megalopolis: Contemporary Cultural Sensibilities.* Minneapolis: University of Minnesota Press, 1992.

Olivares, Julian, ed. *Tomás Rivera: The Complete Works.* Houston: Arte Publico Press, 1992.

Paredes, Américo. *"With His Pistol in His Hand": A Border Ballad and Its Hero.* Austin: University of Texas Press, 1958.

Pérez, Ramón *"Tianguis." Diary of an Undocumented Immigrant.* Trans. Dick J. Reavis. Houston: Arte Publico Press, 1991.

Quirarte, Jacinto. *Mexican-American Artists.* Austin: University of Texas Press, 1973.

Raven, Arlene, Cassandra Langer, and Joanna Frueh, eds. *Feminist Art Criticism.* New York: Icon Editions, 1991.

Rendón, Armando. *Chicano Manifesto.* New York: Collier Books, 1971.

Rosaldo, Renato. *Culture and Truth: The Remaking of Social Analysis.* Boston: Beacon Press, 1989, 1993.

Rowe, William, and Vivian Schelling, eds. *Memory and Modernity: Popular Culture in Latin America.* New York: Verso, 1991.

Rupert García: Prints and Posters, 1967–1990/Grabados y afiches 1967–1990. With essays by Robert Flynn Johnson and Lucy R. Lippard. San Francisco: Fine Arts Museum of San Francisco, 1990.

Schaefer, Claudia. *Textured Lives: Women, Art, and Representation in Modern Mexico.* Tucson: University of Arizona Press, 1992.

Seigel, Judy, ed. *Mutiny and the Mainstream: Talk That Changed Art, 1975–1990.* New York: Midmarch Arts Press, 1992.

Solomon, Jack. *The Signs of Our Time: The Secret Meanings of Everyday Life*. New York: Harper and Row Publishers, 1988.

Spivak, Gayatri Chakravorty. *The Post-Colonial Critic: Interviews, Strategies, Dialogues*. Ed. Sarah Harasym. New York: Routledge, 1990.

Thompson, Becky W., and Sangeeta Tyagi, ed. *Beyond a Dream Deferred: Multicultural Education and the Politics of Excellence*. Minneapolis: University of Minnesota Press, 1993.

Trujillo, Carla, ed. *Chicana Lesbians: The Girls Our Mothers Warned Us About*. Berkeley: Third Woman Press, 1991.

Turner, Frederick Jackson. *The Early Writings of Frederick Jackson Turner, with a List of All His Works*. Compiled by Everett E. Edwards; with an introduction by Fulmer Mood. Madison: University of Wisconsin Press, 1938.

Villanueva, Tino, ed. *Chicanos (selección)*. Mexico City: Lecturas Mexicanas, 1985.

Walker, Alice. *In Search of Our Mothers' Gardens*. New York: Harcourt Brace Jovanovich Publishers, 1983.

Weedon, Chris. *Feminist Practice and Poststructuralist Theory*. New York: Basil Blackwell, 1987.

Weil, Stephen. *Rethinking the Museum and Other Meditations*. Washington, D.C.: Smithsonian Institution Press, 1990.

Willful Neglect: The Smithsonian Institution and U.S. Latinos. Report of the Smithsonian Institution Task Force on Latino Issues. Raúl Yzaguirre, Chair. Prepared for Robert McC. Adams, Secretary, and Constance Berry Newman, Under Secretary. Washington, D.C.: Smithsonian Institution, May 1994.

Wolff, Janet. *Aesthetics and the Sociology of Art*. 2nd ed. Ann Arbor: University of Michigan Press, 1993.

Zinn, Howard. *A People's History of the United States*. New York: Harper and Row Publishers, 1980.

Zuno, José G. *Historia de las artes plásticas en la revolución mexicana*. Mexico City: Biblioteca del Instituto Nacional de Estudios Históricos de la Revolución Mexicana, 1967.

Articles and Papers

Alarcón, Norma. "The Theoretical Subject(s) of *This Bridge Called My Back* and Anglo-American Feminism." In *Criticism in the Borderlands: Studies in Chicano Literature, Culture, and Ideology*, ed. Héctor Calderón and José David Saldívar, 28–39. Durham: Duke University Press, 1991.

Aparicio, Frances. "On Multiculturalism and Privilege: A Latina Perspective." *American Quarterly* 46, no. 4 (Dec. 1994): 575–588.

Baker, Houston A., Jr. "Of Ramadas and Multiculturalism." President's Column, *MLA Newsletter* (Summer 1992): 2.

Barkan, Elazar. "Producing Columbus: American Identity and the Quincentenary." In *The Columbian Quincentenary: A Reappraisal*, 3–7. Exhibition catalog. Claremont, Calif.: Lang Gallery, Scripps College, 1993.

Bertin, Maggie. "The Latino Working Committee: The Challenge of Cultural Representation in a Large Museum." Paper presented at the Inter-University Program for Latino Research, Latino Graduate Training Seminar in Qualitative Methodology—Interpreting Latino Cultures: Research and Museums, June 18, 1995.

Brookman, Philip. "Conversations at Cafe Mestizo: The Public Art of David Avalos." In *Cafe Mestizo*, 6–23. Exhibition catalog. New York: Intar Latin American Gallery, 1989.

Burchard, Hank. "How the West Was Rewritten." Review of *The West as America* exhibition. *Washington Post* (Mar. 15, 1991): 1.

Camnitzer, Luis. "Access to the Mainstream." *New Art Examiner* (June 1987): 20–23.

Cassedy, Susannah. "The High Art of Lowriding." *Museum News* (July/Aug. 1992): 28.

Cembalest, Robin. "Goodbye, Columbus?" *ARTnews* (Oct. 1991): 104–109.

Churchill, Ward, "Deconstructing the Columbus Myth: Was the 'Great Discoverer' Italian or Spanish, Nazi or Jew?" *Indigenous Thought* 1, nos. 2–3 (March–June 1991): 28A–31A.

Connors, Andrew. "Turning the Titanic: Can the Smithsonian Responsibly Face the Art of Non-Mainstream America?" Paper presented at the Faces of Quality: The CARA Exhibit panel for the American Studies Association Convention. Boston, Massachusetts, Nov. 1993.

Córdova, Teresa. "Roots and Resistance: The Emergent Writings of Chicana Feminist Struggle." In *Handbook of Hispanic Cultures in the United States: Sociology*, ed. Félix Padilla, 175–202. Houston: Arte Publico Press, 1992.

Elliott, Jan. "Exhibiting Ideology: A Review of First Encounters: Spanish Explorations in the Caribbean and the United States, 1492–1570." *Akwesasne Notes* (Midwinter 1989–1990): 6–21.

Ellison, Harlan. "Introduction." In *Teenage Mutant Ninja Turtles* 1, no. 1 (sixth printing, Aug. 1992). Ed. Kevin Eastman and Peter Laird, n. pag. Northampton, Mass.: Mirage Publishing.

Gaspar de Alba, Alicia. "The Alter-Native Grain: Theorizing Chicano/a Popular Culture." In *Culture and Difference: Critical Perspectives on the Bicultural Experience in the United States*, ed. Antonia Darder, 103–122. Westport, Conn.: Bergin and Garvey, 1995.

———. "El pueblo que pierde su memoria pierde su destino: un análisis de la esquizofrenia cultural en el pueblo chicano." In *Palabras de allá y de acá: Memoria del sexto encuentro nacional de escritores en la frontera norte de México*, ed. Ricardo Aguilar. Cd. Juárez, Chihuahua: Centrol Editorial Universitario, Apr. 1991.

———. "Literary Wetback." In Infinite Divisions: An Anthology of Chicana Literature, ed. Tey Diana Rebolledo and Eliana S. Rivero, 289–292. Tempe: University of Arizona Press, 1993.

———. "Tortillerismo: Work by Chicana Lesbians." Signs: Journal of Women in Culture and Society 18, no. 4 (Summer 1993): 956–963. Special issue on "Theorizing Lesbian Experience."

Goldman, Shifra M. "How Latin American Artists in the U.S. View Art, Politics, and Ethnicity in a Supposedly Multicultural World." In Beyond Walls and Wars: Art, Politics, and Multiculturalism, ed. Kim Levin, 66–72. New York: Midmarch Arts Press, 1992.

Gómez, Andrea, and Sylvia Gonzales, editorial. El Rebozo. San Antonio, Texas, July 1995.

Gómez-Peña, Guillermo. "Death on the Border: A Eulogy to Border Art." High Performance (Spring 1991): 8–9.

———. "The Multicultural Paradigm: An Open Letter to the National Arts Community." In Warrior for Gringostroika, 45–54. Saint Paul: Graywolf Press, 1993.

Gonzales, Jennifer. "Rhetoric of the Object: Material Memory and the Artwork of Amalia Mesa-Bains." Visual Anthropology Review 9, no. 1 (Spring 1993): 82–91.

González, Deena. "Chicana Identity Matters." In Culture and Difference: Critical Perspectives on the Bicultural Experience in the United States, ed. Antonia Darder, 41–53. Westport, Conn.: Bergin and Garvey, 1995.

———. "On Outside-Insiders." Unpublished paper presented at the American Historical Association Conference in San Francisco, 1994.

———. "Speaking Secrets: Living Chicana Theory." In Living Chicana Theory, ed. Carla Trujillo. Berkeley: Third Woman Press (forthcoming).

Green, Jerald R. "Mexico's Taller de Gráfica Popular, Part I." Latin American Art 4, no. 2 (1992): 65–67.

Heartney, Eleanor. "Ceremonial Art." Sculpture (Sept./Oct. 1992): 31–34.

Hughes, Robert. "Heritage of Rich Imagery." Time (July 11, 1988): 62.

Kerber, Linda. "Diversity and Transformation of American Studies." American Quarterly 41 (1989): 415–431.

López, Sonia. "The Role of the Chicana within the Student Movement." In Essays on la Mujer, ed. Rosaura Sánchez and Rosa Martínez Cruz, 16–29. Los Angeles: UCLA Chicano Studies Research Center Publications, 1977.

López, Yolanda M. Untitled paper presented at the Culture and Society in Dialogue Conference: Issues in Chicana Scholarship, University of California, Irvine, May 14, 1993.

Lord, Catherine. "Bleached, Straightened, and Fixed." New Art Examiner (Feb. 1991): 25–27.

McGee, Celia. "When Museumgoers Talk Back to the Art." New York Times (Apr. 25, 1993), sec. 2: 37.

Bibliography

"Mexico's Loved Clown Exits to Copious Tears." *New York Times* (Apr. 23, 1993): A4.

Montoya, Malaquías, and Lezlie Salkowitz-Montoya. "A Critical Perspective on the State of Chicano Art." *Cambio Cultural* (July 1991): 12.

Nicolai, Dan. "Columbus Commission on the Rocks." *Huracán: 500 Years of Resistance* 2, nos. 1–2 (Summer 1991).

Noriega, Chon. "Installed in America." Curatorial essay. In *Revelaciones/Revelations: Hispanic Art of Evanescence*. Unbound exhibition catalog. Ithaca: Hispanic American Studies Program, Cornell University, 1993.

Reid, Calvin. "Beyond Mourning." *Art in America* 78, no. 4 (Apr. 1990): 51–57.

Salazar, Rubén. "Who Is a Chicano? And What Is It the Chicanos Want?" *Los Angeles Times*, part 2 (Feb. 6, 1970): 7.

Salisbury, Stephen. "Wild in the Streets: Sex, Cities, and the NEA." *American Poetry Review* 21 (Nov.–Dec. 1992): 11–18.

Sánchez, George I. "Pachucos in the Making." *Common Ground* 4 (1943–44): 13–20.

Sandoval, Chela. "U.S. Third World Feminism: The Theory and Method of Oppositional Consciousness in the Postmodern World." *Genders* 10 (Spring 1991): 1–24.

Schudson, Michael. "The New Validation of Popular Culture: Sense and Sentimentality in Academia." *Critical Studies in Mass Communication* 4 (1987): 51–68.

Sleeter, Christine E., and Carl A. Grant. "An Analysis of Multicultural Education in the United States." *Harvard Educational Review* 57, no. 4 (Nov. 1987): 421–444.

Spolar, Christine. "D.C. Police, Hispanics Reach Out." *Washington Post* (May 4, 1992), sec. A: 1+.

Stone, Michael Cutler. "Bajito y suavecito [Low and Slow]: Low Riding and the 'Class' of Class." *Studies in Latin American Popular Culture* 9 (1990): 85–126.

Vance, Carole S. "Issues and Commentary: The War on Culture." *Art in America* 77 (September 1989): 39–43.

Venegas, Sybil. "The Artists and Their Work: The Role of the Chicana Artist." *Chisméarte* 1, no. 4 (Fall/Winter 1977): 3, 5.

———. "Conditions for Producing Chicana Art." *ChisméArte* 1, no. 4 (Fall/Winter 1977): 2, 4.

Wallach, Alan. "Revisionism Has Transformed Art History, But Not Museums." Review of *The West as America* exhibition. *Chronicle of Higher Education* (May 8, 1992): B2.

Wise, Gene. "'Paradigm Dramas' in American Studies: A Cultural and Institutional History of the Movement." *American Quarterly* 31, no. 3 (1979): 293–337.

Ybarra-Frausto, Tomás. "Rasquachismo: A Chicano Sensibility." In *Chicano*

Aesthetics: Rasquachismo, 5–8. Catalog. Phoenix: MARS [Movimiento Artístico del Río Salado], 1989.

―――――. "Sanctums of the Spirit: The *Altares* of Amalia Mesa-Bains." Essay for the *Grotto of the Virgins* exhibition catalog, 2–9. New York: Intar Latin American Gallery, 1987.

Index

Italicized page numbers indicate pages on which artwork appears.

Boldfaced entries indicate exhibition titles.

Index

Index

307